# French Eighteenth-Century Painters

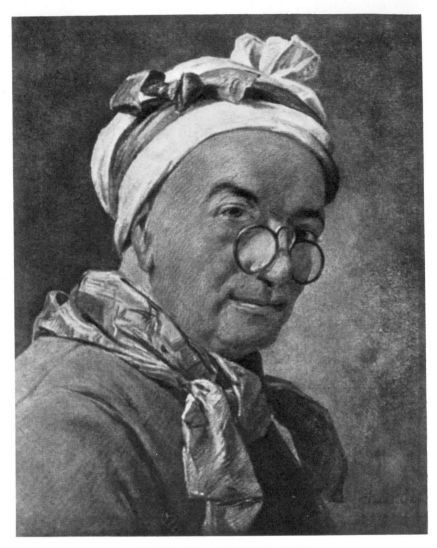

CHARDIN: SELF-PORTRAIT. 1775
Pastel. Paris, Louvre

Edmond and Jules de Goncourt

# FRENCH EIGHTEENTH-CENTURY PAINTERS

WATTEAU · BOUCHER · CHARDIN
LA TOUR · GREUZE
FRAGONARD

A Phaidon Book

Cornell University Press
ITHACA, NEW YORK

First published by Phaidon Press Ltd. 1948
First published, Cornell Paperbacks, 1981

International Standard Book Number 0-8014-9218-1
Library of Congress Catalog Card Number 80-69739

Translated with an Introduction by Robin Ironside

Illustrations selected by Ludwig Goldscheider

Printed in the United States of America

## PUBLISHER'S NOTE

This volume has been photographically reprinted from the first edition, pub-
lished by Phaidon Press in 1948. The four colour plates in the first edition
(frontispiece, and plates facing pages vii, xiv, and 2) are here reproduced in
black and white although they are referred to as 'colour plates' in the list of
illustrations on page 416.

The locations of some of the works reproduced have changed during the
past thirty years. Plate 2 is now in the National Museum, Warsaw; Plates 11
and 15 are now in Schloss Charlottenburg, Berlin; Plate 60 is now in the
National Gallery of Art (Kress Collection) Washington; Plate 65 has been
destroyed; and Plate 82 is now in the Bührle Collection, Zurich. Some other
works listed as belonging to private owners have also changed hands.

# NOTE ON THE 1948 EDITION

A PROPORTION of the authors' multitudinous notes, those, mainly, which would be of negligible interest in translation or those which provide out-of-date or redundant information, has been omitted from the present edition. These omissions include, in the first category, quotations of purely syntactic or orthographic interest, transcripts of birth or marriage certificates, etc., and, in the second, such items as obsolete statements of the whereabouts of pictures, references for illustrative purposes to engraved reproductions, and repetitions from alternative sources of facts given in the body of the text. Lists of exhibited and engraved works are also omitted. In order to avoid, as far as possible, erroneous identifications, titles of pictures have been left in the original French. Titles in English are given in the footnotes; these and all other editorial notes are distinguished from those of the authors by an asterisk. The editorial notes are designed to facilitate the reading of the text; they have been limited, with a few exceptions, to the clarification of allusions to persons and things the significance of which is not apparent in the context and which might otherwise be obscure to the English reader. General annotation or extension of the authors' material in the light of the subsequent fortunes of the works they discuss or in accordance with the findings of the most recent research, is not within the scope of the present edition.

# CONTENTS

*Editor's Introduction*                    *Page* vii

*Biographical Note*                              xii

WATTEAU                                            I

BOUCHER                                           55

CHARDIN                                          107

LA TOUR                                          157

GREUZE                                           207

FRAGONARD                                        259

THE PLATES                                       313

*List of Plates and Index of Collections*       411

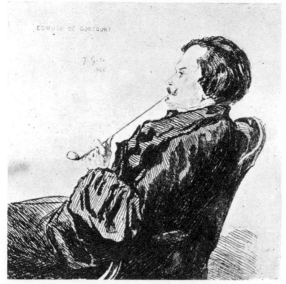

EDMOND DE GONCOURT
Etching by Jules de Goncourt. 1860

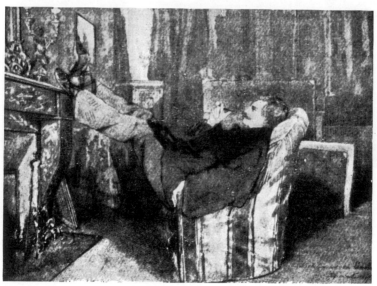

JULES DE GONCOURT
Etching by Edmond de Goncourt. 1857

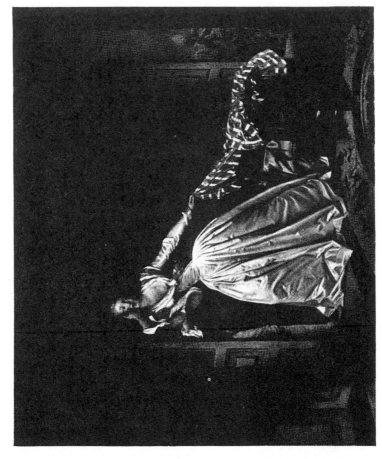

FRAGONARD: THE CLANDESTINE KISS
Leningrad, Hermitage

# INTRODUCTION

*F**INAL** judgements of art criticism must always be literary judgements. Perusing the reviews in defunct magazines, our sympathy and admiration are naturally aroused by the expression, in whatever lifeless form, of aesthetic notions which foreshadow or anticipate those on which the taste of our own times is founded; and we cannot but applaud the occasional contemporary notice in defence of an artist whose fame was otherwise posthumous. Aesthetic notions, however, are subject to constant mutation, and even the laurels awarded by posterity may not be green for all eternity; what stands out for us today as prophecy or insight may escape altogether the notice of our grandchildren; we cannot appraise the criticism of the past by referring its standards to present ones, for no equations discoverable by this method can be proved to have more than a transitory bearing on the essential value of the work. Criticism is neither science nor history: it is a branch of literature which is a branch of art; it is only as a work of art that it endures, and it is as such only that we can appreciate that proportion of the criticism of the past whose quality today continues to fix our attention.*

*Pater's shadowy outline, in his essay on Giorgione, of ideas with which Roger Fry packed the aesthetic consciousness of the twenties of the present century may still impress us as evidence of critical genius; we fasten upon the stray phrase in the countless pages of Ruskin's works if it should suggest to us that the immense pliancy of his mind would have yielded, in a propitious moment, to the beauties of abstract or surrealist art; and Baudelaire is universally approved as the original champion of the now revered Constantin Guys. But it is not on such grounds that the art criticism of these writers continues to exercise an influence and appeal. The passions and sensibilities of Ruskin and Pater, as expressed in their prose, have at times a force which, however misapplied in the light of current thought, would, nevertheless, continue to have its way with us; and it is at least a question whether the charms of Guys are not the reflection, rather than the inspiration, of Baudelaire's essay.*

*The enduring repute of the Goncourts as art critics is not to be explained in terms of their aesthetic opinions. Their view that painting should, in the*

*first place, delight the eyes, that it should not aspire to effect much more than the recreation of the optic nerve, that the pleasures it provides are, in the main, sensuous in a materialistic sense, is one with which recent criticism was in sympathy but which is already losing its hold upon modern sensibilities. For the moment, indeed, the art criticism of the Goncourts provides an emphatic illustration of the vanity, in this matter, of attempting judgements of a scientific or historical character. For if we honour the brothers for their anticipation of the view that, in a picture, the significance of the conception or subject is quite subordinate to the quality of execution, we might be led, in the interests of consistency, to assert the untruth that, amid the growing prevalence of more comprehensive ideas deriving from surrealism, their work should be regarded as obsolescent. The alternative course of explaining the obstinate vigour of their writings by showing how much, also, they conceded to the functions of the imagination in our response to works of art would be a scarcely less honest procedure.*

*With more appearance of reason, the Goncourts have been acclaimed as critics whose instinctive taste and penetrating, independent judgement resuscitated for their generation and established for succeeding ages the glories of French eighteenth-century painting to which informed opinion, still in the eighteen-fifties under the influence of neo-classicism, remained arrogantly blind. A detailed examination of the progress of taste, however, might reveal that such rediscoveries never, in any precise sense, occur; it might reveal that there subsists perpetually a nucleus of connoisseurs and collectors able to perceive the excellence in a work of art whose generic character, out of tune with the taste of the day, provokes less judicious if more passionate spirits to misjudge its specific merits; it might suggest that aesthetic excellence is a fixed, absolute quality, independent of the variations of styles and instinctively discerned, in whatever style it is achieved, by a small minority of enlightened amateurs. Such suppositions may be untrue and are rightly questioned; but, in the instance of the French eighteenth-century school, they are attractive, and they are not, in this case, invalidated by the hostility, maintained for more than half the succeeding century, of the directorate of the Louvre—that misleading index to informed taste—or by the abuse of Watteau and Boucher recurrent throughout the same period in the necessarily prejudiced criticism emanating from academic circles. There were collectors eager to preserve the work of Fragonard at the height of the*

*Revolution, at a moment when governmental, academic and popular authority combined to depress the reputation of the style in which he worked. David himself, the dictator of this reaction, the scourge of the rococo style, also possessed sensibilities which responded with admiration to the innate virtues of Boucher. By the time the Goncourts' great work* L'Art au Dix-huitième Siècle *was in progress, there were available for consultation the invaluable contents of the Marcille, Walferdin and other collections devoted to the representation of the masters whom they were studying; Watteau's fan was already a coveted item in the collection of the* Cousin Pons, *and, seven years before Edmond de Goncourt, at the age of sixteen, acquired his first picture, a water-colour by Boucher, Turner had exhibited at the Royal Academy his tribute to Watteau's genius, the 'Watteau Painting' of 1831. Such scattered facts must impair the claim (on which, indeed, there is no absolute insistence in their book) that the Goncourts rediscovered the art of the eighteenth century. It may be true that the fashion for Watteau that briefly flourished under the July Monarchy is mistakenly linked with the general revival of interest in the eighteenth century, but however that might appear to support the view that the Goncourts were, in this matter, pioneers, it cannot account for Lord Hertford's spectacular all-embracing and acquisitive interest in French eighteenth-century art which developed over twenty years before the appearance of the Goncourts' book. The brothers neither rediscovered the eighteenth century, nor belonged to that rare class of collectors, if it exists, who are content to exercise and reluctant to propagate a quality of taste impervious to the most commanding variations of fashion. The triumph of* L'Art au Dix-huitième Siècle *was a triumph of vulgarization.*

*In October 1894, Edmond de Goncourt wrote in his Journal: 'My favourite day dream, my castle in Spain, would be to possess a hall, like the main hall of the Gare Saint-Lazare, with bookshelves all round the walls up to the height of the chest and, above these, glazed cabinets for ornaments and bibelots. A gallery running round the interior would constitute the first floor, here the walls would be hung with drawings in three rows. Another gallery would form the second floor which would be hung with brightly coloured eighteenth-century tapestries extending up to the roof. I should work, take exercise (on horseback), eat and sleep in this hall of which the ground floor, artificially heated, would be a winter garden planted with the finest*

*evergreen shrubs, whose green leaves would provide a framework, in the centre, for Carpeaux's " The Four Quarters of the Globe", executed in the best quality white stone.' This passage, however flippant it may appear, shows clearly how much the writer was a man of his time, how richly his taste was involved in the modes of the moment. The Goncourts had absorbed the Romanticism of the thirties and abandoned themselves feverishly to the realism, the meticulous modernism, of the fifties. Both in their novels and in their life as men of letters, they revealed themselves as pursuing and sometimes guiding the intellectual currents of the age. Though they did not, as art critics, discover the eighteenth century, they did discover the terms on which the nineteenth might take the rococo period to its heart. They re-created its charms so that it became, as it were, part of the peculiar mythology of the fin-de-siècle, part of its special stock of imagery. That picture of the graces and liberties of the eighteenth century, of its masques and fountains, its ribbons and alcoves, which inspired so many writers and poets of the nineties, was largely of their fashioning. The picture was degraded by such a poet as Austin Dobson or such a painter as Orchardson, but the art of Monticelli, Guérin, Steer, Conder, Beardsley, the poetry of Verlaine or even Dowson display its authentic value.*

*As given by the Goncourts, it glows with a special accent of reality. In their account of eighteenth-century art, its poetry grew out of their subtle analyses of individual works; it was a poetry perceived equally in the variation of a tone or the grace of a brush stroke, and in the elegance of a pose or a costume; they hailed its presence in the tiniest material detail of the work before them with an ecstasy that a woman might display over the minutiae of personal adornment. Their whole vision of the period was coloured by the potent sensuous impressions they received from its paintings, their delight in powder and satin being inextricably fused with their delight in crumbling impasto and filmy glazes. At the same time, they were zealous in the field of documentary research. As historians they sought the same detailed realism which they cultivated as novelists. Like the author of Salambo, they spent a tireless energy upon the study of texts, and the information they accumulated was an additional impetus to the effervescence of their aesthetic perceptions. Their imaginative interpretation of the art of Watteau and his successors was founded upon the strength of the sensations it aroused in them and upon a studied intimacy with the available documents concerning it.*

*In their enthusiasm for their subject they exploited exhaustively both their sensations and their historical findings. It is an enthusiasm which lives in every chapter of their book and engulfs the repetitions, the superfluity of annotation with which the work might otherwise seem burdened. They were themselves passionate collectors and their criticism is the mirror not only of their delight in the beauties they expounded, but also of this passion for its possession, a passion, it has even been suggested, which burnt with that particular intensity reserved by less chaste individuals for their physical loves. The sense of enthusiastic excitement conveyed in their pages is the elixir, so to speak, whose attractive stimulations have ensured, and still ensure, the value of the book for posterity. The language in which it speaks, at once choice and diffuse, sometimes execrable, with its Latin affectations, its inter-minable apostrophes, its allusive rhetoric and abandoned use of technical terminology is the true utterance of its authors' sensuous, romantic but also botanizing approach. The temerity is undeniable of attempting a translation in English of this prose whose peculiarities continue to provoke or impress the French. But L'Art au Dix-huitième Siècle is still the most compact corpus of information on the subject anywhere available; the attempt would be amply justified for this reason alone; and though the translator may only aspire with trepidation to render the capricious eloquence of the book's style, he may hope to communicate some echo of its fervour and will at least convey the treasures of fact and opinion which it contains.*

ROBIN IRONSIDE

# BIOGRAPHICAL NOTE

EDMOND DE GONCOURT was born in 1822, his younger brother Jules in 1830. A critical notice of the Paris Salon of 1852 was one of their earliest published works. An important part of their literary energies was subsequently devoted to the writing of novels, and in this field they achieved a lasting reputation as writers of the 'realist' group of whom Flaubert remains the most illustrious representative. At the same time, an ardent interest in the art and manners of the eighteenth century led them to the composition of various works on its social history in addition to the series of essays on the painters of the period comprised in *L'Art au Dix-huitième Siècle*, their principal contribution to the literature of fine art. Their response to contemporary painting was lively and studied, though much of their criticism of the painters of their day (notably when it was unfavourable) is now seen to have been ill-judged. Gavarni was among the artists of the time whom they most admired, and, in 1868, they published an account of his life and work. They also wrote for the theatre, but were less successful as dramatists than as novelists, critics and historians.

In 1870, at the relatively youthful age of forty, Jules de Goncourt died of a disease affecting the brain. The work of the brothers had hitherto been the production of an intimate collaboration between twin minds. There seems no doubt that Edmond's great personal loss was hardly less a literary one, though the exact nature of the latter remains difficult to assess. The elder brother resumed his career as a writer alone, and it was during this concluding period of his life that his studies on Japanese art were published. He died in 1896.

The Goncourts began to acquire works of art at an early age. Though they were not without private means, the importance of the collection they gathered together, rich in eighteenth-century drawings and pastels, was due more to their industry and ardour than to the prices which they paid.

The nine volumes of the *Journal des Goncourt*, in the writing of which Jules had collaborated, appeared during the lifetime of Edmond, between 1872 and 1896. This great work and *l'Art au Dix-huitième Siècle* are the two achievements on which the fame of the writers' genius now mainly rests. The separate monographs on eighteenth-century artists of which *L'Art au Dix-huitième Siècle* is composed and of which six are here translated, first appeared at varying intervals in contemporary periodicals. They were subsequently published in twelve parts between 1856 and 1875. Each part was illustrated with either two or four etchings. All the illustrations, with the exception of two which were the work of Edmond, were etched by Jules.

The Journal and the published correspondence provide the main source of biographical material concerning the Goncourts. A bibliography of other relevant literature is given in Paul Sabatier's *L'Esthétique des Goncourt* (Hachette, Paris, 1920). Three works, dealing specially with the Goncourts, have since been published; they are *Catalogue de l'Exposition Goncourt* (Musée des Arts décoratifs, Paris, 1933), *Edmond et Jules de Goncourt* by François Fosca (Albin Michel, Paris, 1941), and the catalogue of the exhibition, also held at the Musée des Arts décoratifs, *Les Goncourt et leur temps* (1946). A now rare publication, *Edmond und Jules de Goncourt, die Begründer des Impressionismus*, by Erich Koehler (Leipzig, 1912), illustrated with etchings by Jules de Goncourt after Fragonard, La Tour, etc., is concerned exclusively with the Goncourts as art critics.

R. I.

# NOTE ON THE ILLUSTRATIONS AND
# THE DESIGN OF THE 1948 EDITION

FOR this book, as for the other volumes in this series, I have designed the binding, the wrapper and the title-page. I have made no attempt to invent rococo ornaments, but have used 'fleurons' by Jean Michel Papillon, designed in 1755, for the title-page and for the front of the binding, while the decorative stamp on the spine comes from a book illustrated by Eisen and printed at Paris in 1757. The figure on the wrapper is taken from an etching by Boucher after a Watteau drawing.

In selecting and arranging the plates of this book I had to make a compromise between the taste of 1890 and that of our own time. I have never met a wholehearted believer in eighteenth-century art; while everybody is delighted by a Watteau drawing or a sketch by Fragonard, by the best portrait pastels of La Tour or the genuine still-lifes and genre scenes of Chardin, we find the bulk of Boucher's work conventional and boring, and have lost all patience with the once popular sweet pieces of Greuze, his Innocence, his Psyche, his Girls with birds, alive and dead. My selection includes a number of examples which the Goncourts might not have esteemed very highly, and a few which they mention are not shown. After all, one hundred illustrations, representing an anthology from the prolific work of six important painters, can only aim at a narrow view from a single standpoint; the point of view in this selection of plates is, as I have said above, somewhere between the *fin de siècle* and our own day.

*London, June 1948*                                      L. GOLDSCHEIDER

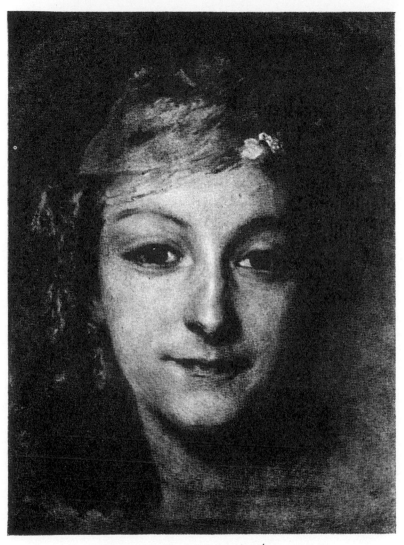

LA TOUR: MLLE FEL, DE L'OPÉRA. 1757
Pastel. St. Quentin, Museum

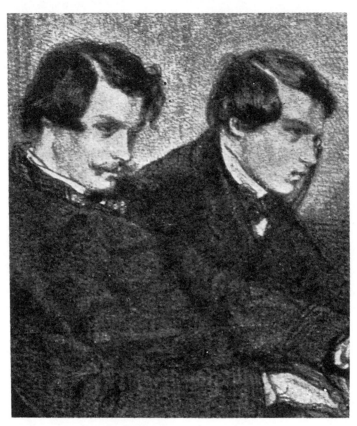

EDMOND AND JULES DE GONCOURT
Lithograph by Paul Gavarni. 1853

# FRENCH XVIII CENTURY PAINTERS

ANTOINE WATTEAU

FRANÇOIS BOUCHER

JEAN-BAPTISTE-SIMÉON CHARDIN

MAURICE-QUENTIN DE LA TOUR

JEAN-BAPTISTE GREUZE

JEAN-HONORÉ FRAGONARD

# FRENCH
# XVIII CENTURY PAINTERS

## WATTEAU

THE great poet of the eighteenth century is Watteau. A world, an entire world of poetry and fantasy, issuing from his mind, filled his art with the elegance of a supernatural life. An enchantment, a thousand enchantments arose, upon wings, from the whims of his brain, from the humours of his artistic practice, from the absolute originality of his genius. He drew magical visions, an ideal world, from his imagination and raised up, beyond the frontiers of his epoch, one of those Shakespearian kingdoms, one of those passionate and luminous countries, such a paradise as Polyphile[1] raised upon the clouds of his dreams for the contemporary delectation of all poetic natures.

Watteau renewed the quality of grace. It is no longer the grace of antiquity that we meet with in his art: a precise and tangible charm, the marble perfection of Galatea, the seductiveness —exclusively plastic—the material glory of a Venus. The grace of Watteau is grace itself. It is that indefinable touch that bestows upon women a charm, a coquetry, a beauty that is beyond mere physical beauty. It is that subtle thing that seems to be the smile of a contour, the soul of a form, the spiritual physiognomy of matter.

All the fascination of women in repose: the languor, the idleness, the abandonment, the mutual leanings upon one another, the outstretched limbs, the indolence, the harmony

---

*[1] The *Hypnérotomachie ou Discours du Songe de Poliphile*, as it was entitled in the French translation, was written by Francesco Colonna, a Dominican monk of Venetian birth who lived from 1449 to 1527. The poem was first published in Venice in 1499. The title *Hypnérotomachie* (The Conflict between Sleep and Love) indicates its principal theme. The work was much read in France during the sixteenth century.

of attitudes, the delightful air of a profile bowed over a lute, studying the notes of some *gamme d'amour*, the breasts' receding, elusive contours, the meanderings, the undulations, the pliancies of a woman's body; the play of slender fingers upon the handle of a fan, the indiscretion of high heels peeping below the skirt, the chance felicities of demeanour, the coquetry of gesture, the manœuvring of shoulders, and all that erudition, that mime of grace, which the women of the preceding century acquired from their mirrors; all this, with its particular intensity of tone, its special lustre, lives on in Watteau, fixed for ever in a form more vital than that breast of the wife of Diomedes moulded from the ashes of Pompeii. And it is not simply that Watteau brought this grace to life, delivered it from quiescence and immobility, bestowed upon it an agitation, a quivering, but it seems also, in his art, that it is a grace which pulsates in accordance with a rhythm, that its balanced progress is a dance drawn onwards by some homophony.

And upon what a stage he produced it, amid what natural prospects, fit setting for a halcyon existence, the painter aired his thoughts! Here is a region that conspires with his mood— amorous woods, meadows overflowing with music, echoing groves and overarching branches hung with baskets of flowers; solitary places, remote from the jealous world, touched by the magic brush of a Servandoni,[2] refreshed by springs and inhabited by marble statues, by naiads dappled with the trembling shadows of leaves; and there are fountains leaping suddenly up from the centre of a farmyard. . . . It is an amiable and pleasant country, where there are suns setting in apotheosis, beautiful lights sleeping upon the lawns, a verdant foliage, pierced, translucent, shadowless, where the palette of Veronese —that flashing harmony as of golden locks wreathed with red violets—lies slumbering. What country delights are here, what

---

*[2] The painter and architect Jean-Jérome Servandoni (1695–1766) was born in Florence, studied under Pannini, but worked principally in France. His great contemporary reputation was due to the imaginative force of his theatrical *décors* (notably the settings for *Orion* produced at the Paris Opera in 1728), and of his designs for processions and other festal or ceremonial occasions.

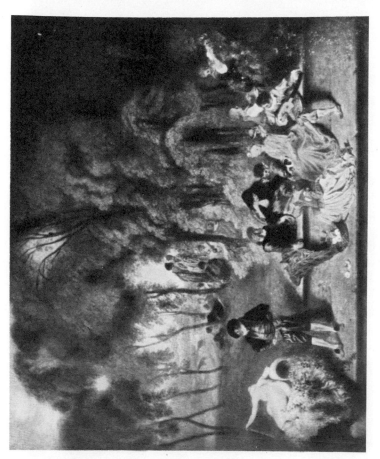

WATTEAU: GARDEN PARTY
Dresden, Gallery

EDMOND DE GONCOURT
By Bracquemond. Paris, Louvre

decorated, rustling scenery! Gardens overgrown with bramble and rose bushes, French landscapes planted with Italian pines, and villages gay with carriages, ceremonies, festivals and fine attire, villages dazed by the sounds of flutes and violins proceeding towards some baroque temple for the nuptials of Nature with the Muse of the Opera. It is a bucolic theatre with a green drop-curtain and flowers for footlights; the *Comédie-Française* has mounted the stage and the *Commedia dell'arte* trips lightly across it.

There seems to be a summons to the *gelosi*[3] to put on their dancing clothes, to adorn and enliven this spring, these skies and these landscapes of Watteau's. A bergamasque laugh is the voice of this poem, its impetus, its action, its movement. You can hear it, this laughter, as it ripples onward, inciting the breezes, provoking noise and gaiety and rousing Folly itself capped with tinkling bells. Ruffles and bonnets, jerkins and daggers, doublets and short cloaks move hither and thither. The troupe of comedians has arrived, bringing along with it beneath the trees the carnival of human passions and the rainbow of its habiliments. They are a variegated family, clothed in light and striped silk! One masks himself like the night, another paints himself like the moon. And over there is Harlequin, posed as if by a pen-stroke of Parmigianino, and Pierrot, his arms flat against his sides like two capital I's, and Tartaglia, Scapino, Cassandre, the Doctors and the favourite Mezzetino, 'that large, dark-haired fellow with a laughing face', always in the foreground, his cap pushed back from his forehead, his clothes striped like a zebra from top to bottom, as proud as a god and as fat as Silenus. It is to the guitar of the Italian Comedy that all these landscapes are attuned, and it is their troupe, thoroughly and arrogantly at home, who give splendid utterance—on the brink of the fountain, at the margin, or in a

---

*[3] From the Italian *geloso*, jealous. *Gelosi* was the name bestowed in France upon more than one troupe of the actors of the Italian Comedy, various companies of whom had been employed in France since the sixteenth century. One was banished by Louis XIV in 1695 after the production of *La Fausse Prude*, a satire which was thought to be directed against Mme de Maintenon.

clearing of the forest—to those sweet accents 'enfants d'une bouche vermeil'.[4]

It is the duet of Gilles and Columbine that is the music and the melody of Watteau's Comedy. How felicitously this Italian manner, with its brilliancy and bizarerrie, is matched with the French manner of the infant eighteenth century! And of the alliance, of the fusion of these two modes, what a ravishing child was born, the mode of Watteau! Adventurous and unhampered, errant but inspired, it is a mode that entraps what is novel, bitter-sweet, piquant. It is as if the scissors of some *couturier* of genius, playfully manipulated, had discovered the negligence of *négligé*, the essential fineness of finery, the sweet disorder of the morning and the ordered elegance of the afternoon—magic scissors, moreover, bestowing upon the future the patterns of the *Thousand and One Nights*, upon Madame de Pompadour the *négligé* that was to take her name, and upon Rose Bertin,[5] wealth and fortune. They are scissors which cut and run in a kind of ecstasy, amid the silver of satins, careless of the material, careless, also, of the roving glances of lover or suitor. With what grace these skirts have been gathered up, how delightful the *rocaille* of the folds and the narrow bodices, tantalizing sheaths of silk, a fastness, nevertheless, that yields fugitive glimpses of the youthful bosom! What a

[4] The origins of the Italian Comedy may be traced back to the Atellane fables of Roman antiquity. In the sixteenth century, the Italian Comedy assumed the forms by which it is now generally known, i.e., the language of the plays was either improvised on the basis of a written draft of the plot or was written in advance for stock personages who spoke in various local dialects. By the seventeenth century, the two forms had ceased to be clearly distinguished. The characters of the stock parts were not permanently fixed. Among those referred to here, Mezzetino and Gilles were personalities akin to Pierrot; Harlequin was usually the type of the blundering, Scapino of the cunning, servant; the Doctor was generally a native of Bologna, speaking in the local dialect, Cassandre was the father deceived by his children and Columbine the *soubrette*.

[5] Rose Bertin was born at Amiens in 1744 and died in Paris in 1813. She achieved European fame as a dressmaker. Marie-Antoinette was one of her principal clients, and, when required by the Revolutionary authorities to state the amount of the Queen's financial indebtedness to her establishment, she courageously asserted the untruth that everything had been paid.

charming lover's kingdom has been cut out, by Watteau's beribboned scissors, from the muffled realm of Madame de Maintenon!

This inspired tailor was also a marvellous Utopian, an embroiderer of all things, the most pleasant and the most obstinate romancer. He touches the subject of war, and at once the blood, the carnage, the horror and the fear are gone. The military glory he celebrates is decked with all the trappings of opera; he is the poet of the rustle of ornamental galloons, of the kaleidoscope of uniforms, of war parading in its Sunday clothes; of love in the stirrup and hope on the crupper, of intoxicating adieux accompanied by the clasping of hands and the clinking of glasses; of 'plumed baggage animals, of the love-child feeding at its mother's breast, of card games and cooking in the open air, of little cookhouse boys in white clothes, of officers' trunks open for the morning toilet, of young beauties alighting from waggons, exquisitely fresh without a crease in their lace caps. In any corner of this theatre of death, we may meet with the fashions of the town carried over into the camp; the tramp of marching feet is measured by the violins of Lerida[6] in the wings; there are stylish La Tulipes and Manons who flirt between cannon shots; men of fashion balancing themselves elegantly on one foot; and deeds of heroism achieved while sitting round the steaming cauldron; it is the art of killing between drinks, it is eighteenth-century war and the armies of Denain, Fontenoy and Rossbach, sketched at their most debonair and nonchalant.

But what is the use of an imagery derived from the spectacle of the world where the inventive faculty is strong enough to create its own world, its own poetry? A poetry as unique as it is delightful, the poetry of dandalled ease, of the colloquies and songs of youth, of pastoral recreations and leisurely

---

*[6] The allusion is to the unsuccessful siege by the Grand Condé of the Spanish town of Lerida. After a counter-attack by the garrison, the Duc de Grammont's regiment reopened the offensive preceded by the music of twenty-four violinists from the retinue of Condé.

pastimes, a poetry of peace and tranquillity amid which the movements even of a garden swing die faintly away, the ropes dragging in the sand. . . . We are on Theleme or Tempe, those enchanted isles separated by a crystal ribbon from the land, as carefree as they are unpastored, where shade converses with repose, whose inhabitants stroll aimlessly and languorously about, matching their leisure with that of the clouds and the tide. These are the Elysian Fields of a master painter—and beneath that cottage roof on the horizon, Time lies sleeping. In some fortuitous and uncharted spot, there exists, beneath the trees, an eternal indolence. Sight and thought languish into a vague, vanishing distance, like the deep floating backgrounds that are the frontiers of Titian's pictorial world. A Lethean stream spreads silence through this land of forgetfulness, the faces of whose people seem only to have eyes and mouths—so many flames, so many smiles. Fancies and tunes, words like the words of Shakespeare's comedies of love, hover upon their parted lips. Contemplate them as they sit beneath the trees, magnetic spirits garmented in satin, clothed and christened by the poets. Linda and Gulboé, Hero and Rosaline, Viola and Olivia, and all the heroines of *As You Like It* are present here. And flower-girls pass gently from one to another, decorating with blossoms the dresses and the dark clusters of curls knotted at the top of the head. The only noise is that of the games of little children with large black eyes who patter about like birds at the feet of the lovers—miniature genii tossed by the poet on to the threshold of this dream. It is a dream in which there is nothing to do but listen to one's heart and leave free utterance to one's mood; to wait for refreshments to be brought, to let the sun move and the world go by; and suffer little dogs, who never bark, to be teased by little girls.

This is the new Olympus, the new mythology, the Olympus of all the demi-gods forgotten by antiquity. It is the deification of the ideals of the eighteenth century, the spirit of the period, of the world of Watteau, gathered into the Pantheon of human modes and passions. It is the new emotional

humours of an aging humanity, languor, gallantry, reverie, that Watteau incorporates in his robed allegories; and it was among the Muses, moral and sentimental, of the modern era that he sought the models for the women—the goddesses, one might say—of his divine paintings.

Love is the light of this world; love impregnates and permeates it, is its youth and its sincerity; and when you have traversed the rivers, the hills, the garden walks, when you have passed the lakes and the fountains, then the Paradise of Watteau opens before you. It is Cythera. Beneath a sky painted with the colours of summer, the galley of Cleopatra sways at the water's edge. The tides are dead; the woods are silent. From the grassy earth to the heavens, beating the breathless air with their butterfly wings, a swarm of cupids flies, flutters, dances, frolics, now joining with a knot of roses some too indifferent pair of lovers, now sealing with love knots the round of kisses that floats up into the sky. Here is the temple, the spiritual destination of this world: the painter's *Amour paisible*, Love disarmed, seated in the shade, the Love whose image the poet of Teos would have engraved upon some vernal drinking cup; it is a smiling Arcady, a tender Decameron, a sentimental meditation; caresses are dreamily exchanged, words lull the spirit; there is a pervasive atmosphere of platonic affection, of leisure preoccupied with love, of youthful, elegant indolence; the press of passionate thoughts composes, as it were, a ceremonial court of courtship; couples leaning on one another's linked arms exchange civilities, the compliments, at once tender and facetious, of the newly wed; looks have no fever in them and embraces no impatience; there is desire without appetite and pleasure without desire. There are audacious gestures, but their audacity is measured, designed to be seen, as if for a ballet; and there are feminine ripostes, but of the same nature, tranquil and disdainful of haste in their assurance. And the stone satyrs, ambushed in the verdant wings of this theatre, laugh with a goat's laugh at this passion which is all idleness. . . . We bid adieu to the bacchanals led by Gillot, the last Renaissance pagan, born of the potations of the Pléiade, with its rural

deities of Arcueil,[7] adieu to the Olympus of the Io Pæan, to
husky reed-pipes and cloven-hoofed gods, to the laughter of
Euripides' Cyclops and Ronsard's Erotié, to all licentious
triumphs and ivy-crowned delights

> et la libre cadence
> de leur danse.

Those gods have gone, and Rubens, who lives on in this
palette of carmine and golden flesh tints, wanders, a stranger,
through these *fêtes champêtres* where the tumult of the senses
has been stilled—occasions which are so many materialized
fancies impatient to recover their incorporeity at the touch of
a magic ring and vanish into the original sphere of fancy like
a midsummer night's dream! It is Cythera; but it is the
Cythera of Watteau. It is Love; but it is poetic Love, the Love
that contemplates and dreams, modern Love with its aspira-
tions and its coronal of melancholy.

It is indeed true that in the recesses of Watteau's art, beneath
the laughter of its utterance, there murmurs an indefinable
harmony, slow and ambiguous; throughout his *fêtes galantes*
there penetrates an indefinable sadness; and, like the enchant-
ment of Venice, there is audible an indefinable poetry, veiled
and sighing, whose soft converse captivates our spirits. The
man impregnates his art; and it is an art that we are made to
look upon as the pastime and the distraction of a mind that
suffers, as we might look, after its death, upon the playthings
of an ailing child.

The painter stands revealed in his portrait. First, that vivid
portrait of his youthful appearance: a thin, anxious, nervous
face; arched, feverish eyebrows; large, restless, black eyes; a
long, emaciated nose; a dry, sad, sharply defined mouth—
with the extremities of the nostrils extending to the corners
of the lips—a long fold of flesh seeming to distort the face.
And from one portrait to another, almost as from one year to
another, we may observe him, always melancholy, always

---

★[7] Arcueil, not far from Paris, was the country *rendez-vous*, probably on
various occasions, of Ronsard and other poets associated with the Pléiade.

getting thinner, his long fingers lost in the full sleeves, the coat doubled over on his bony breast, old at thirty, his eyes sunken, tight-lipped and angular of face, only preserving his fine brow relieved by the long curls of a Louis XIV wig.

Or, rather, let us look for him in his work: that figure with the eyeglass or that flute-player—it is Watteau. His eye rests negligently upon the entwined lovers, whom he diverts with a music to whose flow of notes he gives no heed. His silent glances follow the embraces, and he listens to the love-making, listless, indifferent, morose, consumed by languor, and weary, like a violin at a marriage of the dances it directs, and deaf to the sound, to the song of his instrument.

What record remains of the life of the great French painter? Four pages by d'Argenville and a few anecdotes in a catalogue of engravings. What hopes were raised by that phrase from de Caylus's introduction to his eulogy of Le Moyne addressed to the Academy: 'I believe I have sufficiently explained in my life of Watteau. . . .' The editors of the *Mémoires de l'Académie* examined every manuscript in the Académie des Beaux-Arts, but this invaluable document was not to be found. We invite them, and all other friends of Watteau, to share our exultation; the other day, at a second-hand bookseller's, we chanced upon a manuscript containing this infinitely precious *Life of Antoine Watteau*, by M. de Caylus, attested by the secretary of the Academy, Lepicié. It is this *Life* which we now present to the public for the first time, textually and in its entirety, while remonstrating in advance against the severities and prejudices of the painter's old friend.

# THE LIFE OF ANTOINE WATTEAU

PAINTER OF FIGURES AND LANDSCAPE AND
OF ROMANTIC AND CONTEMPORARY SUBJECTS

BY

## M. LE COMTE DE CAYLUS[8]

CONNOISSEUR[9]

FAR from blaming previous biographers of Antoine Wateau,[10] I am on the contrary very sensible of those feelings of friendship and gratitude which prompted them to make the attempt. It appears to me, however, that these earlier writers have been too liberal in their praises.

The biography of anyone who deserves to be remembered by others should, it seems to me, record not only those aspects of his achievement which set an example to be followed, but those also which set an example to be avoided. It is my opinion that, in works of this kind, praise and censure should be dispensed in a spirit of equity, and that both, finally, should play their part in the work for the primary purpose of the advancement of art.

Personally, gentlemen, I consider the lives of artists as a picture that must be drawn in all sincerity for the benefit of living and future painters and with the object of bringing persistently to their notice standards of eulogy and criticism, in a form as vivid as that of the

*[8] M. de Caylus (1692–1765) was one of the most influential connoisseurs of the period. A vigorous adherent of classicism, he endeavoured to refresh the ideals, as he understood them, of the art of Greece and Rome. His endeavours were based upon the growing volume of archaeological knowledge resulting largely from the activities of the *Académie des Inscriptions*, of which he was a valued member. But the strength of the 'rococo' tendencies of contemporary fine art was by no means spent, and Caylus died before the artistic world was generally prepared to submit to the austere canons of neo-classicism. His praise of Watteau illustrates the equity of his sentiments and his strictures reveal the prejudices of his mind in favour of 'history' painting in the grand classical manner. The principal sources of the biography of Watteau are notices by his friends, Jean de Julienne and the picture dealer Gersaint, by the critic Mariette, by the proprietor of the *Mercure de France*, Antoine de la Roque, and by the connoisseur d'Argenville. They have been printed together and edited by Pierre Champion in his *Les Vies anciennes de Watteau*, Paris, 1921.

[9] Read at the *Académie Royale de Peinture et de Sculpture* on 3 February 1748.

[10] Contemporary spelling generally gives Watteau with a single 't', though, in a majority of cases, Watteau signed with two 't's.

events recorded, and, indeed, with the hope of enlisting the respect of the great masters of all times for that species of tribunal which is necessarily set up by the action of that same sincerity and, above all, by a love of art. I hope that you may share these sentiments, you, gentlemen, who work together with such zeal for the progress of painting and the honour of this Academy.

Moreover, I believe that this sincerity must serve to protect a lecturer from prejudice in so far as any man may be able to escape this defect. It must induce in him that habit of cool reflection which is the basis of the best taste. It will remind him that an excess of approval or of blame will provoke the mildest and most docile mind. It will, finally, enable him to maintain that equilibrium of fairness which is so necessary to the art of persuasion. I shall endeavour to adhere to this principle the more earnestly as it seems to me indispensable to any discussion intended primarily for the instruction of young painters.

It is in this frame of mind that I propose to link the events of Wateau's life with my reflections upon his manner, his execution and all aspects of his technical procedure as an artist. I shall criticize as I shall commend, confident that I need feel guilty of injuring neither my fond remembrances of Wateau, nor the friendship that I bore him, nor the gratitude that I shall always feel towards him for having revealed to me, as far as that was possible for him, the subtleties of his art. But I shall be careful to remember that, in the exercise of my present function, the artist must necessarily be less beloved than his art. Finally, aware as I am how great an effort is required of nature for the production of a great historical painter, I shall certainly not imitate the enthusiasm of those who compare the authors of a few Spanish *nouvelles*, a few little plays given at the *Italiens*, with M. de Thou[11] or Pierre Corneille.

Antoine Wateau was born at Valenciennes in 1684.[12] He was the son of a tiler. Birth is of no consequence in the eyes of philosophers

*[11] Jacques-Auguste de Thou, the lawyer and historian (1553–1617); his principal work is the still valuable *Histoire de Mon Temps*, written originally in Latin.

[12] Nougaret, in his *Anecdotes des Beaux-Arts*, states in a note: 'the manuscript of M. de S. gives 1686'. M. de S. was mistaken. Watteau's certificate of baptism, as M. Dinaux copied it from the register of the parish of Saint-Jacques de Valenciennes, runs as follows: '*Jean-Antoine*, legitimate son of *Jean-Philippe Wateau* and of *Michelle Lardenois*, his wife, was baptized on October 10, 1684. Signed: *Jean-Antoine Baiche*, godfather. *Anne Maillon*, godmother.'

and artists except in so far as it may facilitate education, but when it is of this humble kind it affords a convincing proof of talent and genius bestowed by Nature.

This proof is reinforced in the present instance by the severity which was the dominant characteristic of Wateau's father. It was with great reluctance that he was persuaded to place his son, whom Nature was already inspiring with the desire to imitate her, as apprentice to a painter working in his own town. What he did while with this painter is unknown to us and we need not regret our ignorance; for I seem to recall that this master was one who disposed of his pictures according to their measurements, or at least that his standards were similar, and the point is not worth our discussion.

However that may be, the father was unwilling to provide the expenses of this education for any length of time. Not that he was in a position to judge how unprofitable it might be from the artistic point of view, but he wished to force his son to embrace his own profession.[13] Wateau had more exalted ideas, or, at any rate, Painting had already destined him for her own; and so, rather than settle down in his father's profession, he left him and travelled to Paris,[14] by what rustic means of transport one may imagine, in order to devote himself there to the Muse whom he already loved but scarcely knew.

Ill-informed and helpless, the Pont Notre-Dame was a resource he was only too happy to discover.[15] This miserable factory of hundredth-hand copies made with stiff colours applied flat, even more hostile to the development of taste than illumination which at least preserves the forms of an engraving, was hardly suited to the sentiments that he had received in germ from nature. But to what depths are we not reduced by necessity? I may give you some idea of his natural gifts and aptitudes by reporting the following anecdote.

[13] 'His taste for the art of painting declared itself in his earliest youth, and he took advantage, at this period, of his free time to go and sketch, in the main square of the town, the various comic scenes with which quack doctors and other itinerant charlatans would regale the public.' (*Catalogue raisonné de diverses curiosités du cabinet de feu M. Quentin de Lorangère*, by Gersaint, 1744.)

[14] His first master in Paris was Métayer, a mediocre painter, whom he soon left for lack of work. (*Catalogue, etc. . . . . de Lorangère*.)

[15] 'There was at this time a considerable sale of small portraits and devotional subjects to dealers in the provinces, who acquired them by the dozen or by the gross. The painter to whom he had just attached himself had the best custom for this sort of work and retailed it in substantial quantities. He had at times as many as a dozen pupils whom he employed like manual labourers; the only

He had already been working for some time with a dealer in this type of picture when his gift for painting, a gift which lightens the burden of adversity through imagination and thus through the gaiety with which at times it lends almost a relish to our troubles, enabled him to play a joke which consoled him, at least for the moment, for the tedium of continually painting the same subject. He was employed by the day, and, by noon, on this occasion he had not so far asked for what was called 'the original' from which he was required to copy. For the mistress of the house was careful to shut him up every evening. She discovered his negligence and called to him. She shouted at him several times, but without effect, to make him come down from the attic where in fact he had been working since early morning and had finished from memory the original in question. When she had shouted her fill, he came downstairs and with complete coolness, accompanied by a gentleness of expression which was natural to him, asked her for the 'original' so that he might correctly place the spectacles; for the picture represented, I believe, an old woman examining her account books, a composition after Gerard Dow which, for that kind of merchandise, was then very much in fashion.

I give these details simply as an illustration of the difficulties, discomforts and annoyances that he had to suffer in order to develop his genius, and to show you how the faculty of genius, should Nature bestow it upon us, takes advantage of everything; nothing corrupts it; it finds nourishment everywhere. The life of Wateau substantiates this truth. Instead of being discouraged by this pitiable occupation, he redoubled his efforts to rise above it. Such moments of freedom as he enjoyed—public holidays, even the nights—were devoted to drawing from nature. He set an example whose value to the young could

merit he required of these journeymen was prompt execution. Each had his particular task. Some did the skies, others the heads; others again did the draperies or the highlights; the picture was at last completed when it reached the final workman.

Watteau was at this time exclusively occupied by such mediocre tasks; he was, however, distinguished from the others by his capacity for executing all parts of the picture with the required expedition. He often repeated the same subjects; his rendering of St. Nicolas, a saint much in demand, was so felicitous that commissions for this subject were specially reserved for him. 'I knew my St. Nicolas by heart,' he told me one day, 'and had no need of the original.'

This unprofitable and disagreeable work was very irksome to him, but he was obliged to make a living. Though he was employed all the week he received only three *livres* at the end of it and, out of a kind of charity, was given soup every day.' (*Catalogue, etc. . . . . de Lorangère.*)

hardly be over-emphasized—an example which is all very well on paper, the idlers will reply, but of which we may certainly say that only the love of art could ever inspire it. However that may be, continual study is never fruitless, or without some strengthening effect upon natural disposition. Nor, indeed, could we cite many instances of the same passionate industry that had not been followed by pronounced success.

With this grounding of study and these excessive powers of application, he prepared himself to leave the dismal employment to which necessity had reduced him. He made the acquaintance of Gillot[16] who, at about the same time, had just become a member of this Academy. Gillot was an artist who was known as a painter of bacchanals, of other fanciful or even historical subjects, and had also concerned himself with decoration and fashion; he was now, however, largely confining himself to the representation of themes from the Italian Comedy. For Wateau, this meeting was to prove a stroke of fortune. It was, indeed, this type of subject which determined once and for all the direction of his taste, and the pictures of his new master opened his eyes to various aspects of the art of painting whose existence he had hitherto merely suspected. As a result of affinities of taste, character and temperament, an intimate relationship grew up between master and pupil. But it was these affinities, combined with the talents of the latter as they became daily more manifest, which precluded the establishment of any durable association. They parted on bad terms, and a profound silence was to mark the limit of Wateau's expressed gratitude to his old master. He even disliked to be questioned on the details of their relationship and its rupture; for, where Gillot's works were concerned, he was always complimentary, nor indeed did he make any positive attempt to disguise the debt he owed him.

As for Gillot, whether his motive was the jealousy which has often been imputed to him or whether, in the end, he frankly and justly admitted that his pupil had surpassed him, he abandoned painting and devoted himself to drawing and etching, branches of art in which he won for himself a lasting celebrity by the intelligence and charm of the compositions with which he illustrated the fables of La Motte.

Wateau's talent was now unmistakably, though still faintly, evident;

[16] Gillot, after seeing and admiring examples of Watteau's drawing and painting, invited him to come and live with him (*Abrégé de la vie d'Antoine Watteau*, by M. de Julienne, preface to the volume of etchings after Watteau's drawings).

and he was still in need of further enlightenment. This he found; on leaving Gillot, he was received as a pupil by Claude Audran, concierge of the Luxembourg, an estimable character and a skilful decorator who, in this latter capacity, worthily upheld the reputation of the family which has provided your Academy with so many gifted members.

He was, moreover, a man of natural taste. Ornamentation had been his principal study, ornamentation of the kind that was used by Raphael at the Vatican and elsewhere by his pupils, of the kind also that Primaticcio employed at Fontainebleau. Audran revived the fashion of the latter's compositions, and it was due to his activities that the heavy and oppressive taste of his own predecessors was forgotten. His works were designed, by the reservation of blank spaces, for the reception of figure or other subjects in accordance with the wishes of the various patrons whom he had inspired with a desire to have their walls and ceilings decorated in this manner; it was thus that artists in differing genres found employment in his studio.

And it was there that Wateau's taste for decoration was formed and that he developed that lightness of brushwork required by the white or gilded backgrounds on which Audran's designs were carried out. Skilful examples of his work can be seen at the Ménagerie at Versailles, and there are fine ceilings after his designs at the Château of Meudon.

But I must confess that it is with some regret that I speak with a kind of admiration of his work; for it resulted not only in the demolition of ceilings that had been painted by some of the most gifted artists, but the change of fashion involved, which has now been succeeded by the taste for plaster decoration, deprived you, as you are still deprived, of an opportunity of exercising your talents in a branch of art that encourages the expression of what is noble and heroic.

But let me return to Wateau. It was while he was living in the Luxembourg that he studied and copied, with avidity, some of the finest works of Rubens, that he drew, unremittingly, the trees of that beautiful garden which, less strictly planned, as it is, than those of the other royal houses, provided him with innumerable viewpoints, with that infinity of motives which only landscape painters are able to extract, in all its variety, from the same spot, sometimes by the diverse aspects that are revealed by changing the point of vision, sometimes by uniting parts of the subject that are in fact distant from one another and sometimes in the differences that are produced in the same place by the morning or the evening light.

So far, we have observed simply a young man intent, without any special advantages, on perfecting his talent, a young man who is assiduous and who is at once his own tutor and the architect of his own reputation. In what follows we shall examine this talent in its developed form; but we shall see it in the coils of a life agitated by inconstance and by the artist's disgust with himself and with humanity.

He left Audran[17] when he had mastered those aspects of the art of painting which I have indicated in the foregoing account of his studies. He was so thoroughly versed in their practice that he was able to depart entirely from the manner of Gillot. He carried out a group of pictures, representing soldiers on the march or resting, in a style entirely opposed to that of his master; and these early works are perhaps equal in quality to the finest productions of his maturity. They are full of harmony and colour, the heads are subtly and intelligently

[17] 'Watteau, however, who had no wish to remain where he was, nor to spend his life in another's employment and who felt himself sufficiently advanced to conceive his own themes, attempted a genre subject, showing the departure of a group of soldiers, which he carried out in his leisure hours; he showed it to the sieur Audran and asked his advice upon it. The picture is one of those engraved by the elder Cochin. The sieur Audran, an intelligent man and well able to appreciate a fine thing, was alarmed by the merit that he discerned in this work, and in fear of losing such a useful workman, one, indeed, to whom he frequently confided the arrangement and even the execution of the orders he received, counselled him against wasting his time on such fancy-free pieces which could only diminish his talent for the type of work in which he was already making progress. Watteau was by no means the dupe of this advice. His firm intention to leave, combined with an inclination to revisit his native town of Valenciennes, finally decided him. The pretext of a visit to his family provided an honourable excuse for his departure. But what was he to do? He had no money. It became evident that the picture was his only resource; and he had no notion how to proceed in order to dispose of it. In these circumstances, he appealed for assistance to M. Spoud, a painter who is still living, who was his particular friend and who came from the same part of the country as he did. Chance led M. Spoud to the house of the sieur Sirois, my father-in-law, to whom he showed the picture; the price had been fixed at 60 *livres* and the bargain was concluded forthwith. Watteau called to receive the money and set off in high spirits for Valenciennes like the Greek sage of antiquity. The sum represented his entire fortune, and it is certain that he had never before been so rich. This transaction marked the beginning of my father-in-law's life-long acquaintance with the painter, and he was so satisfied with the picture that he begged its author to paint him a companion piece which was duly executed and sent to him from Valenciennes. This was the second piece engraved by the sieur Cochin; it represents a halt of a regiment, the whole painted from nature; for this work, the painter asked and received 200 *livres*.' (*Catalogue, etc. . . . . de Lorangère.*)

perceived, and the brushwork preserves the particular quality of his drawing even in the extremities and the draperies and, generally, in his conception of the subject.

I cannot make up my mind to attribute the separation from Audran to his inconstant temper. Wateau was aware of his own powers. He had intelligence and he was not the dupe of his master's, who was no better endowed with this quality than he was with a knowledge of the world and who, moreover, finding it very convenient to retain Wateau's services for his own profit, was anxious to subvert his taste for any kind of work except that with which he entrusted him.

It is true that in order to be rid of a man who had treated him with unsparing kindness and consideration, and as a means of resisting the offers that were made and the pressure that was exerted to persuade him to remain, Wateau justified his separation by the journey to Valenciennes, which was, in fact, undertaken. I have never regarded this as a pretext. Wateau was too wholehearted in his desires to make use of such expedients. In any case, what, after all, is more natural than the wish to return to one's native countryside, to reappear there as a man of talent, to confound so honourably and with such incontestable proofs those who had opposed one's natural dispositions, and to display capacities greater than those of one's first teacher?

These reasons would have sufficiently prompted his departure. They doubtless existed in his mind and procured him the satisfactions they forecast. But, apart from the very ephemeral nature of all satisfactions for a man of Wateau's temper, every talent that is a product of the mind is in equal need, as much for its advancement as for its support, of criticism, emulation and the opportunity of communication with other artists and acquaintanceship with their works. In a word, the production of an artist is designed to be seen and judged, and Wateau found nothing of all this at Valenciennes. It was a strong reason for leaving.

After a short stay, he left his native town and returned to Paris. A desire to visit Rome and to benefit there from the excellent academy established by Louis XIV alike for the general advancement of art and the instruction of students, enrolled him, for a period, among the competitors for the prize offered by your school. He won the second prize in 1709,[18] but he was not entitled to make the journey to Italy; he had to be content, therefore, with continuing his studies in Paris,

[18] The subject was *David granting Nabad's pardon to Abigail*. The first prize was given to Antoine Grison.

but he pursued these without renouncing his project of a visit to Rome.

With this object in mind, he submitted to you, in 1712, a group of pictures executed in his more personal style and much superior to the earlier prize-winning composition. A mature and distinguished talent and the inexpedience of the journey he wished to make were the motives that induced the Academy to receive him as a member. His reception was signalized by the support of M. de la Fosse, a man esteemed both for excellence of character and for achievement in various branches of painting; he asserted Wateau's merits and, though knowing him only by his works, took an active interest in his candidature.[19]

It is thus that truth should prevail in the deliberations of the Academy; personal preferences are not a ground for the admission or exclusion of applicants. Prejudices for or against particular persons, based on their connexions, constitute a grave defect. Talent alone should influence our decisions, and shed lustre upon our choices. It was shortly after the Academy had conferred this merited honour upon Wateau that I made his acquaintance.

[19] 'The exceptional manner in which he was elected a member of the *Académie Royale de Peinture et de Sculpture* redounds to the honour of that body. He had had it in mind to visit Rome in order to study the works of the old masters, particularly of the Venetians, in whose colour and composition he delighted. But he was not in a position to make the journey without financial assistance; it was for this reason that he wished to apply for the royal grant; and to settle the matter, he decided to submit to the Academy the two pictures purchased by my father-in-law in the hope of qualifying for the grant. He set off, with no friends or protectors but his two paintings, and arranged for their exhibition in a room through which the Academicians were wont to pass; here they attracted the attention and the admiration of these gentlemen, though they were ignorant of the identity of the artist. M. de la Fosse, a celebrated painter of the time, stopped to look at them longer than the others and, astonished by two such finely painted works, went into the main hall and asked the name of the artist. The two pictures were vigorous in colour and displayed a certain harmony which suggested the work of an old master. He was told that they were the productions of a young man who had come to enlist the good offices of the Academy in his plan to obtain a royal grant permitting him to continue his studies in Italy. M. de la Fosse, surprised, gave orders that the young man should be admitted. Watteau appeared; he did not cut a very imposing figure; he explained modestly the purpose of the course he had taken, and earnestly requested that the favour for which he asked might be granted, should he have the good fortune to be worthy of it. "My friend," replied M. de la Fosse with courtesy, "you do not know the extent of your talent and you underestimate your powers; believe me, you know more of the art than we do; we consider that you would prove an honour to our academy; take the necessary steps; we regard you as one of ourselves." Watteau retired, made the necessary official calls, and was at once elected.' (*Catalogue, etc. . . . . de Lorangère.*)

But the honour you did him and the originality and novelty of his style attracted more commissions than he was willing or able to deal with. It was not long before he also began to suffer from those importunities that distinguished talents tend to draw upon themselves in large towns where semi-connoisseurs abound, all too eager to inflict their presence in studios and private collections. And to what purpose? Merely to talk continual nonsense, to disturb and interrupt those meditations and researches that are so essential to the production of fine work. The best they can do is to utter false praise; flattery, indeed, is their main function. How wearisome and tormenting for an artist to have such people call upon him and establish themselves in his house and to be unable to get rid of them! For they are a tenacious species as impatient to make their appearance as they are difficult to dismiss.

Their multitude is usually followed by those dealers in second-hand goods, self-styled virtuosi of the art, who know how to take advantage of a practice which is common in society and weighs heavily upon painters with any facility of execution.

These persons take possession of sketches and present themselves with studies; and, what is worse, solicit the retouching of the mere leavings of the studio which they amass in heaps; and their whole object is to procure a complete painting by a master which should cost them little or nothing. There is no trick to which they will not stoop to achieve this end.

Wateau was persecuted by them; he distinguished easily these two types of importunates, understood them admirably, and being by nature caustic, he revenged himself in general by depicting in his work the personalities and intrigues of those by whom he was most sorely beset. In particular instances, however, he was none the less their dupe. Moreover, satirical caricature was no consolation for the tedium which in the end overpowered him. I have often seen him distracted to the point of wishing to abandon his vocation.

It might be thought that his brilliant success with the public would have flattered his self-esteem sufficiently to save him from such trifling annoyances. But his temperament was such that he was continually sickened by what he was doing. I believe that one of the strongest reasons for this disgust had, as its motivating principle, the elevated views he entertained on the art of painting. I am in a position to affirm that he conceived the art more nobly than he practised it, an attitude of mind that was unlikely to prejudice him in favour of his

own productions. The prices they fetched left him equally unaffected, and were, indeed, much smaller than those he could have obtained. Money he neither loved nor desired, and was thus deprived of that powerful support that so many have found in the mere passion for gain. I may quote an example that will prove to you his indifference on both these points.

A wig-maker brought him a wig of natural hair, which in itself had nothing to recommend it, but with which, nevertheless, he was delighted. It appeared to him to be a masterpiece of natural imitation. But it was certainly no imitation of Nature as she is manifest in a head of curled hair; I can see it now in all its length and flatness. Wateau asked the price; but the wig-maker, more cunning than he was, assured him that he would be only too pleased to receive in return some specimen of his work. A few sketches would have satisfied him. But Wateau was under the impression that he had never made such a good bargain and, with a liberality that reflected his pleasure at the acquisition, presented the wig-maker with two small finished pictures, a pair which must be counted among his most sparkling and spirited productions. I arrived at his house shortly after the conclusion of this profitable transaction. It must be admitted that the artist had some misgivings about it; he wished, in fact, to undertake yet another picture for the benefit of the wig-maker and it was with difficulty that I reassured his conscience.[20]

Wateau was by temperament not only caustic but also timid, two characteristics that Nature rarely combines in the same personality. He had a quick intelligence, and though he had received no education, he was an acute, even a fastidious, judge of music and the arts. Reading was his great recreation. He knew how to take advantage of what he had read; but, though, in general, he discerned and was able to represent with remarkable insight the absurdities of those importunates who came to disturb his labours, he had not, as I have said, a strong character and was easily defrauded, imposed upon and deceived.

This weakness was the original cause of his adventure with a painter of miniatures whom you will excuse me from mentioning by name. He was a man who talked well, but too volubly, about painting. We may suppose that, on the occasion of his visit to Wateau, he curbed

---

[20] 'Gersaint states: "... and his disinterestedness was so great that on more than one occasion I angered him by wanting to acquire particular works at a reasonable rate which, out of generosity, he usually declined." ' (*Catalogue, etc....de Lorangère.*)

the flow of his words, or that the artist, in order to cut short the interruption, made every endeavour to be rid of him; for he contrived to extract a picture from the artist as smoothly as Patelin[21] extracts the piece of cloth from M. Guillaume. This miniaturist was so convinced of his own merits that he had acquired the habit of attributing the perfections and felicities in the finest painting to the advice he claimed to have bestowed upon their authors, and to the manner in which, so he asserted, he had guided them on questions of arrangement and harmony. He certainly addressed himself to the right quarters for the advancement of his fame. Messieurs de Troy, de Largillière and Rigaud, then all of them at the height of their powers, were the painters he chose. I was young—he had no cause to be wary of me and was even ignorant of my interest in painting. One day, with the confidence and false enthusiasm of a babbler with an audience, he talked for more than two hours of the corrections that these illustrious men had made at his suggestion and of the deference that they felt for the soundness of his taste. I was shocked by his pride and complacency, but though the cause to be defended was an excellent one, I lacked the courage to reply, feeling that I was not yet strong enough and having no wish to add by my defeat to the triumph of which he was assured by the abundance of his speech and the ignorance of his audience.

A few days later, when discussing with Wateau the plight of artists who are unjustly defamed and often suffer from the bad impression that is thereby created among ignorant fools, who are always in the majority, I told him of the conversation I had heard and named its author. 'If I had known that that was his character,' he replied, 'I should not recently have presented him with a picture.' He then told me, with perfect good humour, what had happened to him with the same person and expressed his resolve to take advantage of him in some way.

Not long after this, the miniaturist called upon Wateau, thanked him for his magnificent present, exalted it above the very greatest works but added that, having examined it with care, he had noticed that there were various corrections to be made—in his view necessary

★[21] The lawyer, Patelin, was one of the chief characters of the French farce of that name, thought to have been originally composed between 1450 and 1465. The plot is largely concerned with the confused attempts of the draper, M. Guillaume, to recover, through the courts, a length of cloth extorted by Patelin.

ones. Wateau, secretly delighted, told him that he would make them
with pleasure. The miniaturist replied that, if he would do this in his
presence, he would direct the work. Wateau consented. The other,
flattered by such docility, which he may not have been expecting
when he arrived, produced the picture which, taking no chances, he
had brought with him under his cloak, and Wateau, with great
composure, took some lavender oil and, in a few moments, returned
the canvas, or panel, in its state of pristine cleanliness. The miniaturist
was ready to take offence, but Wateau spoke firmly, vindicated the
reputation of the great painters of the day, brought home to him the
superiority of their merits, and concluded by telling him that he was
scarcely qualified to speak of them as he did.

I do not believe that he was improved by this excellent lesson, but
I do know that he was sufficiently a connoisseur and sufficiently
attentive to his own interests to have regretted as long as he lived the
loss of a painting that the artist, who was not in the habit of praising
his own work, considered, so he informed me, as one of his least
unsuccessful. The most I can say is that Wateau never derived as much
pleasure from painting a picture as he did from effacing this one.

Possessed of an agreeable reputation, he had no enemies but himself,
and a certain spirit of instability which dominated him. No sooner
had he established his residence anywhere than he took an aversion to
the place. Time after time, he changed his abode, and always on some
specious pretext that he was moved to devise by a sense of shame at
his behaviour. He was apt to stay longest in some rooms of mine in
various quarters of Paris which we used only for painting, drawing
and posing the model. In these retreats, consecrated exclusively to art,
free from all importunities, he and I, together with a third friend
impelled by the same tastes, experienced the joys of youth combined
with the vivid pleasures of the imagination, a happiness which was
perpetually enhanced by the charms of the art of painting. I may say
that Wateau, so morose, so splenetic, so timid, so caustic everywhere
else, was there purely the Wateau of his pictures, an artist, that is to
say, such as they evoke, tender, agreeable, faintly bucolic.

It was in this seclusion that I recognized, to my advantage, how
deeply Wateau thought about painting, and how inferior was his
execution to his ideas. Indeed, since he had no knowledge of anatomy
and had never drawn from the nude, he was unable either to com-
prehend or express it; so much so that the complete rendering of
an academy study was for him an exacting and consequently a

disagreeable exercise. The female body, requiring less articulation, was somewhat easier for him. Such difficulties illustrate my earlier observation that the dislike for his own work which so often affected him arose from his being in the situation of a man who thinks better than he acts.

A particular result of this deficiency of draughtsmanship was an inability to paint or to compose anything in the heroic or allegorical vein, or to render the human figure on a large scale. The *Four Seasons* that he painted for the dining-room of M. Crozat are a proof of this assertion. The figures here are almost half life-size, and though they were executed after sketches by M. de la Fosse, they display so much mannerism and aridity that one can find nothing to say in their favour. The style of these paintings differs only from that of his small-scale works in the treatment of the nude and in the draperies; but that light and subtle touch which is so effective in small pictures loses its value and becomes intolerable when employed over a large area such as, in this instance, was unavoidable.

Fundamentally, it must be agreed, Wateau was an infinitely mannered artist. Though he was endowed with certain graces and is captivating in his favourite subjects, his hands, his heads, even his landscape, all suffer from this defect of mannerism. Taste and general effect are his best qualities and these produce, it is true, very charming illusions, more especially as his colour is good, and very exact in the rendering of stuffs which he drew in a peculiarly delightful way. It should be added that he hardly ever painted other stuffs than silk, which falls always in small folds. But his draperies were well disposed and the pattern of the folds was correct because he always drew from nature and never made use of a lay-figure. His choice of local colour was good and was never out of harmony with his tonality. Finally, his delicate touch infused a life and piquancy into everything he painted.

M. Crozat, who was fond of artists, offered Wateau board and lodging at his house. The offer was accepted. This fine establishment, which at that time housed a greater number of valuable paintings and curios than perhaps any private owner had hitherto brought together, provided the artist with a thousand new incentives. Of these the most exciting to his taste was the large and admirable collection of drawings by the great masters. He was affected by those of Jacopo Bassano; and still more so by the studies of Rubens and Van Dyck. He was charmed by the fine inventions, the exquisite landscape backgrounds, the

foliage, revealing so much taste and understanding, of Titian and Campagnola, whose secrets he was able to explore in these drawings. And, since it is natural to consider things in relation to their possible usefulness, it was to these last qualities that he most readily gave attention, rather than to those other qualities of arrangement, composition and expression in the works of the great history painters whose talents and purposes were so remote from his own. These he was content to admire without seeking to adapt himself to them by any special course of study, from which, indeed, he would have derived scant advantage.

It was here that I and M. Henin, the friend to whom I have referred, were able to assist him by preparing copies of drawings by the best Flemish masters and by those two great Italian landscape painters, copies which we carried just sufficiently far for him to capture the finished effect himself by the addition of a few touches. This was to serve him as he would have wished; in everything he required rapidity. And I shall always maintain that, in painting, it was to effects of rapidity that he was most sensitive.

The painting of small pictures facilitates the achievement of such effects. The most trifling adjustment makes or mars their expressive quality. Indeed, there are instances when the principal credit for their success should be assigned to chance. Wateau, in order to stimulate rapidity both of effect and execution, liked to apply his paint thickly. This device has always been widely employed, and the greatest masters have had recourse to it. But to practise it successfully, elaborate and adroit preparations are required, and Wateau hardly ever made them. As some sort of remedy for this omission, he had the habit, when wishing to correct a picture, of heedlessly rubbing it with thick oil and then repainting. The momentary advantage he gained in this way subsequently caused considerable damage to his pictures, damage to which a certain untidiness in his procedure, that must have injured his colour, also greatly contributed. It was very rarely that he cleaned his palette, and he sometimes went for several days without doing so. The pot of thick oil, of which he made so much use, was full of dirt and dust and mixed with all sorts of colours which adhered to his brushes when he dipped them into it. How remote was this method of procedure from the exceptional precautions that certain Dutch painters used to take in order to work cleanly! In this respect, Gerard Dow, among others, has often been quoted; and it has been observed

how he ground his colours on a mirror, that he took infinite precautions to prevent their corruption by a single atom of dust, and that he always cleaned his palette himself and even the handles of his brushes—which our most recent biographer of the painter understood to mean his broomsticks, misled by the double signification of the Dutch word which according to the manner of its use may mean either the handle of a paint brush or a broomstick but ought not, certainly, to have seemed equivocal in this case.

I do not suppose that you, however, would look upon these details as mere trifles. It seemed to me necessary to record them as a recommendation of that care and cleanliness in the use of colour which is a too essential condition of the preservation and survival of pictures for me to refrain from emphasizing the consequences of its neglect for the benefit of any who may have so utterly disregarded it as Wateau. It was listlessness and laziness that prompted this disregard, even more than that vivacity which may be inspired by an eager need to transfer at once to the canvas some effect conceived in the imagination. It was a need that seized him at times, but it was less compelling than his pleasure in drawing. The exercise of drawing had infinite charms for him and although sometimes the figure on which he happened to be at work was not a study undertaken with any particular purpose in view, he had the greatest imaginable difficulty in tearing himself away from it.

I must insist that in general he drew without a purpose. For he never made an oil sketch nor noted down the idea, in however slight or summary a form, for any of his pictures. It was his habit to do his drawings in a bound book, so that he always had a large number that were readily available.[22] He possessed cavalier's and comedian's costumes in which he dressed up such persons as he could find, of either sex, who were capable of posing adequately, and whom he drew in such attitudes as nature dictated and with a ready preference for those that were the most simple. When it took his fancy to paint a picture, he resorted to his collection of studies, choosing such figures as suited him for the moment. These he usually grouped so as to accord with a landscape background that he had already conceived or prepared. He rarely made use of them in any other way.

[22] Watteau left, on his death, a great quantity of drawings. He bequeathed them to four of his friends: M. de Julienne, the Abbé Haranger, canon of Saint-Germain L'Auxerrois, MM. Henin and Gersaint. (*Catalogue, etc. . . . de Lorangère.*)

This method of composing, which is certainly not one to be followed, is the real reason for that uniformity with which Wateau's pictures may be reproached. Without being aware of it, he repeated, on many occasions, the same figure; and it is this also which gives engravings after his work a kind of monotony, a kind of general similarity which prohibits the production of any quantity of them. In a word, with the exception of one or two of his pictures, such as 'L'Accordée de village' (or 'La Noce de village'), 'Le Bal',[23] the trade sign painted for the sieur Gersaint,[24] and 'L'Embarquement de Cythère',[25] which he painted for his reception into our Academy and which he has repeated, his compositions have no precise object. They do not express the activity of any passion, and are thus deprived of one of the most affecting aspects of the art of painting, that is, of action. Action alone, as you are aware, gentlemen, may animate your compositions, particularly in the heroic vein, with that sublime fire which speaks to the spirit, takes possession of it, transports it and fills it with wonder and admiration.

I should not forget to observe here that Wateau was not received as a member of your Academy until five years after his candidature had been approved; that is to say, on 28 August 1717. His dilatoriness in executing and supplying the picture required by the conditions of membership was the only cause of this delay. It even proved necessary to issue two summonses before he complied with this rule.

★[23] 'The Village Betrothal' or 'The Village Marriage', 'The Ball'.

[24] 'On his return to Paris, in 1721, during the early years of my business, he came to ask me if I would admit him to the house and allow him, in order, as he said, *to take the chill off his fingers*, to paint a sign-board which he wished me to exhibit outside my establishment; I felt somewhat reluctant to grant this request, as I should have much preferred to employ him on some more substantial piece of work; but, since it was apparent that it would give him pleasure, I consented. The success of this painting is well known; the whole was executed from nature, and the attitudes were so life-like and easy, the arrangement so natural and the grouping so well conceived that it fascinated the attention of passers-by; and even the most skilful painters returned on various occasions to admire it; it represented only eight days' work, and, furthermore, the artist worked only in the mornings, his delicate health, or, more accurately, his indolence, precluding him from more protracted labour. It is the only example of his work that in any way stimulated his self-esteem; he admitted this to me unhesitatingly. The painting at present forms part of the collection of M. de Julienne, who has had it engraved.' (*Catalogue, etc. . . . . de Lorangère.*)

★[25] 'The Embarkation for Cythera.'

The innumerable comforts and amenities that he found in M. Crozat's house did not prevent him from taking a dislike to such a desirable abode.[26] He left in order to go and live with his friend, M. Vleughels, who subsequently became Director of the Academy at Rome and died in office. But he took with him a precious fund of knowledge which he had acquired from his assiduous and thoughtful study of drawings by the great masters. His work, from this time on, provided ample proof of this enlargement of his education.

Meanwhile, struck by such unfortunate inconstancy of character in a man of his merit, I was distressed to see that his instability prevented him from enjoying any well-being in the present and even banished all hope for the future. I observed with real pain that he was the perpetual dupe of his surroundings. And he was the more to be pitied because, though his physical weakness got the better of him, his mind discerned things, and because the delicacy of his health increased daily, tending towards a general decline capable of producing considerable suffering. I pointed out to him that he had good friends but that the frequentation of society merely taught one how little one could rely, when in adversity, on one's fellow men, and I added that those who viewed the matter more charitably were not less certain to die at last. I employed all the arguments, and there were more than enough of them, that might suggest themselves to any friend of a man in his situation. I even based them on that love of independence which nature seemed to have implanted in him and which men of talent are so often willing to affect. To all my fine words I received no other answer than this—preceded, I must admit, by an expression of his personal thanks: 'The last resort is the hospital, is it not? There, no one is refused admission.' I must confess that I was cut short by this solution and I remained silent. I might flatter myself, however, that my representations had not fallen upon entirely barren ground and that they had at least made upon him one of those impressions to which we are deaf for a certain time, but which are none the less fruitful in due course. For he began to give more attention to his affairs and from time to time consulted enlightened friends, such as

[26] 'It was the love of liberty and independence which induced him to leave M. Crozat; he wished to live as he liked, and he even preferred an obscure existence; he retired to small lodgings at my father-in-law's house and gave orders that his address was not to be revealed to those who might ask for it.' (*Catalogue, etc. . . . de Lorangère.*)

M. de Julienne,[27] who managed to preserve for him the possessions and personal effects which passed to his heirs and which, without counting the drawings he bequeathed to his friends, constituted a value of more than nine thousand *livres*.

But, after his natural instability had driven him from the house of M. Vleughels, he could do no more than wander from place to place. It was also due to this defect of his nature that he was daily at the mercy of new acquaintances. As misfortune would have it, one of these exaggerated to him the charms of living in England with that mad enthusiasm to which many people are subject simply because

[27] As confirmation of the close friendship existing between Watteau and M. de Julienne, we quote from the *Archives des Arts* three invaluable letters from Watteau to M. de Julienne, published from copies. Our readers are unlikely to object to our further quotation of a letter from Watteau to Gersaint:

### TO MONSIEUR DE JULIENNE FROM WATTEAU BY EXPRESS POST

Paris, May 3

Monsieur!

I am returning to you the great first volume of the writings of Leonardo de Vincy and would ask you at the same time to accept my most sincère thanks for it. With regard to the manuscript letters of P. Rubens, I shall retain these a little longer, if you do not mind too much, as I have not yet finished them! That pain on the left side of my head has prevented me from sleeping since Tuesday, and Marietti would like to make me take a purgative tomorrow morning; he says that the present hot weather will assist its action. It would give me a greater pleasure than I can imagine if you would pay me a visit on Sunday week; I shall show you a few trifles like the Nogent landscapes which pleased you well enough because I made the sketches for them in the company of Madame de Julienne to whom I herewith send my respectful affection.

I am not working as I should like at present, because my *sanguine* and grey chalk are too hard and I am unable to obtain any others.

A. Watteau.

### TO MONSIEUR DE JULIENNE FROM WATTEAU

Paris, September 2

Monsieur!

At my request, Marin, who brought me the venison you were good enough to send me this morning, is returning to you the canvas on which I painted the heads of a wild boar and a black fox, and you can despatch them to M. de Losmenil, as I have for the moment finished with them. I cannot hide the fact that I am delighted with this large canvas and look forward to some corresponding satisfaction on your part and on that of Madame de Julienne who is as inordinately fond of this hunting subject as I am. Gersaint had to secure me the services of that fellow La Serre to enlarge the canvas on the right where I

they have never travelled. This sufficed to concentrate on that country the desire for a change of residence that perpetually dominated him. He set off in 1719, arrived at London, worked there, but was soon dissatisfied by the gloomy life which, as a stranger neither speaking nor understanding the language, he was compelled to lead. Although a Frenchman, however, he was tolerably well received and he did not neglect such business advantages as presented themselves. But, towards the end of a year, the fogs and the coal dust in the air damaged his health which, indeed, a purer air would have failed to preserve for any length of time, for his lungs were already infected when he

recomposed the horses under the trees, for I found that my space was congested after I had made all the agreed alterations in that part of the picture. I mean to begin work on it again after midday on Monday, because, during the morning, I shall be busy putting down ideas in *sanguine*. Do not forget to remember me to Madame de Julienne to whom I send my affectionate regards.

A. Watteau.

### TO MONSIEUR DE JULIENNE

Monsieur!

Monsieur l'Abbé de Noirterre has been good enough to send me the picture by P. Rubens in which two angel's heads are represented and above them, on a cloud, the figure of a woman plunged in meditation. Nothing, certainly, could have given me greater happiness, if I was not convinced that it was friendship for yourself and for your nephew which induced M. de Noirterre to part with such a valuable painting for my benefit. From the moment I received it, I have been unable to keep still; my eyes revert tirelessly to the desk on which, as on a tabernacle, I have placed it! I can hardly imagine that P. Rubens ever performed anything so accomplished as this work. Be so good, Monsieur, as to convey my sincerest gratitude to Monsieur l'Abbé de Noirterre, pending the moment when I can myself send him my thanks. I shall take advantage of the next messenger to Orléans to write to him and send him the picture of the Rest on the Flight which I mean to give him as an expression of my gratitude.

Your devoted friend and servant, Monsieur!

A. Watteau.

### TO MONSIEUR GERSAINT, DEALER ON THE PONT NOTRE-DAME, FROM WATTEAU

My dear friend Gersaint,

Yes, I shall, as you wish, come and dine with you tomorrow, with Antoine de la Roque. I mean to attend Mass, at ten o'clock, at St. Germain-de-Lauxerrois [*sic*]; and I shall certainly be with you by twelve, as I only have one visit to make beforehand, to our friend Molinet who for the last fortnight has been suffering from a mild attack of purples.

I remain, meanwhile, your friend,

A. Watteau.

undertook the journey.[28] He returned, therefore to France, and Paris.

Our defects are rarely mitigated by age and disease. Wateau, prematurely aged by the peculiar nature of his personality and increasingly ill since his return, now became an even greater burden to himself than before. The places and the people that used most to please him, even his friends, he now found intolerable. He imagined that the country air might do him good, and one of his friends, the Abbé Haranger, arranged for M. Le Fèvre, then *Intendant des Menus Plaisirs du Roi*, and now an honorary member of your body, to lend

---

[28] In the engraved work of Watteau preserved at the Bibliothèque Nationale, there is a curious plate, designed in London and first engraved as late as 1739 by Arthur Pound. It is the portrait of Dr. Misaubin, a man with a long, melancholy face holding in his right hand a three-cornered hat from which a length of black crêpe unwinds itself of the kind with which Hoffmann was to trip up the councillor, Krespel;[29] surrounding the lean doctor, tombs and sarcophagi are grouped and the ground is strewn with skulls. At the bottom of the plate is an autograph inscription by Mariette,[30] in his subtle, calumnious style: 'He was a French surgeon who had taken refuge in England, a great quack who boasted the possession of pills that were an infallible remedy against syphilis. He was alone in the conviction of their merits; for, though, according to him, they were certain to make the family fortune after his death, our doctor lived in poverty and was dying of hunger. Watteau, who perhaps experienced the inadequacy of the remedy, executed this work in a coffee-house during his visit to London.' But the truth is not at all such as the charitable Mariette so genially supposes; this work is the innocent complaint of a sad, ailing, virtuous body against the insufficiencies of medicine. It is Watteau's renewal of the mournful joke of Molière dying in the role of a doctor. A dying man, Watteau is still ready to arm his art against the healing profession impotent to protect from death either the incomplete poem or the unfinished picture. Later, at Nogent, where he was very ill, he drew the unenlightened Faculty in the train of those amusing *Purgons*[31] in which children so delight; and the cry of pain, disease and agony escapes him only in the inscription at the foot of the caricature:

'What have I done, accursed assassins!'

★[29] The allusion is to the first story in E. T. A. Hoffmann's *Die Serapionsbrüder*. There the Rat Krespel, attending the girl singer's funeral, carries a fiddlestick instead of a sword, and a long narrow strip of black crêpe is hanging down from his hat.

★[30] Mariette, the illustrious collector and critic (1694–1774), whose connoisseurship was internationally respected, was the author of various *catalogues raisonnés*, including an account of the Crozat collection from which Watteau derived so much benefit. A selection from his manuscript notes was published posthumously under the title *L'Abecedario de Mariette*.

★[31] The allusion is to M. Purgon, the pompous and ignorant doctor from Molière's *Malade Imaginaire*.

him his house at Nogent, near Vincennes. But at the stage his illness had now reached he merely languished there, and meditated yet another move which he would have carried out had his strength permitted. He desired to breathe once more his native air. He should not be accused of inconstancy in respect of this final project. Such is nearly always the last resort of sufferers from a lingering disease, a resort authorized and even advised by doctors when they no longer know what to say, when a proposal to take the waters, or even the waters themselves, have met with no success. Death had no remission to grant, for the satisfaction of this wish bore him away on 18 July 1721, at the age of thirty-seven.[32] He died with all the religious feeling that could be desired, and his last days were occupied by painting a crucifixion for the curé of Nogent.[33] If this picture lacks the nobility and distinction required by the subject, it is at least an expression of the pain and suffering experienced by the sick man who painted it.

Wateau had an upright heart, and it is certain that his resignation was sincere. He was, moreover, the victim of no passion; no vice dominated him, and he never painted an obscene picture. He even carried this delicacy to the point of requiring to see again, some days

[32] The death of Watteau left a regret in the hearts of his friends, the connoisseurs and lovers of art. M. de Julienne prefaced the series of etchings after Watteau's drawings with an obituary notice. Crozat wrote on 11 August 1721 to Rosalba: 'We have lost poor Watteau, who ended his days brush in hand. His friends, who are to publish an account of his life and his rare talent, will not fail to pay tribute to the portrait you made of him in Paris some time before his death.' Watteau had rediscovered in Rosalba the accent and the colour of those Venetian masters he would have so much liked to have studied in their own country. On 20 September 1719, his friend, Vleughels, wrote on his behalf to the Venetian paintress: 'We have many critics here who have a high opinion of your talent . . . an excellent man, M. Watteau, of whom you have certainly heard speak, is very anxious to make your acquaintance and to possess some small work from your hand. In exchange, he would send you one of his or, if that is not possible, the equivalent in money. . . . He is a close friend of mine, lives in my house and begs me to offer you his most humble respects, hoping that your reply will be favourable.' Rosalba's response was better than Watteau could have expected; she came to Paris and painted the artist's portrait (*Diario da Rosalba Carriera, Venezia, 1793*). This portrait was sold in 1769 at the La Live de Jully sale for 123 *livres*.

[33] The curé of Nogent, that excellent cleric upon whose worthy features, in the guise of Gilles, Watteau has bestowed an unsuitable grimace, sustained the artist against the approach of death with his exhortations. On his presenting him with a coarsely fashioned crucifix, Watteau replied: 'Take this crucifix away from me, I pity it. Is it possible to have so ill served my master?'

before his death, one or two works which he considered might be
exposed to such a reproach, so that he might have the satisfaction of
burning them; and they were duly destroyed.

He was a man of average height; his face was unrevealing, and his
eyes disclosed nothing either of his talent or of the vivacity of his
mind. He was sombre and melancholic like all persons of atrabilious
disposition, naturally sober and incapable of any excess. The purity
of his morals scarcely permitted him to enjoy even the licences of his
imagination, of which, indeed, one was hardly ever aware in his
conversation.[34]

The Abbé Fraguier, known for his wit and for his love of letters,
has honoured the memory of Wateau in a Latin verse epitaph which
I shall have the satisfaction of depositing with this Academy. He gave
it to me, and without foreseeing the use to which I can put it today, I
gave it to M. de Julienne for publication as a conclusion to his account
of the life of Wateau. It is worthy of your annals and I present it here
as a tribute that rightly belongs to you. Its composition was attended
by certain circumstances which I think it proper to communicate
to you.

The works of Wateau were generally popular in his time; they
were in the fashion of the day and their popularity is not surprising.
But there are certain men of a superior order to have deserved whose
tributes is an honour.

During the artist's lifetime, I often noticed that his works provoked
a kind of ravishment in the Abbé Fraguier, which proved the extent
and wisdom of the latter's taste. His profound knowledge of the earlier

---

[34] Here is Gersaint's portrait of Watteau: 'Watteau was of average height
and weak constitution; his disposition was anxious and changeable; he was
self-willed; he had a wanton, truant wit but his conduct was virtuous. He was
impatient and timid; cold and embarrassed in his manner of receiving; discreet
and reserved with strangers, but a good though difficult friend; misanthropic,
even malicious and caustic in his criticism, always dissatisfied with himself and
others and forgiving with difficulty. Reading, which he loved, was the sole
amusement of his leisure; his literary judgements were sound enough, though
he lacked the advantages of education.' (Catalogue, etc. . . . de Lorangère.) And
here is M. de Julienne's description: 'Watteau was of average height and weak
constitution; he had a lively, penetrating mind and elevated feelings. He spoke
little, but well; he also wrote well, and was much given to contemplation; a
great admirer of Nature and of all those masters who have imitated her, con-
tinual work had made him somewhat melancholic. Cold and embarrassed in
his manner of receiving, a trait which was sometimes troublesome to his
friends and often also to himself, he had no other defect. . . .'

schools of painting, and of what was admirable in their productions, did not prevent him from responding to the talents of this modern master and of doing full justice to his merits. On the artist's death, I was the witness of his sorrow and I heard from his lips, in the presence of a few worthy friends whose custom it was to meet at his house, on what esteem it was founded. He spoke on that occasion with an abundance of sentiment that greatly impressed me, so much so, that I was moved to tell him with fervour that a written record of his words would immortalize the artist.

He consented, but on condition that I should furnish him, so that he could write with greater accuracy, with some account of the most distinctive and important characteristics of Wateau's art. Delighted to procure for an artist who had been my friend the honour of a tribute from a scholar of acknowledged taste, I carried out succinctly the task that his modesty imposed on me. This modesty has always seemed to me so admirable in a man of his ability that I feel obliged to record this instance of it.

The circumstances in which I saw him some days afterwards seem to me equally worthy of record.

He had borrowed one of Wateau's pictures that moved him most and had placed it before him while composing the fine verses for which we are indebted to him.[35] I was greatly struck by this method of seeking inspiration in the presence of the picture; it seemed to me to provide a fine example of the way in which painters in their turn should imitate the poets. The union of the two Muses provided at that moment a delightful picture and one that was very flattering for painting.

Those painters are fortunate whose merits, in the eyes of men of letters, are sufficient to inspire them in this way. Anything that may bring you closer to writers, that may tend to unite your efforts with theirs, gentlemen, constitutes a mutual advantage which, prompted by my devotion to painting and my feelings for your Academy, I shall always ardently desire.

---

[35] These verses, which are valueless, were published by M. de Julienne in his *Abrégé de la vie de Watteau*.

# REPLY

## ADDRESSED TO M. LE COMTE DE CAYLUS

ON THE OCCASION OF THE READING OF THE FOREGOING LIFE
OF THE LATE M. WATTEAU

BY

## M. COYPEL

EQUERRY, COURT PAINTER, DIRECTOR OF THE ACADEMY

Monsieur,

What we have just heard reveals you as a loyal friend and an equitable critic. Your powers of criticism have enabled you to bestow, in just measure, the praises that friendship often lavishes excessively.

There is no doubt, Monsieur, that without such wise moderation, praise dictated by friendship may be prejudicial to the very persons it is designed to exalt.

We do violence to the self-esteem of our listeners when we speak to them of someone in whom we are unwilling to admit any defect, and violence to people's self-esteem can hardly ever, with impunity, be committed.

I would say more, and affirm that when we speak in this way, we become suspect to the most modest and disinterested audience; for experience has proved, only too well, the impossibility of achieving perfection.

Finally, Monsieur, though we may be speaking of someone already dead, when we come to expatiate on his exceptional talents, the surest means of inducing those who were his rivals to believe us, and perhaps to pardon him, is yet to concede, as you have done, anything with which criticism might find fault in his works and even in his character.

I should, however, explain myself more clearly. I do not mean to say that in such a case, to win the confidence that is generally the reward of impartiality, we should adopt uncritically those anecdotes, often false ones, which may tarnish or ridicule the memory of an illustrious artist. It is a gross mistake to imagine that, in order to make a narrative of this kind more curious and interesting, there is an absolute need to insert material likely to arouse horror or contempt for a man who, both night and day, laboured to deserve our respect.

The writer who proceeds on this erroneous principle depresses the

reader. An honourable man is distressed when he is obliged to under-
rate anyone whose talent has given him pleasure. But the same man,
who may frequently lament his own imperfections, does not neces-
sarily learn with displeasure that a person who has been the object of
public admiration was not entirely exempt from ordinary human
defects.

I would repeat, Monsieur, that in what we have just heard, you
have struck the right balance. Allow me to add that, for this bio-
graphical tribute to M. Wateau, you have adopted a literary style
which, in its simple grace and, if I may say so, its occasional pungency,
can only be compared with the charming manner of that excellent
painter.

The foregoing life of M. Wateau was read by the undersigned
secretary, after which the Director addressed the above Reply to the
author, M. de Caylus. The occasion was the meeting convened for
a lecture on 3 February 1748.

<div align="right">LEPICIÉ</div>

# NOTES

THE very mediocre artist to whom, according to Caylus, Gersaint and d'Argenville, Watteau was apprenticed by his father, was a painter called Jacques-Albert Gérin, a kind of official artist to the municipality of Valenciennes; Hécart, while praising, with all the fervour of local patriotism, 'the correctness of his drawing, the discretion of his compositions and the fine arrangement of his history subjects', deplored the absence of colour in his works. Valenciennes today possesses only a few insignificant works from his hand. It is incredible that local writers would have us believe that Watteau's talent was formed by this master and by the example of Valenciennes art, when we know that it was not until his employment in the studio of Gillot that the hack painter of the Pont Notre-Dame was able, as Gersaint affirms, to liberate and develop his talent.

<p style="text-align:center">★ ★ ★</p>

Watteau was, as Gersaint declared, the son of a master tiler and carpenter of Valenciennes and not, as Caylus states, of a simple tiler. M. Cellier (*Antoine Watteau, son enfance, ses contemporains*) who, in his patriotic pride as a citizen of Valenciennes, seems to have been offended that his illustrious compatriot should be considered as the son of a mere tiler, has investigated his family history; he records the existence of Watteaus (then spelt Wattiau) in the exercise of lucrative functions at Valenciennes in the sixteenth century; he reveals that Jean-Philippe Watteau, the father of the painter, was commissioned with the undertaking of such important works as the roofing of the small slaughter house, of the Dominican school, of the barracks, of the citadel, etc.; and shows him, in comfortable middle-class circumstances, as the owner of house property in the Rue des Cardinaux, and as himself living in a new house built near the precincts of the Abbey of St. John.

What is the truth concerning the conditions, easy or difficult, in which Watteau's vocation developed? Is it to be found in the version of M. de Caylus, who states categorically that Watteau's vocation was obstructed by his father? Or should we seek it in the text of *Figures de différents caractères de paysages et d'études dessinées d'après nature* in which M. de Julienne, also a friend and confidant, declares: 'His parents, though of inferior station and with very limited means at their disposal, neglected nothing in his education. In the matter of a choice of a profession, they were influenced only by his wishes; and so, since he had already given signs of his natural inclination towards

painting, his father, who had no knowledge of the art, but wished to assist his son's desire to learn it, arranged for his admission to the studio of a somewhat mediocre painter in the same town so that he might acquire its first principles.' I am personally disposed to believe the version of Caylus, whose allegations are confirmed by Gersaint and who records the father as refusing, after the apprenticeship had proceeded for some time, to make further payments and allowing his son to leave home without money or belongings. And surely Watteau's undeniable, unassisted poverty throughout the early years in Paris is a still more convincing proof.

<p align="center">★   ★   ★</p>

D'Argenville, in his *Abrégé de la vie des plus fameux peintres*, after stating that Watteau, having acquired, by his diligent labours, sufficient skill to recognize the feeble merits of his master, had left him for the service of another who had some talent as a theatrical designer, adds: 'In 1702 [the year, it should be observed, in which Gérin died and Watteau reached the age of eighteen] Watteau accompanied his new master to Paris, whither the Opera had summoned him, and worked there as a scene painter; but his master, when he returned to his native province, left his pupil behind.' This account is confirmed by M. de Julienne, who declares that Watteau, on his arrival in Paris, 'was employed with this painter on this kind of work'.

<p align="center">★   ★   ★</p>

It was doubtless while engaged on these early decorative works that Watteau acquired that taste for the theatre which he later so skilfully exploited in so many charming scenes, so many intriguing pictures, equally delightful whether it was the Italian or the French comedians whom he displayed upon his stage.

'Les Comédiens Français'![36] We have all seen this splendid print which presents the solemn image of Tragedy as it was conceived in the mind of a Racine, as it was declaimed, chanted and danced by a Champmeslé;[37] Tragedy in all the magnificence of its pomp, its rhyme, its grandiose recitative; Tragedy as it appeared within the framework of a portico designed by a Perrault;[38] Tragedy that seemed to issue

★[36] 'The French Players.'

★[37] The tragic actress La Champmeslé (Marie Desmares), who lived from 1642 to 1698, achieved a lasting fame by her performances in the plays of Racine.

★[38] Claude Perrault, doctor, scientist and architect (1613–88), designed, among other works, the Louvre colonnade and the Paris Observatory. As an architect, he was noted for his somewhat dramatic conceptions.

from the notes of a musical quartet, the great speeches sounding like an emphatic accompaniment to the bows and curtsies of a minuet; Tragedy enacted by that *roi-soleil* of alexandrine verse, with a long coat, embroidered cuisses and full wig, and by that tragic queen, in majestic paniers, her bodice ocellated like a peacock's feather; Tragedy as it was supported by those *confidents* and *confidentes* whose sustaining affection was so noble and clear-sighted.

Watteau returned from time to time to this subject of the actors and actresses of the French theatre, but it was a less frequent theme than that of the Italian Comedy. The Italian comedians were the real friends, the intimate companions of his brush, and he has represented their family in the fine, riotous composition painted as a companion piece to 'Les Comédiens Français'. He painted their picturesque, disordered flight when Madame de Maintenon banished them from France. He painted their diversions; their nocturnal, torch-lit loves, mingled with serenades; their holidays, gambollings in the open air which terrified the ducks in some country pond; he painted and repainted their Mezzetino and their Columbine. But soft and glistening as these pictures are, we could be grateful to hardly more than the Providence which led Watteau to start his career in the service of an obscure stage decorator, if he had offered us no more than the silken texture of their clothes, if he had not also been inspired with the idea of transforming these southern types into the lyrical personages of his pastoral scenes and *fêtes galantes*. Indeed, by the introduction of these airy, insubstantial jesters, these graceful mimics, the elegant, musical incarnations of delicate comedy and subtle laughter, of these men and women of such vague corporeity, whose physical presence grows faint beneath the influences of myth and symbol, the painter's conceptions no longer appear to derive from the world of actuality. In his *fêtes galantes* we may suppose the turf to be trodden by allegorical beings bereft by the spirituality and lightness of Watteau's touch of all real resemblance with the actors who may have served as models, and we are given the illusion of a world inhabited by the creatures of a capricious fantasy.

*        *        *

Caylus's account of Watteau's break with Gillot may be supplemented with that of Gersaint: 'Never had there been two characters, two temperaments more closely resembling one another; but since both had the same defects, it was equally true that there never could have been two personalities less compatible; it was impossible for

them to live for long together on terms of mutual understanding; neither did the other any wrong, yet they were obliged in the end to separate in a somewhat disagreeable fashion; it has even been asserted that it was an ill-conceived jealousy, turning Gillot against his disciple, which occasioned the break; but what is certain is that they parted with at least as much satisfaction as had previously united them.'

\*     \*     \*

Watteau did not leave Gillot's studio alone. He appears to have induced Lancret to leave with him, whom he advised, writes Gersaint, 'to ground the formation of his talent, as he himself had done, on the study of nature'. And if Lancret was not his pupil in the rigorous sense of a pupil working in the studio of a painter, he was an artist formed entirely by the study of Watteau's manner, by his conversation and by his profound remarks on the subject of his art.

\*     \*     \*

With reference to the great trees in the Luxembourg gardens which Watteau 'drew unceasingly' while he was working under Audran, it should be said that Watteau was a great landscape painter whose originality in this field has not yet been properly recognized. The painter who, while staying in Crozat's country house at Montmorency, painted the picture engraved under the title 'Perspective' was a creative artist who had invented a new genre. Academic landscape, that is to say, landscape that seeks to convey an impression of nobility, of a more than natural beauty, was achieved by Watteau without any of the tricks and eliminations of his predecessors and contemporaries. With his trees whose branches flow, like a cascade, down to the ground, his groves of hornbeam spreading like a fan behind the reposing forms of his lovers, his arches of foliage which seem to open between the supports of a stage-set, his forest clearings, trodden by the measures of a minuet and illumined by a sunbeam, his tall woods like a half-drawn curtain behind the figures of his bathers; with the airy foliation that pervades his pictures, touched with his liquid colour, interspersed with balustrades, termae, statues of women and children, fountains enveloped in the mist of their waters, Watteau has conjured up a nature more beautiful than nature. But does this mixture of authentic nature with the artificiality of operatic scenery sufficiently account for such a triumph? It is due, on the contrary, to the poetry with which Watteau's genius as a painter was imbued. Look into the hollows of these woods, these cradles of branches, these

groves, into the depths of these leafy shadows; look up at the pene-
trating patches of daylight, the gaps in the forest which lead the eye
onwards to the sky, to remote perspectives, to the horizon, to an
infinity, an empty luminous space inviting us to project our dreams
into its vacancy. . . . The peculiar nobility of Watteau's academic
landscape resides in the poetry of the painter-poet which transcends
the natural aspect of the scene he is depicting. The quality of Wat-
teau's landscape art is an idealized one: he paints landscapes which, by
the force of poetry, acquire a supernatural air to which it would seem
that the mere material craft of painting cannot aspire. It is this quality
which informs the 'Île Enchantée',[39] in which, on the shores of a still,
shining lake, disappearing beneath the trees pierced by a setting sun,
men and women are seated on the grass gazing at the snow-covered
mountains on the opposite bank and at the immense plain, of appa-
rently limitless extent, chequered by the mirages of the low-lying
light of the hours before twilight.

This is a print that remains in the memory, not with the clarity of
an image, but much more effectively as the indecisive reminiscence
of a description of some enchanted island from a romantic book.

<p style="text-align:center">★     ★     ★</p>

After he had left Audran, and after completing at Valenciennes,
apart from the picture of Sirois,[40] 'various studies of soldiers and
military encampments, from nature', Watteau was anxious to return
to Paris. Gersaint states: 'Watteau's restless character combined with
the fact there was little to inspire him at Valenciennes, where there
was nothing in the prospect before him either to instruct him or to
incite his activity, determined him to return to Paris; his reputation
was beginning to be an established one in the capital; the two pictures
owned by my father-in-law were seen by various interested persons
who wished to acquire examples of his work and in a short time his
merits became fully evident and were known to every connoisseur.'

Watteau's natural irony has left its traces in a number of his compo-
sitions. Among them, for example, is a representation of Painting and
Sculpture in the guise of two monkeys. One engraving, entitled 'Le

★[39] 'The Enchanted Island.'

[40] Sirois was the picture dealer with whom Watteau lodged after his visit to
Valenciennes in 1709. According to a manuscript note by Mariette, Sirois was
portrayed by Watteau in the central figure of the picture 'Gilles and His
Family', now in the Wallace Collection.

Départ pour les Isles',[41] shows us, with an evidently satirical intention, the hurrying throng of prostitutes. His pictures and drawings have, moreover, on various occasions, attacked the profession of medicine and its practitioners. But Watteau's satirical productions would amount to no more than these not very original examples, were it not for the existence of a little masterpiece, an intimate work, conceived in a mood of gentle raillery. In this composition, a doctor, a solemn, pompous doctor, in a black skull cap, with long white hair, the *houppelande* falling in great folds over his thin body, is feeling the pulse, with an air of great attention, of a cat wrapped in a blanket and carried nestling against the white, youthful, *décolleté* bosom of its mistress. The cat recoils, spits, is on the point of scratching the ridiculous representative of the Medical Faculty, while its mistress, with head flung back, eyes agog, distended nostrils, wide open mouth, and raised bosom, stands up to see what may transpire between her pet and the consultant. In a corner, the sardonic figure of a valet is seen laughing at the gravity of the episode. There is little invention in the idea, but there is such a naturalness, such a ludicrous charm in the tender solicitude of Iris for her pet and the picture is so prettily arranged, the light so well distributed, the humour of this scene from a comic opera so delicately, lightly and gracefully presented that I know of no other similar subject of the period that exercises the same peculiar charm as this little work. Even the vagueness of the room in which it takes place, of the costumes, of these people who belong, by no distinguishing mark, to a particular time in history, to a particular country, supplements the delights of this engraving with the special quality of the work of art which is never over-described, over-precise, over-defined. We should add that the plate has been engraved by Liotard with a dash and energy, with an originality, an eccentricity in technique which establish this engraving, 'Le Chat Malade',[42] as one of those rare prints which capture and hold the eye—and intrigue the mind.

<p style="text-align:center">★    ★    ★</p>

Gersaint states that, after Watteau's admission to the Academy, the artist 'was not inflated by this new dignity, the new lustre that had just been bestowed upon his name; he continued to prefer an obscure life; and, very far from any faith in his own merits, applied himself

★[41] 'The Departure for the Islands.'

★[42] 'The Sick Cat.'

still more diligently than before to study, and grew still more dissatis-
fied with his work. I have often been a witness of the impatience and
disgust with which his own productions inspired him; I have some-
times seen him totally efface completed pictures which displeased
him, in the belief that he detected faults in their execution or concep-
tion and despite the very reasonable prices I offered for them; on one
occasion, much against his will, I even wrenched one from his
destructive grasp, an action which greatly upset him.'

\*       \*       \*

An interesting portrait of Watteau appeared in a sale at Vignières
on 9 March 1875. The painter is represented seated at a desk with a
pair of compasses in his hand. Beneath the wig, with clusters of hair
gathered on the top of the head, in the fur-trimmed coat of which the
Valenciennes painter seems to have been specially fond, the master
no longer appears as the thin, emaciated personage of Boucher's
portrait, with gaunt, somewhat splenetic features. Watteau's face is
here almost full, and displays the traces, preserved in the adult fea-
tures, of a naïve childhood, a faint suggestion of the village, a just
perceptible rusticity, of which there were indications in the portrait
of Crespy and which sufficiently reflect the temperament of the man
as described in Caylus's phrase, 'gentle and faintly bucolic'. The
portrait is a half-length one and enclosed within an ornamental border
adorned with children carrying attributes and surmounted by an eagle
with the trumpet of fame held in its claws. On the back, written
in wash, appears the title from the *Figures des différents caractères*
inscribed by Oppenort, who has written at the bottom: 'Antoine
Watteau, Court Painter, member of the Academy of painting, done
from the life by his friend Gilles-Marie Oppenort, Equerry and
Director General of Buildings and Gardens to His Majesty.'

\*       \*       \*

Caylus is mistaken when he suggests that the paintings carried out
by Watteau in Crozat's dining-room were done from sketches by
La Fosse. I have in my possession the drawings for the figures of
Spring and Autumn in this series of the Four Seasons. These life
studies are drawn in Watteau's most characteristic and pronounced
manner.

\*       \*       \*

'One of the reasons which determined Watteau to take up residence
with M. Crozat', states Gersaint, 'was his knowledge of the priceless

collection of drawings in the possession of this connoisseur; he took advantage of it with avidity, and his only pleasure was in studying continually, and even copying, all the fragments by the greatest masters which it contained.'

\*     \*     \*

'As for Watteau's drawings,' says Gersaint, 'the drawings of his best period, that is to say, after he had left M. Crozat, there is nothing superior to them in their kind; subtlety, grace, lightness, correctness, facility, expression, there is no quality that one might wish for which they lack, and he will always be considered as one of the greatest and best draughtsmen that France has ever produced.'

Gersaint had the courage, in the face of attacks, to yield nothing of this admiration. When reproached by the *Dictionnaire abrégé de peinture et de sculpture*, published in 1746, with an infatuation for the talents of his old friend, Gersaint replied in the *Catalogue Frospertius* that he was astonished by the unjust treatment of drawings which no one he knew had ever failed to admire, no one even among those most opposed to Watteau's style of art who, while criticizing his pictures, always declared him to be 'admirable in his drawings'. He goes on to speak of the large prices they fetch at sales, when they are of the right period. And, conceding to his adversary that some of the pictures are negligently executed, that they have faults to which he has already called attention, faults arising from the impatience with which Watteau painted them and at the same time from the distaste with which the artist regarded his own productions, he ends by declaring that he prefers the drawings to the most perfect of the pictures. 'Watteau', he adds, in agreement with what had already been remarked by Caylus, 'was of the same opinion in this respect. He was more satisfied with his Drawings than with his Paintings, and I may say with assurance that, in this matter, he was not blinded by self-esteem to any of his defects. It was, for him, a greater pleasure to draw than to paint. I have often seen him out of temper with himself because he was unable to convey in Painting the truth and brilliance that he could express with his Pencil.'

M. de Julienne, in his preface to the 350 engraved studies in the *Figures de différents caractères*, was to express himself thus: 'It has rarely occurred to anyone to have engravings made from a painter's studies. . . . It is hoped, however, that the drawings of the celebrated Watteau presented here will receive the favourable regard of the public. They are in a new manner and their charms are so intimately related to the

personality of their author that they may justly be considered as inimitable. . . .'

What draughtsman, indeed, has been able to endow the most rapidly executed drawings with that inexpressible quality we find in Watteau's? Who else has handled chalk or pencil with such grace and piquancy? Who else has possessed the subtle and brilliant craft with which he rendered a profile, the tip of a nose, a hand? Watteau's hands are known to everyone—such tactile hands, so finely elongated, curling so provocatively round the handle of a fan or a mandolin, whose nervous life was drawn by the master with a lover's touch—hands, Heine might have said, which seem to possess the faculty of thought.

Here are pencil strokes which, we may confidently and resolutely assert, could have been drawn by nobody but Watteau, and whose quality has no need of a signature. Look at the pulsations of the pencil on these heads of men and women, at this complexity of slashing strokes over the original stumpings, tiny reiterated touches, accents put in with a blunted point, rounded indentations following the contour of a muscle, observe these trifles, these little felicities of art which are all-important—an agglomeration of minutiae, inspired and spontaneous, discovered as he worked from the model, enlivening his drawing with a thousand details from nature, vivifying the dull tone of the flat paper with the relief and solidity almost of paint. Look also at these women's *coiffures* darkened and smooth with the thick end of a piece of black chalk, whose broad graining admirably expresses the fleeciness and frizzle of hair; and at these provocative dresses, these *négligés* with broken folds, sometimes drawn in exquisite detail with the sharpest possible pencil point, and sometimes superbly indicated with the breadth and vigour of charcoal. Throughout these drawings, we continue to be aware of the artist's fine, sinuous outline, flowing, undulating, entwining, interrupted by rich powderings of *sanguine* where the form projects. *Sanguine* was Watteau's favourite medium; he loved it not only because he was able, thanks to its use, to obtain 'counter-proofs which provided him with both sides of the figure for his paintings', but also, French Venetian as he was, for the warmth of its tonality; he may even be said to make use of a *sanguine* all his own which is crimson in colour rather than the reddish-brown of the type generally employed and which derives its charming colour, its flush of life from the artist's skilful opposition of blacks and whites. This *sanguine* was, I am inclined to believe, that English red chalk

whose superiority is vaunted in the technical manuals, and a box of which was sold as a rarity at the sale of the painter Venevault. And perhaps it was this that Watteau lacked when he mentioned in his letter to M. de Julienne the hardness of the chalk he was then using and the impossibility of procuring another kind, and complained that he was unable to handle it in his sketches as he would have liked to do—those sketches, those first thoughts, which during the painter's last years seem to have been the only labour of his days, to have provided the satisfying moments of his invalid's existence.

The *sanguines* of Watteau are miraculous works, but they are less miraculously charming than his drawings in three different chalks, those drawings which may be described as painted. I have before me as I write a study of a hand and arm in which the tones and transparencies of flesh have been given—incredibly—by a simple blending, with the thumb, of black-lead with a little *sanguine*. Painted drawings: that is indeed what they must be called. With his cross-hatchings of red and black, Watteau contrives to express the transitions of tone in the human face. With his whites fading into the red chalk of the curve of a cheek-bone, he re-creates the luminosity of the skin. Look at the drawing in the Louvre (No. 1,326), from the d'Ymecourt sale, and at those female heads with their flat caps, drawn in *sanguine*, Italian chalk and white chalk, on that tinted paper, yellowed by time, which has been christened *papier chamois* in the sale catalogues; you will be astonished to find those heads coloured by the amber light which Rubens, with all the resources of his palette, produced on canvas.

<p style="text-align:center">★　　　★　　　★</p>

Watteau's etchings are not of the kind that collectors savour in the delightful handling, the charming, delicate craftsmanship of such engravers as Thomassin and Simonneau. His etchings, showing a lack of familiarity with the medium and the artistic awkwardness of the painter who has by chance turned to engraving, resemble the scrawled prints of an Italian painter. They are free, ingenuous, flowing improvisations: the plate is slashed, scratched, beaten, and the biting uneven; they are works which reveal their authorship only in the skill and feeling with which the extremities, particularly the hands, are rendered. So much was this the case, and such was Watteau's ignorance, marvellous draughtsman as he was, of the differences between two complementary techniques, that Simonneau, in his endeavours

to reproduce 'La Troupe Italienne'[43] never succeeded in making a tolerable plate.

Watteau's etchings, when they are entirely from his own hand, are, it must be admitted, chiefly curiosities—but curiosities of the greatest rarity.    *    *    *

Contemporary biographers are unanimous in reproving Watteau for his excessive use of heavy oil. D'Argenville, Mariette, etc., all make this reproach. Gersaint, after deploring, in a manner worthy of M. de Caylus, the misguided nature of Watteau's early studies, states: 'With regard to his works, we must regret that his early studies were not devoted to history painting, and that he did not enjoy a longer life; we may presume that he might have become one of the great French Painters; his Pictures suffer somewhat from the inconstancy and impatience of which his character was composed; he wearied of objects which he saw in front of him for any length of time: it was his only aim to flit from one subject to another; it even happened that he frequently started on a commission and grew tired of it by the time it was half finished; in order to rid himself more quickly of a picture he had begun and was obliged to finish, he loaded his brush with heavy oil in order to apply the colour more easily; it must be admitted that, as a result, some of his Pictures are gradually perishing, that their colour has totally changed or that they have become irretrievably dirty; but it is also true that those which are exempt from this defect are admirable works which will always hold their own in the greatest collections.'

*    *    *

M. de Julienne states that Watteau stayed with Vleughels until 1718.    *    *    *

'Isn't the hospital the last resource? No one is refused admission.' If this reply of Watteau's to M. de Caylus's anxious inquiries about his future were the only memorable thing in the whole of the honorary academician's pedantic, aggressive account of the artist's life, it would suffice to make his biography a document of the greatest value. It is a reply which provides a key to this character, so uncharacteristic of the period, so free from the material preoccupations, the workman's attitude of the French painters of that date. Watteau announced the type of the modern artist in the fine, the disinterested sense, the modern

*[13] 'Troop of Italian Actors.'

artist in pursuit of an ideal, despising money, careless of the morrow, leading a hazardous—and, I had almost said, if the word had not sunk so low, a bohemian—existence.

On the subject of Watteau's disinterestedness, however, Gersaint adds that 'during his visit to England, where his works were much sought after and well paid, Watteau began to acquire a taste for money of which he had hitherto made light, despising it to the point of indifference and always considering that his works sold at much higher prices than they were worth'.

Watteau's invalid condition was of earlier origin than Caylus indicates. The eccentricity of his moods and the misanthropy in his character attest sufficiently that Watteau was all his life a sick man. In all the portraits and studies left by the master of his bony person, his ungainly silhouette—the sufferer from tuberculosis is apparent. There even exists a gripping, terrible, almost macabre, portrait of the consumptive to which no one has as yet called attention. This is the portrait reproduced as Plate 213 in M. de Julienne's selection. Look at this Democritus in a nightcap, as he appears in this print which, incontestably, is the engraving from the drawing listed in La Roque's catalogue as No. 599: 'Watteau riant et fait par lui-même'.[44] You will seem to see the image of a face in a hospital, an image contorted by a kind of sardonic agony.

<p style="text-align:center">★    ★    ★</p>

A letter in M. Benjamin Fillon's catalogue—is its authenticity certain?—confirms Watteau's ailing, melancholic condition. This letter, from Sirois to Madame Josset, a Parisian bookseller, is dated 23 November 1711, and contains the following: '. . . This singular person who makes paintings in the same abundance as M. Le Sage makes books and comedies, with this difference that M. Le Sage is sometimes satisfied with his books and comedies whereas poor Watteau is never satisfied with his pictures; but this does not prevent him from being, in our time, one of the princes of the brush. He has promised to paint me a picture of the *Foire du Landit*, for which I have paid him in advance a hundred *livres* out of the agreed three hundred. It will be his masterpiece, if he gives it its finishing touches; but if he is again overcome by the black humours which take possession of his mind, then his faculties will desert him and I must bid goodbye to my masterpiece. M. Le Sage has procured him a commission to paint a

★[44] 'Watteau laughing, drawn by himself.'

pair of pictures illustrating *Le diable boiteux*, at one hundred and
thirty *livres* the piece. He is not hopeful that they will be done, for
Watteau paints as he feels and dislikes commissioned subjects. If he
is able to settle down to it, his first picture is to be for Monsieur
Ducange, though the latter is not to be told about it, for fear of
disappointment. The doctor again put him on a diet of *quinquina* five
days after his arrival.'

<p style="text-align:center">★     ★     ★</p>

After completing Gersaint's signboard, Watteau relapsed into a
state of languor in which he feared he might prove an inconvenience
to Gersaint, in whose house he had been living for the previous six
months; he begged him to find him suitable lodgings. 'It would have
been useless to resist,' says Gersaint, 'he was headstrong and argument
would not have been tolerated; I therefore complied with his wishes,
but he did not long remain in his new abode; his illness grew worse,
his tedium redoubled; his inconstancy returned; he believed he would
be much better off in the country; impatience aggravated his condi-
tion, and, in the end, tranquillity returned only when he learnt that
M. Le Fèvre, then *Intendant des Menus Plaisirs*, had arranged a secluded
retreat for him in his house at Nogent, above Vincennes, on the
solicitations of the late M. l'Abbé Haranger, Canon of Saint-Germain
L'Auxerrois and his friend; I took the artist there and came to see
him and console him every two or three days.

'The passion for change began to torment him afresh; he believed
he might be able to throw off his illness by returning to his native air;
he informed me of this project and, as a decisive measure, begged me
to have an inventory made of the few effects in his possession and to
arrange for their sale; this realized about 3,000 *livres*, of which sum
he appointed me the trustee. This was all the fruit of his labours, with
the exception of a sum of 6,000 *livres* which was saved for him by
M. de Julienne out of the wreckage of his fortunes at the time of his
departure for England, and which was returned to his family after his
death together with the 3,000 *livres* left in my hands. From day to day,
Watteau hoped to gain sufficient strength to undertake this new
journey, on which I was to accompany him, but his weakness con-
tinued to increase; life deserted him suddenly and he died in my arms
at Nogent.'

<p style="text-align:center">★     ★     ★</p>

In the course of Watteau's brief, final residence at Nogent, under
the influence of that forgiving state induced by the approach of death,

the artist was struck with remorse for his conduct towards his compatriot and pupil Pater, whom he had had the severity to send back home, where his father had found employment for him, 'too impatient', says Gersaint, 'to attend to the immaturities and the advancement of a pupil'. He now reproached himself for having failed to do sufficient justice to the natural abilities he had recognized in Pater and even confessed to Gersaint that 'he had feared them'. But let us continue the story in the words of Gersaint, who describes the sublime and touching repentance of the dying artist redeeming with his last hours, which were devoted entirely to Pater, the unjust action of the past: 'He begged me to have him come to Nogent so that he might somehow repair the wrong he had done him by his previous neglect, and that he might at least profit from such instruction as he might still be in a condition to give him. Watteau had him to work under his inspection and gave up the last days of his life to this task; but it was only for a month that Pater was able to profit from this precious opportunity; his master died too promptly. He has since admitted to me that he owed all he knew to this brief apprenticeship of which he had taken every advantage. He forgot entirely the vexations he had endured, as a youth, at the hands of this master, and has since preserved a feeling of the purest gratitude towards him; he has done full justice to his merits, whenever he has found occasion to speak of them.' (*Catalogue, etc.* . . . *de Lorangère. Notice on Pater.*)

\* \* \*

A picture which appeared as No. 530 in the sale of the Abbé de Gerigney, keeper of the heraldry section of the Royal Library, a picture in which most of the figures 'were painted by Watteau and the rest by Pater', would suggest that the pictures left unfinished by Watteau may have been completed by Pater.

\* \* \*

The fact, reported by Caylus, that Watteau painted a 'Christ on the Cross' for the curé of Nogent is confirmed by the appearance, in 1779, of this picture, or a sketch for it, at the Marchand sale. It was catalogued by Paillet as follows: 'Watteau, Le Christ en Croix, entouré d'anges[45] (H., 46 p.; L., 35 p.).' It was sold for 130 *livres*.

\* \* \*

Apart from the drawings left shortly before his death to MM. de Julienne, Henin, Gersaint and the Abbé Haranger, Watteau is said to

★[45] 'Christ on the Cross, surrounded by Angels.'

have left others to friends he made during his stay in England. A drawing, the portrait of a man, which appeared at the sale of the poet, Samuel Rogers, which took place in London in 1856, bore the inscription: 'Drawing left by Watteau at his death to my friend Payleur, July 1721.'

<p align="center">★ ★ ★</p>

During the early years of the eighteenth century, at a time when painting was rarely referred to by literature, a pamphlet, published in 1736, entitled *Ennuy d'un quart d'heure,* devotes two poems to Watteau. The first bears the title *L'Art et la Nature réunis par Wateaux* and declares that the Comtesse de Verrue, MM. de Glucq and de Julienne, whose exquisite taste is well known, possess a large proportion of the artist's original works. The second is called *La Mort de Wateaux, ou la Mort de la Peinture.*

<p align="center">★ ★ ★</p>

Watteau, a Flemish painter of the Académie Royale, as M. de Julienne calls him in the second volume of the edition of his Works, —limited to a hundred copies, of first proofs only, printed on large paper—was certainly a Fleming by birth and origin. Before his period of study under Audran, before he had begun to frequent the Luxembourg Gallery, Watteau's pictures, which as yet bore no visible signs of his descent from Rubens, bore witness nevertheless to an affiliation with the Little Masters of Flanders. At that moment of his development when, with a dry brush, like a crow's feather, Watteau carved out, as it were, from a coating of oil tinged with vermilion, his coronets of hair, his eyes, noses, lips, when he lit up the broken, *rocaille* folds of his loose dresses with those streaks of white with which the sixteenth-century painters cut out the folds of their draperies—at this early stage of his artistic growth, there are here and there in his paintings, passages which are remarkable for their minuteness of touch. But this detailed touch was soon to change; it changed when Watteau diverted his studies from the minor to the great Flemish masters, and it was not long before he was capable, as we may see, of enclosing within a picture space of a few inches, the technical breadth of Rubens and the fine sweep of his brush.

At that moment, Watteau would have deserved M. de Julienne's description, if, simultaneously with this appropriation of Rubens, his talent had not also assimilated another manner, quite as skilful, quite as intelligent, quite as consummate, a manner deriving from quite

different masters, the aesthetic attitude of quite another school. In this respect, a curious item of information is provided by a picture (No. 268) in the La Caze collection. This work, representing Jupiter and Antiope, is a revelation of one of the most astonishing conquests of one painter by another. We recognize the warm, rose-coloured legs of Titian, the reddish-black of his shadows lengthening beneath the arms of the sleepers, the blond softness of his flesh painting, the fine frenzy of tone injecting it with violent life, the absence of that prettiness which characterizes the flesh painting in a French picture. This picture is, I know, only a *pastiche*; but from this *pastiche* of Titian and from others of Veronese, mingled with *pastiches* of Rubens, Watteau rose to the level of achievement displayed in his picture 'L'Automne',[46] to that rendering of flesh, flushed and gilded like the pomegranates carried by Cupid in the folds of his uplifted shirt—to the invention of that impasto which was peculiarly his own, which was, mysteriously, fluid and crystallized at the same time.

Watteau's borrowings from the Venetians corrected, attenuated, and dissembled what was instinctively Flemish in his painting and provided him with a method of execution, a mode of confecting his art which is neither Italian nor Flemish, a palette dazzlingly composed of what was most exquisite in the colourists of both schools, yielding, nevertheless, harmonies which were French in everything a picture inevitably reflects of the country beneath whose skies it was painted, and French also in that indefinable lightness and wit, the eroticism, almost, which the artist's brush-stroke acquired in France, in the fatherland of civilized life. Watteau at this stage was no longer a Flemish painter: he was a French painter, French, it should clearly be understood, in his handling, quite apart from the very French quality of his poetic invention. But can we say that this or that picture by Watteau derives from any school, painted as it is with an originality of colour apparently unprecedented and unannounced, with an element of fantasy that seems to aspire to an expression of something transcending the potentialities of colour? Consider 'La Finette'[47] in the Louvre, in which the sky, the dress, the figure of the woman convey the fused impression of a fragment of curiously veined marble. Yet there is nothing here but a greenish tone enlivened in the background by the glow of a storm, a greenish tone that leaves traces of its marine tinge even in the hair of the guitarist and discloses, as it were, her pink

---

★[46] 'Autumn.'  ★[47] 'The Sly Girl.'

face amid a transparency, a plashing of sea green studded with sparkling eddies.

But let us return to that masterpiece of masterpieces, the canvas whose place has been reserved, fifty years in advance, on the walls of the Salon Carré: 'L'Embarquement de Cythère'.

Look at this foreground scarcely covered by a layer of transparent, russet oil, worked up by rapidly applied flecks of paint, skimmed by the lightest of glazes. Look at the green of these trees, pierced by auburn tones, penetrated by the windy air and watery light of autumn. Look at the plastic solidity, amid the delicate wash, as in a water-colour, of heavy oil, amid the sleek texture of the canvas, of this satchel or of this hood; look at the full impasto of the little figures, their glance and their smile visible in the drenched contours of their eyes and lips. What a fine, streaming fluidity of brushwork has produced these *décolletages*, these glimpses of the naked skin, whose roseate voluptuous hue chequers the obscurity of the wood! What a neat intersection of strokes conveys the curving fullness of the nape of neck, what admirable undulating draperies with gently broken folds like the marks of the chisel in the clay of a *bozetto*! And with what wit, what a caressing dalliance in the touch, the artist's brush renders the finger-tips, the *chignons*, the ornamental details of the dress and, indeed, all that it handles! What harmony also in these sunlit distances, in the pink snow capping these mountains, in these waters with their verdant reflections; and how fleet these sunbeams on the pink and yellow dresses, the crimson skirts, the blue hoods, the iridescent grey of the coats and on the little white lap-dogs with orange markings! No painter has expressed, as Watteau expressed, the transfiguring effect of a sunbeam on the inherent enchantments of local colour, its soft etiolation, the diffused blossoming of its brilliance under a full light. Pause a moment before this band of pilgrims hurriedly gathering, under the setting sun, around the boat of Love ready to weigh anchor; here is the most entrancing gaiety of colour caught unawares in a shaft of sunlight, and all this silk, soft and graded in the liquid radiance, will recall involuntarily those splendid insects that are sometimes found dead in a fragment of amber, but still vividly coloured beneath its golden light.

This picture, 'L'Embarquement de Cythère', is the most miraculous of Watteau's works. But it is not the whole of Watteau. There is a Watteau, unknown in France, who merits the acquaintance of all who are the artist's friends. The painter of skies ablaze with storms, of trees

glazed with burnt sienna, of those notes of glowing crimson such as the hand in 'Le Faux Pas' which seems to reflect fire upon the skirt it contacts, this painter of rich bituminous harmonies is also the author of the most deliciously cool, the most limpid pictures imaginable. We are familiar with the painting of Pater, with his pearl-grey chords of colour, his patches of blue, ash-green and saffron-yellow. These are, we might suppose, the originalities of a minor master. But the Museum at Dresden disillusions us, shows us that this pallid scale of colour, all this jingle of coldly shimmering hues derive from the colour sense of Watteau as he has displayed it in the two pictures hanging in the German gallery. Watteau's best pupil cannot even claim to have had a proprietary interest in a few colour notes.

★     ★     ★

Watteau was the dominant master to whose style, taste and vision the whole of eighteenth-century painting was in thrall. I refer not only to the *pasticheurs*, the servile followers Pater and Lancret, but I include all the other painters, both the great and the secondary talents. I include de Troy, who in his familiar prints of the balls and amusements of the Régence was content to inflate the graces and masquerades of Watteau; Charles Coypel, who, in his profile portraits, with their pointed brilliance, pilfered the Venetian lake of his flesh painting; and Boucher also. . . . It seems indeed that during the twenty-six years of his painting life Watteau exhausted every possibility! For it was Watteau who initiated on the panelled walls of La Muette the *chinoiserie* which Boucher exploited as if by virtue of an inventor's patent. And later still, surely the Spanish mode of Vanloo was simply the mantle of Mezzetino reappearing amid those courts of love where the lace collars of the *fête galante* were in fashion.

With the single exception of the works of Chardin, every painting of the century, if it was not dedicated to the cult of Greece and Rome, revived the attitudes, the facial expressions, the style of coiffure, the colour, the drawing, the very touch of the deceased master. Watteau reigned, imposed his authority everywhere. Olivier, the charming painter attached to the household of the Prince de Conti, did no more, surely, than repeat, in his pictures and etchings, Watteau's *Figures de différents caractères*. And where did Fragonard learn his first lessons? In copies of 'Les Fatigues de la guerre' and 'Les Délassements de la guerre'[48] which were put on sale as curiosities. Should Liotard be

★[48] 'The Hardships of War', 'The Recreations of War.'

mentioned? . . . But this all-powerful influence was felt by those who most rebelled against tradition, those who were most jealous of their originality, by Gabriel de Saint-Aubin, for example, who exhibited landscapes, at the Salon de la Blancherie, with 'figures in the manner of Watteau'. And, finally, is it not a fact that at the end, at the very end of the century, during the years preceding the Revolution, there appeared a certain Portail, a draughtsman in the manner of Watteau, to fix and paint the expiring graces of the century with the same three chalks used by the illustrious artist of the Régence? And much more might be said. Painters preserved a vision of the art of Watteau so much in the forefront of their mind's eye that the pupils of the engraver Wille, during the little excursions which he devised for them in order that they should study nature, peopled their sketches of the still wild region of the valley of the Chevreuse—where they often had to sleep in farmyards—with little peasant boys and girls who are the unmistakable children of Watteau.

# BOUCHER

BOUCHER was one of those men who indicate the taste of a century, express, personify, embody it. In him, French eighteenth-century taste was manifest, in all the peculiarity of its character. Boucher was not only its painter but its chief witness, its chief representative, its very type.

Neither the *Grand Siècle* nor Louis XIV himself approved of realism in art. Official encouragement from Versailles and the applause of public opinion had guided the course of literature and painting, of sculpture and architecture, of artistic and intellectual endeavour in general, towards an artificial grandeur and a conventional nobility which confined beauty within the solemn ritual of an etiquette. A type of sublimity, that was all magniloquence, pomp and dignity, had dazzled the mind of France; and French society, heedless of the accents of Shakespeare and disregarding the paintings of Teniers, believed that it had discovered in this fictitious majesty the supreme aesthetic law, an absolute ideal.

When Louis XV succeeded Louis XIV, when a gay, amorous society emerged from a ceremonious one, and when, in the more human atmosphere of the new court, the stature of persons and things diminished, the prevailing artistic ideal remained factitious and conventional; but it was an ideal that had descended from the majestic to the charming. There was everywhere diffused a refined elegance, a delicate voluptuousness, what the epoch itself specified as 'the quintessence of the agreeable, the complexion of grace and charm, the adornments of pleasure and love'. Plays, books, pictures, statues, houses, everything is subject to the taste for ornamentation and coquetry, to the graces of a delightful decadence. Prettiness, in the best sense of the term, is the symbol and the seduction of France at this airy moment of history. It is the essence, the formula of her genius, the quality of her moral tone and the pattern of her manners. It is the spirit of the age—and it is the soul of Boucher's genius.

## II

Boucher's fame belongs to Paris. He was born in Paris, not in 1704, as contemporary biographers stated and as modern biographers have repeated, but on 29 September 1703. A note in a manuscript copy of the *Collected Songs* of Maurepas asserts that his father was a seedsman. Restout's *Galerie Fran-çoise*,[1] better informed, declares him to have been the son of a somewhat obscure painter who, having taught him the rudiments of the art, soon recognized that his pupil was worthy of a more accomplished master and sent him to continue his studies under the then famous Lemoine.

And, not long afterwards, Lemoine, amazed at a 'Jugement de Suzanne'[2] executed by the young man at the age of seventeen, was prophesying a brilliant future for his pupil.

Lemoine, the admirable decorator of ceilings, the creator of a various Olympus, the confectioner of multitudinous clouds and apotheoses, who launched Parmigianino's goddesses into the sky of Versailles, was a great painter, one of those masters of whom it may be said that they would almost certainly enjoy today a serious reputation, a lasting fame, a solid and respectable immortality, had they been born into a more austere and august period. We have only to remember his picture 'Hercule et Omphale' to justify this tribute.

Against the deep, powerful blue of an eastern sky, beneath a brocade canopy entwined among the branches of trees, the legendary couple rise up before us, bathed in light, caressed by shadows. The white-skinned Omphale is standing, her legs crossed, and the tremendous club of the disarmed god rests against the projection of her thigh. The skin of the Nemean lion bound around her, she looks down, smiling and victorious, upon the god, leans towards him and places the distaff in his right hand. The god, with a hesitant gesture of the hands, gazes into the eyes of Omphale for her commands. Next to Hercules,

---

[1] *Galerie françoise ou Portraits des hommes et femmes célèbres qui ont paru en France,* soft ground etchings executed under the supervision of Restout. Paris, Hérissant, 1771.

*[2] 'Judgement of Susannah.'

a cupid, tall and slender like all the cupids of Lemoine, looks laughingly out at us from the picture. The figure of Omphale is a miracle of execution: the wonderful luminosity of flesh, its moisture, its radiance as of satin, its pulpy whiteness, all that is downy, tender and delicate in the brilliance of the naked female form as modelled by the light of day has been admirably rendered in this most polished life-study. The juvenile grace of a goddess has been deliciously mingled with a budding maturity in the drawing of these forms, which are at the same time plump and elongated, of this adolescent throat, of these burgeoning thighs. By means of a contrast which Poussin loved, the glowing, brick-red body of the hero-god serves to throw into still greater relief the white form of Omphale, hardly tinged in the shadows with mother-of-pearl blue and softly heightened with pink at the breasts, the elbows and the knees.

The author of this work was predestined to be Boucher's master. Inevitably, fatally, he was the initiator of Boucher's art. His manner, inherited from the great Italian schools, reminding us simultaneously of Correggio, Veronese, Baroccio, but rescued from imitation and servility by the French taste and the personal temperament of the artist, was so exactly the manner whose revelation Boucher instinctively awaited and for which his genius was prepared, that the pupil was able to assimilate it almost entirely and at once. Two of his pictures, 'La Naissance d'Adonis' and 'La Mort d'Adonis',[3] reveal how thoroughly he penetrated the style of his master before the complete development of his own artistic personality: the vehement values of the foreground, the curled locks and turns of the head borrowed from Veronese, the profiles of the *putti* reminiscent of Correggio, the tonality of the shadows on the drapery, the broken tints in the flesh and the heads which everywhere raise and animate the general colour scheme, the scratchings and hammerings of dry impasto, the crystallized texture which has prompted the attribution of certain Lemoines to Watteau, the lake colours of the Venetians which Boucher was soon to abandon—all this, in these two early

★[3] 'The Birth of Adonis', 'The Death of Adonis.'

canvases, reveals the touch of Lemoine; and nothing less than the signature 'F.B.' on a vase, the evidence of the engravings by Michel Aubert and Scotin and the citation in the La Live de Jully catalogue establishes their authenticity. 'Les Quatres Éléments',[4] painted for the Count of Brühl, must be a work in the same vein, as also 'L'Amour oiseleur' and 'L'Amour moissonneur'[5] in which Lemoine's drawing is visible through the interpretation of the engraver.

Later, I know, Boucher was to tell Mariette that he worked very little with Lemoine, who took a very mediocre interest in his pupils, and that he only remained with him for three months. But was Boucher telling the truth? What is certain is that when he left Lemoine's studio, his talent was fully formed and he possessed all the secrets of his master's practice. It should be added that he always retained the highest esteem for Lemoine and habitually praised his works.[6]

While he was at Lemoine's studio, Boucher was in need of money, not only to live, but in order to satisfy the tastes of a young bachelor and his passion for pleasure. Some years previously, Carle Vanloo, in similar circumstances, had made money by doing decorations at the opera and selling small portraits wholesale. Oudry, at this same youthful, necessitous period of an artist's life, used to draw puzzles. Boucher subjected himself to the trade of commercial illustrator, doing ecclesiastical subjects of which the reproductions, engraved by hacks, display no hint of the young master's hand. He supplied the trade of Notre-Dame-des-Victoires with innumerable Virgins and a whole army of saints. He did the illustrations for a Paris breviary in which the Virtues were represented above little views of the city and which resulted, for Jansenists, in the following ironic conjunctions: Faith and

---

[4] 'The Four Elements.'   [5] 'Cupid as a Fowler', 'Cupid as a Harvester.'

[6] After he had become famous, Boucher was one day shown a picture by Lemoine. The collector to whom it belonged had had the picture enlarged in order to match a companion piece, and he asked Boucher to complete it. 'I shall certainly not do so,' he replied. 'Such works are for me sacred vessels. I should be afraid lest my touch should profane them.' (*Almanach littéraire*, 1778.)

the Invalides, Hope and the Louvre, Religion and Notre-Dame, Charity and the Pont-Neuf. We need not be surprised to find Boucher illustrating a prayer-book, for it is the century during which Baudouin, the painter of brothels, was chosen to illuminate the missal of the Royal Chapel at Versailles.

As a result of these labours, Boucher established contact with what must be called the factory owned and conducted by De Cars, the engraver, a business which possessed a monopoly of the decoration and illustration of theses. Boucher drew there, for engraving, the trophies, the attributes, the tailpieces with which the eighteenth century loved to adorn the tedium and gravity of the most solemn letterpress, and, in return for this work, he received board, lodging and sixty *livres* a month, 'which, at the time,' states Mariette, 'he considered a fortune'. It was not long after the conclusion of this singular arrangement that, in 1721, Cars's boarder drew the vignettes for a new edition of Daniel's *Histoire de France*, which appear as No. 1,164 in Mariette's catalogue. We may assume that he continued for several years in this employment, drawing to order, almost as a daily wage-earner. It is also likely that, working in an engraver's studio, he was tempted to try his hand on the plate, to handle the burin, to engrave some of his own drawings himself and, so to speak, interpret himself; and it must have been as a result of such experience that he was fortunate enough to be chosen by M. de Julienne to engrave the majority of the studies left by Watteau. And Boucher's interpretation of *Les Figures de différents caractères de paysages et d'études* drawn by the master was one which lost nothing of the ardour and brilliance of the originals. With a broad, playful touch, a bold, felicitous technique, he gives a swift indication of the anatomy of a gesticulating hand, the broken folds of silk, the *rocaille* of drapery; he has rubbed in the landscapes with all the liberty with which Watteau handled his red chalk; he has been able to capture a silhouette with his needle as deftly as the draughtsman with his pencil; he has flicked his shadows upon the faces, caressed them with stipplings and hatchings with all the facility of his model. Even in the swift, sharp modelling of the legs

and the accentuated drawing of the high-heeled slippers, he has preserved, in his plates, the style and accent of the master which indeed he rendered more accurately than his fellow-engravers, than Tremolières, Basan, Silvestre or Cochin, and with all the intimacy and familiarity of Caylus. From this time on, we may say that Boucher was a thorough master of the peculiar charms of free-style etching.

While engaged on this work, Boucher's position improved. 'M. de Julienne gave him 24 *livres* a day, and both parties were satisfied; for Boucher was very expeditious and engraving for him was merely a game.'

He continued to paint in the midst of his work as an engraver and illustrator; in 1724, with a picture of the set subject 'Évilmérodach, fils et successeur de Nabuchodonosor, délivre Joachim des chaînes dans lesquelles son père le retenait depuis longtemps',[7] Boucher, barely twenty years old, won the first prize of the Académie de Peinture. And, on the Saturday following the feast day of St. Louis, the young man was hoisted on to the shoulders of his friends, in accordance with the immemorial custom, and paraded round the Place du Louvre, which was full of students, artists and others curious to see the spectacle, and deposited, when the ovation was over, at the doors of the lodgings of the Academy students.[8] His success brought him three years of free board and lodging and free instruction; he enjoyed, in addition, a gratuity of 300 *livres* a year and sufficient leisure for employers such as M. de Julienne and others. When the three years were over, he left for Rome. According to a notice of M. Durosier's, the brilliance of his début and the favour in which his work was held, drew upon him hostilities and jealousies within the Academy, as a result of which he was deprived of his acquired right to be sent at the expense of the State to Rome, and was reduced to

[7] *Abecedario*, by Mariette. Published by Ph. de Chennevières and A. de Montaiglon. Paris, Dumoulin, 1851, Vol. I. [ *'Evilmerodach, son and successor to Nebuchadnezzar, delivers Joachim from the chains in which he had long been held by his father.']

[8] *Œuvres de Diderot, Salons.*

undertaking the journey to Italy with a connoisseur and collector who was indifferent to such school disputes. On the other hand, the *Discours sur l'origine et l'état actuel de la peinture* (1786) states that Boucher remained for a very little time in Italy, and in a state of continual ill health which prevented any application to work. The obituary notice and various contemporary pamphlets contradict both these assertions, recounting that Boucher returned from Italy at the end of the statutory four years which the pupils of the Academy spent there.[9] In any event, whether the truth about Boucher's stay in Italy is to be found in the obituary or in the *Discours sur l'état actuel de la peinture*, the circumstances in which the future painter of the Graces lived at Rome were sufficiently wretched. The director, Vleughels, in a letter dated 3 June 1728, quoted by M. Lecoy de la Marche, having announced that the young men privileged to live under his protection had arrived during the afternoon of 1 May, and that their rooms had been ready for them, adds: 'There is also a young man named Boucher (who came in the company of Vanloo), a modest youth of considerable merit; almost outside the house, there is a little hole of a room, and I have packed him in there. I am afraid it is really no more than a hole; but at least he will be under cover.'

Though already esteemed in the artistic world, Boucher was still unknown outside it. He felt the need, at any cost, to display himself, if his name was to reach the public at large. And it was doubtless then that a sculptor in marble, named Dorbay, took advantage of the young artist's impatient needs by inducing him, for a mere song, to decorate his house with paintings; these included the fine 'Enlèvement d'Europe' which later entered the collection of M. Watelet.[10] After the

[9] Boucher had returned to France by 1731 and his candidature for the Academy was approved on 24 November of the same year (*François Boucher*, by Paul Mantz, Quantin, 1879).

*[10] (The Rape of Europa.) Claude Henri Watelet, painter and engraver (1718–86), is better known as the author of *L'Art de peindre* and of a *Dictionnaire des peintres, graveurs et sculpteurs*. The charms of the garden of his country house, 'Le Moulin-Joli', and his *Essai sur les jardins* were influential contributions to the growth of interest in the 'English garden'.

sculptor, a genuine patron and collector, the Baron de Thiers came forward and commissioned pictures from the young painter which were to prove entirely worthy of their place in his invaluable collection.[11]

### III

Lively and ready for anything, especially for pleasure, full of the ardour which he preserved throughout his life, Boucher had not yet lost his youth. He had lived fully and with gaiety, earning money rapidly by his facility, yet perpetually harassed by financial needs, starting eagerly to work at the end of a night's debauch with a peculiar enthusiasm generated by the fatigues and follies of the lingering night, of the still smoulder-ing fires of its pleasures. As for his loves, they are told in his art: they were the unions of passing fancy, adapted only to their moment, charming, banal affairs, strokes of luck to which he devoted his purse and which made no demands upon his heart. He could never, like the painter Doyen, who was in love with the little Mlle Hus, have taken his love so much to heart that he lost the strength to work. The women who are visitants in a laborious life but do not engross it, Manon or Morfil,[12] were the women of his choice. He liked a romance

[11] *Galerie Française*, by Restout.

[12] Boucher had one more illustrious adventure. *Le Palais Royal, ou Mémoires secrets de la duchesse d'Orléans* (Hamburg 1806) cites Boucher as the first lover of the mother of Philippe-Egalité. The book has no historical value and the account of the adventure is fabricated. But there is reason to believe that the fabrication is the echo of a court anecdote and as such the following passage deserves quotation:

'Henriette had nothing to complain of in her husband; he overwhelmed her with his attentions and his affection; he endeavoured to anticipate her slightest wishes; he employed the most skilful artists to capture on canvas those features of whose repetition he never wearied. She submitted indolently to their attendance on her; only one interested her: this was the painter of Cupid and the Graces—Boucher, in fact; and he knew how to profit from that charming abandonment of manner which, in a beautiful woman, indicates a mood of eager surrender. Mme la Duchesse de Chartres had authorized the painter to finish his picture from the life; the subject was Hebe dispensing nectar to the eagle of Jupiter. A garland placed upon a light gauze drapery was the goddess of

that was ready in advance; one of his biographers credits him
with never having attempted a seduction,[13] an observation that
is the judge of both Boucher and his mistresses.

Somewhat weary of a bachelor life, Boucher planned to
take a wife, and on 21 April 1733, he married Marie-Jeanne
Buseau, an extremely pretty girl of seventeen whom he had
chosen for her appearance, first of all to be his wife and also,
to some small extent, and according to the custom of the time,
as an inspiration and a model for his drawing. Once established
in his home, Mme Boucher, who had entered his studio
almost as a child, was not slow to follow the example of the
wives and daughters of artists of the period who nearly all
tried their hand at the profession whose practice they daily
observed, at painting, pastel or engraving; she began, with a
certain skill and a quite felicitous natural aptitude, to copy in
miniature the pictures of her husband. These miniatures, which
are today usually attributed to Boucher himself, enjoyed a
vogue which, for a moment, popularized the name of Madame
Boucher in collectors' circles; there were no fewer than eight
of these little works in the catalogue of the sale of the painter
Aved. Mme Boucher also made use of the engraver's tools
of her husband.

Boucher was not very faithful to his wife. Was the young
woman more faithful to her husband? There has survived, as
an indication of her inconstancy, a pretty enough anecdote.
According to a manuscript note of one of M. de Paulmy's
librarians, the novel entitled *Faunillane* or *L'Infante Jaune*, a

youth's only apparel. The fortunate artist, who had made use of models whose
beauty was much inferior to that of the princess, was granted the dangerous
privilege, at the final sitting, of posing the garland himself. His hand may
have strayed, the princess could not withhold the glance of her long, slender
pupils . . . she wreathed a lovely arm about his neck and raised her lips. . . .
What man could resist such blandishments? . . . Boucher was young and hand-
some; and he loved beautiful women as he loved fine pictures, classical statues
and, in general, everything that was rare and beautiful. A pretty model was
never allowed to leave his studio before bestowing upon him all the favours at
her disposal.'

[13] *Le Nécrologe*, 1771. *Eloge de Boucher*.

fantasy by the Comte de Tessin,[14] illustrated with drawings by Boucher and printed in 1741 at Badinopolis by the brothers Ponthome, was really no more on the Count's part than an adroit method of introduction into the painter's household. M. de Tessin, it would appear, had only written the book in order to ask Boucher to illustrate it and to establish contact by this means with the delicate Madame Boucher, to see her while he explained his subject-matter to her husband, and to pay his court to her behind the easel of the poor husband busy at his painting. When the drawings were finished and engraved by Chedel—and the dénouement of the comedy had doubtless proved to M. de Tessin's taste—two copies of the book were printed and the Count presented the plates to Duclos, the Academician, who, in order to make use of them, wrote an allegorical novel, *Acajou et Zirphile*,[15] based on Boucher's designs.

IV

On 30 January 1734, Boucher was admitted to full membership of the Academy, his candidature having been approved almost immediately on his return from Italy as a result of his submission of the painting 'Renaud et Armide', now exhibited at the Louvre.

From this time on, Boucher's real artistic production began and, with it, the applause of the public, growing more enthusiastic at each of the exhibitions which, closed since 1704, reopened in 1737 and ensured an unexampled popularity for the fame and paintings of the fortunate artist. And from Salon to Salon, from triumph to triumph, his imagination smilingly unfolded itself. From his unwearying pencil emerged the mythology of the eighteenth century. His Olympus is neither the Olympus of Homer nor of Virgil: it is the Olympus of Ovid. And there is indeed a resemblance between these two

*[14] Carl Gustave, Comte de Tessin, the Swedish statesman (1695–1770), was also an eager patron of the arts and it was through his agency that a number of important French eighteenth-century paintings were acquired for the Swedish royal collections.

[15] *Archives de l'Art Français* by Ph. de Chennevières and A. de Montaiglon, Paris, Dumoulin, 1851, Vol. VI.

painters of decadence, between these two masters of sensuality, Ovid and Boucher! A page of the former has all the brilliance, the fire, the style and the appearance of a canvas by the latter. Ovid's poem *The Art of Love* was performed as a ballet at a Roman theatre: was not this the poem that Boucher redis-covered at the Opéra and out of which he fashioned his genius?

Voluptuousness is the essence of Boucher's ideal; the spirit of his art is compact of it. And even in his handling of the conventional nudities of mythology, what a light and skilful hand is his, how fresh his imagination even when its theme is indecent and how harmonious his gift of composition, natu-rally adapted, it might seem, to the arrangement of lovely bodies upon clouds rounded like the necks of swans! What a delightful concatenation in these garlands of goddesses that he loosens out into the sky! What a display of flower-like com-plexions, undulating curves, forms that might have been modelled by a caress! How well he understands the indiscreet pose, the coquetry of relaxed postures, the provocations of Nonchalance reclining full-length against a background of mythological apotheosis as though upon the carpet of a harem! The more severe aspects of nakedness were unknown to Boucher: he was able neither to envelop the human form with its beauty nor to veil it with modesty; the flesh he paints has a kind of inviting effrontery; his divinities, nymphs, nereids, all his female nudities are women who have undressed; but who knew better how to undress them? The Venus of whom Boucher dreamt and whom he painted was only the physical Venus; but he knew her by heart. With what cunning he endowed her with all the seductions of an abandoned gesture, of tolerant smiles, of an engaging carriage! In the midst of what a sensuous setting he establishes her! And how com-pletely Desire and Pleasure are incarnate in this light, volatile, perpetually renascent figure!

Round this Venus, in this Cytheran sky, in the midst of this aerial seraglio, over these clouds illumined by the reflected light from the naked forms of his goddesses, the painter has flung a cloud of cupids; he has suspended them in festoons,

linked them into a coronet, diffused and gathered them like a
frieze by Clodion; he has somersaulted them into the laps of
the Graces. He disperses and reassembles them, bestows on
each their power of eager flight and throws them, naked and
mischievous, into the heavens. They are the spoilt children of
Boucher's brush. With plump cheeks, their locks floating on
their foreheads in enormous kiss-curls, the wide pupils of their
eyes smiling through their long lashes, their miniature up-
turned noses, and their foreheads cloven by a dimple, they
appear everywhere in Boucher's work. They flutter about
their mother like a feathered court; they amuse themselves at
the feet of the Muses by playing with the attributes of the Arts
and Sciences; they leap across the dove-drawn chariot; and,
whether they are cramming their mouths with Bacchanalian
grapes or blindly aiming their shafts at someone's heart, or
whether they represent the Seasons, or, armed with mallet
and chisel, appear as fugitives from the opera *Pygmalion*, or
whether they are simply children at play, they are always a
charming spectacle, with their little fat hands, their rotund
stomachs and navels like dimples, their cupid's bottoms, their
chubby calves and their fluid, puffed-out forms which some-
times, under Boucher's touch, assume an almost stately ampli-
tude. And what games, the sport of elfs and infant gods, they
play amid these allegorical scenes, near the water where Diana
bathes, or on the knees of these nymphs reclining back to back,
or in the triumphs of these goddesses, whom the master, in his
elegant Parmigianesque period, was so fond of posing with
their backs to the spectator, with sloping shoulders and plump
buttocks, the curve of the hips projecting, one leg folded across
the other, the sole of the foot with its network of delicate
wrinkles trailing below the thigh. Boucher understood so well
the physiognomy of these charming *putti* that he almost always
repeated it in his women. A foreshortened, freshly coloured
oval, a low forehead, prominent, wide-apart eyes placed well
beneath the brows, almost on a level with the tip of the ear,
a turned-up nose, a heart-shaped mouth, a child's chin, such
are the features of which he habitually made use. His type of

beauty is thus somewhat petty, and rarely amounts to more than a kind of faint, dull charm. His faces are simultaneously bovine and mincing. It is, perhaps, only in his delightful illustrations to Molière, in the charming drawings for *L'École des femmes* and *Les Précieuses ridicules*, that he has achieved expression, the subtle smile of a woman of the period, a witty, wayward beauty.

When Boucher descended Olympus, his imagination found refreshment in pastoral subjects. These he painted in the only manner that was then permitted: he banished from his idylls 'that particular crudity that is always somewhat distasteful'. He presents them in the most chivalrous disguise, in the vesture of the masked balls of the court. Rustic life at his touch became an ingenious romance of nature, an allegory of pleasures and loves, virtues subsisting, remote from city and society, in the 'enchanting deserts' of Mme Deshoulieres.[16] He evoked Sylvio, Phyllis, Lycidas, Alexis, Celadon, Sylvanus, in all those compositions arranged, so to speak, on the banks of the Lignon:[17] 'Pensent-ils au raisin?', 'Les Charmes de la vie champêtre', 'Les Bergers à la fontaine', 'Le Pasteur complaisant', 'Le Pasteur galant', or 'La Foire de campagne'.[18] These delightful shepherds, these adorable shepherdesses are all satin, paniers, beauty spots, necklets of ribbon; their cheeks are painted, their hands fit only for the task of embroidery and their feet, escaping from their slippers, are the feet of aristocrats; their sheep are silken and their crooks flowered; and these peasants are posed like a salutation by Marcel and their ladies seem to have issued from the hands of a wardrobe mistress of the *Menus Plaisirs du Roi*. . . . It is a society dropped upon the green

*[16] The poetess, Antoinette Ligier de la Garde, Mme Deshoulieres (1638–1764), was the pupil of the libertine poet, Jean Henault, and the authoress of a tragedy and various idylls, eclogues and songs.

*[17] The river Lignon, a tributary of the Loire, flows through the plain of Le Forez; the Lignon was celebrated in the pastoral novel *L'Astrée*, by Honoré d'Urfé (1568–1626).

*[18] 'Are they thinking of the Vine?' 'The Delights of Country Life', 'Shepherds by a Spring', 'The Willing Shepherd', 'The Amorous Shepherd', 'The Country Fair.'

turf of a pastoral by Guarini,[19] a song upon its lips and pink
rosettes upon its shoes. It is an eclogue of the kind of which
Fontenelle spoke when he said, as if foreseeing the phantasy
of Boucher: 'It appears to me that the eclogue is gradually
becoming analogous with the peasant costumes in a ballet:
their material is much finer than that worn by real peasants;
they are even adorned with lace and ribbons, and it is only
the general cut that suggests the authentic peasant.'

To accompany these eclogues, these rustic scenes, to serve
as their background, Boucher created a landscape, a sympa-
thetic natural setting. He did not adopt the deep perspective
of Watteau, he did not open up groves like fans or lay out
behind his figures those illuminated parks whence the glow
subsided on the horizon and whose shadows died away like a
murmur. Boucher's springs and fountains do not disappear in
the distance, in vapour; his countryside is not that refuge of
silence and peace where sensuality is meditation. For him,
nature is a charming tumult. He loves above all some little
plot of ground, singing and trembling with fresh colour, full
of bursting foliage, encumbered with complex tree forms,
with pollarded willows, with volleys of branches. In the fore-
ground a stream chatters and splashes, running water glitters in
the sun, some rivulet of France, bordered with reeds, flings
forward its freshness and gaiety. He trains the moss over
agglomerations of marble ruins; he hides the grass beneath the
broad leaves of the mullein; he entwines the saxifrage and
knots into curtains the reckless vine; he frames his nymphs and
landscapes in hangings of 'branchèd evergreen' which lean
and rock their long green fringes over the bodies of bathing
nymphs. And we may recognize in this luxuriant, capricious
vegetation, the verdant, alfresco chamber of which the
eighteenth century dreamt in its moments of tender fancy and
bucolic yearning.

While he was working for the Beauvais factory, Boucher
painted views of the surrounding country from nature,

---

*[19] The poet and diplomat, Battista Guarini (1538–1612), was the author of
the pastoral tragi-comedy *Pastor Fido*, published in 1590.

farmyards glimpsed through ruined arcades, country barns, the repositories of confusion of rustic objects; thatched roofs sprouting flowers sown by the birds; reed shelters supported, sometimes pierced, by ill-cut beams; mill wheels, sheds repaired with planks, dovecotes covered with mossy tiles, the curbs of washhouses, their stone worn by the knees of laundresses; backyards bewildering the eye with their debris, old straw, old ladders, wheelbarrows, hatching baskets —to all this he gives in his painting a richness, an abundance of disorder, an unprecedented picturesque quality which the eighteenth century defined with a word expressly created to describe this aspect of Boucher's art: *le fouillis*. And to increase still further the *confusion* of his landscapes, to give them more life, more disorder, a more bewildering animation, flocks of birds are flung into his skies, while below the hens are squabbling, the dogs barking, the children running about the yards where their feet slip on the grain; and on the roads, he launches convoys of animals into the dust, caravans from Castiglione, a kind of exodus from the Ark, the tumult of herded sheep and of the return from the market, the donkeys clinking, as it were, with the noise of the copper pans shaken about on their backs. As a landscape painter, Boucher's unique pre-occupation seems to have been to preserve his generation from the tedium of nature.

## V

The popularity of Boucher was due as much to his drawings as his paintings. Until his time, drawings by the French masters— projects, sketches from nature, the germ of an idea, a line, the inspiration of a moment thrown boldly on to the paper by a hand in haste—had had neither commercial value nor general publicity. Thrown off, for the most part, on the back of some unsatisfactory sketch-book—as was the habit of Watteau, Lancret, Oudry and others—or simply on odd sheets of paper nailed to the wall in a corner of the studio, the artists kept them, without special care, as reminders, projects for pictures, as their *Liber Veritatis*. They rarely left the painter's house

unless carried off by an enthusiastic friend; or else at the painter's death they were sold in lots for a few *livres* by the valuer and dispersed in all directions. Boucher was the first to turn drawings into a profitable enterprise for the artist, one that secured him publicity and one which attracted money, taste and fashion. The sheets on which he drew studies and fancies emerged from the portfolios of collectors exclusively of drawings and were used for the adornment of apartments, appeared on their walls, became part of the decoration of the most splendid interiors. They were soon at home—like the easel picture—in the boudoir, the drawing-room and the bed-room. Women liked them; such men as Joullain and Basan bought them; it became the correct thing to possess them.

These drawings, so charming and so much vaunted, were lively, facile sketches produced by the painter without effort, figures broadly and rapidly drawn in Italian chalk or *sanguine*, country scenes lavishly sketched in, pastorals in which we may discern the bold touch, even the shorn heads of the Carracci, mythological conceptions in which the forms of nymphs and goddesses displayed themselves voluptuously in all the attitudes of pleasure, all the coquetries of undress; or, again, the black chalk might fix upon the paper the image of some marquise in a collar of Spanish lace, her skirt broken into a thousand folds. Sometimes, upon a ground of *sanguine* which warms the drawing with a bloom of dim red, a frenzy of bistre conjures up a landscape prepared with a few strong, rapid brush-strokes. On rare occasions, the artist produced water-colours, full of liquid washes, bathed in the colours of old silk and the harmonies of half-light; then he returned to chalk or pencil, and beneath his flowing, rolling, rich lines like the cuttings of a chisel, garlands, bands, bouquets of cherubs were born and burst into flower; female nudes, plump, starred with dimples, rose in their opulence, seeming to reveal the blood of Rubens flowing in the veins of his bastard—charming, un-varying studies of the same soft, dimpled body, young, in brilliant health and whose prototype was provided by a model who might almost be said to have a history.

There is nothing in eighteenth-century art of which we know less than the subject of painter's models. Nothing is more anonymous than the immortality bestowed upon them by brush or pencil. Almost the only documents on the subject are the correspondence in which the father of one of Doyen's pupils gives expression to his serious fears of the possible effect of these ladies upon the morals of his son, and that engraving of the Academy by Cochin in which he represents a model of the period, in full regalia, the skirt flounced and tucked up over the high-heeled slipper, the hair surmounted by a crown and posing for a study of expression. Let us consider Boucher's model for a moment and record here the following fragment of the private history of studio life during the reign of Louis XV. This habitual model of the painter, whom Parisian society called *la petite Morfil*, was Mlle Murfi, of Irish origin, sister of the Academy's official model, to whose position she had secured the succession. When Mme de Pompadour resigned herself to the role of providing the King with mistresses, it was Mlle Murfi whom she ordered to pose for a Holy Family destined for Maria Leczinska's oratory; her foresight was not deceived: the portrait aroused the King's desire, and Boucher's model had the honour of opening for the first time the gates of the Parc-aux-Cerfs.[20] But, by that time, Boucher had no further need of Mlle Murfi; he had almost ceased to make use of models; he had finished with the teaching of nature and the tentative procedure of the life-study. Reynolds relates that, when he visited Boucher during his French tour, he found him busy on a large picture for which he made use neither of a preliminary oil sketch nor of any kind of model; and when Reynolds expressed his surprise, Boucher replied that he had considered models necessary in his youth, but that he had long since ceased to employ them.

What could be more charming than Boucher's female

[20] *Mémoires d'Argenson*, Paris, Jannet, Vol. IV, and *Madame de Pompadour*, by Edmond et Jules de Goncourt. Charpentier, 1878. [*Le Parc-aux-Cerfs was the villa, destined to acquire an almost legendary reputation, in which the more transient mistresses of Louis XV were accommodated.]

life-studies! They amuse, provoke, titillate our eyes. How well his pencil hollows the fold of a thigh! What felicitous accentuations of red chalk suggesting, in the shadows, the reflection of blood beneath the skin! What rich, facile draughtsmanship, seeming to tease the flesh, and what a skilful blurring of black and white producing a satin sheen upon the skin! With a few broad hatchings, Boucher renders the sun's rays turning and curling upon naked limbs which he appears to have struck with light. A single stroke of black and a white dot suffice to express a perfectly placed dimple. And with what a variety and diversity of attitude this tantalizing poem of nakedness is perpetually renewed! Female forms move and change at his touch as though in the mirror screen of an alcove. He flings them upon the curtains of a bed, raises them against a cloud of silk, lays them down, overturns them; Venus triumphant alternates with wanton shepherdesses; and when he uses tinted paper, when it takes his fancy to enliven his study with touches of pink, when his cross-hatchings combine red chalk with the black, when he powders white chalk on the shining flesh, when he scatters here and there bouquets of colour in pastel, in the sky or on the drapery, he manages to give life and substance, on a mere sheet of paper, to the charms of the most delightful nudity.

A press of illustrious collectors competed for his drawings. The *Financiers* filled their portfolios with them. M. Nera contended for their possession with M. de la Haye, M. de Grandcourt with M. de Fontaine, and M. Dazincourt with M. d'Argenville. Mme Dazincourt and Mme de la Haye vied with each other for the honour of possessing the best collection of them. And, since Boucher was lucky in all things, it happened that, at the height of this infatuation for his drawings, an engraver discovered a process that would reproduce the particular quality of a chalk drawing: Demarteau,[21]

---

★[21] Gilles Demarteau (1722–76) improved the technique of engraving by introducing the use of the roller by means of which the effects of pencil could be successfully reproduced.

with his astonishing facsimiles, put this aspect of Boucher's art into general circulation.

There still survived, as recently as two years ago, in an old house near the Sorbonne, the house in which Demarteau had lived, an interesting testimony to the gratitude of the painter whom he had so successfully interpreted, a charming tribute from the painter to his engraver; it was the salon painted by Boucher, on whose four walls he had depicted the interior of the home of a fashionable artist of the time. This salon was like an arbour and an aviary. A chequered trellis, like the marquetry on the sides of rosewood furniture, ran along the base of the panelling, framed the mirror, and clambered round the two windows, sparing only four large wall-panels and four small doors with their over-doors. Between the trellis-work was the countryside. On one side were river banks peopled with flamingoes and peacocks with their tails outspread, and, beyond an uprooted tree fallen into the water, a glimpse of fighting·swans; on another, the caperings of a sporting dog, a magpie fluttering among hollyhocks as tall as the sky, and again, in the distance, a river streaked with ducks in the most variegated colours; and on another, the river bank reappeared, overgrown with verdure, brightened by the diapered plumage of birds in pink, blue and green; on the fourth side, a trellis, devoured by climbing roses, stood amidst a confusion of rustic utensils and squabbling poultry. Billing doves were represented above the four doors on which cupids, thickly painted in grisaille, crushed fruit against their lips, or made the water spurt out from a spring with their half-closed fingers.

## VI

The commissions that were showered upon him, the requests from all quarters for his drawings, by no means exhausted Boucher's activities. The task, enormous as it was, did nothing to allay that fever of production, that furious industry that had gripped him the day on which he first took up his brushes, and which was to chain him to his easel for ten hours a day for the

rest of his life.[22] In the midst of all this labour, Boucher still
found moments of leisure; he still found time to make con-
tinual note of a thousand fancies, a kind of supplement to the
main body of his work; he amused himself by caressing with
his chalk or his colours a variety of small, even miniature,
objects. He enhanced with his brush the most trifling articles
of fashion, fans, watch cases, ostrich eggs, china, carriage doors
and innumerable other things of the kind. M. Thoré claims to
have seen a little cartouche which he painted in oil for Mme
de Pompadour, a medallion, about the size of a hand, on which
he had depicted a shepherd's declaration of love to a shepherd-
ess, a little scene in which baskets of roses, beribboned hats, air,
space and sensuality, felicitously intermingle. He could have
compressed all Cythera within the circle of one of Guay's[23]
engraved plaques.

It was his recreation to deal with such trivialities; and it
was, for him, a vocation to leave some trace of his art on every
passing manifestation of fashion. There were moments in the
life of this court painter when he seems to be drawing in the
evening by lamplight for the delight of a group of children
jogging his elbow in their curiosity. When, towards the
middle of the century, there burst upon Paris a craze, one of
those crazes to which French society periodically succumbs, a
craze for puppets which succeeded, from 1746 to 1748, the
craze for cut paper-work, when the Duchesse d'Orléans took
it into her head to have a doll worth 1,500 *livres*, to be made
by the best maker and really worth its price, it was Boucher
who designed and painted it, laughing in advance at the
mediocre epigram in the songs of Maurepas which this com-
mission was to provoke.[24]

But it was in vain that he sought to occupy his leisure hours
on toys; such diversions failed to absorb all his energy. He still

[22] *Galérie françoise* by Restout.

*[23] Jacques Guay, engraver and carver of semi-precious stones (1715–87),
was attached to the 'Cabinet du roi' and was employed by Mme de Pom-
padour to instruct her in the practice of his art.

[24] *Journal historique et anecdotique de Barbier*, Paris, Renouard, Vol. III.

had time, vitality and ideas to spare; he took up stage decoration. In 1737, 1738 and 1739, he had worked on scenery at the Opéra; and he worked there again, for a fee of 5,000 *livres*, from August 1744 to July 1748.[25] His activity in this field was not confined to scenery for the Opéra. When Monnet,[26] who was his friend, wished to revive the Opéra-Comique and to assure his venture a brilliant début, at the Foire Saint-Laurent in June 1743, with a parody of *Les Indes Galantes*, it was Boucher whom he commissioned to design the highly successful scenery. For the theatre built by Monnet in thirty-seven days for the Foire Saint-Laurent of 1752, Boucher designed almost the entire auditorium, the ceiling, the ornamentation and the scenery, and supervised all the painting. And at the Foire Saint-Germain, in 1754, it was again the talent and the brush of Boucher that all Paris came to applaud in the *décor* for Noverre's ballet, *Les Fêtes chinoises*.[27] And it was not simply sketches for scenery or mere models that Boucher provided, but canvases such as his decoration for the *Hameau d'Issy*, measuring three feet by two, and which he sent to the Salon of 1742.

This activity, this fertile imagination, always prompt to expend itself on 'luxury goods', to flatter the taste for the pretty and the fashionable, to provide the Vincennes factory with models,[28] also played a role in one of the great artistic industries of the eighteenth century. Oudry, who had been appointed by Fagan, Minister of Finance, to revive the Beauvais factory founded by Colbert and now in a state of decay, felt obliged to summon to his aid the multiple talents of

[25] *Histoire manuscrite de l'Opéra*. The Beffara papers, Bibliothèque de l'Hôtel de Ville.

★[26] Jean Monnet (1710–85) was the Director of the Opéra Comique de la Foire de Paris and later of the Opéra Comique. One of his companies played, with considerable success, in London.

[27] *Supplément au Roman comique ou Mémoires pour servir à la vie de J. Monnet.* Barbou, 1772.

[28] *Observations sur les ouvrages de MM. de l'Académie de peinture et de sculpture exposés au Salon du Louvre en 1773*, by the Abbé Leblanc.

Boucher, who was so expert on all questions of luxury and ornamentation. And when Boucher, appointed Director at Beauvais, replaced Oudry, on 21 June 1755, as Inspector of the Gobelins factory, the contractors, embittered by the pestering supervision of Oudry, welcomed the new directorship as a deliverance and warmly expressed their thanks to M. de Marigny for such a happy and well-deserved choice.[29]

## VII

'Psyche, conduite par Zéphire dans le palais de l'amour', 'La Naissance de Venus', 'Le Bain de Diane', and 'Les Forges de Vulcain'[30] had already placed Boucher in the front rank of the painters of his time, when as a reply to the reproach that he had ceased to do more than paint easel pictures,[31] he exhibited, in 1753, 'Le Lever du soleil' and 'Le Coucher du soleil'.[32]

In the first of these great canvases, *putti*, high up in the sky, draw aside the veil of night and fold up the darkness like a tent. Aurora, wearing the morning star upon her brow, plucks one by one, with the tips of her fingers, the rose-red rays of the awakening light. Beneath the caresses of the dawn, the youthful Apollo rises in nascent splendour; crimson drapery floats like a scarf about his body; under his feet, the ocean foam breaks into vapour, disintegrates into clouds. A winged divinity presents his chariot reins and the bridles of his horses pawing the ether, while the daughters of Doris, the sea nymphs, the waist-high waters beating against their sides, fasten upon his legs the ribbons of his buskins. In front of the rising Phoebus, a cherub plays with the pearl necklace that has fallen from Aurora's neck; tritons listen in shells to the murmur of the seas, questioning the ebb and flow of the echo.

---

[29] *Notice historique sur la manufacture de tapisseries des Gobelins*, by Lacordaire. Paris, 1854.

*[30] 'Zephyrus leading Psyche to the Palace of Love', 'The Birth of Venus', 'Diana Bathing', 'The Forge of Vulcan.'

[31] *Lettres sur la peinture, sculpture et architecture à M. . . .* , 1748.

[32] These two pictures, disposed of at the sale of Madame de Pompadour's property and subsequently in the possession of M. de Saincy, now belong to Mr. Richard Wallace. [*'Sunrise' and 'Sunset'.]

Dolphins with ruby eyes and nostrils, rocked on the heaving waves, softly cradle the nereids, pillowed upon their heads, who, turning towards us their wet backs, on which the sea's tears linger like drops of mother-of-pearl, throw us a tantalizing smile across their shoulders.

In the 'Coucher du soleil', at the top of the picture, cupids unfurl the dark-blue mantle of night. Their feet are lit by reflections from the expiring day. Out of a pink-and-violet mist, almost lost in the background of shadows, amid which a garland of *putti* unwreathes itself above the lapping of the green waves, Apollo gleams in the glorious twilight. His rococo chariot, surrounded by a swarming press of cupids, gently enters the sea and glides towards the abyss; his white horses, with their pink nostrils, are still aglow with the last fires of the sun; one of them is still silvered by the light; the other has already plunged into the obscurity! The god, as slender as an ephebe, advances with his arms outstretched towards Thetis. Leaning forward in an attitude of amorous welcome, the goddess glides towards him in a conch adorned with the colours of the sea, her robe dyed in the subtle hues of a wave, her hair powdered and silvered by the spray. A nereid has taken shelter with her and leans against the conch, her hand gracefully shielding her eyes against the god's last beam; and all around Thetis, her court of tritons and *putti* plough up, exhaust the ocean with their frolics in which a group of women share, their undulating forms mingled together, bathed by the sea, caressed, and tossed upon its trembling bosom.

These works are Boucher's two masterpieces. They have all the radiance, the blaze, the magnificence of the sun chariot of the *Metamorphoses* effusing the fire of gems and chrysolite. They represent the painter's grandest endeavour, the two most ambitious productions of his art. They aroused the enthusiasm of his contemporaries, and they still dazzle us today. And yet, for a proper appreciation of Boucher's talent, and in deference to his fame, we do better to judge him in smaller, less pompous, less official pictures. As an artist full of a natural

spontaneity, his personality is nowhere more delightfully manifest than in his compositions on a less ambitious scale, in which his heart and hand penetrate every corner of the canvas without fatigue. A lively esquisse completed in a single morning with a demon-like gift of improvisation, a preliminary sketch moulded in the colours of the dawn, a group of figures, the soft contour of a torso wavering in a pale, vaporous light, a goddess flung upon a couch of clouds—it is in such works that the real mission, the real achievement of this fluid, liquid art declares itself, an art whose colours the painter's friends compared to rose petals floating in milk. And even if the only extant work of Boucher's was the fascinating reclining Venus in the Marcille collection, we should still recognize in the magic of this single work the temperament of a great painter, nor could we refuse to the creator of such colour the just tribute that David himself paid him when he said: 'One cannot be a Boucher by simply wishing it.'

## VIII

The reins of power in France were, at the time, in the hands of a woman whose protection Boucher was pre-destined to enjoy. This king's mistress, Madame de Pompadour, who had the intelligence to create,with the power she wielded, a kind of ministry of art and literature, found in Boucher the painter whom a benevolent Providence had destined for her. Was he not the ideal artist, matching her reign, her tastes, born, fashioned, evolved as her courtier, her poet and her historian? Without him, our conception of the favourite would lack some essential but indefinable light and emphasis; he illumines and completes her character as a woman artist, just as Bernis signifies her role as a woman politician.

As soon as she progressed from the caprice of a single night to the command of a reign, Madame de Pompadour attached herself to Boucher. She gave him commissions. She granted him a kind of monopoly for the decoration of the royal buildings and residences. As early as 1746, he painted for her

'L'Éloquence et l'astronomie',[33] destined for the *Cabinet des Médailles*. In 1747 she placed his picture 'Les Forges de Vulcain' in Louis XV's bedroom at Marly, as if to keep her protégé continually in the royal presence. In 1750, she commissioned him to paint the picture that was to decorate the chapel of the Château de Bellevue; and in the château itself he decorated with *chinoiseries* her charming boudoir furnished with chintzes and gilt with gold; she placed at his disposal, to be covered with his brightest colours, his gayest fantasies, the panels of the gallery which she conceived and designed herself, in which wonderful garlands of flowers carved by Verbeck served as frames to the painter's fancies.[34] And it was she who purchased his two great pictures 'Le Lever du soleil' and 'Le Coucher du soleil'. Whenever she deemed it necessary to reawaken the King's sensuality with the stimulus of indecent suggestion, she turned to Boucher who would throw off a series of panels illustrating a story which began in the idyllic and ended in the pornographic vein. When she wanted her own portrait it was Boucher whom she chose, with La Tour, to leave an image of her that was to survive her heyday and cheat the oblivion of death. And Boucher painted her in that attitude of languor which a *chaise longue* naturally induces, and with the absent-minded yet attentive air of a woman who is loved, and who, half turning her head, awaits love's favours. Mme de Pompadour's right arm is pillowed upon a cushion of painted Pekin; with her left she holds a book lightly upon her knees. Boucher has adorned her hair with powder and rosettes; he shows her in a square-necked dress, and has slightly widened, at the base of the throat, the border of the opening; it is a magnificent blue flounced frock, flowing with silver lace and embroidered with little roses; and below the skirt are visible the favourite's two sprightly feet, crossed as was her wont, and shod in pink slippers, embroidered in silver. And all over it there are ribbons and bows, at the neck, at the small of the arm, on the

---

★[33] 'Oratory and Astronomy.'

[34] *Dictionnaire historique de la ville de Paris*, by Hurtant, Paris, 1779, Vol. I.

breast. The model is seated in a room hung with yellow silk, and seems almost to emerge between two heavy curtains from a mirror in whose reflection, as if in a mist, appears a bookcase surmounted by a clock in the shape of a lyre and watched over by a cupid. On the floor, at Mme de Pompadour's feet, Boucher has arranged the insignia of the tastes and pleasures of his patroness: a pencil-holder set with black and red chalk, an open portfolio of drawings, the half-unfolded ground-plan of a château, rolls of music and an engraver's burin are lying here and there, together with a recumbent King Charles spaniel and two fallen roses. On her right, nearer to her, the painter seems to have wished to characterize the more serious aspect of her life, her affairs as a favourite: here there is a little writing-table in rosewood, a chased silver candlestick, the seal of the marquise, a stick of sealing wax, an opened letter, a pen standing in an inkpot, and, in an open drawer, pamphlets, books, volumes bound in morocco and stamped with coats of arms, and, again, two roses negligently left there by the chambermaid in the midst of all these appurtenances of a favourite and a prime minister.

This portrait is, so to speak, an example of display, a presentation portrait of Mme de Pompadour; the refinement of her charms has here an amplitude, and the creases in her dress, the ornamental ribbons and rosettes have a regal opulence and sumptuosity: it is the favourite in full dress, in her coronation robes.

Boucher was not only a protégé, but was also an intimate of Madame de Pompadour. He had free access to the room where Guay kept his lathe; and the favourite did him the honour of confiding to him her tastes, her projects, her dreams. She consulted him about the decorations she conceived. She conversed with him about the artistic world, whose patroness she had become. She was at home with the imagination of the painter who gave such a charming form to all the cheerfulness and pleasantness with which she wished to surround herself. Boucher was a connoisseur with whom she enjoyed discussing collector's pieces, he was the teacher who had first shown her

how to handle the etcher's needle and who guided her uncertain hand on copies of his plates: 'Les Buveurs de lait', 'Le Petit Montreur de marmottes', 'Le Faiseur de boules de savon',[35] and on the complete series of Guay's plaques. He was the artist to whom she confided the most intimate commissions, the alterations to her private apartments, the design of her personal ornaments. Every day she was in fresh need of this man, who was her private artist. When she required designs for the statues at the Château de Crécy,[36] a cherub or a frontispiece to engrave, a portrait to send to a woman friend, it was to Boucher she turned, who promptly designed figures of shepherdesses for the sculptor, made a sketch of flying cherubs or, with a few pastel strokes, improvised a medallion representing the marquise in a framework of flowers and other suitable attributes.

Madame de Pompadour had so accustomed the King to the name and merits of Boucher that even after her death he continued to enjoy her protection; and after the death of Vanloo, it was under the auspices of the vanished favourite that Boucher was appointed First Court Painter.[37]

We are able to publish here, for the first time, the certificate of appointment in which the royal condescension has been given such fine, tutelary expression:

## CERTIFICATE APPOINTING THE SIEUR BOUCHER TO BE CHIEF COURT PAINTER

September 8, 1765.

Today, the eighth of September, seventeen hundred and sixty-five, the King being at Versailles, His Majesty, always

---

★[35] 'Drinking Milk', 'The Little Kerchief Seller', 'The Soapmaker.'

[36] Catalogue de différents objets composant le cabinet de feu M. le Marquis de Menars, 1781.

[37] When Boucher was presented to Louis XV, the King, who had supposed him, from the warmth and vivacity of his work, to be a much younger man, expressed his surprise at finding him older than he had expected. 'Sire,' replied Boucher, 'the honour that Your Majesty has done me will rejuvenate me.' (Restout, Galerie françoise.)

prompt to recompense those who excel, by their talents, in the
Fine Arts and wishing to make known his particular benevo-
lence towards those who, by consistent application, have
achieved perfection and proved themselves worthy of his
esteem and of that of his country, considers that no one is more
worthy to exercise the function of Chief Court Painter left
vacant by the decease of the Sieur Carle Vanloo than the Sieur
François Boucher, Elector of his Royal Academy of Painting
and Sculpture. The reputation he has acquired in his art by
the superiority of his talents and by the great number of fine
works he has executed, and His Majesty's further desire to
reward him for the care with which, since seventeen hundred
and forty-eight, he has supervised the work of the tapestry
weavers at the Royal Factory of the Gobelins, have determined
His Majesty to bestow upon him this honourable title, which
will make known to the Academy of Painting and Sculpture,
while justifying His Majesty's choice, the special esteem in
which he holds each of its members and how much the services
of their company are agreeable to him. And, to this end, His
Majesty has installed and will maintain the said Boucher in
the position of Chief Court Painter left vacant by the Sieur
Carle Vanloo, and authorizes his use and enjoyment of the
honours, rights, powers, precedences, prerogatives, privileges,
licences and liberties which belong to that position for the
period of His Majesty's pleasure, who herewith informs of his
will in this matter and orders the Sieur Marquis de Marigny
. . . to ensure the Sieur Boucher full and tranquil enjoyment of
his rights in conformity with the present certificate, which, as
a guarantee of his will, His Majesty has signed and commanded
to be countersigned by me, Councillor and Secretary of State,
Private Secretary and Secretary for Finance.

Signed: Louis; and beneath: Bertin.[38]

IX

What, meanwhile, was criticism saying of the artist created in
the image of a society of which he appeared to be the spoilt

[38] *Archives nationales.* o' 1060.

child? How did the eighteenth century judge this painter, the offspring of its intimate essence endowed with all its graces, the accomplice of its imaginative modes, the artist predestined to bestow upon it the kind of immortality which it merited and would have chosen?

The critics of the period agreed to admire the consistent richness, amplitude and grandeur of his compositions, his fresh, agreeable colour, the tender sweetness of his attitudes, his felicitous grouping, the picturesque element, the bustle and activity of his rustic scenes. They acknowledged his gay, lively, fertile imagination, his treatment, always refined and graceful, of the movements of the head, his variety and the subtlety of his expression. They were almost unanimously of the opinion that he was an admirable painter of 'history', landscape, architecture, fruit and flowers; and that his composition and drawing were equally good. They praised the facility of his flowing brush-work, his mastery of the handling of light which he put to such beautiful uses, his open-air scenes, his flying draperies ideally suited to the nude figure. They even discerned a celestial spirituality in the Virgins of his Nativities and Holy Families—though it should be added that the same critics recommended to him the features of Mademoiselle Coupé of the Opéra as a model for those of the Virgin.[39]

Amid this concert of eulogy from the connoisseurs and authorized judges, which was but a faint echo of the general enthusiasm and of the idolatry of the public, there were scarcely audible a few dissonant voices timidly accusing Boucher of an excessive refinement in his treatment of the human face, of painting too raw, with too much superficial brilliance, of squandering his lights, of not contrasting them sufficiently with his shadows, of an abuse of crimson,[40] of a

---

[39] From the Reply to an anonymous publication entitled: *Lettre critique sur les ouvrages de Messieurs de l'Académie exposés au Salon du Louvre*, 1759.

[40] To this reproach that the reflected tones of his flesh painting were those of a red curtain, Boucher replied with the excuse of his fading eyesight, which, he said, now perceived only *an earthy colour on objects where others supposed they saw vermilion*. (*Galerie françoise*, by Restout.)

lack of repose, of addiction to a female type that was pretty
rather than beautiful, attractive—and even flirtatious—rather
than noble, of burdening his draperies with a superfluity of
broken folds, of an unsympathetic rendering of the nude, and,
finally, of a lack of expression.

But these voices were smothered by the chorus of acclama-
tion, by a general enthusiasm which could express itself in
these terms: 'Boucher's brush is a magic agent inducing in us
a state of tender admiration which suspends the functions of
the mind.'[41] Boucher enjoyed that crowning glory of success,
popularity. His fame radiated in all directions, was everywhere
dominant. The admiration that surrounded his name and his
talent was like a contagion in the air. The young artists who
departed to study the masterpieces of Italian painting, did so
with their mind's eye full of his pictures; and when they
returned from Rome, it was not having learnt the lesson of the
old masters, but with the memory of the Parisian painter still
fresh in their minds, and with Boucher's style at their finger-
tips. It seemed that the future of art would be determined by
a 'School of Boucher'.

One man, Diderot, resisted energetically, brutally, the
intoxication, the kind of spell-bound state which the painter's
talents provoked in his contemporaries. On every occasion,
this critic rose, with all his force and vitality, against Boucher's
painting and its success; the fact alone of writing Boucher's
name seemed to destroy his composure as if it had been the
name of a personal enemy. He stoned the popular god, be-
smeared the painter, assaulted the man. Listen to him as he
pauses at the Salon before one of these admired canvases; he
ejaculates his judgement, his scorn, his anger in hurried,
furious phrases, jotted down in a state of maniac rage: 'Graces
borrowed from Deschamps . . . simperings, affectations . . .
nothing but beauty spots, rouge, gew-gaws . . . frivolous
women, libidinous satyrs, bastard infants of Bacchus and
Silenus . . . the degradation of taste, colour, composition,

---

[41] *Description raisonnée des tableaux exposés au Salon du Louvre*, 1789. Printed
by Claude-François Simon, the younger.

characterization, expression, drawing . . . the imagination of a man who spends his time with prostitutes of the lowest grade. . . .' That was all that Diderot perceived in the art of Boucher, of whom, nevertheless, he was one day to remark in a moment of self-forgetfulness: 'Nobody understands the art of chiaroscuro so well as Boucher.' But we must be careful not to consider Diderot an infallible judge: his taste was frequently subject to freakish lapses. Passion was the essence of his wonderful genius as a writer; and even his criticism was the child of passion, with its transports, its wonderful effusions, its living descriptions, its flood of ideas and colours, its improvisations, its apostrophes, and its eloquence which speaks, converses, enthuses; the fiery impulsion of a powerful instinct sustained him; he was often unprotected by the moderating influence of any justness in his perceptions and feelings. We may ask, furthermore, whether Diderot's appreciations were always entirely his own. The professional artists who gathered about him, and in whose company he learnt the technology of art, Cochin, Chardin, Falconet, may well have inspired his first reactions before a canvas, a statue or an engraving, by their conversation, by some chance remark, by some studio sarcasm. It is possible that the critic in all good faith may have sometimes derived the severity of his opinions from some professional rivalry between painters. But we need not examine the point so closely: there was already a substantial reason for Diderot's unjust treatment of Boucher. We must remember that if Diderot recognized Chardin, he invented Greuze. Diderot was, above all—or so he believed—a philosophic critic, the apostle of an art that should be useful and profitable to humanity. He taught that the function of the beautiful was not only to be beautiful but to be good. He required of the plastic arts some practical teaching, some contribution to the sum of truth or of the moral perceptions then current in society. This was a singular point of view from which to judge Boucher, and one that inevitably led Diderot to serious censure of Boucher's gallantries as being useless, unsuitable for either reading, writing or the scutching of hemp.

Boucher no more deserved the cruel severities of Diderot than he did the wild enthusiasm during his lifetime of the public, of society, of women and of dandies. He was neither a mere dauber of fans nor 'a master in all branches of the art'. He was simply an original, highly gifted painter who lacked one superior quality, the birthmark of all great painters, namely distinction. He had his own particular manner, but lacked style in the best sense of the term. It is in this that he ranks so far beneath Watteau, together with whom he was readily named and paired by the fashionable world, as if there could be any parity between Boucher and the master who elevated wit to the level of the grand style. Elegant vulgarity— that is the hallmark of Boucher. It is not only in the totality of his composition, it is also in the movement of his line, the extremities of his figures, the particular emphases of his heads, that he lacks a certain expression, a certain character, a certain rare, delicate grace exempt from the banality of accepted technical methods. In a word, though his imagination is of the most facile, and his execution of the happiest, Boucher revealed in his drawing and in his modelling an indefinable roundness, a yielding softness deriving from custom and set processes. If we are to tell the truth, and if we may risk a term borrowed from the parlance of the studios which characterizes his talent somewhat brutally, he was *canaille*.

Boucher the painter was considerably superior to Boucher the draughtsman. We must repeat that there was in his composition a rare and authentic colourist and he was perhaps the finest natural painter of the French school. But Boucher, a born painter and one who was able to raise himself, in mid-career, to the expression of that true, virile colour with all the warmth of a sunset by an Italian master, was yet distracted and ruined, as were all his followers, by the demands and temptations of the applied arts. It has been largely forgotten that it was the art of tapestry which transformed Boucher into a decorator. Consideration of his development as a colourist shows, year by year, the corrupting influence of the commissions from Beauvais and the Gobelins upon that scale of

colour characteristic of French painting, whose earliest mani-
festations, at the beginning of the century, in such works as
Lemoine's 'Omphale' and Watteau's 'Embarquement pour
Cythère' were so potent. The more Boucher worked for the
weavers of Cozette and d'Audran, the more his painting was
burdened by faulty tone, and the more his colour grew simul-
taneously paler and more gaudy. Obliged to conform to
harmonies that would reproduce in wool and silk, to restrict
his shadow values, to make sacrifices for the sake of gay
colour, to seek an all-over effect of clarity, softness and sparkle,
Boucher mollified his tones and colours by dilution and
flattening. His verdure fades off into blue, his trees into grey,
his distances into mauve and his lights into a curdled white;
and, in the end, the colour register of the tapestry maker so
thoroughly replaced, in Boucher's art, the palette of the painter
that he seemed only to paint in a transparent medium, land-
scapes suitable for the decoration of fire screens, rose-coloured
figures, and fanciful scenes of the wallpaper variety.

## X

Honours were showered upon Boucher, whose reputation
extended throughout Europe and whom the Academy of St.
Petersburg appointed its Free Associate. In 1765, on the death
of Vanloo, the position of Chief Court Painter had been
assigned to him, and the Academy, so as to install him as the
full successor of Vanloo, appointed him their director, a
function that was not necessarily attached to that of Chief
Court Painter.

The period of Boucher's directorship was a somewhat feeble
one; he was old, in ill health, and entirely absorbed in painting
his own pictures, which brought him in an income of a
thousand *livres* yearly.[42] He lacked the inclination, the strength
and the leisure to carry out this exacting function, to order
personally all the works of sculpture and painting, to direct
the school himself and to perform conscientiously all his duties

[42] *Notice sur François Boucher*, by Durozoir. *Annales de la Société libre des
Beaux-Arts*, Vol. VI, 1841–2.

of patronage towards the general body of artists. He imitated his predecessor; he made use of the title and the advantages of his position, and left the rest, the work and the detailed administration to Cochin, who had already been the effective director of the Academy under Carle Vanloo. Under such a negligent and carefree director, it turned out that the 600 *livres* due to the Academy's model was left unpaid, that the lodging allowance of the students was not remitted, and that, without the soup provided for them by Michel Vanloo, they would hardly have had anything to eat. At one moment the Academy, its finances reduced to the income derived from the sale of its exhibition catalogues, was on the point of closing; and its survival could only be ensured by means of a voluntary subscription from a group of connoisseurs and art lovers. It is Diderot who left us this picture of the state of the Academy in 1769.[43] It is probable that he exaggerated the degree of its indigence; it is difficult to admit that Boucher, a man of generous and benevolent character, could have carried heedlessness to the point of insensibility. But it is indisputably true that, as a director, he lacked both zeal and initiative.

## XI

Absorbed in his work, living almost exclusively in his studio, Boucher hardly deserted his easel during these years except for one short journey. In 1766, M. Randon de Boisset, desiring the benefit of his taste and advice in the matter of certain important purchases he proposed to make, took him with him to Holland and Flanders, the fatherland of Rubens, where, in the eighteenth century, enthusiasm for the art of Boucher was such that he was known as 'the unique Boucher'.

He passed the remaining years of his life in the studio where he was so much at home, surrounded by his own possessions and bibelots, that bouquet of enchanted colour, the glow and the splendour which he had so often infused into his canvases. He dwelt there amid the objects whose brilliance he loved to reproduce in his paintings, a world of shining, sparkling

[43] *Œuvres de Diderot, Salons.*

objects, the reflection of whose fires, the magic of whose lights
had been captured in his art. As he grew older, he collected
about him precious stones whose bewitching rays warmed his
vision, his talent, into life; he encumbered his studio with their
rocky brilliance, with quartz, rock crystal, Thuringian ame-
thyst; tin, lead and iron crystals; pyrites and marcasite.
Native gold, clusters of unwrought silver like vegetation,
copper iridescent like the feathers of doves and peacocks,
fragments of lapis, Siberian malachite, jasper, flint, agate,
sardonyx, coral, the contents of Nature's jewel-box, seemed
to have been poured out on to his shelves and tables. And to
this wonderful museum of celestial colours garnered from the
earth was added a collection of shells, with their thousand
delicate shades of colour, their prismatic sheen, their changing
reflections, their rainbow glisten, their pale, tender pinks like a
drenched rose, their greens as soft as the shadow of a wave,
their moonlit whites; there were conchs, purpurae, oysters,
scallops, muscles, flora of pearl, mother of pearl and enamel,
arranged like sets of gems in Boule showcases, in cabinets of
amaranth wood or spread out on tables of Oriental alabaster
beneath carved wood candelabra.[44]

But it was not only the colours of his palette which thus
surrounded him. In addition to this ideal range of magical
colour, there was also material to inspire the painter's fantasy.
China, the fairyland adored by the eighteenth century, had
provided Boucher with its porcelain, sea-green, sky-blue,
speckled and crackled, and with all its exquisite, fantastic curio-
sities ranging from a teapot with a reed handle to a book of
arithmetic; China was the chimerical land where Boucher's
imagination found diversion, amusement, distraction, despite
the reproaches of contemporary criticism, and was delightedly
inspired to re-create on paper, on canvas, on over-doors, on

[44] See the *Catalogue raisonné* of pictures, drawings, prints, bronzes, terra-
cottas, objects in lacquer and porcelain, mounted and unmounted; rare
furniture, gems, minerals, crystals, shells and other curiosities comprising the
collection of the late M. Boucher, First Court Painter. Paris, at Musier's,
MDCCLXXI. The sale of the collection whose estimated worth was 100,000
écus, realized 110,919 *l.* 19 *s.*

fans, on the business cards of picture dealers, those baroque
personages, originally deriving from Watteau, which at the
touch of Madame de Pompadour's accredited painter were to
transform China into a province of the rococo world.

In the midst of this paradise for his eyes, surrounded with
the objects of his predilection, Boucher lived happily. We may
picture him sitting near his colour-box with eleven drawers,
with his porphyry grinder at his side, holding his maul-stick
ornamented with ivory, his vision playing abstractedly upon
all the miniature models with which the walls of his studio
were decorated; these included a boat, a galleon, a canon, an
upholstered carriage—wonderful little toys, to the list of which
we should add those of which he made more frequent artistic
use, a cart, a harrow, a wheelbarrow, a barrel, a fishing smack,
the furniture of a toy farmhouse, and the various implements
and accessories of country life that we may rediscover so char-
mingly transfigured in his pastoral subjects. And every day,
after dinner, a few intimate friends made protracted visits to
this studio, whose collections were daily augmented by some
curious or delightful accession, where the contents of port-
folios, already bursting, were continually supplemented with
new drawings, of which, for Boucher, there could never be
too many. The friends would admire the new acquisition, the
admirable temptation which Boucher had been unable to
resist; they would then amuse themselves by watching him
paint or draw, delighting in the spectacle of the composition
developing, taking shape beneath the rapid play of his pencils
and brushes, enjoying the demonstration of such a divine
facility, such an inexhaustible fertility. They lay in wait for,
and carried off as it was completed, any successful drawing or
felicitious composition, the inspirations of a truly providential
energy. Among them, the most devoted was M. de Sireuil,
who, in his passion for Boucher, sharpened by the painter's
death, went on collecting his drawings, the first thoughts for
his most important pictures, and was to leave behind him that
wonderful collection so happily entitled by its cataloguer,
'Boucher's Notebook'.

Familiar companionship, trustful friendship, the talk of connoisseurs, conversation whose winged words accompanied his work, the inspiring presence of so many brilliant objects, flashes of light playing amid the glitter of his mineral collections, echoes of the dreams and fancies of the painter repeated all over the room—Boucher lacked nothing in this place where, indeed, he felt himself so close to his Muse that the idea occurred to him one day to paint his own portrait there visited by Venus and Cupid.

This representation of Boucher in his studio is non-extant. But Lundberg's pastel is preserved in the Louvre; it is a portrait of Boucher as a young man, with animated features, as if alight, his eyes bright and his expression lively and happy; Lundberg seems to have captured him at the height of some supper party, in the middle of a sparkling conversation, at a moment of laughter and pleasure. There is also the portrait by Roslin, engraved by Salvator Carmona for his reception into the Academy, an official portrait, a portrait of the artist who was destined to become Chief Court Painter; in it, he wears a rich velvet coat, the finest lace crinkling in frills upon his breast, and frothing around his hand, which carries a pencil-holder. Look at his head, his big, fat nose, his prominent eyes, his thick wrinkled eyelids, his mouth broadly incised, so to speak, in the ample flesh and moist like the mouth of Piron, his strong features, his subtle glance; it is the agreeable countenance of an aging epicurean, a sympathetic face breathing benevolence, gaiety, sensuality, and voluptuousness of the imagination. And, on the evidence of all his contemporaries, the character of the man did not belie his lineaments; he was sensitive, obliging and disinterested, generous with his productions to the point of prodigality, incapable of base jealousies, immune from any low appetite for money gains, refusing to take advantage of the vogue he enjoyed by raising the prices of his pictures, strongly averse to intrigue, and preferring to leave the interests of his career to his talent alone or to the fortuitous action of circumstances. Such he appeared to be to his contemporaries, who have added that there was not a painter who

would laugh more readily at his own defects,[45] none who was more indulgent to others; and his one vice, the most amiable of social vices, was too great a love of pleasure, a love he preserved throughout his life, together with Tocqué, who loved it almost as much, and Monnet, the impresario, whose love was as great as Tocqué's; a joyous companion, an amusing story-teller who would contribute the wit of the studios to an occasion already gay with wine, women and song, a wit whose salty flavour never turned to bitterness on his lips.

The friend of youth, and liking to have young people about him, as if to recover some of the vanished years, Boucher allowed free access to his studio at all hours of the day. Since he was not subject to any of those gropings, those technical uncertainties, those momentary failures which may induce a painter to prefer working in seclusion, he gave his lessons with the doors open, declaring that 'he could only give advice with a brush in his hand',[46] and one or two of his brush-strokes on the canvas that was submitted to him taught the young painter more than anything that he could have said. He was, moreover, surrounded by the affection of his young friends and students who had known him, as long as health remained to him, to be ever ready to support an equitable cause and to speak out on behalf of justice with all the natural warmth of his character. They remembered particularly what he had done for Vien. On his return from Rome, Vien, rejected twice by the Academy, had suffered with fortitude the first occasion; but, stricken by the second, he had declared that he renounced for ever the honour of belonging to the Academy. Boucher, on seeing the picture he had submitted, flung his arms about the despairing candidate and announced that if his colleagues refused him, then he, Boucher, would never more set foot within the Academy. In 1767, when, as the result of an intrigue between Pigalle and Lemoine, the first prize for sculpture was won by Moitte to the detriment of Milon, on whom the judgement of the majority would have conferred it—a judgement

[45] *Le Chinois au Salon*, 1776.

[46] *Almanach Littéraire*, 1778.

to which the students gave expression by rioting in the Place du Louvre in an endeavour to compel Moitte to crawl round the square on all fours with Milon on his back—shouts of abuse were hurled at Cochin, Pigalle and Vien when they appeared, and the students punished their partiality by turning their backs upon them as they passed between their ranks; but when Boucher arrived everyone turned round, youth greeted him face to face, he was hugged and embraced: he had opposed with all his might the intrigue, and had defended, together with Vanloo and Dumont, the cause of Milon, which was also that of all the students.[47]

## XII

Boucher's wife had borne him a son whom, to his secret grief, he had been unable to educate as a painter of 'history' who would be worthy of the inheritance of his father's fame, and who confined himself modestly and quietly to architecture and decoration.[48] He also had two daughters, and married the elder to Deshayes. Deshayes died at the age of thirty-four, just as his talent was reaching the climax of its youthful vigour; he left to posterity that admirable picture 'Saint-Benoît mourant' which announced the future of a painter who might have become a master of the French school; his wife followed him into the grave a few years later.

Boucher had married his younger daughter to Baudouin,[49] who, whatever the contemporary judgements upon his talent, judgements which our own time has accepted, was a genre painter of talent. His gift properly ranks, in the eighteenth century, with, for example, that of the younger Crébillon. He had the lightness, the pretty audacity, the cultivated eroticism,

[47] Œuvres de Diderot, Salons.

[48] Juste Boucher, the son of the painter of the Graces and the godson of Meissonnier, received twice, in 1761 and 1763, the second prize for architecture. He was sent to Rome in 1764, returned to France in 1767, and thereafter was occupied, somewhat obscurely, on architectural and decorative undertakings until his death in 1781.

[49] The double marriage of Boucher's two daughters with Deshayes and Baudouin took place on 8 April 1758.

the charming accent, the delicate playfulness, the nimble style, the specifically French tone of the best passages in *La Nuit et le Moment*. He was not merely a pornographic miniaturist; he was an erotic artist, inspired by all that was graceful in the audacities of the period, consistently witty and refined, who expressed, in a series of illustrations suggestive of Collé,[50] the social scene of the century. Surpassing in his feeling for composition, in the rhythm of his formal arrangements all other 'vignettists' of the time, he revealed, in his gouaches, the qualities of an exceptional colourist. What a gulf subsists between the laboured gouaches of such heavy-handed Teutons as Lavreince and Freudeberg and these free, sparkling sketches by Baudouin, warmed with burnt sienna in the shadows, neatly alive with tender greens, whites, blues and pinks, splashed with those touches that Hall was to attempt to imitate, and liquefied with water-colour washes whose brilliance surpasses Fragonard and rivals Bonington!

Boucher loved his son-in-law; he loved the man and his talent. Baudouin worshipped his father-in-law. But it turned out that towards the end of Boucher's life, a life saddened by the deaths of those nearest and dearest to him, Baudouin also left him and died, a young man, in 1769. Boucher, who had long suffered from asthma, had now for some years appeared to his friends to be no more than the 'reflected image of a ghost'. But he continued to work, shutting himself up in the studio that he loved so much, labouring implacably like a workman persevering with the day's task though the day be already fading. When death came to him on 30 May 1770 at five in the morning, there stood upon his easel an unfinished picture which he had asked his wife to give to his doctor, Poissonnier.[51]

Boucher, who never boasted, declared, so Desboulmiers[52]

*[50] Charles Collé (1709–83), *chansonnier* and writer of charming and licentious plays, of which *La vérité dans le vin* is the best known.

[51] *Nécrologe*, 1771. Obituary of Boucher. [*The *Nécrologe* was a periodical publication devoted to the obituary notices of distinguished persons.]

[52] *Mercure de France*, Septembre, 1770. [*Jean Augustin Julien Desboulmiers (1731–71), libertine novelist and historian of the theatre.]

records, that, according to his own computation, he had
executed no fewer than ten thousand drawings, either sketches
or finished works; and that he had painted no fewer than a
thousand pictures, including sketches in oils and rough drafts.

# NOTES

MARMONTEL, in his character sketches of the regular guests at Madame Geoffrin's Monday dinners, writes thus of Boucher:

'There was an ardour in Boucher's imagination, but not much veracity and still less elevation; his encounters with the Graces had never had a respectable setting; he painted Venus and the Virgin from the nymphs of the green room; and his language suffered not less than his pictures from the manners of his models and the tone of his studio.'

<p style="text-align:center">★    ★    ★</p>

Madame Boucher was an enchanting creature. We may judge her beauty from the portrait by La Tour, exhibited in 1737, preserved subsequently by the Cuvilliés family, and today in the possession of Mme Fozembas, at Bordeaux.

The pastellist represents her as fair-haired, with infinitely sweet, dark eyes, and the most mischievous smile. She appears in a dress of white satin with a low-cut, square neck, and adorned with a ruche, her neck lightly veiled by a lace scarf, and agitating a closed fan in her charming hands protected by white mittens with a rose-coloured lining.

The wife of Boucher is assumed to have engraved only the single plate signed 'uxor ejus sculpsit'. I am in a position, however, to cite another etching, somewhat rarely found, showing cupids engaged on hanging up an egg-shaped escutcheon bearing three flaming hearts above a stork. It is signed 'Jane Boucher'.

Recently printed documents, states M. Mantz, contain two new pieces of information concerning Madame Boucher. On 25 July 1770, she was granted a pension of 1,200 livres, in consideration of the services rendered by her husband. And later, as an old woman when she was by no means affluent, Louis XVI doubled her pension.

Madame Boucher died at a great age, having preserved the flirtatious manners of her youth and wearing, to her dying day, the mittens shown in the La Tour portrait. M. Desmaze, who gives these details (derived from a communication from Madame Nata Roux), relates that, in spite of her age, Madame Boucher continued to follow the fashion and was distressed, in the midst of her up-to-date elegance, to see herself in her portrait with her hair dressed in the style of a vanished day. She thereupon requested David, who was one of her friends, to

modernize the style of the hair. David charmingly complied with this request by substituting in La Tour's pastel the coiffure with which, many years later, La Tour himself had represented Mme Boucher's own daughter, Mme Cuvilliés.

*   *   *

A letter from Berch, secretary of the Comte de Tessin, published by M. de Chennevières in his *Portraits inédits d'Artistes*, provides information about the popularity of Boucher's painting in Sweden, on the prices of his pictures and on his manner of painting and composing. Here is the paragraph from this letter (October 1745), which concerns Boucher:

'Boucher is working more quickly; he has promised the four pictures for the end of March. The price is to remain a secret between your Excellency and himself, on account of the practice he has established of normally charging 600 *livres* for works of these dimensions when they are highly finished. He asks for the money only after the delivery of each picture. But he has urged me to arrange that this be done more regularly than with the previous works (N.B. those for the château), in connexion with which he has been kept waiting a great while. Yet another couple of posting days have passed: if the gentlemen of the bank cannot allow a draft on a Swedish bank for the payment of completed works, he would regretfully agree to accept money in advance for half the commissioned works.

'I have communicated to M. Boucher my ideas on the arrangement of the various subjects; these he did not disapprove and, in fact, appeared to be very satisfied. Morning will be represented by a woman who has just finished with her hairdresser, is still wearing her peignoir and is amusing herself by inspecting the knick-knacks displayed by a modiste. Midday will be a conversation between a lady and a wit who reads out some bad verses, which are probably found wearisome by the lady who points out the time on her watch: it is past noon. Evening or After Dinner is proving the most difficult; there will either be notes fixing a rendezvous or mantles, gloves, etc., brought by the maid to her mistress, who is about to leave the house on a visit. Night can be represented by revellers passing by in ball dress and laughing at someone who has fallen asleep. An attempt will be made so to characterize the subjects that the Four Hours of the Day will also represent the Four Seasons. Such, Monseigneur, are the preliminary projects formed by M. Boucher and myself; before the Morning is

completed, we shall have moments for reflection as to how best the remainder of the day should be treated. I hope in due course to have some sketches to send to your Excellency ; M. Boucher seems willing to provide them.'

Were these projects for pictures eventually transformed into the paintings of Morning, Noon and Evening, engraved by Petit? Or were they the starting point of larger compositions based on the same ideas which were not engraved and might now be hidden in one of the Swedish Royal castles?

★    ★    ★

A number of the heads in coloured chalks from the Sireuil, Randon de Boisset, Conti, and Blondel d'Azincourt sales, works that Boucher was in the habit of executing in pastel on *papier-de-soie*, as the Trudaine catalogue indicates, are quite frequently portraits disguised beneath the fantasy of pastoral costume, portraits whose titles were inscribed only in the memory of the friends or lovers of the sitter. In his *Lettres sur différents sujets*, printed in Berlin, Bernouilli records having seen, in 1777, in Michel's picture and print shop at Basle, nine heads in pastel by Boucher, measuring one foot three inches in height by one foot in breadth. 'This little series,' he writes, 'a varied selection of the well-known pastels by this celebrated hand, might be called the "Cabinet des beautés". All are portraits, from the life, of beautiful women, and from the finest models then flourishing in Paris ; they include, among others, the portrait of Madame de Pompadour. The pastel in this work has been fixed.'

★    ★    ★

Baillet de Saint-Julien, in his *Lettre sur la peinture*, 1749, though preferring Servandoni as a scenic artist, declares that no finer pictures had ever been seen than Boucher's bucolic subjects. He discusses his admirable gardens and grottoes, his fine landscapes in which views of Rome and Italy mingled felicitously with views of Sceaux or Arcueil. He praises his *décor* for the palace of the River Saugar, the perpetual movement of its watery roof, and the brilliance of its light reflected on the columns in the background, the dull, restful tone of the foreground and the picturesque quality of the pillars half carved from the rock and their extraordinary ornamentation with shells and marine plants.

★    ★    ★

Boucher left a certain number of erotic pictures. Thoré speaks somewhere of a series of paintings designed to stimulate the sensuality

of the youthful Louis XV. These paintings were still in existence during the reign of Napoleon, in some hidden corner of one of the royal châteaux. I have no knowledge of what has become of them and, never having seen them, I cannot judge their value; but I was able to examine, some years ago, at the house of Baron Schwiter, a specimen of this erotic painting which certainly was a most frank, broad, and most harmoniously decorative work.

It shows a woman seated on her *bidet*. Relieved against a background of yellowish bed-curtains, like Indian chintz, she faces the spectator with her head slightly turned. Her hair is encircled with a saffron kerchief; her dress, cut very low, is pink, and her naked breast and arms, glistening with a pearly lustre, seem to start out from the disorder of flimsy, white linen, the pale violet colour of the ruche decorating her bodice and her lace under-sleeves of the same hue. In the halftone enveloping the lower part of her body, a shaft of light falling upon the curve of an exposed thigh produces all the effect of real sunlight caressing the skin. And the violet note recurs, amid this voluptuous obscurity, on the garters to which the stockings are attached, and the pink in the slippers with which she is shod. A chambermaid, half concealed behind the back of a chair, brings in a pile of linen suffused in an amber tonality amid which the soft green of her bodice and the rouge on her cheeks stand out. A cat arches its back beneath the *bidet*.

Related, almost decently, to this group of pictures is the 'Femme nue et couchée sur un sofa avec de gros oreillers',[53] which was engraved in colour by Demarteau and was a companion piece to a statue of Io, and an 'Antiope endormie'[54] by Vanloo in the collection at whose purpose M. de Menars hinted in one of his letters to Natoire: 'I must add that, since the room in which these works are to be displayed is *extremely small and very warm*, I wanted nudes only for its decoration.' (Letter dated 14 March 1753, published by M. Lecoy de la Marche.)

\*     \*     \*

Writing on the Salon of 1769, the last at which Boucher exhibited, Diderot declared: 'The aged gladiator did not want to die without showing himself once more in the arena. . . .

'One of those ragamuffins to be seen at the entrances to the various booths of a fair should have been stationed beneath this picture; he

---

\*[53] 'Nude Reclining on a Sofa with Large Cushions.'
\*[54] 'Antiope Sleeping.'

would have cried out: "Step this way, gentlemen, the great blusterer is on show." '

<p align="center">★     ★     ★</p>

The following is a letter from Boucher, quoted in the *Isographie* and addressed to the actor and playwright, Favart.

I am astonished that the Abbé de la Garde has not written to you. I shall tell him how much you would like to hear from him. He is, at the moment, very much a man of the court. He has been given Peronet's position in the *Petits Apartements* of the royal household; he has abandoned clerical costume and now wears a tie wig with a bag at the back and cuts a very elegant figure. The women will lose their heads over him and I am not, in this respect, entirely without anxiety on Madame Boucher's account. Please convey my compliments to Madame Favart. Adieu, mon cher ami. I send you all my affection and remain your humble and obedient servant     Boucher.

Paris, August 17, 1748.

According to M. Étienne Charavay, this letter is from the pen of Boucher's wife who usually wrote the painter's letters, and the only genuine autograph letter by Boucher known to us at present is the letter catalogued in *Inventaire des autographes*, by M. Benjamin Fillon (Series IX and X). I quote this letter from the facsimile published in the catalogue:

I forgot to ask you for my things from Bertelard and to thank you for the little lecture you gave him on this account. I hope he will be more punctual in future.

I have been obliged to take purgatives and have been unable to go out until today.

I think, therefore, that it is really necessary for me to have my things. Please give my respects to your wife.

I have the honour to remain, cher Monsieur, your very grateful friend     Le Chevalier Boucher.

This letter is also addressed to Favart. It is interesting as revealing that the painter signed his letters: 'Le Chevalier Boucher'.

<p align="center">★     ★     ★</p>

Devosge, who was employed in the studio of Deshayes, relates how one day, as he was looking at Poussin's 'Enlèvement des Sabines',[55]

★[55] 'The Rape of the Sabines.'

Boucher, who was the father-in-law of Deshayes, and who had
known Devosge at Cousto's, approached the young artist as he
contemplated the work of the great master. 'You think, then, that
this is very beautiful?' said Boucher. 'I am never tired of admiring
it,' replied the young artist. 'My friend,' continued Boucher, 'try to
take better advantage of it than I have.' (*Éloge de Devosge*, by Bremiet-
Monnier, Dijon, 1813.)

<p style="text-align:center">★    ★    ★</p>

Boucher, throughout his life, remained young, very young, and
Natoire,[56] writing from Rome to Antoine Duchesne for news of his
old friends in Paris, asked whether Boucher was *behaving himself*.

<p style="text-align:center">★    ★    ★</p>

BAUDOUIN—The works of Baudouin surely provided the con-
tents of that portfolio of erotic prints which, in the true *Manon Lescaut*
of the eighteenth century, Thémidore, the amorous hero of the book,
had brought to his bedside to distract him, to console him for the
infidelity of his mistress, Rozette.

<p style="text-align:center">★    ★    ★</p>

There has been no lack of moralists to censure the art of Baudouin
from the author of *la Réligieuse* down to the meanest scribbler on
artistic subjects. Each, in emulation of the other, has blasted with
indignant phrases the immorality of his work. Why so much indul-
gence for the eroticism of mythological subjects, and such great
severity for the same element in genre painting? And why, again,
such violent indignation at the wickedness of themes which the same
moralists forgive so easily in La Fontaine, in the *novellieri*—and which
Diderot forgave so easily in his own prose?

Personally, I am grateful to Baudouin for having shown us Eros in
the dressing-gown of Clitandre,[57] for having conveyed to us, much
better than any printed description, a sense of the brief intimacies, the
fancies, ordeals, arrangements and encounters, of those liaisons which
had no morrow, which might have been contracted by the members
of a society existing only in and for the moment. I am grateful to
him for enabling us to be present in some measure of reality at the

★[56] The painter Charles-Joseph Natoire (1700–77) is better known as
Director of the French Academy of Rome; his correspondence while in office is
a valuable source of information for the history of eighteenth-century painting.

★[57] Clitandre, a lover, was a traditional character of the French comic stage.
In Molière's *Les Femmes Savantes*, Clitandre is distinguished by his rejection of
platonic love in favour of physical affection.

drama of Love in his time, with its tender scenes and sensual environment. And I assert without shame that if Baudouin had not painted, if such erotic illustrations as the four 'Parties du jour', 'L'Épouse indiscrète', 'L'Enlèvement nocturne', 'Le Fruit de l'amour secret',[58] etc., did not exist, there would be a serious gap in the social history of the eighteenth century. And again, if we no longer had the engravings 'Le Danger du tête-à-tête' or 'Le Carquois epuisé',[59] where could we form an adequate conception of the voluptuous atmosphere emanating from the hangings, the silks, the rococo furniture, the warm nights lit by the dying light of an open fire in front of which amorous silhouettes move as if in a fading glow of footlights?

⋆      ⋆      ⋆

The talent with which Baudouin transformed a common technique into an original art is less contemptible than is willingly supposed, and the delicate form in which the painter expressed, by means of gouache, his amorous fancies is almost an original invention. To have liberated *guazze* from the impasted manner of the Italian water-colour painters, to have revived the medium by a brilliance and lightness of touch, to suspend it in the *vaghesse* characteristic of the preliminary sketch of a painter and a colourist without any of the cold finish of a miniature, to enliven, to vary it with the frolics of a playful brush, to stripe with little streaks of broken rebounding light, like the scratchings of skates on the ice, to have shivered it with an unprecedented scintillation of colour; in a word, to have transformed it into a medium so adapted to the soft, gay forms and colours of the century that it died with the epoch that produced it—such was the merit of Baudouin, the achievement which so promoted the art of gouache in eighteenth-century France that the Academy was compelled, in 1763, to admit its practitioners. From Baudouin, the first and most gifted of all the painters in gouache of the period, descends that charming little host of French and Swedish artists, that Parisian studio of delicate craftsmen, working in flowerlike colour, Lavreince, the recently rediscovered Hoin, Taunay and the elder Moreau, the landscape painter of parks delightfully green and everywhere redolent of the artifice of Flora. Nor should we omit Hall, who, in his youth, schooled himself by colouring in gouache his etched outlines of Baudouin's compositions

⋆[58] 'Divisions of the Day', 'The Indiscreet Wife', 'The Nocturnal Abduction', 'The Fruit of Clandestine Love.'

⋆[59] 'The Dangers of the Tête-à-Tête', 'The Empty Quiver.'

and who acquired, at this work, the brisk habit of those gouached passages which he later introduced into his miniature portraits.

\* \* \*

The *Philotechne français*, an anthology of encomia, criticisms and curious anecdotes (1766), paid tribute to the beauty of Boucher's two daughters married to the painters Deshayes and Baudouin.

\* \* \*

Baudouin possessed in a special degree a gift for the *mise-en-scène* of his subjects. No other small-scale painter rivalled him in the arrangement, disposition and combination of the lines of a composition, or knew, as he did, how to give it balance, harmony and felicitous grouping. Baudouin himself laboured, and laboured long, to achieve these results, as we may verify from the little sketch, covered in alterations, for 'Le Fruit de l'amour secret', which is preserved in the print room of the Louvre; or from the gouache 'L'Épouse indiscrète' in my collection, where the movement of the figure of the standing wife is much less successful than that of the same figure kneeling which was substituted by the painter in the engraved version of the gouache. And we may affirm that Moreau, the finest composer among the vignettists, owes this aspect of his talent to his youthful study of Baudouin's compositions and the etchings he made from them. The particular equilibrium of Baudouin's pairs of figures recurs in Moreau, and also his habitual lighting midway in the picture striking obliquely the centre of his scene as if proceeding from the radiating triangle of a magic lantern.

\* \* \*

The print known as 'Le Modèle honnête'[60] reveals the interior aspect of the studios in which contemporary genre painting was practised. They were studios with nothing severe about them, rooms contemptuous of bare walls and indifferent to the value of a bleak north light. They were much more like charming boudoirs with carved cornices where the sun called at all hours through the big window, where a couch in gilded wood was at the disposal of the model for her poses, and where, on a writing-desk by Riesener, there were roses in a Sèvres vase mounted in dull gold by Gouthière.

It should be said, in conclusion, that no painter has been more slandered than Baudouin by the sale of works falsely attributed to him.

\*[60] 'The Virtuous Model.'

Hardly a sale takes place at which oil paintings are not catalogued under the name of this painter in gouache, who painted all his life exclusively in this medium, and by whom no work painted otherwise than in a water medium is mentioned in any contemporary catalogue. But who is aware of this? The piquant aspect of the matter is that grave collectors accept as authentic these dim little oil paintings and talk to us with a disdainful pity for our poor taste. Such wretched creatures have never seen a Baudouin, either in gouache or in oils. They would otherwise know that the admirable French colourist never painted *rose*, that his style was never niggling, that he continually aimed at an effect of vigour in his handling, at warmth and substance, even at the splashed effect of an oil sketch. They would know that he never produced more than preliminary studies, than ambitious sketches, than the mere colour effects of a picture, than simply first thoughts flung into the full impasto of the gouache, and which show no trace of the finical brushwork of Lavreince. It was from these embroiled studies that were engraved his sensuous prints with their charming finish—a miracle we must acknowledge since the appearance, some years ago, at the Gigoux sale, of Moreau's drawings for the *Monument de Costume*, fluid indications of scenes, vague *bistres,* dreams, clouds, on which the skilful and intelligent engravers of the eighteenth century bestowed line, modelling and substance.

There is one curious fact to be recorded. Apart from those mediocre paintings falsely attributed to Baudouin, those of which he is the authentic source are for the most part no longer his own work, such is the extent of the embellishments and rehandlings they have suffered. We may still find in some corner of them the detail of a piece of furniture or a costume bearing the signature of his brushwork, but all the rest, and always the figures, are by another and a most feeble hand. The explanation is simple. Amid the disrepute into which the French school had fallen, works in gouache, the most delicate of all painting mediums, did not survive exposure in the open air as well as drawings in *sanguine* or Italian chalk. Gouaches did not escape with the mere trace in outline of a damp stain or a few spots produced by humidity; parts of them were often chipped, torn off, destroyed. Thence arose the need of restorations, of restorations designed to flatter the taste of the collectors of such works who, during the early years of the present century were connoisseurs of pornography rather than of art. Such people like pictures to be highly finished, and would never have

purchased a genuine Baudouin with the pristine force of its colour and the true artistry of its handling. There took place, therefore, a general licking over, which extended from the parts in need of restoration to the whole delicate surface of the painting, tightening and attenuating its forms in accordance with the accepted appearance of small-scale illustration. I have made this observation once before, with regard to the 'Coucher de la mariée',[61] which was purchased by Roqueplan at the Tondu sale. I found that there was a genuine Baudouin beneath the surface and a few authentic details, such as the clock on the mantelpiece, which pierced the superimposed work of the restorer. Baron Vincent's recent sale has convinced me of the accuracy of this view.

At this sale, the first sale of the century to contain a series of works by Baudouin, I found only a single example which was, in its entirety and without any retouchings, incontestably by the artist. This was 'L'Épouse indiscrète'. 'La Soirée des Thuileries'[62] contains nothing certainly by Baudouin except the hand of the nobleman holding the rose and the long gloves of the woman rising from the bench. In 'La Nuit',[63] only the charming statue of Cupid, the colour of loam, is certainly attributable to the artist; the two little figures have been abominably repainted. And it was the same with the others.

I would say, to sum up, that ever since I have been a collector, ever since I have frequented dealers and sales, I have never seen a finished Baudouin or—as it might be better expressed—one that displayed the same degree of finish as a Lavreince, a Hoin or a Freudeberg.

Secondly, among all the Baudouins I have examined, I have encountered only five in whose total authenticity I am able to believe. They are: 1. A drawing in the print room at the Louvre which is the first project for 'Le Fruit de l'amour secret'; 2. 'L'Épouse indiscrète', which appeared at Baron Vincent's sale; 3. A repetition in my possession of the same subject, but with the wife shown standing, a first, a trial version of the composition; 4. 'Le Précepteur', engraved under the title of 'Le Matin',[64] the most charming and vaporous water-colour imaginable; 5. 'Les Soins tardifs',[65] a gouache that is peculiarly interesting as revealing a pre-occupation with the effects of oil mixed with water-colour. Both 'Le Matin' and 'Les Soins tardifs' passed into my hands at the Tondu sale.

★[61] 'The Marriage Bed.'

★[62] 'Evening Reception at the Tuileries.'  ★[33] 'Night.'

★[64] 'The Schoolmaster', 'Morning.'  ★[65] 'Tardy Attentions.'

# CHARDIN

## I

TO speak of the art of the eighteenth century, to touch upon the memory of its artists, is to undertake a task that must provoke at its inception a great feeling of despondency, a kind of melancholy anger. Confronted by such a prodigious example of forgetfulness, such an excess of ingratitude, such an impertinent contempt as was manifest in the first response of posterity to the great achievements of the period of Louis XV, our faith in the justice of France falters. We may wonder whether fashion is not the substance of our taste, whether our national pride itself is not, together with the morality of our judgements, a mere dependence of fashion. Is this France, we may ask ourselves, the France so jealous, elsewhere, of her honours, who has neglected these, the living issue of her temperament, of her character, of her heart, and the mirror of all her lineaments? Is this France who has refused to recognize for half a century the artists who, more than any others, were her progeny, the true children of her wit and of her genius?

And this neglect flourished while, all about us, neighbouring nations devoted a fervent admiration, a pious cult to the least illustrious of their artists; while, abroad, popularity, publicity, eulogy, biography, the clamour of the sale room, the nobleman's and the banker's money reached the least talented artists, the most modest decadents of the native schools. There, there was no reaction, no change, no revolution in doctrine to suppress a style or a man; no immortality grows too old there; and time, flowing over names and achievements, merely adds that consecration of tradition and respect which in the end repels criticism as an insult and analysis as blasphemy.

Let us return to the beginning of the present century: French taste declares its attitude in the form of a public disavowal of all the eighteenth-century masters, great and small. Their works are thrown into the junk stalls on the quays, moulder in the

street air or leave.the country, banished from this France that is
now too poor to buy them back. No one troubles about them,
no one wants them, no one looks at them. The adminis-
trators of the National Museum release for five hundred *livres*
the finest work of Boucher's master, Lemoine's 'Hercule et
Omphale', that brilliant frontispiece to eighteenth-century
painting. There is hardly more than a handful of collectors
sufficiently audacious to be tempted by their cheapness into
acquiring works of art of the Louis XV period; and they have
to buy clandestinely, almost with shame, hiding their purchase
as an extravagance, a caprice, an act of wanton curiosity, a
collector's debauch. And who thinks of preserving the history
of these masters whose works seem to express something
compromising for an art gallery, dishonouring for a wall?
It fades gradually and is left to disappear with those who were
its contemporaries; witnesses die, traditions are obliterated;
there is no paper to waste by covering it with notes about
disgraced artists, a corrupt school, contempt for which we
would even propagate abroad.

It was a dismal epoch of correct taste. 'L'Embarquement
pour Cythère', the masterpiece among Watteau's master-
pieces, that enchanted canvas on which wit and fancy flicker
among the figures like a flame among flowers, that poem of
light that would support the rivalry of any picture in any
museum, this great work was cast aside, hidden, buried—in a
student's room of the Academy where it became a target for
the ridicule and the bread pellets of David's students.[1]

Not one of these artists escaped the neglect and the dislikes,
the prejudiced injustice, the conspiracy of blindness which
animated the period. What, for example, was the price of
works by La Tour, that annalist of the national physiognomy,
that great painter who affects us all by the vivacity of his
drawing? The portraits of Crébillon and of Madame de
Mondonville fetched barely 20 and 25 *livres*; that of Rousseau

[1] *Lettres d'un artiste sur l'état des Arts en France*, etc., by P.-N. Bergeret.
Paris, 1848.

seated, a replica of the work commissioned by the Duc de Luxembourg, was withdrawn at 3 francs, the highest price offered. With Chardin, it was the same mockery. At the Lemoine sale, his 'Dessinateur' and his 'Ouvrière en den-telles'[2] were given away for 40 francs; and at the Sylvestre sale, the two pastels now in the Louvre, his portrait and that of his wife, went for the derisive price of 24 *livres* and not a centime more.

But, after all, what do prices, what does fashion matter? Before a hundred years had passed Watteau was universally recognized as a master of the first order, La Tour was admired as one of the most skilful and intelligent draughtsmen of all times, and it no longer requires courage to say of Chardin what we shall say here, that he was a great painter.

## II

Genre painters are, for preference and almost naturally, born in Paris; and there, on 2 November 1699, Jean-Baptiste-Siméon Chardin was born. His father was a skilful carpenter well known in his trade, and whose speciality was to provide the king with those monumental billiard tables whose design has been preserved for us in an engraving by Bonnard. Burdened by a numerous family, his single thought was to provide his offspring with a means of earning their living. Jean-Baptiste-Siméon, his first-born and destined for his own profession, received, therefore, no more than a workman's education until the day when, his vocation for painting having revealed and asserted itself, he was permitted to enter, not, we may assume, without some objections from his father, the studio of the court painter, Cazes, who was then much in fashion.

There is no sign in Chardin's work during this studentship of the painter he was to become. The teaching he received, moreover, was ill-calculated to release his temperament: the students copied the master's pictures and drew in the evenings

*[2] 'Artist at Work' and 'The Lace Worker'.

at the Academy; that was all. The study of nature was not provided for; indeed, the example of the master discouraged it. Too poor to employ a model, Cazes painted everything according to the rules with the assistance of a few sketches that he had made in his youth. Chardin left his studio much the same as he had entered it. It was in his destiny to learn everything himself, to develop unaided, to owe nothing to education.

Chance determined his genius. Noël-Nicolas Coypel, who had had him called in as an assistant, instructed him to paint a gun in the portrait of a huntsman, requiring him to make an accurate representation of it. The pupil of Cazes had believed until that moment that a painter should do everything out of his head. Surprised by the care that Coypel bestowed upon the placing and the lighting of the gun, he set to work; it was the first time that he had painted from nature. Truth, light, painting, art, the secrets of vision, the secrets of execution, all this was revealed to him in an instant in a ray of light falling upon a mere accessory of a composition.

Chardin was nothing more at this time than a kind of labourer working for a wage under a known painter, today painting an accessory for a portrait, tomorrow employed at 100 *sols* a day on the restoration of a gallery at Fontainebleau undertaken by Vanloo.

A lucky chance soon made him known and proved the beginning of popular favour. A surgeon, a friend of his father's, asked him to do a signboard, a *plafond* as it was then called, for his shop, and Chardin, who may have seen the picture Watteau painted for Gersaint's signboard, attempted a similar work, a lively scene from the Paris of his time on a panel fourteen feet in breadth by two feet three inches in height. He painted a surgeon-barber attending a man wounded in a duel, who had been deposited at the door of the shop.[3] There is a crowd, a clamour, a ferment; the water-carrier is there, his buckets on the ground; dogs bark; a man dragging

---

[3] *Mémoires inédits sur la vie et les ouvrages des membres de l'Académie royale de peinture et de sculpture*, edited by MM. Dussieux, Soulié, Mantz, etc. Paris, Dumoulin, 1854, Vol. II. *Éloge de Chardin*, by Haillet de Couronne.

a *vinaigrette*⁴ is running towards the scene; a woman, perhaps the woman for whom the antagonists had drawn their swords, leans out of the window with an affrighted air. The varied background is full of the buzz of loiterers, of the press of the inquisitive, trying to see, trying to peer over one another's heads. Paternally, the night-watchmen ward off the indiscreetly curious with their crossed rifles. The injured man, naked to the waist, with the sword wound in his side, and supported by a sister of mercy, is being bled by the surgeon and his assistant. The superintendent of police, in a full wig, walks up and down with the slow, grave tread of justice followed by a clerk, all lean and black. There is a general bustle, a coming and going, in the whole scene which has been rendered above all with verve, abruptly, and without second thoughts, with an uproar of gestures and tones, a tumult and outcry as of the actual scene. And what a crowd, what a gathering, what a fine show of popular enthusiasm when one morning the signboard appeared, hoisted up on the front of the shop before anyone in the house had risen! The surgeon, to whom Chardin gave no warning, asked what was happening and why there were all those people. He was taken to look at the sign and searched it for the subjects he had commissioned: trepans, bistouris, a parade of all the instruments of his profession. He was on the point of anger, but was disarmed by public admiration. Gradually, the success of the picture gathered strength, and it was through this signboard that the Academy discovered the name and the ability of the painter. How long was this picture left hanging above the shop front, and how long did it remain at the foot of the Pont St. Michel, where, according to the *Journal des Arts*, it was placed? The history of the signboards of Paris tells us nothing. But it is recorded as having been auctioned at the Le Bas sale in 1783, where it was acquired for 100 *livres* by Chardin, the sculptor and nephew of the painter, who, according to a manuscript note in our catalogue,

---

*⁴ The *vinaigrette* was a small carriage on two wheels in the form of a sedan chair and was drawn by a man.

'believed that he recognized in this picture the portraits of the principal members of his family whom his uncle had taken as models'. And that would have been the last trace of the sign-board had not a subtle and sensitive scholar, M. Laperlier, been fortunate enough to bring to light not the work itself but a sketch, a 'model' for the large picture, a frank, precipitate notation, full of the spirit and the fire of the last Venetian masters, in which the figures are merely spots, but spots which recall Guardi.[5]

The streets were to bring good fortune to Chardin. At another exhibition in the open air, the exhibition of the Place Dauphine, held on Corpus Christi day, he won notice with a picture representing a bas-relief in bronze in which his peculiar qualities were already evident and an element of *trompe-l'œil* was introduced. Jean-Baptiste Vanloo purchased this picture for a higher price than Chardin presumed to put upon it. His modesty, however, remained unaffected, and he hardly thought of seeking membership of the Academy. Ruled by the ideas of his father, a good bourgeois who was very proud of being a member and syndic of his local corporation and desired no further future for his son than that he should master his trade of painter, he allowed himself to become, with the carpenter's money, a master of the Academy of St. Luke. It was the last reception of which this little academy might boast.

In 1728, at another of the exhibitions of the Place Dauphine, he exhibited, together with several other canvases, the beautiful picture 'La Raie',[6] now in the Louvre. Confronted by this masterpiece and all the promise that it revealed, the academicians, brought by curiosity to the exhibition, yielded to the first impulse of admiration; they sought out Chardin and urged him to submit his name for membership of the

---

[5] All that remains of this sketch, which was purchased by the Musée Carna-valet for 400 francs, in 1867, at the Laperlier Sale, and was destroyed by the fires during the Commune, is the small etching of it executed by my brother.

*[6] 'The Skate.'

Academy.[7] We may quote here the *Mémoires inédits sur la vie
des membres de l'Académie royale:*

'Wishing to form some advance notion of the opinions of
the principal officers of this body, Chardin had recourse to an
innocent artifice. He placed his pictures in a small room at the
Academy, as if by chance, and waited in the adjoining room.
M. de Largillière, an excellent painter, one of the best colour-
ists and one of the most learned theorists on the effects of light,
arrived shortly. Struck by the pictures, he paused to consider
them before proceeding to the second room, where the candi-
date was waiting. "You have some very fine pictures," he
said, on entering. "They are evidently the work of an accom-
plished Flemish painter; the Flemish school is an excellent one
for colour; now let us look at your own works." "But,
Monsieur, you have just been looking at them." "What, are
these the pictures which . . .?" "Yes, Monsieur." "Oh!" said
M. de Largillière, "then you must submit your candidature,
you must certainly submit your candidature." M. Cazes, his
old master, deceived by the same harmless trick, also praised
them strongly, never suspecting that they were the work of
his former pupil. It is said that the deception gave him some
slight offence, but he forgave the artist at once, encouraged
him and took charge of his candidature. M. Chardin's appli-
cation was approved amid general applause. Nor was this all;
when M. Louis de Boullongne, Director of the Academy and
a court painter, entered the Assembly, M. Chardin observed
that the ten or twelve pictures he was showing were his own
property and that the Academy might therefore accept those
it preferred. "His application is not yet approved," said M. de
Boullongne, "and already he is talking about membership.
However," he added, "you were right to speak to me about
it." He reported the proposal and it was accepted with pleasure;
the Academy took two pictures; one represented a sideboard
with fruit and silver; the other was the fine still-life of a skate
with a group of utensils, a work which continues to be the

[7] *Le Nécrologe*, 1780, *Eloge de Chardin.*

admiration of artists, such is the glory of its colour, and the merit of its execution and total effect.'

The reception of Chardin into the Academy as a painter of flowers, fruit and genre subjects took place on 25 September 1728.[8]

### III

The Academy was not mistaken; the author of 'La Raie' was a master, one who was destined to become one of the great painters of still-life.

Still-life was the speciality of Chardin's genius. He raised this secondary branch of painting to the highest level of art. And never, perhaps, has the material fascination of painting dealing with objects of no intrinsic interest and transfiguring them by the magic of handling been developed so far. In his pictures of animals, in his hares, his rabbits, his partridges, in those works that the eighteenth century would describe as *retours de chasse*, there is no master to equal him. Fyt himself, more sparkling, provocative and amusing to the eye, with his more minutely rendered textures of hair or feathers, must yield to him in strength, solidity, breadth of execution and truth of effect. Fruits, flowers, accessories, utensils, who has painted such things better than Chardin? Who has expressed, as he has expressed, the life of inanimate objects? Who has

[8] Chardin was appointed Councillor of the Academy on 28 September 1743; treasurer on 22 March 1752, and Royal Pensioner the same year. The privilege he most desired—lodgings in the Louvre—was granted to him in 1757. On 30 January 1765, he was appointed an Officer of the Academy of Rouen in the place of Slodtz. From 1752 to 1775 he exercised the difficult office of treasurer, which he accepted in the knowledge that his predecessor, the concierge of the Academy, had subverted a year's revenue from the royal grant and would die without adjusting the deficiency. Chardin re-established order in the accounts and continued to perform his duties satisfactorily until 1774 when, weary of the work which they imposed both on himself and on his wife, he sent in his resignation. For twenty years, Chardin also carried out the equally exacting and much more delicate task of *Tapissier* to the Louvre which included the duty of hanging the pictures for the Salon. In this capacity he dealt repeatedly with problems of personal vanity, gave general satisfaction, and was universally commended for the modesty with which he placed his own works.

given our eyes such a sensation of the actual presence of things ? Chardin penetrates like a ray of sunlight into the beautiful but sombre little kitchen of Wilhem Kalf. He wields a magic beside which all else pales, all others fade away : Van Huysum with his herbals and dry flowers, de Heem and his airless fruit, Abraham Mignon and his poor bouquets, meagre, cut out, metallic.

Against one of those muffled, mixed backgrounds that he knows so well how to rub in, and amid which a coolness, as in a grotto, mingles vaguely with the cast shadows of a sideboard, on one of those tables coloured like moss and topped with dull marble, which so often bear his signature, Chardin arranges his dessert service : here is the shaggy velvet of the peach, the amber transparency of the white grape, the sugary rime of the plum, the moist crimson of strawberries, the hardy berry of the muscatel and its smoke-blue film, the wrinkles and tuber-cles of an orange skin, the embroidered guipure of melons, the copperas of old apples, the knots in a crust of bread, the smooth rind of the chestnut and the wood of the hazel nut. All this is placed before you in the light, in the atmosphere, within reach, as it might be, of your hand. Each fruit has its peculiar note of colour, the down on its skin, the pulp of its flesh; it might have fallen from the tree on to Chardin's canvas. Mingled with these bouquets of summer and autumn, there are Meissen tureens with flowered finials, massive silver dishes, jars of olives, thick-set bottles reflecting in their glass sides the gold of liqueurs or the crimson lights of wine, and a thousand other table objects which, at the painter's bidding, are caressed by the light and the pattern of the casement entering through a little luminous square barred with shadow.[9]

Chardin paints everything that he sees.

[9] M. Camille Marcille gave me some interesting details about these still-lifes of which his father had acquired a considerable number (now in the possession of his two sons) from the dealers on the quays. His father purchased most of them at between twelve and twenty francs and never paid more than a *louis*. At M. Camille Marcille's sale, some of them fetched 12,000 francs, 7,000 francs, etc. The son of a collector told me the ensuing anecdote. Aubourg, a picture dealer in the Place Pigalle, acquired a still-life by Chardin in the

No theme is too humble for his brush. He enters the peas-
ant's larder; he paints the old-fashioned cauldron, the pepper
box, the wooden mortar with its pestle, the humblest pieces
of furniture. There is nothing in nature that his art cannot
respect. After an hour's work upon a breast of mutton cutlet,
the blood, the fat, the bones, the pearly lustre of the tendons,
the meat, are all there on the canvas, and we may feel that the
juice of the flesh oozes from his impasto. He scarcely seems to
trouble to compose his picture; he simply flings upon it the
bare truth that he finds around him. A silver goblet and a little
fruit suffice to produce an admirable work. The brilliancy, the
sheen of the goblet is given by a few touches of stencilled,
impasted white; while in the shadows there is a multitude of
tones and colours, threads of an almost violet blue, streaks of
red which are the reflections of cherries against the goblet, and
there is a red-brown, faded and as though stamped in the
shadow of the metal, and points of yellowish-red playing
among touches of Prussian blue. There is, that is to say, a con-
tinual recall of the circumambient colours glancing over the
polished surface of the goblet. Look at another picture, quite
as simple and quite as full of light and harmony: it shows a
glass of water standing between two chestnuts and three
walnuts; look at it for a long time, then move back a few
paces; the contour of the glass solidifies, it is real glass, real
water, it has a nameless colour produced by the double
transparency of the vessel and the liquid. The tenderest colour
range, the subtlest variations of blue turning to green, the
infinite modulation of a certain sea-green grey, crystalline and
vitreous, everywhere broken brush-strokes, gleams rising in
the shadows, high-lights placed as if with the finger on the
edge of the glass—that is what you see when you stand close.

following circumstances: he noticed at a cobbler's booth, a broken stretcher
which served to protect the cobbler's feet from the cold. 'A board would suit
you better,' said Aubourg. 'But I haven't got one,' replied the cobbler. A
bargain was forthwith concluded—a board and a litre of wine in exchange for
the stretcher. The picture represented a globe of the world, with various
mathematical and artistic implements grouped around Pigalle's bust of Mercury.

In one corner there is apparently nothing more than a mud-coloured texture, the marks of a dry brush, then, suddenly a walnut appears curling up in its shell, showing its sinews, revealing itself with all the detail of its form and colour.

Consider also those rare bouquets composed, so to speak, from the flowers of his palette, and in which his genius shines out with a light that obscures, extinguishes, the talents of all other flower-painters. These two carnations, for example; they are nothing but a fragmentation of blue and white, a kind of mosaic of silvered enamellings in relief. But when we stand away from the picture, the flowers seem to rise up from the canvas; the foliated pattern of the carnation, its heart, its soft shadow, its crinkled, laciniate substance coalesces and blossoms. Such effects are the miracle of Chardin's art; the objects he depicts, modelled in the mass, in the surroundings, so to speak, of their outlines, drawn with their own light, fashioned out of the essence of their hues, seem to detach themselves from the canvas, to become alive by means of a mysterious and wonderful optical process, occurring in space, between the picture and the spectator.

IV

For a long time Chardin continued to paint still-life without daring to fly higher and attack the problems of figure painting and the subject picture. He was living at that time in intimate companionship with his lifelong friend, the portraitist Aved, whose portrait he painted—it is a little-known fact—in the picture, exhibited at the Salon of 1753,[10] of the philosopher in long coat and a fur cap, reading a large book bound in parchment. On one occasion when Chardin was with him, a lady called to commission a three-quarter-length portrait for which she offered to pay four hundred *livres*. Aved considered the price too small and refused. Chardin, accustomed to more modest prices, endeavoured to persuade him not to forgo this opportunity, telling him that it was always worth while to make four hundred *livres*. 'That would be true,' replied Aved,

---

[10] *La Bigarrure*, Vol. IX.

'if a portrait was as easy to make as a sausage.' Chardin was at the time employed in decorating the front of a mantelpiece. He had thought of nothing better than to depict, honestly, finely, and with his broad touch, a table with its white cloth; beneath, a jug and a bottle standing in a wine-cooler; and, on the table, two glasses—one upset—a knife and a sausage on a silver plate. Stung by Aved's remark and fearing, perhaps, to weary the public with uninteresting subject-matter and to lose his popularity unless he renewed his inspiration, Chardin vowed to make a start on the figure and, as a result, rapidly discovered a new vocation.[11]

We should not, however, place too much trust in this anecdote. A careful examination of the work of Chardin suggests that the artist's passage from still life to life itself was not accomplished with this suddenness. Two large monkeys, their muzzles spotted with black, one an antiquarian macaco lost in the contemplation of a medal with the meditative placidity of a scholar and a collector, the other disguised as a painter and, armed with a maul-stick, painting an academic study after a bust, reveal as early as 1726—the date is inscribed on a board in the picture—the first attempt on the part of the young painter at working from the life. The monkey seems to have served as the transition to human nature and to have been the painter's first model. Chardin seems to treat this very human animal as a kind of approach to the human figure, a preliminary study. But, despite the assertion of Haillet de Couronne, the two monkeys are not the only evidence for our view. Before he had started exhibiting, before he had discovered his bourgeois vein and antedating, so to speak, his own manner, Chardin had painted, in 1732 according to the indication on the engraving, a little figure piece which seems to predict, curiously, a painter of quite a different kind from that which he became.[12] And were it not for the name inscribed on the engraving, we should scarcely attribute to Chardin this graceful,

[11] *Abecedario*, by Mariette, and *Mémoires de la vie des Académiciens*.

[12] This figure piece was part of Chardin's contribution to the exhibition of 1731 in the Place Dauphine.

flirtatious work, these stuffs that seem to exhale the scent of
amber, this pretty head with short curled locks and a wisp of
lace floating away from them, this receding profile lost in the
softness of a shadow, this neck caressed by a thread of pearls,
the seductive attitude of this charming creature, in a fever of
love, holding out the sealing wax over the recalcitrant flame
of the candle, which is being lighted by a lackey whom the
inscription on the engraving addresses in these words:

> Hâte-toi donc, Frontain, vois ta jeune maîtresse,
> Sa tendre impatience éclate dans ses yeux;
> Il lui tarde déjà que l'objet de ses vœux
> Ait reçu ce billet, gage de sa tendresse.
> Ah! Frontain, pour agir avec cette lenteur
> Jamais le dieu d'amour n'a donc touché ton cœur?[13]

And the girl who is all sweetness and softness is set in an
atmosphere where everything floats, flickers, takes shape in
terms of luxury and elegance. The rugs are braided with gold;
carving twines round the back of the gilded chair with its cane
seat; the drapery of a brocade canopy is gathered up by pen-
dant tassels to the ceiling. And there is an air of opulence in the
great-coated lackey, a pedigree slimness in the greyhound who
is scratching at the silk of the full, striped dress clinging so
gracefully around its mistress's waist.[14]

----

*[13] 'Hurry, Frontain; look at your young mistress; amorous impatience
sparkles in her eyes. She wishes that the object of her desires had already
received this note in which she has pledged her love. Ah, Frontain, to see such
dawdling, one might think that the god of love had never touched your heart.'

[14] A sketch for this picture used to be in the collection of M. Peltier, in Paris.
The woman's dressing gown is in a material with broad green and white
bands, and with a narrow red stripe next to the green. The skirt is blue. Broken
tints of a predominantly soft, violet hue flicker over the valet's cloak. The
profile of the woman outlined in black is somewhat brutally defined, but the
cheek and neck are in the full-blooded, golden colours characteristic of the
master's flesh painting. This little sketch was purchased at the d'Houdetot sale.
It was previously in the Hubert Robert sale (5 April 1809) at which it was
catalogued with the following note by the expert, Paillet: 'Two figures in an
interior, one of whom, a woman, is about to seal a letter while her valet lights
a candle for her. The work is curious and interesting on account of the costume
which suggests that of Madame Geoffrin.'

At about the same time, by 1725, a history painter had also turned his attention to the modes and gallantries of the period. He had painted the beauties, the pleasures and the loves of the aristocracy of the regency with a kind of magisterial splendour. His brush had expressed the nobility of taste in draperies, stuffs, dresses, interiors. He had known how to crinkle the lace of the fashionable Graces, how to display the stately folds of a skirt, how to render the fluttering *négligé* of Phyllis and the circumfusion of its folds like a fan about her legs. In the 'Pied de bœuf', in 'La Lecture sous bois', 'La Déclaration à la fontaine', in 'La Toilette pour le bal' and 'Le Retour du bal',[15] the painter de Troy had already expressed the soft, lax, abandoned voluptuousness of that moment of history which, both physically and morally, is like the reign of Louis XIV in undress. Nothing is more facile, more exquisite or more magnificent than the manner in which he moulds a slipper, loads a waistcoat with golden tracery, scatters diamond buttons on a *peignoir*, enrobes a domino, draws every aspect of that Decameron of the Palais-Royal and enwraps his figures in a cloud of drapery through which they laugh at us with the air of flirtatious nuns or of an Abbesse de Chelles.[16] There is, evidently, in this picture of the lady sealing a letter—which is of a kind that may be less unique in Chardin's career than is generally believed—a feeling of hesitation, a groping towards his vocation and a proof of the seduction of de Troy.

However that may be, Chardin's first effort in his authentic manner shows a young man, a sort of overgrown, adolescent booby, making bottles of soap; it is a study from the life, sincere, naïve, a little flat, without intensity in the flesh tints and in which Chardin hampers himself with the difficulties of a large-scale figure, difficulties which, for him, proved an almost constant stumbling block. I am inclined to include among

*[15] 'Pied de bœuf', 'Reading in a Wood', 'Love Plighted at the Spring', 'Dressing for the Ball', 'The Return from the Ball.'

*[16] The Abbey of Chelles was founded by St. Clotilde in the sixth century. It was suppressed during the Revolution (1790). The list of its Abbesses is distinguished by various ladies of royal blood.

these beginnings of his development as a figure painter, another somewhat large-scale example, one that is quite unknown and seems to convey a foretaste of Fragonard. It represents a little girl in a short, green mantle, with a white kerchief round her head, and her sleeves tucked up to her elbows; she wears a white apron and rose-pink skirt, is seated in the corner of a room and offers a biscuit to a little simpering spaniel. It is a work which reveals the true Chardin, but in a diluted form. Its unctuous colour becomes somewhat slimy in the flesh tints. The fine, frank, forceful artist, certain of his technique, is fully evident only in the dressing-table, almost in the background, in the towel, the small book and the glass bottle which have been placed upon it and are enveloped in the harmonies of his palette. But his entire talent, firm, untrammelled, at ease in smaller dimensions, in full possession of the picture space, the figures and the technique, is manifest in 'La Fontaine',[17] commissioned by the Chevalier de la Roque and engraved by Cochin; it is manifest in every corner of this brilliant little canvas—in the whites, broken and limpid, of the cap and jacket worn by the woman bending down to turn the tap, in the warmth of that glimpse of a profile full of colour and health, the sun-lit source, as it were, of the liquid tints of her skin, in the variegation of the petticoat, in that brush-work that expresses so well the texture of coarse cloth and the down of wool. We should be careful not to forget the special quality that Chardin henceforward, by his treatment of accessories and furnishings, gave to all his subjects. Cisterns, stoves, saucepans, chafing dishes, turnspits, cotton-reels, pin-cushions, hand-screens, folding screens, corner cupboards, and even the battledores and skittles of children, all these things in his pictures have the consistency and intensity of reality. Everything at his touch, under the influence of his gnarled, vigorous drawing assumes a mysterious solidity, a kind of dilated amplitude. He gives stuff and substance to the sewing bag, inflates into full relief the curves of the pitcher, establishes the wardrobe in all

★[17] 'Woman Drawing Water from a Tank.'

its massiveness and the cauldron with all its inequalities of sur-
face; and by a kind of sleekness of contour, a breadth of line, a
robust, large-as-life density, the inanimate objects in his figure
compositions achieve a peculiar grandeur of style.

Chardin sent this picture, 'La Fontaine', to the exhibition
of 1737, with which the series of exhibitions suspended since
1704 reopened. It occurred at precisely the right-moment to
bestow the consecration of public success on the painter's
figure subjects. Together with 'La Fontaine' he exhibited his
'La Blanchisseuse',[18] also commissioned by the Chevalier de la
Roque, the connoisseur with a wooden leg who has been
immortalized in one of Watteau's canvases. Besides his 'Two
Cousins'—the name given by the public to this pair of pic-
tures—Chardin was also represented by six other works which
were an attraction for the public, and an enchantment for
artists; his contribution to the exhibition captivated French
taste, which had for so long been deprived of familiar unpre-
tentious subjects, perceived in all the simplicity of their
actuality, in the heedlessness and intimacy of contemporary
manners. Three of these pictures are simply of children, caught
unawares by the painter in the offhandedness of their attitudes,
in their natural grace, excited and still breathless from their
games. But how delightful these cherubic creatures appeared to
the public at the Salon, full, as they are, of the health, joy and
laughter of infancy! Chardin depicts them without rouge on
their cheeks or powder in their hair, their little linen caps poised
at a mischievous angle, their bodices supported by the bibs of
their aprons, curiously dainty in their thick woollen skirts; one
has dropped the heavy battledore of the period; another walks
proudly past, carrying her drum from a bandolier and pulling
after her a little windmill cut out of a pack of cards; another,
with a basket and a thick piece of bread and butter placed in
front of her, clambers on to a wooden chair and juggles with the
cherries for her lunch. It is thus that Chardin handles children,

*[18] 'The Laundress.'

with naïveté and naturalness, observing them in their instinc-
tive attitudes and expressions. And how well he renders
their charming seriousness, the tranquil pleasures to which
they apply themselves, quietly, assiduously, almost medita-
tively, in a corner of the room! How well, also, he expresses
their alertness, when they stand on tip-toe, holding their
breath, for example, in front of the scaffolding of a house of
cards! And how intelligently he translates the surprise, the
wonder, in the child's eye at some conjuring trick or other
adult feat! With what emotion he endows this little world
intent upon a game of goose, its ear and its very soul concen-
trating upon the rattle of the dice in the box; and with what
subtlety he suggests the features of a woman in these childish
airs: the pout of the little girl who is scolded; her self-impor-
tant air of maternity when she nurses her doll dressed as a nun;
and her charming expression of pedagogy when she points out
the A B C with her needle to a little brother, wearing the
heavy, padded cap of the period.

The success of this intimate, familiar art, neglected in France
since Abraham Bosse and the Le Nain brothers, established
Chardin's reputation. Engraving brought him popularity; it
diffused the reflection and the renown of his talent beyond the
public of the exhibitions, to that vast clientele of Parisian taste
throughout eighteenth-century Europe, a Europe imbued
with our art, in love with our genius, *l'Europe française*, as
Caraccioli called it. Not one of his still-lifes was popularized
by engraving, not even the superb 'La Raie' which had won
for its painter the title, among connoisseurs, of the French
Rembrandt. Even today, these works have not been engraved,
and lithographers have hardly paid them any attention. But
the engravers disputed the little genre scenes as soon as they
appeared; the finest competed for the privilege of reproducing
them. They were engraved, so to speak, on sight; there exist
as many as three separate plates of a single subject. We may
search unremittingly among Chardin's recorded pictures in
this genre, and find only one that escaped the engravers: its

title is 'Les Aliments de la convalescence',[19] and it was, so to
speak, kidnapped from the exhibition by the Prince of Liech-
tenstein.[20] Publication was not less expeditious; by May 1738
Fessard was selling, in the Rue Saint-Denis, at the sign of *Grand
Saint-Louis*, 'La Dame cachetant une lettre',[21] of which the
picture itself was not exhibited until the Salon of the same
year. The following month, at Cochin's in the Rue Saint-
Jacques, at the sign of *Saint-Thomas*, engravings after 'La
Petite Fille aux cerises' and 'La Petite Fille au moulin à vent',[22]
exhibited at the Salon of 1737,[23] were on sale. At the sight
of these pictures, almost before they were dry, the most
illustrious engravers hastened to attack the plate. After
Fessard, after the Cochins, father and son, come Le Bas,
Lepicié, Filloeul, Surugue and his son (the author of that
masterpiece 'Les Tours de cartes'[24]), all the great engravers,
misunderstood today, but who nevertheless were so exact, so
clever, and so supple. A moment ago they were at work on
Watteau's airy scenes, his palpitating touch, his nervous
technique, his shimmering arcadias, his garlands of flying
cupids, his clusters of women, his bewitched colour; and now
they turned to Chardin, to the expression both of the matter
and the spirit of his painting, his cool, quiet lights, his hushed
backgrounds, his rich whites, his interiors which are almost
severe in the tranquillity of their harmonies. From their
vigorous, hatched incisions, from the controlled malleability
of their technique following the directions of the lines and
shapes, from the grain of their stippling, Chardin's picture itself
seems to emerge on to the paper. We recognize his darks and

★[19] 'The Menu of the Convalescent.'

[20] 'La Garde attentive' [★'The Attentive Nurse'] or 'les Aliments de la
convalescence', the only large composition by Chardin which was not repro-
duced by contemporary engravers, has been etched by my brother after the oil
sketch for the picture formerly in the possession of M. Laperlier.

★[21] 'Lady Sealing a Letter.'

★[22] 'Little Girl with Cherries', 'Little Girl with a Toy Windmill.'

[23] *Mercure de France*, 1738.

★[24] 'Card Tricks.'

his lights, the buttery quality of his touch, his strong emphasis on accessories, his decisive modelling of the flesh. Chardin owed much to these admirable interpreters of his draughts-manship, even, one might say, of his palette. It was to them he owed his entry into the private house of the period, into the family, and his popularity as the decorator of family rooms with these scenes from contemporary life, long before Greuze, Baudouin or Jeaurat, prints of whose works were finally to supplant, to the great regret of Mariette, engravings of histori-cal or mythological subjects. It was to them, also, he owed that immense reputation, that universal fashion of which one result was that Germany was flooded with bad native copies of his engravings and another that the public acquired, on the recommendation of his name alone, falsely inscribed at the bottom of the plates, the crude productions of the elder Dupin and of Charpentier, such as 'La Souricière', 'La Ménagère', 'L'Enfant gâté', 'Le Chat au fromage', etc.[25]

In 1739 Chardin exhibited 'Le Garçon Cabartier' (sic) and 'L'Écureuse';[26] he was also represented at this exhibition by an exquisite little picture 'Le Dessinateur', within whose minia-ture dimensions it seems to have been his intention to concen-trate, in a bouquet, all the variety of tone of which he was a master. The subject was surely specially congenial to him. Drawing, the first studies, the beginnings of a painter who, pencil in hand, feels his way, these things recalled his youth, a remembrance he was always ready to indulge. The studio providing quiet backgrounds in which the shadows sleep so tranquilly, the palette hanging on the wall, the life-study in red chalk by some Vanloo or other nailed to the wall, the sketched-in canvas, the bulging portfolios, the mutilated plaster cast, all the picturesque paraphernalia of the art that lends itself so well to being painted, this, the background of his life, recurs frequently in his work. He readily depicts the boy student, the scapegrace with his little three-cornered hat

---

★[25] 'The Mouse Trap', 'The Housewife', 'The Spoilt Child', 'Cat with a piece of cheese.'

★[26] 'The Tavern Waiter', 'The Kitchen-maid.'

and large knot of hair at the back of his head, his coat bursting
at the shoulders in a rent revealing his poverty, seated cross-
legged on the ground, his nose buried in the drawing-board
on his knees. And together with this picture of the draughts-
man, of which he made various replicas, he exhibited in the
same year another draughtsman; the latter work shows a slim,
elegant figure, his three-cornered hat at a stylish angle and a
long wig flowing down his back, indolently sharpening his
pencil and leaning his elbow on a sheet of paper on which the
drawing of a satyr's head may just be discerned—it is thus that
he appears in a very rare mezzotint published in London, by
Faber, in 1740. In a final and more important composition,
'L'Étude du dessin',[27] Chardin returned, some years later, to
this theme of the artist and the studio. On this occasion, under
a north light, in a great, cold attic heated by one of the braziers
common in studios of the period, the draughtsman, seated
with a drawing-board on his knees, his head forward and his
look strained, is copying Pigalle's 'Mercury', while one of his
friends, carrying a roll of paper under his arm, and with a
small muff in his hand, is watching him over his shoulder.

v

At the next exhibitions, at the Salons of 1739, 1740 and 1741,
Chardin's art revealed no new development. He maintained
his level, however, displaying, in the same light and at the
same stage, a talent which he had presented to the public
fully formed and whose maturity had preceded its renown. For
we must be beware of a confusion which might falsify our view
of the painter's progress: the exhibited works of 1737 and
1738 had been finished much earlier, but had remained unsold,
like 'La Raie', which was not exhibited at the Place Dauphine
until some years after it had been completed. But by these
three exhibitions at which Chardin, continuing in the same
vein, almost repeating himself, remained more than ever him-
self, his reputation as a genre painter was confirmed. He

★[27] 'The Drawing Lesson.'

established the foundations and deepened the interest of his art; he settled himself in his particular manner, became rooted and rested in it. French art recognized and hailed him as the painter of the bourgeoisie.[28]

What, indeed, is Chardin but a middle-class artist painting the middle class? It is in the lower middle class that he finds his subjects and his inspirations. He confines his art in this humble world, of which he is himself a member and to which his habits, thoughts, affections, the very essence of his personality are bound. He searches for nothing beyond himself, for nothing higher than his immediate field of vision; he confines himself to the representation of the scenes that touch him in his familiar environment; he introduces into his pictures his wash-basin, his mastiff puppy, the objects and the creatures to which he is accustomed in his home. In the same way he paints the people whom he sees around him, the faces to which daily habit has accustomed him; not the types of that already ambitious middle class, so remote from the people, which in the eighteenth century was beginning to assume the pride, the trappings, the luxury and the wealthy air of a secondary aristocracy, but the pure, simple features of the working middle class, happy in its tranquillity, its labour and its obscurity. The genius of the painter was the genius of the home.

Painted at such close quarters and by a man who shared its spirit, this lower middle class, the robust mother of the Third Estate, lives authentically, immortally in Chardin's art. We may consult the books, which deal with the private life of the time, we may go, in order to familiarize ourselves with the manners of the middle class, to the stories of Challes or the novels of Rétif, and thence to the memoirs of Madame Rolland, but we shall not there find the light with which a single work by Chardin illuminates this theme. The bourgeoisie was nowhere better seen than in this faithful and sincere mirror in which the Parisienne of the period was eager to examine

[28] *Lettre à M. de Poiresson-Chamarande, lieutenant générale, au sujet des tableaux exposés au Salon du Louvre,* 1741.

herself and in which she was astonished to recognize herself
from tip to toe, from her dress to her heart. 'There is not a
single housewife', states a curious pamphlet of the time with
reference to Chardin's pictures, 'who does not see an im-
pression of herself, her domestic routine, her manners, her
daily occupations, her morals, the moods of her children,
her furniture, her wardrobe.'

How could she fail to recognize herself in pictures so elo-
quent of her being? Her sleeves rolled up above the elbow,
her bibbed apron, the little gold cross round her neck, the
painter overlooks no detail of her costume. He attires her in
her own clothes and in the colours she would choose; he
shows her in her austere, almost *evangelical* dress, as a woman
of the time described it, and sets her in motion against the
background and amid the events of her ordinary, daily life.
He represents her busy with the housework, with those
peasant occupations that survived in the routine of the lower
middle class. He paints her in the kitchen, cleaning the coarse
vegetables for the soup. He catches her on her return from the
market with the mutton in a napkin. He shows her laundering
and soaping. The housewife recurs continually in his work,
relieved against those backgrounds in the manner of Peter de
Hooch where the painter arranges the brushes, brooms and
drying materials of the family. She emerges luminously from
those bakehouses where the wood is stored, where the joints
of meat are hung up, where the candles are kept and where
there are old barrels exhaling an odour of vintage. Elsewhere
we may see her busy with her needlework, bent over the
basket full of balls of wool, or chidingly correcting her little
girl's tapestry work, or brushing the three-cornered hat of her
little boy leaving for school, with a parcel of tied-up books
under his arm. It is the entire life of the bourgeoisie that
Chardin unfolds, with its activities and its hardships, the
routine of its housekeeping, the regular measure of its
progress, its resignation, its happiness in hard conditions, its
modest pleasures, and the joy and duties of its motherhood. It

was of all this that Madame Phlipon[29] recovered in these pictures the memory, the expression, the living sensation.

They are smiling scenes, homely and devout, which seemed to bestow, from the wall on which they were hung, a blessing on the family: a mother, for example, who, a plate in one hand and with the other dipping a spoon in the pewter soup tureen, makes her little girl say grace who, with her eyes closed and her hands joined, hurries through her little prayer; or another who prompts her little daughter's Bible recital, a slightly older child, standing, embarrassed, not knowing what to do with her hands, gazing at the floor for her words. In the little picture, 'La Toilette du matin',[30] the mother, that favourite figure to whom Chardin always returned, gives the final touches to her daughter's dress; the shadows of night are beginning to disappear from the room. On the disordered dressing-table, the candle, by whose light the child had risen and begun her dressing, still burns, leaving smoke-rings in the air; a little daylight falling from the window, glides along the squares of the floor and illumines with a silvery glow a corner of the room where a clock stands marking seven in the morning. In front of the big, indented basin full of hot water and the stool on which lies mamma's fat prayer-book, the mother wearing a black hood, her skirt tucked up, adjusts the bow of the kerchief on her daughter's head, while the child, impatient to go out, her muff already in her hand, gives a sidelong glance at the mirror, turning her head and half-smiling. The picture is an epitome of Sunday, of the bourgeois Sunday.

One can recall so many of Chardin's scenes which have just such a glow in their softness, such an innocence in their charms, such a naturalness in their setting, such a penetrating effect of truth. One is touched, captivated, enchanted by a grace of indefinable purity, peculiar to Chardin and unique in

---

★[29] Jeanne-Manon Phlipon was the celebrated Madame Roland (1754–93). Her husband was Jean-Marie Roland (or Rolland) de la Platière.

★[30] 'The Morning Toilet.'

this period of sensual, libertine art, frivolous in its very touch. Like the class it represents, his painting may be said to have escaped the corruptions of the eighteenth century and to have preserved intact something of the health and sincerity of bourgeois virtue. One easily feels that Chardin does more than love, that he respects, what he paints; and from this reverential attitude emerges the atmosphere of purity that surrounds his models, that perfume of honesty and decency that emanates from his interior scenes, that breathes from every corner of his canvases, from the arrangement of the furniture, the sobriety of its forms, the rusticity of the chairs, the nudity of the walls, and from that tranquillity of lines in which is lapped the tranquillity of his characters.

Chardin is the only genre painter who conveys this impression of intimate truth. Look at the works of his best imitator, at the compositions of Jeaurat; how remote they are from the style and accent of his master! The pictures of this competitor are impoverished by their adornments. It was in vain that Jeaurat borrowed the wardrobe of Chardin's women: his costumes are no longer those of Third Estate; his gestures are those of the puppet-maker of the time, of Perrault. The backgrounds are disturbed, the interiors are overcrowded, the accessories lack substance, the attitudes are pre-arranged, the sketch from nature becomes deformed and its character disappears; the painter is no longer at home. What a difference of aspect and profundity in prints by the same engraver after the two artists! We may look at the Jeaurat, but we penetrate the Chardin.

The secret and the force of Chardin, his grace, his rare intimate poetry, resides in the placidity of things in agreement with one another, in harmony and in quiet light. It is through such qualities that he rises to an ideal summit in his particular sphere, to the exquisite feeling of 'Les Amusements de la vie privée',[31] to the expression of the woman in this picture with her smiling features, an expression tinged with thoughts as

---

★[31] 'The Recreations of Private Life.'

delicate as the shadow falling from her white cap. She is shown sitting in an armchair, the body relaxed leaning over a cushion, with her feet crossed in the fashion of her time. Beside her, on a little table, stands her spinning wheel, motionless, and, next to it, the loaded distaff. A small book, dropping from her hands, has almost slipped into the lap of her skirt, and she meditates softly, rocked by her reading as though by some fading sound. Serenity—that is the true title of this picture in which Chardin harmoniously combines a woman's day-dreams with the philosophy of his maturity.

## VI

What an admirable painter's temperament inspires this historian, this witness of bourgeois life! What a gifted hand, what a display of technique in his interior scenes, what a feast for the eye in these simple rooms, these tranquil subjects, these modest personages! How Chardin delights our vision with the gaiety of his tones, the softness of his high-lights, his fine, rich touch, the twists of his loaded brush in full impasto, the charm of his blond harmonies, the warmth of his backgrounds, the brilliance of his whites glistening like frost in the sun, seeming to be, as it were, the very sanctuaries of light. And what a freshness in the enchantment of his tonality! Chardin had his artistic ancestors, but he had no master. He was inspired neither by Mieris, Terborch, Gerard Dow, Netscher nor Teniers. Of all the Flemish masters, Metzu is perhaps the only one of whom he reminds us, in the soft downy brushstrokes of his *fichus* and hoods. I know of only one picture in all the galleries of Europe from which the art of Chardin may be said to derive, and that is the admirable 'Milkmaid' in the Six collection, by the various and many-sided master Van der Meer.

Examine the finest works of this self-created, self-taught painter, those masterpieces that have not yet entered the Louvre: what could be more marvellously luminous than 'L'Écureuse' or 'Le Garçon Cabartier'? Over undertones of blue, yellow and pink, that seem to have been hatched with

chalk, the cotton cap, and the shirt, the apron play upon the three notes of grey-white, rusty-white and pure white a triumphant symphony of warm light.[32] To these two works, which perhaps convey the highest idea of the artist's capacity, we should add 'La Pourvoieuse',[33] recently exhibited in the Boulevard des Italiens; and we should recall the cap, the white jacket, the napkin, the long blue apron up to the neck, the *fichu* spotted with little flowers, the violet-pink stockings and the model, radiant from her shoes to her cap in a white, creamy limpidity; it all emerges victoriously and harmoniously from the canvas, from the contours which are both rich and concise, from the rugged markings of the brush, from the clotted quality of the colour, from a kind of crystallization in the impastos. Soft, light, pleasant tones dispersed all over the picture, apparent even in the white of the jacket, rise like a thread of daylight, like a faint prismatic mist, a floating vapour, a sun haze, and enwrap the figure, her dress, the sideboard and the loaves upon it, the walls and the ante-room in the background. We find the same effects, in miniature, in 'L'Aveugle',[34] in which Chardin has so well expressed the scurvy appearance of an inmate of the Quinze-Vingts hospital. And when we reconsider the Louvre pictures, 'Le Bénédicité' and 'La Mère laborieuse',[35] we recognize the same touch, the same flavour; but here, the degree of finish seems to have chilled the painter's hand. There is a lack of fire in this somewhat flat, dull paint which has lost under the strain of labour the lively spirit of those *esquisses* in which the connoisseur most readily discovers and enjoys the essence of Chardin's art. I remember a first sketch for 'L'Économe',[36] a woman by a window with green curtains. Against a brown background in which the roughcast character of the technique is evident, the brush, loaded,

[32] Decamps, the finest of the artistic heirs of Chardin in our time, used to cry out again and again to M. Marcille in front of these pictures: 'Chardin's whites! . . . I can't re-create them!'

★[33] 'The Caterer.'      ★[34] 'The Blind Man.'

★[35] 'Child Saying Grace', 'The Hard-working Mother.'

★[36] 'The Thrifty Housekeeper.'

saturated with white, following the folds of the dress, twisting and, so to speak, crushing itself at the elbow and the turn-up of the sleeves, leaving, in the high-lights, trails of dry impasto, achieves with nothing but white and dirty grey an admirable rough draft; a note of pink on the face and hands, a suggestion of violet upon a ribbon, a suspicion of red in the trimmings of the skirt are barely perceptible; and yet there is a face, a dress, a woman, and the final harmony of the picture is already present in the faint dawning of its colours. Another *esquisse* known to me, 'Les Tours de cartes', is, by contrast, all glitter and agitation; it is all noise, show, vivacity. The glazes have the brilliance of enamel; the tones throughout are modulated upon a radiant scale ranging from amber to burnt topaz. It is a rare and precious example of that glowing, ardent manner, singed by bitumen and burnt sienna, which characterized Chardin's early development, and of which the finest examples, as far as one may judge from the great height at which they have been hung, are unfortunately at Vienna in the collection of the Prince of Liechtenstein.

## VII

The Salon of 1743 revealed the painter of domestic scenes departing from his genre, from his previous successes, and attacking a different branch of the art. It was in this year that Chardin exhibited the portrait of Mme Lenoir. To the exhibition of 1746 he sent the portraits of M. Levret, of the Académie de Médecine, and of M—— with his hands in a muff. Eleven years later, he exhibited the medallion portrait of M. Louis, professor and royal proctor of medicine.

These portraits have disappeared. Not one has survived, not one has been saved from destruction or oblivion. There was no family, no gallery, no museum to preserve them; and they are gravely wanting as a comparative test, on stylistic and technical grounds, of the authenticity of the portraits that are so freely attributed to Chardin. Two canvases are today more or less accepted as representing Chardin's talents in this field:

one is the female portrait in the museum at Montpellier, which is claimed to be that of Madame Geoffrin; but the majority of experts with any insight find no trace of Chardin's manner in this fine painting, none of those technical habits, nothing of that recognizable imprint that any painter, even when dealing with subjects and problems to which he is not accustomed, leaves upon his work. And the examination that I recently made of this portrait at the exhibition of 1878 leads me to believe, in respect particularly to the painting of the linen and the pearl-grey dress embroidered with gold, that it is almost certainly a Tocqué. The other portrait generally attributed to Chardin is that of Mme Lenoir in the Lacaze collection, an admirable picture whose title, quite apart from the intrinsic beauty of the work, gives it an authenticity that has remained almost uncontested until today. But what reasons are there for identifying the sitter as Mme Lenoir? It is an absolutely gratuitous designation. We know what Chardin's portrait of Mme Lenoir was like, even though the work itself is not extant; the engraving after it, entitled 'L'Instant de la médi- tation',[37] is not a rare print. There is not the slightest resem- blance either in the face or even in the composition between the engraving and the painting in question. In the latter, the sitter is full face; the picture is an upright and without any accessories. In Chardin's portrait, which is landscape shape, the sitter is seated towards one side of the picture with a folding screen behind her and, in front, a mantelpiece and fire-screen. It is true that both hold in their hand a small book bound in fine paper; but that is surely insufficient ground for confusing the two pictures. It is clear that the picture in the Lacaze collection has nothing to do with Mme Lenoir; this excellent work, the technique of which is quite different from that of Chardin, is not the portrait exhibited in 1743; it is not—and it is with regret that it should be said—a painting by Chardin.

Though a master of the first order in his still-lifes, inferior only to Rembrandt, the Rembrandt of the 'Flayed Ox', though

★[37] 'A Moment of Meditation.'

an equal of the finest Flemish painters in his domestic scenes, Chardin has a weak spot that compels us to rank him beneath Metzu. He is inadequate in his treatment of the figure; his flesh painting is apt to be heavy, insufficiently differentiated from his painting of stuffs and accessories, and lacking in the requisite lightness and transparency. Furthermore, when he attempts the human figure on any scale, when he seeks to express it in its actual proportions, it is easy to discern his un-easiness and embarrassment, the laboured quality in his work. We may quote as examples M. Laperlier's 'Les Bouteilles de savon', 'La Maîtresse d'école', which appeared at the Dever sale, or 'Le Toton'[38] of the recent exhibition in the Boulevard des Italiens. Is it possible that Chardin, passing from the human figure to the portrait, should have suddenly acquired facility in flesh painting, an untrammelled grasp of the light and life in a human face? The criticism of the period scarcely suggests that this could have been the case. It is worthy of remark that amid the clamour provoked by the name of Chardin, amid the public triumph of his still-lifes and genre scenes, so little attention should have been paid to his portraits, that they should have provoked so little surprise and such a meagre and discreet admiration. The accounts of the Salon barely refer to them, the collectors and connoisseurs neglected them, the critics hardly mentioned them, and those who paused an instant to consider them have expressed their regret that Chardin should have attempted this branch of his art. Diderot himself, who was his passionate friend, who proclaimed him the finest painter of the time, who cited him in every possible connexion, found no word to say about his portraits; there is not a single allusion to them in his notes on the Salons.

Ought we, in this case, to modify our judgement of Chardin's talent? Is it in fact true that he was never the great portraitist that we might, with every justification, expect a painter of his stature to be? This disillusionment may well overcome us when we consider his only signed

★[38] 'Soap Bottles', 'The Schoolmistress', 'The Top.'

portrait,[39] dated 1773, which is the property of M. Chevignard. It represents a black-eyed, hard-featured woman, wearing a muslin cap, a short black cloak lined with miniver, and with her hands in a muff of striped white satin. The whiteness of the cap, the black silkiness of the fur, the watered light on the muff, the linen *fichu* round the neck display the master's best handling; in the impasto on the ear, we may still discern the authentic touch; but the painting of the face is hard, its colours tired. The colour scheme is at once brick red and cold, and the quality of the paint recalls the detestable Saxon school.

Should we conclude, after an examination of this portrait painted by Chardin in old age, who nevertheless produced his finest pastels in the same year, that all his portraits were mediocre? The evidence of an unknown masterpiece suspends our judgement and prevents us from committing an injustice on this point. We have been privileged to see in the collection of a lady, who is also an authoritative connoisseur, Mme la Baronne de Conantre, a portrait of an old woman in which the talent and the fame of Chardin as a portraitist seems to blaze out and demand recognition. At the first glance, doubt and hesitation disappear; the picture has the same warmth as 'La Raie', the same rich annealed tone, the same muffled fire in the colours amid which life seems in a state of fusion. In this admirable picture from the life, just as in the admirable still-life to which we have compared it, the golden light in which the canvas is suffused declares the authorship of Chardin. What solidity, nobility, what ease and strength there is in the treatment of the dress! How boldly the cap has been creased, so to speak, on to the head. We can sense the stitching in the lace; and the soft delicacy of the folded *fichu* is given with the lightness and spontaneity of a sketch. What harmony there is in the dove-grey dress against which the blue love-knot is softly relieved! With what a fine stroke of the brush the short black

---

[39] It is curious that this work, as far as we are aware, should be the only portrait signed by Chardin, nearly all of whose other works, panels, small canvases, even studies, carry his signature. In the collection of M. Lacaze, for instance, there is a little study of a tank acquired from the de Troy Sale, a study for the picture 'La Fontaine', which is fully signed.

cloak has been flung across the shoulders, and how beautifully are drawn and modelled the long lace under-sleeves flowing over the arms, their folds accentuated in a wash of thick oil and ridges of dry impasto. But the miraculous aspect of this picture is in the flesh painting. Chardin here surpasses himself. The painting of the face mirrors the variations of skin. The enamel of the colouring, guided over the structure of the features, expresses the very blemishes of actual flesh. A little red, placed upon the cheeks, fires them with the health of old age. A touch of white in the corner of the eye seems to make the sitter actually look out from the picture and to smile with her eyes as she does so. And over the whole there shines that radiance of an old face, lit by all the suns to which it has been exposed in the quiet triumph of a declining life. We must also notice the hands, holding and stroking the cat with its red collar hung with little bells, the hands, gleaming in a luminous penumbra, drawn with a line of light, a reflection on their edges, drenched and lucently afloat—with the back of the cat, the bottom of the sleeve and the skirt of the dress—in the divine, tawny transparency of Rembrandt.

## VIII

Chardin married at the age of thirty-two. At a modest family dance to which he was taken by his father, who had already chosen a fiancée for him, he was introduced to a young woman who found him attractive and soon learnt to love him. The pair became engaged, but the marriage was postponed for several years at the instance of the girl's parents, who felt that the young man's position should be more secure; at the end of this period, Marguerite Saintar, Chardin's affianced bride, was in a situation of financial ruin, approaching destitution. Chardin's father wished to cancel the marriage, but his son's generous integrity of character did not permit him either to fail in his undertaking nor to betray the affection that the poor girl felt for him.[40] Of charming aspect, states the *Nècrologe*, but

[40] *Mémoires de la vie des Académiciens*, Vol. II.

delicate, sickly and valetudinarian, the poor woman died from a disease of the lungs four years after her marriage, leaving Chardin with a son.

There was both discomfort and poverty in this first marriage of Chardin's. The wife was ill and the husband's earnings were small and uncertain. Throughout his youth the painter lived a hard life, and the beginnings of fame, even fame itself, brought scant alleviation of his difficulties. For his pictures, so esteemed by the connoisseurs and so much to the taste of the critics who declared them worthy to be hung with the works of the best Flemish masters, did not fetch the prices that such a comparison might suggest. At auction, exposed to the dangerous competition of the most celebrated sales of the time, they were sold for only mediocre prices. At the sale of the collection of the Chevalier de la Roque, in 1745, 'La Fontaine' and 'La Blanchisseuse' fetched only 482 *livres*. 'L'Ouvrière en tapisserie' and his companion piece 'Le Dessinateur' were given away at 100 *livres*, and 'Le Toton' for 25 *livres*. These prices necessarily provided the basis of the painter's negotiations with collectors and dealers; and we may easily realize what small sums found their way into his pocket before the period when his name represented a value that had been tested at the sales. It seems, indeed, that Chardin, at no stage, even during his last years, was able to earn his living by his art. All his life the price of his pictures remained at a wretched, insignificant level. In 1757, twenty years after his first exhibition, 'L'Aveugle' fetched only 96 *livres* at the Heinigen sale. In 1761, at the sale of the Comte de Vence, 'La Bonne Education'[41] and 'L'Étude du dessin' went for 720 *livres*; and in 1770, at the Fortier sale, 'Le Bénédicité' was sold for 900 *livres*; and these prices were among the highest his works realized. His still-lifes went for sums that were nothing like as high. At the Mollini sale, a rabbit—perhaps the early work which cost him so much effort, that long, patient study of the hair, of the structure, of the whole animal—a rabbit,

*[41] 'A Good Education.'

with a game bag and a powder flask, reached only 25 *livres*; and Wille, in his Memoirs, congratulates himself on having bought for 36 *livres* two little pictures of kitchen utensils.

At the very moment when his works were being sold for such prices, Chardin was nevertheless at the height of his celebrity in Paris and Europe. The Prince of Liechtenstein included four of his pictures in his gallery at Vienna. His art enchanted and inspired a collector worthy to appreciate him, the Comte de Tessin, who acquired successively for his gallery at Drottningholm 'Le Négligé ou la toilette du matin', 'Les Amusements de la Vie privée', and 'L'Économe', and who passed on his enthusiasm for Chardin to the Prince of Sweden. It is the period during which the Empress of Russia commissioned pictures from him for the Hermitage. The competition between such rich and powerful collectors and buyers in France ought to have raised the painter's prices and given him at least a reasonable competence. But nothing of the sort occurred. A fashion for paying expensively for his work never came to Chardin's assistance. It must be said, however, that he did nothing to encourage such a vogue. Lacking all desire for profit, he was so little grasping and so simple in business matters that, after his gifts had been acknowledged, he continued to be content with the meagre prices of his youth without thinking how he might derive material advantage from his growing fame and the popularity of his canvases with the public. Mariette, indeed, speaks of a price of 18,000 *livres* paid for his picture 'La Gouvernante',[42] but the *Mémoires de l'Académie*, presumably more reliable, affirms that the picture which sold most expensively at the height of his fame was disposed of at only 1,500 *livres*; this was 'La Serinette ou la dame variant ses amusements',[43] acquired by M. de Menars.

Producing so little, and with so little understanding of the commercial possibilities of his talent, Chardin was lucky to secure for himself, by a second marriage with a widow aged thirty-seven, a sure living and a share in a small fortune

★[42] 'The Housekeeper.'     ★[43] 'The Bird-Organ.'

which permitted him to work at his ease, on what day and at
what time he liked, a freedom that suited both his character
and his manner of painting. Cochin has left us an agreeable
portrait in profile of this second wife of Chardin, Marguerite-
Françoise Pouget,[44] widow of Charles de Malnoé. The
features, finely chiselled, are still young; the eyes are black
and vivacious, and there is a serious air in the smile. An attrac-
tive clarity, an engaging logic are the essence of this face, a
face worthy to have been the model for 'Les Amusements de
la vie privée'.

## IX

We have said that as soon as Chardin appeared, his gift was
recognized. He had but to show himself and his reputation was
made. Diderot did no more than confirm and prolong the
admiration of the public. As early as 1738 criticism placed him
in the first rank. The author of the *Lettre à la marquise S.P.R.*
writes ecstatically of his originality and of his handling of the
medium which is so entirely his own. The following year
(1739), in a further letter, the same writer declares him to be
unique in his choice of subjects and extraordinarily free from
affectation. Lafont de Saint-Yenne, in his *Réflexions sur quelques
causes de l'état présent de la peinture en France*, admires the
interest with which this new and original talent imbues his
representations of the events of everyday life, and states that
he shares enthusiastically the taste of the public who throw

[44] Marguerite-Françoise Pouget was to survive her husband. A letter from
Cochin to Descamps provides the following details concerning her life after
the death of Chardin. 'Mme Chardin is now living in the Rue du Renard,
Saint-Sauveur, in the house of M. Atger, an *agent de change*. M. Dachet, an
uncle of M. Atger's, had married a sister of Mme Chardin. They had always
been friends. M. Dachet is now dead; M. Atger offered Mme Chardin a
lodging in his house where she would be able to lead a quiet, comfortable life
with no other worries but her health. Mme Chardin accepted and is quite
happy in her new home. They possess a country house where they spend most
of the summer and she is thus able to enjoy rest and open air and to take exer-
cise without tiring herself. Though she underwent a serious illness last autumn,
she is now recovered and is at present in excellent health.' She died at the age of
eighty-four in 1791.

themselves upon the engravings. Another critic, writing in the same year, congratulates the painter on his manner of treating familiar subjects without being trivial. *Les Observations sur les arts et sur quelques morceaux de peinture exposés au Louvre en 1748* repeats these eulogies, compliments Chardin on the foundation of a genre in the style of Marot, and declares him to be the equal of the best Flemish artists and worthy of representation in the most valuable collections. The *Sentiments sur quelques ouvrages de peinture etc., écrits à un particulier de province, 1754,* give him the credit of perceiving simplicities and subtleties not revealed to others and of having an admirable sense of the play of light. The critics even adopted the patronage of his name: a *lettre à M. Chardin sur les caractères de la peinture* was published in 1753. The poet of *Portefeuille d'un homme de lettres, Cosmopolis, 1759,* exclaims: 'O Chardin, the eye is engulfed, loses itself in your touch!' We are not far from the lyricism of Diderot, who hardly mentions his name without such qualifications as: 'He is the great colourist . . . the great magician . . . the sublime technician . . . he is nature itself.'

Towards the middle of the century, however, criticism begins to express certain reserves. It presumes to discern a certain weakening of his talent. There are complaints against the comfortable, material circumstances which allowed him to work at leisure and against that philosophic frame of mind which relieved him of all interest in profits, of any desire to earn a lot by producing a lot. He is accused of ingratitude towards a public so eager and impatient to enjoy his works. His indolence is quoted in order to point the example of the fertile and laborious Oudry. The *Jugements sur les principaux ouvrages exposés au Louvre, le 27 août, 1751,* having praised Chardin, speaks with gentle irony of an apocryphal picture describing it as a work on which he was at the time occupied: 'It is a painting of himself', declares this malicious tract, 'with a canvas placed before him on an easel; a little spirit representing nature brings him his brushes; he takes them but Fortune removes a number of them and while he gazes at

Idleness who bestows her languishing smile upon him, the rest fall from his hands.' The critics also displayed a certain disappointment at no longer, after 1755, seeing anything by Chardin, apart from still-lifes, that was not a repetition of his previous work; they expected, they continued to hope for a new subject; and it was always the old subjects which reappeared, with insignificant alterations. These repetitions produced in the long run a certain contempt for the painter, for the poverty of his imagination and the niggardliness of his vein; from year to year, Chardin's name becomes fainter and gradually inaudible in the clamour produced by the Salons. Attention and admiration revive only for a moment, in 1765 and 1767, before his 'Attributs des Arts et des Sciences',[45] and his pictures of musical instruments commissioned by Choisy, brilliant pictures in which the red velvets of the bagpipes, the blue bandoliers of the viols, the banners on the trumpets, the copper kettledrums are superbly arranged in the midst of an opulent, magnificent tonal harmony. And then the critics withdraw once more, having nothing new to say about him, and turn their attention to Jeaurat. Even Diderot, the professed advocate of his art, grew tired at last, and in 1767 the statement escaped him that 'Chardin's art is dying'.

But Chardin had not uttered his final word. Aware that his painting was neglected and that his talent as a painter had endured too long, he deserted the brush and, addressing himself to another process, he assayed the art of pastel, of which La Tour had lately revealed the resources and enchantments. At the age of seventy, tired, ill and weakened, he took up the chalks which his trembling hands were yet to manipulate for another ten years. 'It was the effort', says a pamphlet of the time, 'of a gladiator who, reeling after a fearful contest, gathers up all his strength in order to expire in the arena.'[46] It was indeed the supreme effort, but it was also the supreme triumph of the old painter; it was, so to speak, the evening of

---

*[45] 'Attributes of the Arts and Sciences.'

[46] *La Prêtresse, ou Nouvelle Manière de prédire ce qui peut arriver.*

his genius, the warmth of the last rays of his sun. His pastels are the farewells of his light.

Look at the two portraits in the Louvre in which he has seen himself, it might be said, the old grandfather of his art, unadorned, in the intimate, negligent undress of a bourgeois septuagenarian, in nightcap, eyeshade and spectacles, a *mazoulipatam* about his neck. What a surprising vision! This furious execution, with its powderings, hammerings, strummings, slashings, loadings of the chalk, these rude, frank, scattered strokes, these audacious matchings of unmatchable tones, these raw colours hurled on to the paper, these subcutaneous 'underpaintings'—all this, a few paces away, harmonizes, draws together, fuses, explains itself, and we see the living flesh before us with its wrinkles, its sheen, its porosity, its bloom. The weathering of the cheeks, the bluish tints of the aged, shaven chin, the pink and white, the softness in the complexion, and that liquid beam of light which bathes the eyes and determines the expression—these things also Chardin has captured on the paper. He achieves truth, the complete illusion of flesh and blood, by bold touches of bright red, pure blue and golden yellow, with unmixed primary colours which, one would have thought, must have conveyed an exaggerated sense of life, a forced impression of reality. The modelling is not less miraculous: the drawing of the entire head, the planes of the face and their transitions, the rotundities, the accentuation of the muscles take shape and substance under his broad, abrupt handling in the same fashion as forms emerge from the impasto of Rembrandt.

This work, nevertheless, is not his masterpiece as a pastellist; it is in the portrait of his wife that are revealed the full measure of his ardour, the potency of his spirit, the force and fever of his inspired execution. He never displayed more genius, more audacity, more felicity, more brilliance than in this pastel. With what an impetuous touch, yet full and dense, Chardin attacks the paper, frays it, thrusts into it his chalk, with what wild, impulsive strokes, not least assured when they are most

accidental and freed from the hatchings that had hitherto dulled his sparkle and bound his shadows! How triumphantly he brings to life the features of the aged Marguerite Pouget, enveloped up to the eyes in the almost conventual coif so often worn by his figures! There is nothing lacking, not the slightest tone, not the least significant detail of form, in this prodigious study of an old woman. The ivory pallor of the forehead, the chilled glance whose smile has flown away, the wrinkles round the eyes, the thin emaciated nose, the receding, half-closed mouth, the complexion like a fruit that has been exposed to the winter, Chardin has given us all these signs of old age; he gives us the feeling of them, almost a sense of their physical proximity by his inimitable workmanship which defies our analysis and which, in some mysterious manner, bestows the very breath of the sitter upon the lips in the picture, the very flutter of daylight upon the drawing of the face. How can we capture the secret, define the substance of this toothless mouth, which wrinkles, recedes, breathes, which displays all the infinite subtleties of nature's lines, twists and inflexions? Yet there is apparently nothing more than a few streaks of yellow, a few sweeping strokes of blue. What is the essence of this shadow cast by the cap, this light on the temples filtered through the linen, this transparency which trembles round the eyes? There is nothing here but a few strokes of pure red-brown, broken by touches of blue. And the coif itself, white—absolutely white—is in fact composed of only blue. The whiteness of the face is the result of the exclusive use of yellow; not a touch of white has gone into these limpid features; in the entire head, there are only three spots of white chalk, the highlights at the end of the nose and in the eyes. To have painted everything in its true colour and nothing in its particular colour, that is the *tour de force*, the miracle to which the painter has here risen.

With these pastels, which were more to the taste of the public than of artists, Chardin won a last success. A few months before his death, at the Salon of 1779, he exhibited a pastel of the head of a young *jaquet* (lackey) which was noticed by

Madame Victoire,[47] who fell in love with its truth and inquired its price from the painter. Chardin, whom fame could no longer spoil, sent word to the princess to say the honour done to his old age by her desire to acquire the picture was sufficient payment; the next day the Comte d'Affray, on behalf of the princess, presented a gold box to the much-affected and delighted artist.[48]

## X

Chardin's work reveals the man he was. We can divine his character, or rediscover it, from his painting. He gives an account of himself, displays his intimate side in the scenes he paints, in their commonplace quality and in the middle-class ethic that animates his subjects. The people he paints resemble his own family. It is with the tranquil light of his own life that he illumines his interiors. The ordinary daily life, whose peace, whose honest toil and whose measured joys he represents, is his own. Without education or any knowledge of the humanities, he is like the poor families he paints, not without traces of the peasant in his nature. We may conceive him living with the same decent kind of people who bore him to the font and would follow him to the grave, hardly emerging beyond the circle of his father's friends and, without frequenting the world of the court or the aristocracy, remaining content with his company of cronies, carpenters and shopkeepers, the good bourgeois people of Paris, painting them and their wives and their children, and them alone. The portrait of Mme Lenoir, wrongly identified as the wife of a police lieutenant, represents, in fact, the wife of the painter's friend Lenoir, who was a merchant, the same Lenoir who had been a witness to his marriage and whose son, playing with a house

*[47] Victoire de France (1733–99) was the daughter of Louis XV and his queen Marie Leczinska. She was her father's favourite child and, together with her sister, Madame Louise, she tended him in his last painful and distressing illness, when courtiers and valets had abandoned him. After the Revolution Madame Victoire was obliged to lead an errant life, mainly in Italy; she died at Trieste.

[48] Le Nécrologe—Mémoires de la vie des Académiciens.

of cards, he had painted in 1731. Chardin, I am prepared to state, never portrayed the aristocratic or the illustrious. He is the doyen of that race of artist workmen of the period—of those family men, artists of the fireside, such as Le Bas and Wille. He has the vigour, the warmth of this race, the broad honesty, the good sense and good humour, the practical philosophy and the solidity. There is a charming good nature in the following anecdote which displays him with the vividness of an artist's sketch. One day, as he was occupied in painting a dead hare watched by a cat, his friend Le Bas came to visit him. Le Bas's admiration was set on fire by the work and he expressed a desire to acquire it. 'That can be arranged,' replied Chardin. 'You have a coat which I should very much like.' Le Bas at once took off his coat and bore away the picture.

Chardin is, *par excellence*, the simple good fellow among the artists of his time. Modest in the midst of success, he liked to repeat the phrase: 'Painting is an island whose shores I have skirted.' He was quite without jealousy and surrounded himself with pictures and drawings by his fellow-artists. He was fatherly towards young men and judged their youthful efforts with indulgence. Those charities which are an attribute of genuine talent dwelt in his mind and heart. The quality of his goodness has been handed down to us, vivid and vibrating, in the words recorded by Diderot. They must be quoted here as showing us the essence of the man and the spirit of the artist:

'Gentlemen, you should be indulgent. Among all the pictures here, seek out the worst ones; and know that a thousand unhappy painters have broken their brushes between their teeth out of despair at never being able to do as well. Parrocel, whom you call a dauber, and who indeed is one, if you compare him to Vernet, is nevertheless also an exceptional man, relatively to the multitude of those who have abandoned the career upon which they entered in his company. Lemoine used to say that the ability to retain in the finished picture the qualities of the preliminary sketch required thirty years of practice, and Lemoine was not a fool. If you will listen to what I have to say, you may learn, perhaps, to be indulgent. At the

age of seven or eight, we are set to work with the pencil-holder in our hands. We begin to draw, from copy-books—eyes, mouths, noses, ears, and then feet and hands. And our backs have been bent to the task for a seeming age by the time we are confronted with the Farnese Hercules or the Torso; and you have not witnessed the tears provoked by the Satyr, the Dying Gladiator, the Medici Venus, the Antaeus. Believe me when I tell you that these masterpieces of Greek art would no longer excite the jealousy of artists if they had been exposed to the resentment of students. And when we have exhausted our days and spent waking, lamp-lit nights in the study of inanimate nature, then living nature is placed before us and all at once the work of the preceding years is reduced to nothing: we were not more constrained than on the first occasion on which we took up the pencil. The eye must be taught to look at Nature; and how many have never seen and will never see her ! This is the anguish of the artist's life. We work for five or six years from the life and then we are thrown upon the mercy of our genius, if we have any. Talent is not established in a moment. It is not after the first attempt that a man has the honesty to confess his incapacity. And how many attempts are made, sometimes fortunate, sometimes unhappy ! Precious years may glide away before the day arrives of weariness, of tedium, of disgust. The student may be nineteen or twenty when, the palette falling from his hands, he finds himself without a calling, without resources, without morals; for it is impossible to be both young and virtuous, if nature, naked and unadorned, is to be an object of constant study. What can he then do, what can he become ? He must abandon himself to the inferior occupations that are open to the poor or die of hunger. The first course is adopted; and, with the exception of an odd twenty who come here every two years and exhibit themselves to the foolish and the ignorant, the others, unknown and perhaps less unhappy, carry a musket on their shoulders in some regiment, wear a fencing pad on the chest in some school of arms, or the costume of the stage at some theatre. What I am telling you was

in fact the fate of Belcourt, Lekain and Brizard, who became bad actors in despair of becoming mediocre painters.'

And he recounted with a smile how one of his colleagues, whose son was a drummer in a regiment, would reply to those who asked for news of him that he had abandoned painting for music; and then, resuming a serious tone, he added:

'All the fathers of such strayed and incapable children do not take it so lightly. What you see here is the fruit of the labours of the small number who have struggled more or less successfully. The man who has never felt the difficulty of art achieves nothing of value; and he who, like my son, has felt it too much, does nothing at all; let me assure you that every superior rank or condition in society would be a mockery if admission did not require tests as severe as those to which artists are subjected. . . . Goodbye, gentlemen, and I beg you to be indulgent, always indulgent.'[49]

We may picture him speaking these words, with his large, angular head, powerful and good-natured, and the shrewd smile of the Louvre portraits. Or rather, I see him in that sketch by La Tour in the collection of M. Marcille, in which the speaker seems to have been caught in the act of utterance, his face bent forward, the eyes somewhat veiled, with his expression of rustic malice and that nose and those lips which Diderot has celebrated.

## XI

Old age crept upon Chardin and brought with it its griefs and infirmities. For many years he had suffered from gall-stones which were dispersed fragmentarily without solidifying. Sadness was now added to his physical suffering. The death of his only son,[50] to whom he had dreamt of leaving his

---

[49] Œuvres de Diderot, Le Salon, 1765.

[50] This son, who, it has been sometimes said, was drowned at Venice, but who, more probably, as has been asserted by others, died in France shortly after his return from Italy, won the Grand Prix de Rome with a composition on the subject of 'L' Asmonéen Mathathias, père des Machabées'. One of his works, an Italian subject, is in the Museum at Nantes. But he seems to have soon abandoned 'history' painting in order to become his father's pupil. After his death

name and his talent, was not for him a forgotten grief. It was present in his mind and returned more acutely with harder and less affluent times. And beneath his short, somewhat massive exterior, beneath the rugged earthy manner, Chardin concealed a great sensitiveness, a tenderness of disposition too easily touched by offence, false dealing and injustice. Wounded by the indifference of criticism, by the severe judgements whose echoes are perceptible in Mariette, his friendship for Cochin, the zeal with which he defended and supported him during his long directorate of the arts, cost him innumerable vexations and annoyances. All these difficulties embittered the last years of his life, a life to which material comfort, the attentions of a devoted wife and an active and meritorious career had seemed to promise a blissful close. And at the last, Chardin, who had been ill for so long, was overcome by fresh misfortunes. His legs became swollen and dropsy attacked his chest. On 6 December 1779, Doyen wrote to one of Chardin's most intimate friends, Desfriches: 'I am asked by Mme Chardin to make her apologies to you for having been unable to thank you herself and to inform you of her present unhappy situation. M. Chardin has received the sacrament; he is in a state of weakness which gives ground for the greatest anxiety; he is in full possession of his mind; the swelling in the legs has burst in various places and we do not know what may develop.' That very day, the day on which Doyen wrote these words, Chardin was dying.

XII

Chardin's painting, his novelty, his originality and his personality produced the greatest interest among his contemporaries. Their curiosity was sharpened by his unique manner,

in 1791, a picture representing a bas-relief in bronze of children playing was shown at the free Salon de la Blancherie. M. Laperlier formerly possessed one of his works very much in the manner prescribed by his father. It depicted a plaster cast of Pigalle's bust of Mercury emerging from an agglomeration of rolls of paper, books, toolcases, mathematical instruments and every sort of accessory connected with the arts and sciences.

by his inexplicable gift of natural representation, by the miracle of imitation that he achieved. They were intrigued by that competition between Oudry and Chardin painting the same bas-relief and both attaining a complete illusion of the truth by contrary methods, methods that might be said to represent the two extremities of art: Oudry working with the trivial, dull, commonplace skill that produces mere deception, and Chardin by the personal methods of genius. They questioned one another about his art and endeavoured to acquire a knowledge of the trituration of his impasto, of his colour mixtures, and of the confection of his painting. They asked one another for his colour recipes, for the technical secrets of his talent. They complained of knowing nobody who had seen him paint. They accepted the legend that Chardin more often painted with his thumb than with his brush. It seemed to them impossible that this man could paint as he painted with the usual material means which were at the disposal of any artist.

And yet such was the case. Chardin, whatever they might believe, did not owe his talent to any wretched trick in preparing his colours, or to any sleight of hand in his procedure. The secret of his art lay neither in the application of colours with his thumb nor in a recipe designed to give transparency to the half-tones. Belle, in possession of this recipe, remained the painter he had been before he acquired it. What Chardin wished to conceal in refusing permission to watch him while at work was not any mysterious process but simply the fumbling, the painful effort, the anguished birth pangs of his works. We must not suppose that Chardin painted in the manner described by the *Biographie Universelle*, which shows us the painter eating on the morrow the skate that he had painted the day before: art of this kind is not the fruit of improvisation. Though he painted steadily for sixty years, Chardin left only a few canvases. He was slow to conceive, to produce, to finish. We may easily imagine, in looking at his least laboured works, the anxious, toilsome days they exacted, days of struggle with the model, with nature, throughout

which the painter corrected, erased, remained obstinately at
work, straining his intelligence and his vision, and hesitant
over his arrangement, until a certain moment of illumination,
an instantaneous flash of clearsightedness: then, suddenly, his
mind was full of daylight, and he dashed off the picture often
over the first drafts of two or three others. We should add that
Chardin was reluctant to make use of separate sketches or
drawings; he developed his picture and worked upon it from
nature, from the first roughing-in of the sketch until the final
brush-stroke. 'Moreover, he was continually saying', writes
Mariette, 'that his work caused him infinite pains.'

Conscience and science—those are Chardin's only tricks, his
only secrets, and they are all his talent. His admirable tech-
nique was founded upon a deep theoretical knowledge, the
fruit of long and solitary meditations. The science of his art is
a result of that science of vision, of knowing how to see,
whence Diderot derived what was best and most sure in his
artistic education. It arises from that extraordinary sensitivity
which enabled him, on first sight of a picture, to define in a
word the harmony it might lack and what might be required
to achieve it. In a word, behind the great executant, there was
a great critic. His unique style was the issue of this combina-
tion. Of what importance to him was the stupid guide book of
the colourists of the period, the theory of the spectrum that
set each in its place, parcelling them out over the canvas, the
agreed colours of light? In his art there is neither systemati-
zation nor convention. He did not recognize the prejudice that
listed friendly and hostile colours. Like Nature herself, he
boldly united the most contradictory tints. And he did so
without mixing or fusing them: he applies them side by side,
frankly opposing them 'so that his workmanship somewhat
resembled mosaic or patchwork like that kind of tapestry
which is worked with a needle and is called *point carré*'. But
if he does not mix his colours, he binds, assembles, corrects and
caresses them by a methodical process of reflections which,
while it leaves unimpaired the frank character of his touches
of colour, seems to envelop everything in the hue and in the

light of whatever else is in its vicinity. Upon an object painted any colour, he always bestows some note, some brightness, deriving from the other objects surrounding it. On close inspection, we see that there is red in this glass of water, red, also, in this blue apron, and blue in this white linen. This is the source—these reminders, these continual echoes—whence springs the harmony in everything that he painted, not the barren harmony wretchedly extracted from the blending of colours, but that noble harmony of correspondence and apposition which flows only from the hand of the masters.

# NOTE

MARIETTE, in his *Abecedario*, tells us that Chardin worked without the aid of any sketch, any preliminary drawing on paper, and that he painted from nature on the actual picture, from the rapid chalking-in of the composition on the canvas to the final brush-stroke. This detail provided by Mariette is of great importance in the history of Chardin's drawings. It explains the peculiar rarity of well-authenticated drawings by the master and reveals how few the total quantity of these drawings must be. The most rapid notation, a thought, as it would have been described at the period, vague and undefined, a movement caught unawares, the hasty indication in broad strokes of a woman's attitude, the suggestion, in a few touches of the pencil, of some scene which he wished to remember—we should expect no more than this from his drawings. If Chardin drew, it is thus that he must have drawn, and he did draw; eighteenth-century catalogues confirm the fact. In the catalogue of the d'Argenville sale, item 482 is described as a woman standing with a basket over her arm, a drawing or charcoal heightened with white, by Chardin, and various compositions by the same artist are recorded under item 483. It is therefore certain that studies from his hand exist; but we seek in vain in the sale catalogues of the period for any trace of a single finished drawing. The public of recent years has given scant attention to Mariette's information, and purchasers have been seen to pounce on the most finished, the most polished and elaborate drawings—drawings which are much closer in manner to the precious handling of Boissieu. I would cite, as an example, the *sanguine* in the Norblin sale, (1855), representing a 'woman seated and drawing'. I am even prepared to state that, in spite of the period handwriting in which the name of Chardin and the date 1774 have been inscribed, I have no great confidence in the portrait of a young man in a three-cornered hat formerly belonging to M. His de la Salle. This drawing appears to me to be very petty in execution for the artist who, at the same moment, was attacking vigorously and brutally with his pastel the rugged portraits now in the Louvre. I would say as much of the 'Intérieur de cuisine', with its sharp white lines which are entirely without that quality produced by the blunting of white chalk when handled by a master. At a sale held on 19 November 1783, an anonymous and unauthorized sale, there indeed appeared a drawing of the

interior of a kitchen, but it contained figures drawn with the pen, and it is not the drawing in the His de la Salle collection. Finally, there are other collectors, and among them persons of subtlety and perception, who have been deceived by a particular handling of pastel which gives to drawings a *chardinesque* appearance.

Here is the curious story of a Chardin drawing generally accepted as genuine, but whose spuriousness I was able to demonstrate. A good many years ago, M. Reiset, while showing me his wonderful Watteaus, called my attention to a little scene in pastel representing a young girl giving a reading lesson to a little boy. 'What do you think of this Chardin?' he said. 'Chardin! Chardin! Did you say Chardin? I can't myself believe that it's by Chardin.' 'But that's impossible. . . . M. Ingres has never doubted it for a moment.' 'M. Ingres may be a very great painter, but he has looked at drawings of the French school much less than I have. . . . Perhaps you would like me to speak my mind frankly. . . . Where I am amazed at finding myself in disagreement with your M. Ingres is in the fact that this drawing has nothing in it of the quality of a great master . . . it displays the elegant handling of a minor draughtsman, of an illustrator and engraver.' We parted company, the owner of the Chardin somewhat nervous, and myself in the grip of that obstinacy peculiar to collectors, determined to prove that I had been right to oppose the judgement of M. Ingres. Shortly afterwards, I saw M. Reiset again, and when he asked if I still believed that his drawing was not a Chardin, I replied: 'Certainly, and all the more so since I have found in an eighteenth-century catalogue, the title of which I've forgotten, two pastel drawings ascribed to Aubert and called "La Double Education", and I now remember having seen a drawing in the collection of the Baroness de Conantre, exactly similar in execution to yours, representing a youth giving a reading lesson to a little girl and which is there also attributed to Chardin.' 'But all that', he answered, 'is simply imagination, daydreaming, hypothesis.' Six, ten months went by. Then one day I was going with my brother to arrange for the printing of an etching at Delatre's shop in the Rue Saint-Jacques when, in a glazier's window I noticed an engraving by Mlle Papavoine of M. Reiset's drawing, inscribed at the base 'Aubert'. I was sufficiently cruel to take it to him at once at the Louvre. And it was thus that this drawing, described as by Chardin in M. Reiset's already published catalogue, came to be exhibited last year among the Duc d'Aumale's drawings as 'La Lecture' by Aubert.

I would, however, cite three standard examples of drawings by Chardin. The first represents a man in a three-cornered hat wearing the same kind of coat as the youth in the 'Tours de cartes' and holding a ball or some other round object in his hand. It is, as far as my knowledge goes, the only drawing by Chardin bearing the artist's autograph signature. It is dated 1760. It is the suggestive expression, in *sanguine*, of a movement, full of hollows, protrusions and unctuous loadings of the chalk which appear to have been produced by passing the thumb over the surface of the *sanguine* and crushing it.

The second, in *sanguine* on brown paper, drawn in a style somewhat resembling that of Hogarth, represents, amid a fluidity of lines in which figures seem to float, a man giving a display with a magic lantern to a group of street children—the showman of a *curiosité*, as the eighteenth century would have said. The authenticity of this drawing is proved, interestingly and curiously enough, by an inscription in Chardin's handwriting—an invitation to partake of a chop at the Plat d'Étain on the following day.

The third, which has Chardin's name inscribed in a contemporary hand on the back, is a first thought for the picture 'Vieille Femme tenant un chat sur ses genoux',[51] a study, drawn with slashing strokes, for the fine portrait in the collection of the Baroness de Conantre.

★ [51] 'Old Woman Holding a Cat in her Lap.'

# LA TOUR

## I

SOMETIMES in those collections which reveal the occupation, the privations and the joy of a lifetime, collections housed, usually, on the fourth floor of some Parisian house, we may chance to notice on a corner of the wall a little black frame[1] to whose base has been affixed a fragment of paper on which is written, in faded ink and in an old-fashioned hand, a scarcely legible name. Under glass, within the frame itself, with its pinewood under-frame, there is a sheet of paper which must once have been blue but now has the withered hue which only time can give. It fits crookedly, the framer having evidently folded into four a large sheet and thrust it, as well as he might, without taking special care, into the frame. A glance at the surface of the paper reveals a few chalk strokes, a few broad high-lights rubbed in with powdered chalk, a few slashes of black and red, nothing more—nevertheless, these marks compose a head. On closer examination, the head seems to approach us, to emerge from the frame, to rise from the paper, and we may feel that we have never seen, in the drawings of any school, a comparable representation of the human face, a work in chalk that at the same time was so much a living, breathing creature. And the longer we look, the more our wonder increases at this creative force, this power of animation, this unmatched mastery of the anatomy of the human face, of the underlying structure of its features, at the indication of the orbicular formation in which the eyes are set, at the miraculous rendering of the direction and interpenetration of the muscles, of the elevators of the nose and the lips, the risorius which produces the smile and the irony of the mouth. . . . And we ask ourselves what,

---

[1] This little black frame is the frame in which La Tour preserved all his *préparations*; he appears to have kept these carefully throughout his life, and indeed to have made a sort of museum of them. A few years ago they could still be seen in these black frames at the Museum at Saint-Quentin.

precisely, this miraculous portrait in this unworthy frame may be. It is the first thought, the draft, the instantaneous seizure of a likeness, what is called in the technical language of art, a *préparation* by La Tour—one of those masterpieces which drew from Gérard the humble exclamation: 'You could crush us in a mortar, Gros, Girodet, Guérin, myself, all the G's, and you couldn't squeeze out of us a single fragment of such quality.'[2]

## II

La Tour was born at Saint-Quentin in 1704. His father was a musician attached to the royal chapter of the collegiate church. He had the usual legendary childhood that is attributed to almost all painters: at school, under the headmastership of Nicolas Desjardins, he covered his Greek and Latin notebooks with the pictured record of everything he saw about him, sketches of the class, of his fellow schoolboys, of the master and of his cane.[3] This evident vocation made little impression on his father who wanted to make him an engineer in spite of his short-sightedness. Undaunted by reproof and punishment, however, the boy persevered in his tastes, made copies in pen and ink of any prints he could find, and exhausted his schoolboy's allowance in the purchase of pencils and models for copying. In the middle of these attempts, a pupil of the painter Vernansal appeared at Saint-Quentin, bringing with him some of his master's life-studies. These the young La Tour saw and, seized with a passion to do the same thing, announced his wish to be a painter to his father who, rooted in his middle-class outlook without any trust in such a hazardous profession, countered this infantile whim with a clear and brutal prohibition. The young man thereupon ran away to Paris; he was at the time scarcely fifteen years old.

[2] *La Tour*, by Charles Blanc. *Histoire des peintres de toutes les écoles*, Paris, Renouard.

[3] The biographers mention a view of St. Quentin drawn at this time by the young man and offered to Nicolas Desjardins. Perhaps this is the drawing in the Museum at Saint-Quentin (No. 94), there attributed to La Tour's father.

The interest of these details, which are given in Mariette's *Abecedario*, is that they record, contrary to the accounts of the Chanoine du Plaquet and the Chevalier Bucelly d'Estrées, La Tour's arrival in Paris, not as an already-known painter but as a truant from school, with neither resources nor talent, though already armed with a strong personality and prepared to confront life and the future with the courage of a man with a mission. Knowing no one connected with the arts in Paris, and having seen on a print the name of Tardieu the engraver, he had written to him for help and advice, and Tardieu, supposing the young man wished to become an engraver, had replied that he should set forth and come and see him. He was considerably embarrassed when the young man told him on his arrival that he wished to become a painter. To whom should he be sent? Tardieu thought first of Delaunay who had a picture shop on the Quai de Gesvres. But La Tour's application in that quarter was refused. He fared no better with Vernansal, to whom he was next taken. He was finally received by Spoëde, a mediocre painter, but a kindly man, with whom La Tour set to work with the perseverance of someone having everything to learn, every difficulty to overcome.

The Saint-Quentin biographers state that at the very beginning of his career, he made a journey to Reims where, so they say, since he was too poor to go to Italy, he went in order to study the works left in the historic city by artists whom the coronations of our kings had attracted thither. The precise details given by Mariette, and which leave no doubt about La Tour's escape to Paris, allows us to assign a more reasonable date to the painter's journey to Reims. We must remember that La Tour arrived in Paris at the age of fifteen. He remained there for several years.[4] What event about this time could have occasioned a journey to Reims? Surely it must have been the coronation of Louis XV, which took place on 25 October 1722. La Tour was then eighteen; he had recognized the feeble

[4] The birth of a child, by La Tour, to Anne Bougier, his cousin, on 15 August 1723, suggests that the painter may have returned to his native town in 1722.

talents and the inadequate lessons of his master; he wanted to
try his luck by working on his own. There could have been no
finer opportunity for the début of a young portrait painter,
unknown as he was, than the coronation, a great assembly of
celebrities, of foreigners, of the nobility.

The same idea, the same hope, mingled, perhaps, with a
desire to study in Flanders the works of Rubens and Van Dyck,
took him, some years subsequent to his stay in Reims, to the
Congress of Cambrai, planned in 1720 and inaugurated in
1724; it was an important Congress to which all the European
powers sent delegates to settle those differences between Spain
and the Holy Roman Empire which had not already been
disposed of by the Peace of Baden; it was a congress at which,
while it lasted, 'the kitchen staffs', according to Saint-Simon,
'were kept much busier than their employers'; it was, in fact,
contemporary diplomacy's Field of the Cloth of Gold at
which the ceremonious luxury, the ruinous struggle, the mad
rivalry as to who should have the greatest number of carriages
and magnificent equipages of all kinds, the greatest number of
gentlemen-in-waiting, the richest and most varied liveries,
almost provoked an international regulation limiting the
splendours of ambassadorial suites for the whole of Europe.[5]
The spot was an ideal one for the luxury trades and attracted
them in a flood. In the ostentation, the uncontrolled expendi-
ture, the social activity of this world, there was a possibility of
money and notoriety for a painter. Any talent would certainly
be recognized and extolled; and La Tour had hardly had time
to complete a few portraits, before everyone, inspired by such
excellent likenesses, wished to possess a portrait by the young
artist. He painted the wife of the Spanish ambassador. The
English ambassador offered him lodging in his London house,
and he made an excursion to England. The aristocratic auspices
under which he there made his appearance assured his success.
He raked in guineas and, after a short stay, returned to Paris
with the germs of an authentic talent and money enough to
allow him to work in freedom. Fearing, however, to lose in

[5] *Mémoires complets et authentiques du duc de Saint-Simon*, 1858, Vol. XVIII.

Paris the benefits of his London success, and recognizing the human instinct—a pronounced instinct in the French—to admire foreign talent, the subtle Picard was inspired by the neat idea of exploiting the dawning anglo-mania of the century: he had himself announced, and habitually posed, as an English painter.[6]

## III

La Tour painted his portraits in pastel. The irritable condition of his nerves and the delicate state of his health had forced him to abandon the practice of oil painting.[7] By devoting himself to the art of painting with coloured chalks, a method which was to reveal his genius to him, he was following the tendency of his period. He was following that movement of taste that sought to reanimate, to renew, in eighteenth-century France, the taste for French chalk drawings of the sixteenth century. And it is possible that the presence of Rosalba in Paris in 1720, and again in 1721, may have had some influence on his vocation. La Tour might have witnessed that triumph of the art of pastel, the great success of the Venetian pastellist who was visited by the Regent, sought after by the highest aristocracy, crushed beneath money and commissions, from

[6] *Éloge historique de M. Maurice Quentin de la Tour, peintre du roi etc.*, delivered on 2 May 1788 at the Town Hall of Saint-Quentin; by M. l'Abbé du Plaquet. Published at Saint-Quentin by F. T. Hantoy, 1789. Also, *Mémoires de la Société des sciences, arts, belles-lettres et agriculture de la ville de Saint-Quentin*, 1834–6. *Notice historique sur Maurice Quentin de la Tour*, by M. Bucelly d'Estrées.

[7] It is our belief that collectors and connoisseurs must renounce any hope of seeing or buying examples of painting in oil by La Tour. There exists no authentic work in this medium to provide a standard of criticism. The portrait heads in oil exhibited in the Saint-Quentin are unwarrantably attributed to La Tour. A local legend ascribes to the artist a picture in the possession of M. Rigault, a portrait of a woman in a red dress embroidered with black lace and wearing satin mittens. A few brushstrokes on the little finger suggesting the technique of pastel are hardly sufficient evidence for christening this portrait a La Tour; it is a work which lacks the artist's characteristic 'handwriting', nor is the tradition of its authenticity sufficiently established to serve as recommendation; it is, moreover, a very mediocre picture of the kind that appears every day in the sale room ascribed to Chardin or Torqué.

whom such women as Mesdames Parabère and de Prie[8] solicited, implored their portraits,[9] enthralled by the charm of her art which somehow contrived to invest the female face with a vague, cloud-like insubstantiality, the breath of a resemblance exhaled from a bouquet of colour. However that may be, La Tour found that he benefited rapidly from this popularity of the art of pastel generated by Rosalba. 'He took very little time', wrote Mariette, 'to finish his portraits; he arrived at a likeness without tiring his models; and he was not expensive. The affluence in his studio was enormous. He became the portraitist whom everyone employed.'

At about this time, it happened that a group of his portraits carried out for the Boullongne family were seen by Louis de Boullongne, who was then Chief Court Painter. Boullongne, discerning beneath the looseness of their handling that natural gift which enables a portraitist to achieve a likeness without difficulty, expressed a wish to see La Tour, encouraged him and promised him that diligence and application would assure him a successful future. And it might well have been Boullongne's voice which, amid the unanimous chorus of compliments for a newly completed portrait by the young painter, proffered this austere counsel: 'Young man, you should draw; you should keep on drawing.'[10] It was this powerful word of advice that saved La Tour from sacrificing his talent to mere professional facility. Renouncing all profit, all easy triumphs, he passed two years without painting, plunged in the study of drawing; and from these two years devoted to self-development, and from the years which followed, laborious years guided and advised by the friendship of Largillière and

---

*[8] Marie Magdeleine de la Vieuville, Comtesse de Parabère (1693–1750) was, for several years, a mistress of the Regent. Jeanne Agnès Berthelot de Pléneuf, Comtesse de Prie (1698–1727) was the mistress of the Duc de Bourbon. Her political influence was decisive during the years 1723–6. She was largely responsible for the Anglo-French *rapprochement* and it was she who proposed the marriage of Louis XV with Marie Leczinska of Poland.

[9] *Diario degli anni MDCCXX & MDCCXXI scritto di propria mano in Parigi da Rosalba Carriera, dipintre famosa.* Venice, MDCCXCII.

[10] *Éloge historique de Maurice Quentin de la Tour*, etc., by Du Plaquet.

Restout,[11] there emerged the great draughtsman, the greatest, the most vigorous and profound of the entire French school, the draughtsman who was also a great physiognomist.[12] There emerged, at the same time, the unprecedented pastellist achieving, by the very softness and tenderness of his chalk-strokes, effects of energy, solidity and power, chalk-strokes that were apparently uniquely destined to express the pulpiness of fruit, the velvet quality of skin and the 'downiness' of contemporary costume; and there emerged, finally, the painter who re-created the art of pastel, this art exercised by women and appealing to women, this technique appropriated to the drawings of Rosalba, full of aerial charm, impermanent, volatile, like stardust, and who was able to transform it into a mode of expression, serious, ample and masculine, and of such intensity, such plastic force, such lifelike vigour that it constituted a disquieting threat to all other modes of painting, and, for a moment, the Academy closed their doors, in fear, against the entry of its votaries.[13]

## IV

La Tour began to exhibit in 1737. He was at once noticed and recognized: the *Mercure* remarked upon the effect of his contribution on the public.

The following year, amid the ebb and flow of the spectators,

---

*[11] The family of Restout produced numerous painters and engravers. The reference here is to Jean Restout (1692–1768) who was appointed an official of the Academy at an early age and who, in 1761, became its Chancellor.

[12] '. . . He confessed to me that he owed a very great deal to the advice of Restout, the only man of talent who appeared to him to be genuinely communicative; that it was this painter who had taught him how to give relief to the contour of a head and to produce the effect of air between the face and the background, by reflecting the lighted side of the face in the background and the background in its shadowed side; that, whether it was Restout's fault or his own, he had experienced the greatest difficulty in mastering this principle in spite of its simplicity; and that when the reflection is too strong or too slight, the natural effect is lost, with the result that the work is either hard or feeble, and truth and harmony disappear.' The *Salon* of 1769, by Diderot, published by M. Walferdin in the *Revue de Paris*, September 1847.

[13] The Academy resolved not to accept pastellists in future (*Lettre sur la peinture, la sculpture et l'architecture*, 1749). As a result of this resolution, a

the crowd stops, positively takes up its position, struck by their truth of presentation, in front of the two portraits whose success the *Mercure* briefly and naïvely notices by marking them with the asterisk with which it always indicated the most popular pictures in the Salon. The two works which so attracted the public were the portrait of Restout and the charming representation of Mademoiselle de la Boissière, which we may see reproduced in Petit's engraving, with her easy, natural attitude, *artistement négligée* according to the contemporary phrase; the sitter is shown bareheaded, with a flat coiffure, a half-smile upon her lips, intelligence and malice in her expression; her eyes dark and alert, a charming example of the plain woman who is nevertheless full of fascination; she is dressed in the Polish style, in silks, furs and lace, of which the pastellist was so fond; her elbows rest upon the stone sill of a window, her hands hidden in a little muff which, says the author of the *Lettre à la Marquise S.P.R.*, would reconcile to these little articles of dress the women who had most cause to be dissatisfied with them.[14]

In 1739, the most popular portrait among the works contributed by La Tour was that of Father Fiacre, Mendicant Brother of the P.P. of Nazareth, a personality well known throughout the fashionable world, and at whose likeness all the children of Paris came to gaze at the Salon; 'a portrait that

---

pastellist called Loir abandoned pastel for sculpture. It was this Loir, and not La Tour, who had already modelled a portrait bust of Vanloo and a figure of the satyr, Marsyas (*Réflexions nouvelles d'un amateur des beaux-arts*). As La Tour's success increased, this movement of jealous hostility against pastellists grew more pronounced. *Le Jugement d'un amateur sur l'exposition des tableaux*, 1753, declares: 'M. de la Tour has so developed the art of pastel as to make us fear that he may provoke a distaste for oil painting.' In the same year, the *Salon* complained that 'pastel is the favoured medium for portraits'; and the critic proceeds to attack pastel, its crudity, its mealy dustiness, its 'hard and disagreeable' texture, which neither art nor talent can compensate. It is true that the glazed frame acts as a brilliant varnish, but glass merely disguises the defects without destroying them. Nor does it prevent the eventual disintegration of the chalk and the gradual disappearance of its lustre. The spirit which informs the pastels of M. de la Tour takes gross advantage of this specious quality.'

[14] *Description raisonnée des tableaux exposés au Louvre. Lettre à Mme la Marquise de S.P.R., 1738.*

is impatient to resemble the sitter', exclaimed one critic. A
new aspect of the artist's talent was evident in this work;
before this personage, in whom all the characteristics of his
rank are evident, all the signs of his clerical condition, the
public began to recognize La Tour's peculiar gift for portray-
ing the trade or profession, the rank, the social character of his
sitters.[15] The success of his pictures in the Salon on this occasion
led to his painting some months later the King's mistress,
Madame de Mailly.[16]

In 1740, his exhibit, comprising three pastels, was a triumph.
The contemporary press spoke of an explosion of admiration.

In 1741, jealous of his own success, and desiring to broaden
and elevate his own particular manner, he sent to the exhibi-
tion an elaborately composed portrait, larger than any of his
previous works. He depicts, in this large pastel—a *picture*, as it
is described in the catalogue of the Salon—the Président de
Rieux, wearing a black justice's robe and red gown, seated in
his study in an armchair upholstered in crimson velvet, with
a screen behind him and, on his right, a table covered in blue
velvet enriched with a gold fringe; this is an ambitious work
which provoked ecstatic praise of its every detail: the wig, the
neckband, the fineness of the hair, the weave of the linen and
the nice style of its workmanship, the delicacy and the elabor-
ate pattern of the lace, all these things were visible, tangible.
Nobody mentioned chalks, 'such refinements were the actual
products of the industries of Dresden; M. de la Tour had
mastered the secret of every branch of manufacture'. The
snuff-box on the table, a pen slightly stained with ink on the
quill, were declared to be the last word in deceptive realism.
A priceless masterpiece, said the critics; and the public, among
whom the rumour was current that the frame and the glass
alone had cost fifty *louis*,[17] agreed with the critics.

[15] Ibid.

[16] 'December 23, 1739. Mme de Mailly is having her portrait painted in
pastel. The artist is called La Tour.' *Mémoires du Duc de Luynes*, vol. III.

[17] Letter from M. Poiresson-Chamarande on the pictures exhibited at the
Salon du Louvre, 1741.

In 1742, the year in which two poems in Maurepas' *Recueil* [18]
celebrated his fine portrait of the Turkish ambassador, there
was the same affluence, the same throng of admirers in front
of his pastels. They were besieged, spectators were reluctant
to leave them and returned again and again. Interest was
equally inexhaustible in the portrait of Mademoiselle Sallé, 'as
she appears at home', an intimate work, a portrait, so to speak,
in undress, familiar and charmingly provocative, in which the
celebrated ballerina is represented in the simplicity and truth
of a pose that was habitual to her, seated in a green damask
armchair, 'the arms close to one another, the hands turned
towards the elbows', without gloves and wearing a long pink
coat. And this year, too, there was a eulogy in verse, a poetic
effusion by Pesselier in honour of the artist. [19]

The exhibitions continued, La Tour's contributions suc-
ceeded one another and enthusiasm increased; the loud voice
of public admiration stifled the jealousy and envy provoked
by these pastel paintings, which were already competing with
the oil medium, were stealing its customers and its prestige,
and even some of its talented exponents, such as Coypel, who
was now using only chalk and in the process of becoming
the charming pastellist who was to execute in this medium the
portrait of Madame de Mouchy [20] dressed for a masked ball.

In 1745, by his portraits of the King, the Dauphin and the
Minister of State, Orry, La Tour established contact with the
Court, with Versailles, where he was shortly to be granted
regular admittance and where his capricious nature was to
provoke a minor sensation.

In 1746, he sent to the Salon his portrait of Montmartel. We
might easily see in this financier, whose likeness by La Tour
has been engraved by Cochin, [21] the great nabob of the period,

[18] *Recueil manuscrit de Maurepas*, vol. XXI.

[19] *Mercure de France*, September-October, 1741.

*[20] Anne Louise d'Arpajon, Mme de Mouchy (1718–94), was lady-in-
waiting to Marie Leczinska and subsequently to Marie-Antoinette. She and
her husband, the Maréchal de Mouchy, died on the guillotine in 1793.

[21] We may refer here to certain evidence whose implications no biographer
of La Tour has hitherto considered. The engraving after this portrait bears the

tranquil and majestic, with his cold, haughty forehead, his large, tightly closed lips, seated stolidly and heavily, his legs crossed, engrossed by the serene, the austere digestion of his millions, somewhat too much in the grip of his gilded arm-chair, his brocade waistcoat fitting tightly over his spherical stomach, his hands at rest, in cuffs of Valenciennes lace, upon the superb embroidery of his coat. And with what opulence he is surrounded! In his proximity, rococo splendour achieves a kind of stertorous sumptuosity; its oppressive magnificence explodes in this ornate study, in its panelling, its tapestries, its gold and copper mouldings, its sculptures and carvings, its dazzling agglomeration of elaborately turned furnishings, each of which is a gem of craftsmanship. This is a superb engraving: riches could never have been more richly represented.

In 1747, the new Academician[22] appeared at the Salon with

following inscription at the base: 'The head only after M. La Tour, the clothes and background drawn and the whole work supervised by C-N. Cochin.' In the last resort, this might be understandable in the case of an engraving in which the head had been taken from the original and the rest from a reduction drawn by Cochin. But at the base of another engraved portrait, of the Maréchal de Belle-Isle, a full length, the following inscription occurs: *De la Tour effigiem pinxit; Moitte, sculptor regis, tabulam integram delin. et sculp.* In this portrait also, only the head is ascribed to La Tour. Considered together with the scant mention these two pastels received from the critics of the Salon, works which have, moreover, been lost and in which La Tour's handling cannot be verified, the two positive inscriptions quoted above attest incontro-vertibly that the two portraits, whose dimensions were probably the same as those of the artist's usual heads or half-lengths, were thus enlarged and arranged by foreign hands for the purposes of engraving. Although a daughter of M. Lebas de Courmont, the translator of Vasari and a friend of La Tour's, informed us verbally of the tradition, communicated to her by her father, that La Tour never painted more than the head and had recourse to a specialist for the clothes, this completion of his pastels by another pastellist or by an en-graver cannot have been more than an occasional occurrence. The proof is provided by the general harmony, the evidence of a single hand at work in his pastels and the substantial praise bestowed by contemporaries upon the excellence of detail, of stuffs and accessories, in the portraits of Rieux and Mme de Pompadour and upon the deceptive reality of the various objects, books and pieces of china which the great painter put in with such a personal touch and which he disposed with such a sure taste round his sitters.

[22] La Tour's candidature for membership of the Academy had been approved on 27 May 1737. He was admitted to full membership on 24 September 1746 and elected Councillor on 27 March 1751. Note communicated by M. Duvivier.

eleven pastels interesting for the varied notability of the sitters, all either members of the nobility or celebrities. The portrait of the Abbé Le Blanc[23] was acknowledged as one of La Tour's most powerful works, that of M. de Mondonville[24] as one of his most piquant. It was considered that in the latter work the sitter who appears to be listening to his violin to make sure it is in tune, had been posed with an admirable naturalness, that his expression was eloquent and that, in his fiery eye, impatient inspiration and musical genius were visible.[25]

In 1748, La Tour's exhibit was still more numerous. The catalogue entry under his name reads like the first page of the Royal Almanack: the King, the Queen, the Dauphin. And the Queen's portrait, that of the Duc de Belle-Isle and that of Dumont le Romain were declared to be comparable with any of the finest of his previous productions.[26]

In 1750, the year in which the poet of the *Mercure* informs us that he was engaged upon a portrait of Sylvia, the Salon proved to be a victory for La Tour, a victory over a rival whose inferiority as a draughtsman alone relegates him at once to the second rank. He was an approved Academy candidate whose pastels, since 1746, constituted a threat to La Tour's supremacy. 'La Tour feared', says Diderot, 'that the public would only be made fully aware of the gulf which separated them by means of a direct comparison.' A malicious, indeed a somewhat mean, idea occurred to La Tour: he asked his rival to paint his portrait. The latter, out of modesty, refused. La Tour insisted, solicited, and finally, by repeated persuasions, overcame the scruples of the innocent artist who carried out a

---

★[23] L'Abbé Le Blanc du Guillet (1730–99), an Oratorian father, was known as a writer of tragedies, comedies, novels and criticism. One of his more celebrated works was the tragedy *Manco-Capac, premier Inca du Pérou.*

★[24] De Mondonville (1711–72), the violinist and composer, chiefly of opera, was also Director of the *Concert Spirituel*, the regular series of concerts of religious music held under the royal auspices at Versailles.

[25] *Lettre sur l'exposition des ouvrages de peinture*, 1747.

[26] *Réflexion sur quelques circonstances présentes, contenant deux lettres sur l'exposition des tableaux au Louvre cette année*, 1748.

portrait of the master in a black *surtout*. While he was thus occupied, La Tour, on his side, also set to work on a portrait of himself. In due course, the Salon opened. Perronneau, who was the rival pastellist in question, exhibited his portrait of La Tour in the black *surtout;* the waistcoat is in pink brocade embroidered with gold, and one hand is raised and concealed beneath the lace cravat. It is a beautiful and subtle portrait which today, in the Saint-Quentin Museum, courageously resists the proximity of the pastels by its author's rival. La Tour, however, seems to have had the cruel notion of posing for this portrait in a state of exhaustion, on the morning after a night's dissipation;[27] his face still young, sly and sharp, is here worn out and drawn, with the complexion and reddened eyelids of a roué. But this admirable achievement of Perronneau's was ambushed, so to speak, by the appearance of La Tour's portrait by La Tour. La Tour had arranged with Chardin for it to be hung next to the Perronneau. And the Perronneau was killed by its vicinity. La Tour had played a deceitful trick. Perronneau, however, recovered. Contrary to the assertions of La Tour's biographers, it is not true that his rival became an expatriate in Denmark. He remained in France, and the Salons of 1751, 1753 and 1755 provide the proof of his lively reputation. He seems to have become the official painter of the dancers and actresses of the opera, of those *demoisillons* with vague lovers' names, who appear in the catalogues as Mademoiselle Rosalie or Mademoiselle Silanie. At the same time, there were princesses, such as the Princesse de Condé, who gave him preference over La Tour. Finally, there were

[27] A contemporary publication, now rare and unknown, *L'École de l'Homme*, 1752, whose author seems to have been a kind of eighteenth-century La Bruyère, indited, in this connexion, the following bitter epigram on La Tour: 'Choose your own time for your self-portrait, ambitious Toural; you are in a good humour, your eyes are shining and your complexion is clear and bright. Seize the occasion; paint yourself. Today, a sleepless night has deadened your complexion, your eyes are burdened by a smarting headache, you are swollen, unrecognizable. What are you waiting for? Could there possibly be a better moment to have a portrait painted which shall not resemble you? Do not miss it; hurry off to your rival, commission your portrait from him and pay him handsomely.'

Academicians, such as Lemoine, Adam, Oudry, who con-
tinued to order their portraits in pastel, or those of their wives,
from Perronneau. And it would be unjust to think of La Tour's
rival as comparatively such an inconsiderable artist: in the
Louvre portrait of a man in a grey coat, the delightful con-
fection of little touches, the firm modelling in the midst of a
dispersion of emphases, the clever, graceful workmanship—
the workmanship of a true artist—the greenish note, recalling
Correggio, of the half-tones whence the flesh tints emerge, the
pale pink of the forehead, the nose, the cheeks and the chin, the
smiling animation of the entire head, reveal an artist by whom
La Tour was justly awed and who, though usually following
in his footsteps, must often have overtaken him.[28]

In 1753, the public, accustomed as it was to La Tour's
prolific production of masterpieces, was nevertheless some-
what surprised by his exhibit of eighteen portraits. In the midst
of what can only be called this gallery of his works, public
curiosity was concentrated upon a portrait of Rousseau who
had almost quarrelled with the painter, declared Fréron,[29] for
having posed him too much at his ease seated in a cane-bottom
chair whose woodwork was adorned with ornamental carv-
ings of apples; he would have preferred a bench, a stone, or,
quite simply, the ground.[30] The connoisseurs, however, gave

[28] Perronneau is a better colourist than La Tour. There is something of the
luminosity of the English school, something of Reynolds, in his pastel style,
and nothing could be more frankly charming than his portrait of a little boy
belonging to M. Groult.

★[29] Elie-Catherine, known as Jean, Fréron (1719–76), the sensitive but
reactionary critic and enemy of the Encyclopaedists was also the editor of,
among other periodicals, L'Année Littéraire which continued to appear after his
death until the Revolution.

[30] This portrait, in which Diderot perceived no more than 'the composer
of the Devin du village, well dressed, well combed and seated in a ridiculous
posture upon a chair', was first intended for Mme d'Epinay but was in the end
given by Rousseau to the Maréchale de Luxembourg. La Tour made another
portrait of Rousseau, which the philosopher was pleased to accept and for
which he thanked La Tour, saying in his letter that 'this admirable portrait'
somehow made the sitter seem 'a respectable person'. One of these portraits is at
Saint-Quentin; the other, according to M. Mantz, is at Geneva, in the possession
of M. Coindet.

their preference to the portrait of Madame Lecomte, the mistress of Watelet, holding a sheet of music in her hand, a hand which seemed to emerge from the frame, and whose arm seemed to have all the tone and colour of oil paint.[31] They also much admired the portrait of Silvestre[32] executed in that particular style which seems to have been destined by La Tour to appeal above all to artists. For, throughout nearly the whole of his long career and at all his exhibitions, it is a notable fact that the pastellist had two distinct styles, one for the public, the other for the artist, the one soft and melting, the other free and jerky. This had already been noticed in 1741 with respect to the contrast between the technique of the portrait of the Président de Rieux and that of the negro, and, in 1746, between the portrait of Restout aiming, with its juxtaposed, ill-matched strokes, at an effect almost of brutality in the face, and that of Pâris-Montmartel the technique of which was so mellow and unified. At this moment, about 1753, La Tour's 'artistic' manner was beginning to predominate, and at this year's Salon, criticism was able to affirm that the pastellist had gone over definitely to his less smooth, less caressing manner, even in his portraits of women.[33]

## V

La Tour had now achieved the heights of artistic success. He was acknowledged, famous; he had entered into the full possession of his renown. He was received in Society, by the nobility, by the best company; and he was regularly invited to Madame Geoffrin's Monday dinners, which, Mariette noticed, he attended assiduously for a period of years. He was a member

[31] *Observation sur les ouvrages de MM. de l'Académie de peinture et de sculpture*, 1753.

*[32] The family of Silvestre included numerous painters and engravers. La Tour's portrait is of Louis de Silvestre (1675–1760), who became a Vice-Rector of the Academy, and subsequently went to Germany as Director of the Dresden Academy where he played an influential part in the propagation of a taste for contemporary French art.

[33] *Sentiments d'un amateur sur l'exposition des tableaux du Louvre, 1753.—Lettre à un ami sur l'exposition des tableaux faite dans le grand salon du Louvre, le 25 août 1753.*

of M. de la Popelinière's [34] charming *opéradique* circle at his house at Passy.[35] He was among the intimates of the Minister, Orry. He had established the most delightful and the most flattering contacts, relations with the higher nobility and with the literary and scientific worlds. His studio, in his lodgings (No. 8)[36] at the Louvre, the palace which the monarchy of the *ancien régime* had transformed into a kind of royal hostel of the arts, was visited at various times by every notability of the century: Nollet,[37] his neighbour, Crébillon and the Abbé Hubert,[38] of whose conversation he was so fond; the victor of Fontenoy, for whom he contrived to secure, according to a legend propagated by the biographers, the pension of 200,000 *livres* derived from the Artois estates; Paulmy d'Argenson, Mondonville, Buffon, la Condamine, Duclos, Helvetius, Dupuy, D'Alembert, Diderot and the entire personnel of the *Encyclopaedia*—the Academy of the philosophers; Restout, whom he called 'his master', the sculptor, Lemoine, who made a bust of him,[39] Pajou, at whose marriage he acted as a witness, Gravelot, who designed the ornamental borders of his engraved portraits, Carle Vanloo, Pigalle, Vernet, Parrocel and Greuze. He made as much money as he wanted. At his well-served table he daily entertained acquaintances from his native Picardy, friends with whom he sauntered after dinner in the *jardin de l'infante*.[40] In the midst of this life of substantial

*[34] Alexandre Joseph le Riche de Popelinière or Pouplinière, the farmer general (1692–1762), was also a composer of songs and the author of licentious books. These included the *Tableau des mœurs du Temps* of which only one copy was printed. His luxurious house at Passy was a meeting place for bohemian and literary society.

[35] *Mémoires de Marmontel.*

[36] These lodgings were granted to La Tour in 1750.

*[37] Jean Antoine, l'Abbé Nollet, the physician (1700–70), was the discoverer of endosmosis and published various studies of electrical phenomena.

*[38] La Tour was on close terms with the Abbé Hubert or Huber, with whom, it would appear from the artist's will, he had financial dealings.

[39] It was at Lemoine's dinners, which were attended by Le Kain, the barrister Gerbier and Grétry, that La Tour was introduced to Mme Lebrun.

[40] *Mémoires de Diderot*, September 1765.

comfort, of an opulent simplicity, in which he rubbed shoulders with the famous personalities of the age, with its men of talent, an extant letter from a friend, the Abbé Le Blanc,[41] shows us the artist passing from his studio to the wings of a theatre, on his way to dissipate the fatigues of work in a theatrical party, one of those pleasure parties or fashionable suppers—delightful evenings whence arose the passion that was to absorb his bachelor existence and to be with him still in his eightieth year, as he drained his last glasses of wine to the memory of his mistress. Her name, the name of the singer for whom the poet Cahusac died insane in a cell at Charenton,[42] mad with sorrow because he could not marry her; the singer for whom the chronicler, Grimm, fell ill with that singular malady of the heart, with that lethargy that Rousseau has described; the singer who created the role of Colette in the *Devin du Village*, the 'silver-toned'[43] singer, the singer with such a buoyant, airy voice; her name, Mademoiselle Fel, may suffice to explain La Tour's great and durable passion. We may examine her traits in the Saint-Quentin Museum: a strange face, charming, unexpected, which is somehow out of place in this gallery of characteristically eighteenth-century women, with its pure forehead, its fine eyebrows, the languor of its large black eyes curtained at the corners by the velvet of their lashes, its Greek nose, straight features, indolent mouth and long oval contour; it is a countenance exotic in every detail, beautifully crowned by a gauze handkerchief bordered with gold, falling obliquely upon the forehead, dropping towards the right eye, caressing one temple and drawn up towards the posy of flowers attached to the other; it is thus that one might picture a Levantine girl brought back from the East upon a page of the sketchbook of some Liotard; or, rather, it is thus that one might suppose Don Juan's Haydee to be an inhabitant of one's dreams.

[41] An undated letter from the Abbé Le Blanc to La Tour. It was sent to him the day after a party which had been prevented from taking place on Thursday by a rehearsal which Mlle . . . (the name is crossed out) could not afford to miss. *Catalogue de Laverdet*, October 1862.

[42] *Le Colporteur*, by Chevrier.　　[43] *La Bigarrure*, Vol. IX.

La Tour was rich, happy, and in love. In the portrait en-
graved by Schmidt, in which the painter has depicted himself,
according to the advertisement in the *Mercure* of 1743, in the
picturesque undress of his studio clothes, and in which his
gesture is a gesture of mockery provoked by the sound of the
importunate Abbé Hubert knocking vainly at his locked door,
La Tour, in his short working coat, seems full of the joys and
pleasures of existence. A life of happiness seems written in his
smile, glitters in the sparkle of his blue eyes, palpitates in
his sensual features, his thin lips and mocking mouth, in his ex-
pression of ironical gaiety. In this powerful, well-set, intelligent
head, mature, quizzical and already bald, in this face recalling
Democritus and Scapin, there is a kind of cynical felicity; and
there emerges from the figure of the painter-philosopher the
image of a trivial Voltaire, fleshy, materialistic, the image
almost of a satyr.

## VI

In 1755, La Tour exhibited only one pastel. This was the
full-length portrait of Madame de Pompadour, measuring five
and a half feet in height by four feet in breadth. It is the work
that can now be seen at the Louvre.

Dressed in white satin, embroidered with a flow of golden
branches, bouquets of roses, rosettes—a silver dress with full
lace sleeves falling from the elbow, the bodice laced together
by ribbons of pale violet as soft as the corolla of a lilac-poppy,
Madame de Pompadour is seated upon an armchair covered
with Beauvais tapestry in an easy, unceremonious attitude
which slightly raises her skirt, revealing a fragment of lace
petticoat beneath which her crossed feet are visible, shod in
pink high-heeled slippers. Her right hand only just rests, with
a fluttering gesture, upon the page of a music book which she
holds in her left, the arm folded and leaning upon a console
table. Her hair is unpowdered. She is not looking at the
music; her gaze, soft and abstracted, seems to listen, while
a faint smile wanders across her lips. Behind her is a blue
hanging starred with gold circles which, on one side, sets off a

painted panel representing peasants marching along a country road. Near her, on a sofa, a guitar still quivering sleeps upon a piece of music. On the console table which supports her elbow, a collection of volumes, bound in calf, books for ordinary use, the friends of every day, reveals the quality of the intellectual companionship which she chose to have readily available; the collection comprises *Pastor Fido* printed by the firm of Elzevir in 1659, the *Henriade* which was sold at her death as Item 721 in her library catalogue, volume III of *L'Esprit des Lois*, and volume IV of the *Encyclopédie*. Lying next to a globe, a half-open book, bound in blue and entitled on the back *Pierres Gravées*, has shed one of its plates on to the golden-footed table, an engraved plate inscribed at the base: 'Pompadour sculpsit', with the following legend: 'Représentation de la situation où est le graveur en pierres fines et des divers instruments. . . .' The portfolio beneath, tied with a blue ribbon and adorned with a coat-of-arms showing three towers, contains the Engraved Works of Madame de Pompadour.

In this portrait, which was La Tour's major effort, and which he intended to be his masterpiece, all the artist's ambitions are discernible. Instead of seeking, like a Nattier, to carry off his sitter to Olympus, to subject her to a kind of mythological deification, his idea was to offer her image to posterity as an immortalization of contemporary reality. He indicates the virtuoso in the sheet of music which she holds in her hand, the music of an opera written for the *Petits Appartements* of the King, whose harmonies seem to be expiring on her lips. He reveals the royal mistress in the pose, the abstracted, preoccupied air, the turned head, the gaze *à vue perdue*, the apparent interest in what might be taking place 'off-stage', the smile that seems to have risen to her lips at the distant sound of a door, at the approach, hoped for and expected, of the King. But that was not enough. Breaking with the French tradition of portrait painters such as Rigaud and Largillière, renouncing the winged allegories, the noble draperies of vast decorative curtains, the pompous colonnades, the vaguely tragic backgrounds which were invented to serve as the

conventional setting of all official portraiture, La Tour risked
the revolutionary procedure of displaying his subject in the set-
ting of her everyday existence, in the midst of her daily pre-
occupations, in a scene adapted to her role in life. As a finishing
touch to the physiognomy of his sitter, it was his idea to depict
with her the physiognomy of her chosen surroundings, any-
thing that might reveal something of her character in the
objects among which she lived. Just as he had represented the
Président de Rieux amid the opulence of the magistrature, so
now he painted the royal favourite in a room redolent of her
personality, which reflected her tastes, which contained her
books, her furniture, her engravings, which illustrated the
charm of her reign and provided its excuse. In these furnish-
ings, these accessories, which seem to be simply an accompani-
ment to the figure of Madame de Pompadour, in that love of
the arts, that intellectual freedom with which these objects
appear to be imbued, the great and original portraitist has
evidently sought to devise a celebration, an apotheosis of the
thoughts and activities, the mind and the spirit of the woman
whom Voltaire was to mourn as a philosopher.

## VII

There is a curious anecdote concerning this portrait, and
one that is very characteristic of La Tour. Summoned to
Versailles to paint Madame de Pompadour, he replied : 'Kindly
inform Madame de Pompadour that I do not go out to paint.'
One of his friends, however, overcame this prejudice, and he
promised to attend at court on the appointed day, but on
condition that no one should interrupt the sitting. On admis-
sion to the apartments of the favourite, he reiterated his
conditions and asked permission to set to work at his ease and
in his own way. This was granted. He at once undid the
buckles of his pumps, his garters and his collar, removed his
wig and hung it upon a branched candlestick and drew from
his pocket a little taffeta cap and placed it upon his head.
'In this picturesque *déshabillé*, our genius, or if the expression
should be preferred, our eccentric, began his portrait. The

admirable artist had hardly been at work for a quarter of an hour, when Louis XV entered. "You gave me your promise, Madame," said La Tour, raising his cap, "that your door would remain closed." The King laughed in good humour at the costume and the reproaches of the modern Apelles and urged him to continue his work. "It is impossible that I should obey Your Majesty," replied the painter, "I shall return when Madame is alone." He rose immediately and, taking his wig and his garters, went to dress in an adjoining room with the repeated expostulation: "I do not like to be interrupted." '[44]

Such were La Tour's manners. The fashionable painter used and abused his vogue. No other painter so successfully imposed upon the century the arrogant tyranny of the artist, such a deference to the foibles of talent. The King himself, who both housed and pensioned the artist, had to submit, in order to have his portrait, to La Tour's impertinences.[45] The portraitist left unfinished the pastels of Mesdames de France, the King's daughters, to punish them for failing to keep appointments for sittings. The Dauphine was unable to obtain hers because she committed the imprudence of wishing to change the scene of the sittings from Fontainebleau, which had been agreed, to

[44] *Almanach littéraire* or *Etrennes d'Apollon* for the year 1792.

[45] When he was summoned to paint the King's portrait, he was ushered into a room which admitted the light on every side. 'What do you expect me to do in this lantern?' exclaimed La Tour. 'In order to paint, there should only be one source of light.' 'I particularly chose this sequestered room,' replied Louis XV, 'so that we should not be interrupted.' 'I did not know, Sire,' said the artist, 'that you were not the master in your own house.' On one occasion he annoyed the King by his irritating praise of foreigners. 'I thought you a Frenchman,' said the King. 'No, Sire.' 'You are not?' said the King, with an air of surprise. 'No, Sire: I am a Picard, from Saint-Quentin.' On another occasion, relates Chamfort, his expressions of regret, in the presence of the King, for the inadequacy of the French fleet prompted this neat reply from Louis XV: 'And what about Vernet?' He is also recorded to have said to the Dauphin, who had been misinformed about some affair which La Tour had recommended to his attention: 'You see how easily people of your kind allow yourselves to be taken in by swindlers.' He was the sort of man 'who boasts of only going to court in order to tell home truths to the members of court society', the sort of person who delights in teaching others their own business and whose misplaced audacities are regarded as amusing follies, comical and disarming. *Almanach littéraire*, 1792—Diderot, *Salon*, 1763.

Versailles.[46] 'My talent belongs to me,' La Tour proudly declared. He made his conditions, which were almost treaties, in a dramatic and sensational manner; and should the most trivial clause be infringed, he would abandon the work; nothing would induce him to continue, and the portrait remained unfinished. When he consented to paint, he dictated the pose, the expression, the complexion of the model, taking a brutal revenge for the torture, endured by most portraitists of the time, of submission to all the foolish stipulations of the female sitter.[47]

[46] *Abecedario*, by Mariette.

[47] We may quote here an amusing sketch of the sufferings endured by the portraitists of the time:

'*Milord:* People do not yield to the requirements of an artist. They try to dictate to him.

'*M. Remi:* It appears, milord, that you have seen some of our women sitting for their portraits. It is an amusing business. . . . "But, dear Sir, I am not as pale as that. . . . You have given me large, stupid eyes. . . . My mouth is smaller, my nose is not so fat, my chin is less pointed. . . . You have made the collar bone too big, and put in protuberant bones on the chest." The onlookers then give their opinions and the wretched painter is obliged to listen to everything.

'*Milord:* And, indeed, to do everything—to provide a full throat, small mouth and round, dimpled arms, to apply white in abundance and carmine to animate the eyes which must at all costs be bright. This is a point that can never be relaxed. And then there must be six curls, neither more nor less, on either side of the face, the hat must be raised, there must be black eyebrows with fair hair and red hair with a dark complexion.

'*M. Fabretti:* I can well believe it; they see themselves in their portraits as they are, but they would like to be painted as they see themselves in the mirror. Nature does not furnish artificial complexions or symmetrical hair styles and attire; they would not permit the truth of Rembrandt or Van Dyck. In France, the costume of an Indian appears a simple one: nose rings, green and yellow paint on the face, and patterns, in compartments, painted on the throat and the arms.

'*Milord:* I can see that that might well be so. Women, however, are incapable of realizing that there are countries in the world where it is possible to make a decent appearance in company without a clip in the middle of the hair, without bows of ribbon and other furnishings of similar importance. They would say that they were not dressed. If I was a painter, I should not give in to such fancies. I should find a way to quell them and I should see to it that, after a thorough laundering, they handed over their bodies entirely to me to use for such purposes as I thought fit. . . .'

*Dialogue sur la Peinture*, 1773, Paris. Printed by Tartouillis, at the expense of the Academy.

Towards the business world, his capricious manners reached the point of insolence. The story of his portrait of La Reynière is well known. Dissatisfied with the picture, on which he had worked without inspiration, he asked for an additional final sitting. On the agreed day, the financier sent a servant to tell La Tour, who was already seated at his easel, that he would not have time to keep the engagement. 'My friend,' said La Tour to the servant, 'your master is a fool whom I ought never to have painted. . . . Your face, on the other hand, I like; sit down there, you have an intelligent expression, I'm going to do your portrait. And, I repeat, your master is a fool.' 'O no, Sir, please don't think of such a thing! If I don't go back to the house, I shall lose my place.' 'Very well then, I'll find you another one. Let's begin.' La Tour completed the portrait, and M. de la Reynière dismissed his servant. The portrait was subsequently shown at the Salon, the anecdote became current, and everyone wanted to make the acquaintance of the intelligent valet of such a wealthy man, and very soon the valet's only problem was to choose the most suitable place from among the innumerable offers he received.[48]

Is there nothing more in this behaviour of La Tour's than the simple manifestation of boredom and regret at having attempted the portrait of a fool? Might it not also reveal an element of bitterness against the financier and his wealth? The artist was a man eager for gain. The esteem in which he held himself personally and the value he put on his works made him exacting on the matter of prices, whose amount he appears to have adjusted in accordance with the circumstances of his models. In 1745, he almost quarrelled with a close friend, Duval d'Epinoy, about payment for the portrait sent to the Salon with the following verses which he had had engraved on the mount:

La peinture autrefois naquit du tendre amour.
Aujourd'hui, l'amitié la met dans tout son jour.

Another friend, Mondonville, among those who received

[48] *Notice*, by Bucelly d'Estrées.

him on terms of the greatest familiarity, had no better reason
to be satisfied in the matter of his wife's portrait. Before the
painter had begun it, Madame de Mondonville had told him
frankly that she had only twenty-five *louis* to spend. On this
confession, La Tour nevertheless compelled her to sit and com-
pleted a delightful portrait of her. Enchanted by his reception
of her, Madame de Mondonville went at once to her coffers
for the money, and having packed it into a box under a layer
of sweets, sent it to the painter. La Tour kept the sweets and
returned the money. Madame de Mondonville supposed this
move to be a chivalrous gesture and that La Tour wished to
make her a present of the picture. Unwilling to appear laggard
in her compliance with any of the more delicate refinements
of manners, she sent him a silver dish, costing thirty *louis*, of
which, as she had noticed in his lodgings, his sideboard was in
need. This new present was not found more acceptable than
the first; it was returned and Madame de Mondonville was
informed that M. de la Tour had put a price of twelve hundred
*livres* on her portrait, and that furthermore he could give no
consideration to those who did not share his opinion of the
'Bouffons' whose comic musical performances had, at that
time, divided into two camps everyone in Paris who flattered
themselves on their knowledge of music.

Money seems also to have played a part in the completion
of the La Reynière portrait. It would appear that La Tour had
made known his intention to ask 10,000 *livres* for the portrait
of the financier and his wife. M. de la Reynière countered this
claim by leaving the two pastels in the painter's hands. After
some years had gone by, however, La Tour, tired of keeping
the two pictures in his studio, summoned M. de la Reynière
to relieve him of them, and, under the threat of a suit the
financier decided to pay La Tour 4,800 *livres*, the sum to which
the two artists, Silvestre and Restout, had persuaded their
friend to reduce his price.[49]

Finally, we would cite this curious item of information,
hidden in the *Journal des Arts*, for *nivôse* 25th in the year VIII,

[49] *Abecedario*, by Mariette.

about La Tour's demands in respect of the famous portrait of
Madame de Pompadour:

'Would it be inappropriate to remind these gentlemen of a
little anecdote about La Tour, the painter of pastel portraits?
He had just finished that of the Marquise de Pompadour and
had modestly asked for a fee of 48,000 *livres*. Madame la
Marquise considered the artist's pretensions to be exorbitant
and sent him 24,000 *livres* in gold. La Tour, furious, was pacing
up and down his room, complaining that his talent was
degraded, when Chardin, his neighbour at the Louvre,
addressed him in a perfectly calm manner, asking him whether
he knew the cost of all the paintings decorating Notre-Dame,
which included the masterpieces of Lesueur, Lebrun, Bourdon
and Testelin. "No." "Well then, calculate; about forty pictures
at 300 *livres*, that makes 12,600 *livres*. . . . And, in addition,"
continued Chardin, "each artist presented the small version
of his picture to the officiating churchwardens." La Tour was
reduced to silence.'

## VIII

What a strange personality was La Tour's! He had a con-
fused, complex nature, a bizarre assemblage of the most
disparate of human traits. Rapacious, prompt to fleece his
clients, draining the utmost out of the contemporary vogue
for his portraits, he was, in other things, disinterested, generous,
charitable. He was a munificent alms-giver, paying always in
German silver. He was sometimes genial, sometimes irritable
and capricious. Everything in his character was mixed, petty
vanity and proper pride, passion and cunning, quackery and
generous honesty; he combined a Voltairian gentlemanliness
with a middle-class attitude like Chardin's. He was a provincial
from Saint-Quentin and yet a typical representative of the
eighteenth century, of the period of Rousseau and of that of
M. de Montyon.[50] He had returned from London with the

★[50] Jean Baptiste Antoine Auget, Baron de Montyon (1733–1820), philan-
thropist, economist and politician; he was the founder of various prizes at the
Institut de France.

independent spirit of a free citizen; he was untutored at court, churlish towards influential persons, insolent to the rich, a character from Duclos embodied in a Danubian peasant. He would show to the nobility, as a lesson, the Abbé Coyer's[51] pamphlet on the word *Patrie*.[52] He blamed the Maréchal de Saxe for the spilt blood on which his fame was founded. He was a great reader, dabbling in everything, stuffed and ill with badly digested culture, and a bold and rebellious politician, settling the destinies of Europe as he gave his sittings;[53] he was a man of many systems, creating for his own use systems of art, of religion, of medicine;[54] he was a man, also, of many manias, doing nothing in accordance with custom, perpetually desirous of distinguishing himself from others, mystifying his friends, for example, as to how he had come from Paris to M. de la Popelinière's at Passy without a carriage, a horse, an ass

*[51] Gabriel François, l'Abbé Coyer, chaplain-in-chief to the Cavalry, writer and moralist (1707–43).

[52] The editor of the *Memoirs of Condorcet* assigns this anecdote, which he treats as a revolutionary anecdote, to the year 1788. He is mistaken; the Abbé Coyer's pamphlet appeared in 1755.

[53] *Mémoires de Marmontel*, Vol. II.

[54] The following curious letter, supplied by M. J. Boilly and published in the *Archives de l'art français*, Vol. II, displays an aspect of La Tour's views on health questions:

Mon cher Monsieur,

I am touched and honoured by your remembrance of me and by the charming compliment of copy of your new London edition. I have told your cousin that I am very willing to supply him with the chocolate you desire; it gives me great pleasure to learn that this does you good.

I believe that water first thing in the morning is an excellent protection against illness: it cleans out the stomach, washes the kidneys and aids digestion. By gradually getting used to this prescription, a daily consumption of as much as two pints may become possible. Those who carry it out look upon me as their saviour. It is the interest I take in your health which prompts me to adopt here the role of a doctor prescribing fresh water; you cannot rely on other remedies with anything like the same assurance: this was an axiom for M. Cocchi of Florence.

I have the honour to remain, mon cher Monsieur, with all the sincerity and cordiality of a Picard,

Your humble and obedient servant,

De la Tour.

Aux galeries du Louvre, April 24, 1774.

or a boat, without walking or swimming: he had, he declared, been tugged thither by a barge.[55] He was the perfect eccentric.

But we must be fair to La Tour's eccentricity. It was justified, saved, elevated by the nobility of his spirit, the quality of his character, the grandeur of his aspirations as a man and a painter, his feeling for the dignity of the arts, the scholarships he endowed, the many charities he practised,[56] and the fine example he set of high-flown modesty by his refusal, the only refusal of the century, of the cross of Saint-Michel and the title of nobility it would have conferred.

IX

La Tour is magnificently shown at the Louvre. He is represented there by thirteen pastels whose quality overshadows

[55] *Mémoires de Madame de Genlis*, Vol. I.

[56] In 1776, La Tour endowed the town of Paris with three prizes: the first for anatomy, the second for perspective, and third for the painted half-length. To provide for the necessary income, he paid over, on 27 April 1776, the sum of 10,000 francs to the lawyers for the deed settling the foundation which was signed by Pierre, Dumont-le-Romain, Coustou, Doyen, Chardin, Cochin and Renou.

He founded a further prize of 10,000 francs for a medal to cost 500 francs and to be awarded for the finest action or for the discovery most useful for the arts in Picardy.

He gave about 30,000 francs towards the foundation in his native town of a charitable institution for providing the new-born babies of poor families with clothes, for assistance to indigent mothers during their period of confinement and for the support of disabled workmen.

According to a note in the *Mercure* by M. Mantz, he also founded at Saint-Quentin, in 1778, a free drawing school for which he applied, in a letter dated 21 September 1781, from his lodgings in the Louvre, for the protection of the Intendant of Amiens, thanking him for his supervision of 'an establishment which he hoped would prove useful to all his fellow citizens'.

The drawing school at Saint-Quentin was officially recognized with the title of *École Royale* by letters patent during the month of March 1782, and, in March 1783, classes were started in its three branches of study: geometry and architecture, the human figure and animals, flowers and ornamentation.

La Tour's initial contribution to the foundation of this school amounted to 18,000 francs; but, recognizing the inadequacy of this sum, he remitted, yearly, supplementary amounts which, together with gifts of money with which he increased the capital of his other foundations, raised the total amount of his liberality, according to a computation of *Thermidor* 16th, in the year IX, to 90,174 *livres*, 3 *sols*, 4 *deniers*.

completely the works of his predecessors with which they are hung, the hard, black pastels of Vivien and the airy, agreeable works of Rosalba. There is, first of all, the portrait of Madame de Pompadour, his great popular picture; then, the self-portrait[57] which looks in its faintness and deliquescence like the portrait of some ironic phantom bathed in the colours of the dawn; next there is the portrait of René Frémoin,[58] with its powerful colouring; and that of the member of the Order of the Saint-Esprit which astonishes us by its wonderful differentiation of the three blacks in the costume, contiguous but not confused, the black velvet of the coat, the black satin of the lining, and the black silk of the stockings; then there are the portraits of the King, the Dauphin and Marie Leczinska, this last an enchanting work compelling our admiration for the soft, charming tonality of the face, of the expression and modelling of the delicate skin, of the complexion suggesting the valetudinarianism and religiosity of the sitter, on which a tranquil light is at play and which little touches of pure yellow amid the bluish notes of the half-tones connect with the general colour scheme of the work. The admirable drawing of the smile concentrates an air of benevolence at the corners of the mouth. The chalk impasto stopping on the edge of the shadows, which are scarcely more than a kind of chalk glaze, invests the entire head with the transparency of flesh. The pastellist has achieved a miracle of skilful handling in the dress, adorned, decorated all over with little ornaments, *passequilles* and *pompons*, such as the wife of Louis XV delighted in, intermingled, interwoven, with chenille, braid, milanese, gold and curled lace, sown here and there with tufts of that lace embroidery

---

[57] What a metamorphosis in this wild, diabolical old man from the young La Tour, the La Tour shown in the portrait of M. Lagrange, and even in that of Perronneau, spruce, erect, his nose in the air, firmly mounted upon his five feet two inches of stature, his whole nervous structure elegantly controlled, his clothes neat, choice and refined!

*[58] René Frémoin or Frémin, the sculptor (1672–1744), was employed on statuary for the Invalides, Versailles and Marly. He subsequently worked in Spain under Philip V.

which, I believe, was known at the time as *soucis de hanneton*.[59]
This portrait of Marie Leczinska, however, with all its finished
perfections, is not the finest work by La Tour in the collection.
There is a better example, considerably superior to the large
portrait of Madame de Pompadour, though much less famous
and important. This is the portrait of the Dauphine de Saxe
playing with the mount of a pendant fan—a charming gesture,
beloved by the portraitist, and which he had already bestowed
upon Marie Leczinska. The technique of the portrait of the
Queen is somewhat frigid, somewhat over-prudent. In the
case of the Dauphine, the refinement of the handling has been
supplemented by wonderful technical audacities. Imagine the
typical complexion of a German woman, an admirable blue
in the eyes, a dazzling glow upon the cheeks whipped into
health by a multitude of little red hatchings, the soft vermilion
of the cheekbones enlivened by one or two dabs of carmine, a
palpitation of crisp strokes over a soft sub-surface, the play
of chalks in another colour which proceeds by twists and turns
in the direction of the muscles, fragmenting, diversifying the
general tone, giving it the broken, mingled hue of flesh; 
superimposed, there is a final almost imperceptible network
of hatchings in white chalk seeming to spread a veil of milky
white over the underlying assemblage of varied tints; and
here and there in this portrait there are little miracles of draw-
ing, of touch, of lighting—the reflected light from beneàth the
chin, the pallor of the throat on which three little azure
chalkings indicate the blue of the veins; and that delicate
hand! . . . its indefinaþle, pale-pink hue, the colour of a
woman's hand in the half-light, a single shaft of sunlight
staining it with mother-of-pearl and with little reflections
playing upon the satin surface of the skin and the pearly glaze
of the nails. . . . But words cannot describe such a portrait; it
must be seen, its true beauty can only be inhaled from the pastel
itself.

[59] This head of Marie Leczinska seems to have become the official likeness
of the Queen. The *Mémoires de Luynes* record that, in May 1747, there was
exhibited in the royal apartments at Versailles a large portrait of the Queen by
Vanloo, who had copied it from La Tour's pastel.

X

The Louvre, however, counts for little in the history and study of La Tour beside his own museum at Saint-Quentin. There it is not a question of fourteen pastels, but of an entire gallery hung from top to bottom, populated, encumbered, even on the return of the walls, with the master's works, a collection of more than eighty portraits completed or merely begun, highly finished or simply sketched, a collection that composes a procession of his contemporaries, of the various social levels, of the types of his epoch, showing side by side, in the inescapable jostling of contemporaneity, the philosopher Rousseau and the financier La Reynière, Mlle Camargo the ballerina and the Duc d'Argenson, M. de Breteuil[60] and the Director of the Théâtre Monnet, Mlle Favart the singer and the economist Forbonnais, the clown Manelli and the Prince Xavier de Saxe, Moncriff[61] and Parrocel, the Abbé Le Blanc and Silvestre and the tragedian Crébillon, almost the entire iconology of the period.

What an astonishing museum of the life and the humanity of a society! On entering it we receive a strange impression, an impression which no other painting of the past conveys elsewhere, the impression that all these portraits turn towards us, that all these eyes are gazing at us, and we seem to have interrupted, in this spacious gallery in which every voice is suddenly silent, the conversation of the eighteenth century.

From this concourse, from all these portraits in which La Tour, as Gautier Dagoty[62] observed, so successfully overcame the difficulty of preserving the luminosity of the flesh without risk of darkening next to the white of powder, one picture and one portrait head, before all the others, emerge, rise up before us.

*[50] M. de Breteuil (1730–1807), Secretary of State under Louis XVI, was responsible for the abolition of the system of imprisonment by *lettres-de-cachet*.

*[51] François Auguste de Moncriff (1687–1770), actor, musician and comic writer, author of *L'Histoire des chats*.

*[52] The family of Gautier Dagoty produced various painters and engravers. The reference here is to Jean Baptiste, painter and author of the *Galerie française des hommes célèbres qui ont paru en France*, 1770.

The latter is the portrait of Silvestre, in a dressing-gown of blue figured damask, and wearing a mauve handkerchief round his head, an admirable study in which art and sincerity have combined to express the totality of an aging countenance—the clarity of the cool pinks in the flesh-tones of old age, the nectarine hue of the complexion, the furrowing of the wrinkles, the folds induced by the piling up of the years, the powerful creases in the forehead, the swollen flaccidity of the cheeks and the chin, all the wavering sculpture of age on the face of an octogenarian.

The former picture represents the Abbé Hubert.[63] The good abbé appears half-length, seen from the side and seated on the edge of an armchair, the elbow supported on a table covered in green damask. In front of him, a large folio, bound in calf, has been leant against two large books placed one on top of the other so as to make a desk. One of his hands is hidden beneath an open page; the other fingers the red edge of the book from which a white marker emerges. Seen in three-quarter view, the abbé is reading. Leaning over the table, his broad, blue cravat pushed up and loosened by the great size of his stomach, his lips protruding and his expression avid, he seems lost in a kind of ecclesiastical jubilation, in the pleasures of a Benedictine epicureanism; he sucks the very marrow out of his big book, seeming to roll around his lips its letters, its lines, its layout. Perched on top of a portfolio a small two-branched candelabra provides light for the reader; only one of its candles is still burning; the prism of its flame is blue at the base and its white tongue of light at the end of the blackened wick blazes out against the muffled darkness of the background; from the other, whence great streaks of wax descend in festoons, stalactites, cascades, on to the sconce, two smoke-rings rise into the air revealing that its light has only

[63] The Abbé Hubert represented in this magnificent pastel is hardly known except by the comic inspiration with which he provided La Tour for this delightful portrait, and by the tribulations he brought upon Rousseau at the hands of Madame de la Popelinière, who included all the citizens of Geneva in her sworn detestation of this abbé, a native of that city, who had almost prevented the celebration of her marriage with M. de la Popelinière.

just been extinguished. The picture contains no more than this. An abbé, a book and two candles—but from this material La Tour, relying on the harmony of truthful presentation and the contrast of effects of light, has created a masterpiece which, in a setting reminiscent of Chardin, proves that the art of pastel is capable of effects which almost rival those of Rembrandt.

It is not even in this picture, however, among so many accomplished works, so many precious records, that, for the connoisseur, the main revelation, the principal enchantment of the Saint-Quentin Museum resides. The *préparations* exhibited here reveal the charms of La Tour's first thoughts, and these perhaps are superior to any of his others. Their fruits are these astonishing studies in which a living countenance seems to have been caught behind the glass of the frame. Look, on the right-hand wall, at this great group of sketches, all hung on the line, this series of heads which, for some unknown reason, recall those portraits made during the Terror—portraits of heads only—for the work of the executioner made it impossible for the artist to proceed further. In these sketches technique and medium have vanished, we are offered nature itself, alive, breathing, without the intermediary of interpretation or translation. On the faces of these men and women we no longer perceive the colours which compose their complexion, but the complexion itself; this is no longer art, but life.

These persons who do not exist from the neck downwards, whose life fades at that point, from the blue paper, in a few untidy strokes or a few broad hatchings in brown, these persons constitute an amazing revelation. Their hair is no more than a kind of uncanny *arrosion* having all the consistency and grey cloudiness of powder, with bold, dark hatchings just above the glimpse of the ear; and this hair, roughly and powerfully executed, frames the vision of a face, the most fleeting of its aspects, set down vigorously, triumphantly, by a master hand, a hand impelled by a productive fever, the hand of an inspired master in a diabolical struggle with nature, oblivious of all rules and regulations, forgetting all he has learnt for the sake of what he sees. Touches of pure carmine give

the transparency of a nostril, heavy strokes of Troyes white streak with broken, dancing lights the marble surface and blended hues of a complexion, eruptions of pure blues or yellows split up the flatness of the tones, furrows in the flow of the muscles leave traces, like the marks of a comb, on the curve of the cheek; and the excitement of the moment, the effect of the model provoke a thousand audacities which re-create instantaneously on the paper—far better than a brush could do on canvas—the full intensity of life, a miraculous illusion of flesh and blood.

These *préparations* provide, furthermore, likenesses in which the historian, the social commentator, the doctor or the physiologist may study with equal profit the temperament of the individual. The type of health, the type of intelligence, the physical constitution of the particular man or woman, the various pigmentations of the skin resulting from the blood, from bile, or from the lymph, and the individualities of character—all these have been expressed by the pastellist.

In this humorous mouth, for example, in these subtle and almost simian features, in the irony of these eyes which contrive to glitter though there is no point of light in their pupils, we recognize at once the mocking adept of mystification, the philosopher, the parodist, the quiz. The whole of d'Alembert is in this sketch.

And this thick-set face beneath its untidy locks, disordered by the wayward fluttering of a kerchief, these distended eyes, this short, sensual, surprised, mischievous nose, this pursed mouth trained to utter buffooneries for the public, this woman's face, the shameless, malicious image of village wit —it is at the same time Bastienne[64] and Madame Favart.[65]

Next to it hangs another theatrical figure: relieved against a bright blue background, a dry little face emerges from

★[64] The libretto by Weiskern of Mozart's one-act opera, *Bastien et Bastienne*, commissioned by Mesmer, was a satire on Rousseau's bucolic opera *Le Devin du village*.

★[65] Mme Favart, the actress (1727–72), was the wife of the playwright Charles Simon Favart, a *protégé* of Mme de Pompadour.

beneath a powdered lock contrasting with corkscrew curls, in black chalk, in which the rest of the hair is dressed; it is a face tingling with pink and blue, glowing with a kind of roseate life; there is intelligence in the protruding forehead, the eyebrows are black and delicately arched, black also the eyes— of the kind that used to be described as prunes—the nose slightly aquiline and the features in general, refined, chiselled, almost pinched; there is a charming slimness in the oval of the face and the brightness of the complexion denotes a nervous, sanguine temperament: it is Mademoiselle Camargo.

And if you should seek the authentic Pompadour, the Pompadour of the preliminary study not of the portrait, the bourgeois favourite, perceived, so to speak, in the raw, stripped of the idealizations of the official portrait, you may study her here, her eyes of porcelain blue set wide apart, the down on her upper lip, her complexion no longer young, somewhat blotchy and chlorotic, blue in patches, mottled, in the words of a popular song of the period, like a trout, a faded rose upon her cheeks and a pale vermilion on her lips.

Together with these famous faces have been hung the likenesses of others, anonymous persons, young or mature, sensuous or pensive, rebellious or profound, whose features divert and engross our thoughts as we seek among them, or, at some sign, persuade ourselves we have identified, a character from Rousseau's *Confessions* or the heroine of one of Diderot's passionate stories.

## XI

It is not only by the truth of the modelling, the realism of the drawing, the material illusion of the physical qualities of the individual that these works by La Tour contrive to live; the painter and penetrating observer is equally accurate in his moral qualities. As a physiognomist of genius, he succeeds in portraying character in his representation of outward appearances. His faces speak, think, confess, yield up their secrets. To each La Tour has given that spirit and intelligence which is visible in the eyes, that *mens oculorum*, in which the personality

of a man wells up, reveals itself. As was justly observed at the time, you might take away Mondonville's violin, but you would still see in him the personification of musical enthusiasm; you might divest Manelli of his theatrical costume and remove his comic wig, but he would remain the archetype of the Italian comedian; and when we look at the portrait of M. de la Condamine, we see and feel his deafness. Diderot neglected this essential aspect of La Tour's talent when, on one occasion, he was reluctant to recognize him as anything more than a great technician, a mechanical genius. He himself said of his models: 'They suppose that my understanding is only skin deep, but I delve, without their knowing it, into the recesses of their personality and take possession of them in their entirety.'[66] It is in this that the portrait painter rises superior to the technician, in this effort, this ambition to become, by means of his art, a confessor for humanity. To penetrate beneath the surface of his subjects, by cultivating their company, by cultivating an astute familiarity with their ways, to take them out of themselves by conversation, to draw them towards him, to extract their quintessence and their secret, 'to take possession of them in their entirety', that is what he desired and needed to achieve in his portraits. He needed to embrace the total individuality of a person, to represent the whole man in body and mind, in his habitual pose, in his instinctive movements, involuntary gestures, and revealing attitudes, to characterize his social function by the insignia of his rank, profession or trade. Such was the high ideal, the noble aspiration that La Tour sought to realize and which exalts above that of a mere craftsman, however superbly gifted, his vision and eminence as an artist. We may listen to his own words on this subject: 'In nature and, consequently, in art, there is no creature who is completely idle. But all have suffered, in varying degrees, from a weariness resulting from their occupations. And, in varying degrees, all bear the imprint of this suffering. The first point is to grasp thoroughly the nature of this imprint so that whether the sitter be a king,

[66] *Tableau de Paris*, by Mercier, Vol. II.

a general, a minister, a magistrate, a priest, a philosopher, or a
street-porter, he may reveal as clearly as possible his rank and
condition in life. But since emphasis on any one part of the
work must affect, more or less, all the others, the second point
is to be certain of giving each part just that degree of emphasis
which it requires so that the king, magistrate or priest should
not be king, magistrate or priest in the head or the expression
only, but should display their rank from tip to toe. . . .'[67]

La Tour painted the women of his time with the same
penetrative vision as the men. In his portraits of them, he
expresses the thoughts and reflections which occupied the
minds of these 'readers of Newton'. He renders all the pro-
fundity, diversity and complexity of their physiognomy.
While preserving the powder and patches, all the manifesta-
tions of fashion, he was still able to present them as far above
the pretty creatures of convention, the repetition of whose
traits was abused by so many portrait painters of the time. He
stripped them of that resemblance to an animated doll which,
in the average portraiture of the day, made of them the type
of the empty, hollow, deceitful personage such as we might
conceive to flourish among the frivolous women of *Angola*.
The painter of Marie Leczinska and the Dauphine de Saxe
knew how to endow his feminine sitters with an attentive
amiability, a calm benevolence, the gravity that is still con-
sistent with grace, all the most delicate shades of meaning that
are written on the features of a woman in repose. I have before
me as I write the portrait of an unknown lady, wearing a
neckband of blue ribbon and a bodice in velvet, lace and
swan's-down; in her limpid eyes, with their slightly lowered
and almost quivering lids, there shines the most gentle intel-
lectual calm imaginable, and on her grave lips there hovers the
most meditative of smiles. Next to it, I have one of the *prépara-
tions*: Mademoiselle Dangeville; here the expression is quite
different: it is the mysterious, enigmatic look of a sensual
Gioconda, of a Gioconda worthy of the *Menus-Plaisirs du Roi*.
And this image of Mlle Sylvia, peeping out of the half-open

---

[67] *Le Salon de 1769*, by Diderot.

portfolio, might be expected to present the frivolous, piquant features that we might look for in an actress from the Italian Comedy. We are, on the contrary, tempted to believe that these subtle traits, this piercing eye, the delicate perspicacity of this expression compose the portrait of a diplomat disguised as a woman. And we might examine all the feminine smiles that La Tour has rendered for us and find none that was banal; each is personal, belongs exclusively to its wearer, indicates or emphasizes some aspect of her character, her disposition, her mind, her spirit, her heart. Consider, for instance, at Saint-Quentin, the difference between these two smiling portraits hung one beside the other: in one of them, representing Madame Massé,[68] we discern the fine, delicate, witty, voluptuous budding of middle age, of the age of forty, of that age that represents the rich maturity of the eighteenth-century woman, a smile suffused by some tender reminiscence, spreading over the whole face, prolonging itself in the dimples of the cheek, almost moistening the subdued gaiety in the eyes; in the other, we have a complete contrast with these lips, the lips of a doll-like girl, innocent, ingenuous, recognizing their ignorance of life with a smile expressing all the naïve effrontery of its wearer's seventeen years! Here, as in all his female portraits, La Tour proves himself the most exquisite draughtsman of the mouth, that most subtle medium of feminine expression.

## XII

The mind of no other painter of the eighteenth century was so dominated, so obsessed, so tormented as that of La Tour by a philosophic conception of art. In the effort of his genius, 'in that struggle with an ungrateful nature which obstructed his progress', he was the most thoughtful, the most self-questioning artist, the most assiduous in quest of the general laws, the high secrets of painting. In order to judge him, to understand him completely, we need the full record of his informal

---

*[68] Mme Massé was the wife of the engraver and enameller, Jean Baptiste Massé (1687–1757).

discussions with Diderot, who declared him 'good to listen to', and who has preserved for us the following sample of his critical thought on the subject of 'La Petite Fille au chien noir'[69] and the shirt-sleeve maltreated by Greuze.

'The origin of this defect of treatment', said La Tour, 'is also that of an infinity of more important faults. It arises from the fact that we exhort the young at too early an age to adorn nature, instead of urging them to render it with scrupulous accuracy. They devote their energy to this alleged adornment before they really know what it should be, with the result that when exact imitation is needed, such as we must make up our minds to achieve in these small details, they no longer know what they are about. . . .

'The teachers in our art schools', he continued, 'make two serious mistakes: the first is to talk too much about this principle to the students; the second is to recommend its application without any accompanying idea. The effect of this upon the students is that some slavishly subject themselves to the canons of Antiquity, to the ruler and to the compass, a subjection they are incapable of escaping, and remain for ever cold and false; while others abandon themselves to excessive imaginative licence, which delivers up their art to falsehood and mannerism, whence they are equally unable to liberate it.'

He concluded by confiding to Diderot 'that a mania for the adornment and exaggeration of nature declined with the acquisition of skill and experience, and there came a moment when nature appeared so beautiful, so unified and inter-connected, even in its defects, that a tendency arose to render it as it presented itself to the eye, a tendency which could only be diverted by the opposite habit and by the extreme difficulty of producing a pleasing effect by sheer truthfulness of presentation'.[70]

As a result of thus revolving in his mind, of pondering from every angle, the question of the ends and means of art, of searching for principles and theories, of aspiring to discover the quintessential rules of his profession, La Tour lost, little by little,

*[69] 'Little Girl with a Black Dog.'   [70] *Le Salon de 1769*, by Diderot.

the spontaneity of his talent. In the long run, his aesthetics paralysed his inspiration. And, as often happens in old age to painters of a too reflective and theoretic cast of mind, he lost in the end the ardour for work, and the fire went out of his productions.

'I have been watching La Tour paint,' said Diderot, 'his manner was quiet and cold; there was no self-torture, no pain, no breathlessness, none of the contortions of the enthusiastic modeller in whose facial expressions we may foresee, in succession, the works he is proposing to produce and which seem to emerge from his mind on to his forehead and pass thence from his forehead to the clay or the canvas. He did not mimic the gestures of rage; nor raise his eyebrows like a man in disdainful mood; nor assume the expression of a woman in a moment of tenderness; he was not ecstatic, nor did he smile upon his work; he remained frigid.'[71]

Diderot wrote this in 1767, that is to say at the very time that La Tour's genius began to wane. The painter he described was over sixty and living out the evening of his talent. The climax of La Tour's energy and potency occurred about 1742, the year in which he carried out the pastel of the Abbé Hubert. As a colourist he had already, for some time, been growing duller. He was being criticized for the brick-like hues which had not appeared in his work at the earlier exhibitions,[72] and for a technique of stumping which deadened the quality of his pastels. The portrait of Madame de Pompadour failed to live up to everything that had been expected of it. And, indeed, this important and popular work cannot remotely compete, in execution, with the artist's earlier productions; the face of the favourite is arid, flat, as if cut out; her complexion lacks life; the surface quality of the pastel is pasty, farinaceous, shaggy, and as if flayed and heightened with harsh, hard lights such as those on the gilding of the console-table. La Tour's favourite blend of colour, of whose harmony the backgrounds of his portraits, and even of his *préparations*, are nearly always composed, that bluish harmony which recurs repetitively in

[71] *Le Salon de 1767*, by Diderot.   [72] *Lettre sur la sculpture et l'architecture*, 1749.

this large picture, suffers here from an indefinable dimness, from a kind of false tonality, suggesting tissue paper. But we are not yet in the presence of La Tour's decline. We can observe, at the Louvre, the decadence of the great artist, if we pass successively from the fine portrait of the Queen, from that masterpiece, the Dauphine de Saxe, to the portrait of Chardin, heavy, laboured, brick-coloured, ploughed with white chalk, with the beard appearing to have been rubbed with soot, the high colour of the complexion lacking all suggestion of the real glow of flesh,, a typically provincial pastel justifying all the criticisms made by the enemies and rivals of the master. Even at Saint-Quentin, in the midst of his finest things, we may observe his degradation in the detestable portrait of the Père Emmanuel[73] in which he was so unworthily defeated in his efforts to compete with the quality of Chardin's pastels. It has not been sufficiently noticed that working in this chancy medium, struggling with its perilous ideal, La Tour's art is not exempt from an inequality that is frequently astonishing. The enthusiasm of the Abbé Le Blanc, however, had now ceased to be heard; and the critics gradually relapsed into the silence in which the last exhibited works were lost. Only a few more years were to pass before the *Dialogues de la peinture* spoke of his talent as dead. It was already frozen, numbed by theories, a talent almost incapable of producing anything new; a talent, moreover, to which the enfeebled physique of the painter was to prove fatal. The old man was overcome by a mania for revision; he wanted to retouch his works with the skill provided by his newly acquired knowledge, and he spoilt them.[74]

★[73] According to Du Plaquet's biographical notice, the Père Emmanuel, a Capucin monk from Saint-Quentin, may there have played the part of spiritual adviser to La Tour and have later made his acquaintance again in Paris.

[74] 'He does not know when to stop,' states Bachaumont. 'He continually endeavours to improve upon what he has done with the result that by overworking, tormenting, his picture, he frequently spoils it. He then takes a dislike to it, erases it and begins again; and the second attempt is often inferior to the first. He has, moreover, an obstinate prejudice in favour of a particular kind of varnish which, so he believes, he invented himself and which frequently ruins his work.' *Mémoires de Wille*, Vol. II, note by Bachaumont.

'What a loss!' was the exclamation which greeted him on all sides on the appearance of these remade, unmade portraits, on the appearance, notably, of his portrait of Restout, the work officially submitted on his reception into the Academy, which he had thoroughly revised, transforming the brilliant silk coat into a simple brown garment in conformity with the great and just principle that all the brilliance of accessories should be sacrificed for the sake of concentrating the interest in the head.[75] But his aging fingers were no longer the effective ministrants of his mind; his eyes could no longer perceive the lustre of the physical world. And in the midst of this vain pre-occupation, this supreme but pathetic labour, the last impulsion of his conscience, accompanied by the search for a varnish which might preserve his ephemeral medium, prevent its flight, his genius for pastel, 'half dispersed in the breeze and half settling on the wings of the aged Saturn', floundered, fluttered, and little by little expired in the bosom of the pastellist, at last diverted from his art by higher speculations. 'On my way back from the Salon,' wrote Diderot, 'I visited the eccentric La Tour, the man who is learning Latin at the age of fifty-five, and who neglects the art in which he excels, in order to fathom the profundities of metaphysics which, in the end, will upset the balance of his mind.'

## XIII

In spite of the pallor of his complexion, the delicacy of his health as a boy, of an existence prodigally expended on work and pleasure, La Tour reached a ripe old age, an old age free from physical infirmity. His last years he passed in the fresh, reposeful atmosphere of the verdant outskirts of the capital. When he was approaching his eightieth year, he left his lodgings at the Louvre to go and live in his small house at Auteuil, a patriarch's retreat where the Maréchal de Saxe came to visit him, and where the King never passed without inquiring how he was. After surviving his eightieth birthday, the

[75] *Le Salon de 1769*, by Diderot.

wish to die in the place of his birth prompted his return there, and on 21 June 1784, the artist, once more in his native town, greeted by salvos of gunfire, the ringing of bells and the acclamations of his fellow-citizens, received, on entering his house, a crown of oak leaves with which Saint-Quentin sought to express its gratitude for the charitable foundations of its benefactor and to honour the fame of its great painter.

He survived this ovation by four years, encompassed by the devoted care of a brother,[76] his thoughts and feelings sunk to a state of harmless infancy, his reason weak and wavering; a little insane, and the prey of a sort of delirious adoration for Humanity and Nature. This somewhat inflamed head which resembled Diderot's beneath the black taffeta cap which the artist wore for his portraits, this brain intoxicated by its readings—by science, mathematics, politics, theology, metaphysics, ethics, poetry, full to bursting with an accumulation of confused grandiose notions; this prolific, disordered imagination, possessed by the chaos of an encyclopaedia and the utopia of a revolution, achieved a pitch of exaltation, of frenzy during the old man's last days. His ideas were lost in a sublime, insensate cosmogony,[77] and a passionate pantheism imbued him with a kind of all-embracing worship of creation. On a fine, bright spring day in the country, he would drop upon his knees to thank God for the sun, speak to the trees and, thinking of the winter, would tell them, as he measured them with his arms, 'Soon you will do very well to warm the poor with'.

He died on 17 February 1788, kissing the hands of his servants in the last minutes of his agony.

## XIV

'A magician', that was the name with which Diderot baptized the pastellist. It is one that La Tour will always retain. His work is a magic mirror in which, as in the Comte de

---

[76] La Tour had two brothers: one, whom he outlived, became a financier, and the other was a soldier and famous as a duellist. It was Jean-François to whom the artist left his fortune and his pastels.

[77] Supplement to the *Dictionnaire des Arts*, by Watelet.

Saint-Germain's vase of resurrection, the dead return and come to life. We see again in this mirror the men and women who were the artist's contemporaries. From this gallery of portraits, the physiognomy of History itself arises. The artist ushers us into that 'Salon of likenesses' conjured up from a court, from a society by the great portraitists, portrayers of truth and sentiment, such as Holbein and Van Dyck. On the one hand, there are the princes, the noblemen, the *grandes dames*, the dazzling splendours of Versailles; and, on the other, the features of Philosophy, Science and Art, features in which the painter saw genius, and which his chalks, so recalcitrant in the betrayal of fools, rendered with love and enthusiasm. This is La Tour's achievement, this is what he has bequeathed to us. From the dust of the pastel, from this art which, so to speak, was blown from the face-powders of the period, he extracted the frail, delicate immortality, the miraculous illusion of survival which the humanity of the epoch deserved. His work is the great and charming portrait of that France born of the Regency and herself destined to bear the France of 1789. The Museum of La Tour's art is the Panthéon of the century of Louis XV, of its wit, its grace and its thoughts, of all its talents and all its glories.

# NOTES

THE facts of La Tour's first love affair, at the age of nineteen, are revealed in the legal records of the town of Laon. On 15 August 1723, Anne Bougier, spinster, aged 22 years, gave birth to a still-born child at the municipal hospital where she had been admitted for treatment as suffering from dropsy. On the evidence of the midwife who reported the event to the lieutenant of police, offering him at the same time on behalf of and at the expense of the sick woman, two chickens and a turkey, the woman, arraigned and convicted for having concealed her pregnancy until the day of her confinement, was cautioned, in the Council Chamber, not to repeat the offence and ordered to pay three *livres* to be used for the benefit of the poor in the General Hospital of the town of Laon.

In the course of the hearing, Anne Bougier declared that she was the daughter of Philippe Bougier, precentor at the metropolitan church of Sens, where in consequence of this office he resided, and of Anne de la Tour, her mother, with whom she had been living at Laon, her only profession being that of knitting stockings; that her family originally came from Laon; that her paternal grandfather, Nicolas Bougier, was precentor of St. John's Church, in the borough of Laon; and that her maternal grandfather, Jean de la Tour, was a master mason in the same town. She further stated that she had always been well behaved, that she had never had improper relationships with any man or boy except on three occasions while she was staying with her mother at Saint-Quentin, with Quentin de la Tour, a youth of nineteen years who was a painter by profession, resident at Saint-Quentin and her first cousin. She replied, on being questioned, that she became pregnant as a result of association with the said La Tour and that, on 15 August, she was delivered of a still-born child and that she supposed herself to have contracted dropsy, because, though menstruation had taken place in the ordinary course eight days after she had had intercourse with her cousin, it had not done so since. (Article by M. Charles Desmazes, in *L'Art*, 13 February 1876.)

<p style="text-align:center">★     ★     ★</p>

M. Desmazes established contact with a descendant of La Tour, Madame Sarazin Varluzel, and subsequently published, in *Le Reliquaire de M. Q. de la Tour*, a certain number of letters addressed to the artist. These letters confirmed La Tour's liaison with Mlle Fel, three

of whose letters are among those published by M. Desmazes. The first, which appears to have been addressed to the painter in connexion with a dinner given jointly by both of them, concludes with this postscript: 'I took some medicine this morning to cure me of my procrastinations, and I feel better.' The second, dated 5 January 1783, and addressed to La Tour's brother, thanks the Chevalier for confirming her right, during her lifetime, to the use of the painter's furniture. As the following extract indicates, possession of the furniture seems to have included possession of the pastels: 'M. Dorizon must have informed you that in accordance with M. Paquier's warning about the risks of damage by smoke to M. de la Tour's pastels it is urgent that you should make arrangements to repair the walls.' The third, dated 5 January 1788, gives distressing details about the artist's insanity: 'I am delighted to hear that your poor brother continues to be in good health; it is not surprising that at his age he should no longer be as strong as he was; time imposes a proportion on everything; we are bound to reckon with that. I believe, however, that it might do some use if he could be persuaded that *la lelerte* thinks it very bad that he should drink his urine and that he should stay in bed for two days without eating anything.'

M. Desmazes is the owner of a further letter from Mademoiselle Fel, her reply to a request for information from the historian d'Argenville; it is, however, without biographical interest.

Other correspondence includes notes from the Bishop of Verdun, concerning a change of sitting requested by the Cardinal de Tencin, from the Comte d'Egmont, arranging to meet the painter at the Opéra-Comique to take him to a supper at Passy, probably at the house of Madame de la Popelinière, from the Duc d'Aumont,[78] from the Abbé Pommyer,[79] from the oculist Demours, from Voltaire and from Madame Thelusen,[80] thanking La Tour for her portrait by writing: 'My husband leaves tomorrow, and it would be kindness on your part, Monsieur, if you would do me the pleasure of dining with me.'

<p style="text-align:center">★    ★    ★</p>

★[78] The Duc d'Aumont, collector and patron of the arts (1709–82).

★[79] The Abbé François Emmanuel Pommyer, or Pommier, was a member of the Chapter of Rheims. He became its Doyen in 1748. He was also Councillor of the Paris Parliament.

★[80] Madame Thelusen, or Thélusson, was the wife of the banker of that name, of whose firm, Thélusson-Necker, the Queen was a client.

The following extract from a letter by Ducis, appearing in the *Catalogue d'autographes* on 18 May 1859, bears witness to the passionate importance which his contemporaries attached to being painted by the great pastellist.

'I am in a state of gloomy vegetation. I am unable even to conceive how my spirits might be revived. I need pleasure of some kind to rouse them from their present coma; and it is to your portrait whose arrival I await with eagerness and impatience that I shall be obliged for providing it. . . .'

\*       \*       \*

Fragments from letters published by M. Courajod in his notes to the *Livre-Journal* of Lazare Duvaux afford evidence of La Tour's impossible character and all the nuisances in which the commission of a pastel from the artist might involve the sitter.

On 26 February 1752, M. de Marigny commissioned a pastel of his sister, the large pastel of Mme de Pompadour which was exhibited at the Salon in 1755. On 24 July 1752, he was obliged to write to the artist on behalf of Madame de Pompadour, to find out '*definitely* whether he wished to continue the portrait'. He complained with a sort of affectionate irony of an incomprehensible postscript in a letter from the artist accusing him of being the author, 'the innocent cause', of the various accidents that had occurred in connexion with the two portraits of his sister. He concluded with these words: 'Be so good, Monsieur, as to write and tell me what your grievances may be and what you would have me do that they may be remedied; I must ask you to put your trust in the high esteem in which I hold your talents and to believe that it will give me pleasure to prove it to you by doing justice in this matter. Can my sister rely on your painting her portrait? She is impatient to see the work completed. I would beg you to honour the sentiments you have professed by coming as soon as possible to finish this portrait and thus satisfy my sister who merits your gratitude and her brother who deserves more friendly feelings from you.'

\*       \*       \*

An extract from a letter written by the Abbé Le Blanc to La Tour, dated 12 May 1766, and published in the *Catalogue d'autographes* of 31 January 1854, indicates that the artist made a journey to Holland in May of that year. 'He knows that he is leaving tomorrow for Holland and asks him to inform the court of the Stadhouder that there is in Paris, at M. Fortier's, a fine picture by the celebrated Vandeck (sic), a

portrait of the Prince, his Highness's great-grandfather. . . . M. de la Tour's renown and the general esteem in which he is held all over Europe will certainly give weight to everything he says.'

<p align="center">★     ★     ★</p>

La Tour was full of solicitude for the materials and implements of his art. We find in the *Catalogue d'autographes* of 25 March 1852 a certificate signed by him as *Conseiller de l'Académie de peinture et de sculpture*, stating that he considers the Sieur Nadaud's pencils worthy of the approval of MM. Renon and Descamps. This document is dated 5 July 1781.

<p align="center">★     ★     ★</p>

We may quote here a letter from La Tour, addressed to Mademoiselle Zuylen, later Madame Charrière. It was published by M. Piot (*Cabinet de l'amateur et de l'antiquaire*, 1861–2). In it, La Tour speaks of the labour of his retouchings and betrays the confusion of his mental processes:

Mademoiselle,

Overwhelmed by contradictory and conflicting projects, by a multiplicity of worries, I often hardly know what is to become of me. Whatever the relaxations I allow myself, my troubles continue to afflict me and I pass my days in doing none of things which I ought and would like to do; when I am in a purposeful mood, the importunacy of intruders regularly compels me to postpone the execution of my intentions till the morrow, followed by other morrows. I am taking advantage of a free moment to cast myself at your feet and beg the forgiveness which, as I believe, the earnestness of my regrets certainly deserves.

When it was eventually known that I was in the country, I was sent the charming portfolio from Aix-la-Chapelle accompanied by a note that was, in every way, worthy of you and which I value as I do your person. With my heart and mind in thrall to your charms, I was unable to resist the pleasure of telling you how touched I am, and how much I regret having missed the opportunity of receiving the visit of M. le baron de Thuyl; by the time I had hurried back he was no longer in Paris. I have never been in the country at such an inopportune moment. I wish that a desire to witness the birthday celebrations of Mgr le Dauphin might give me the pleasure of proving to you how strong a gratitude and affection I feel, and always will feel, towards everything that bears the name of Zuylen or Thuyl.

I would ask you to give my respects and my best wishes to your father, M. le baron, to your brothers, to your dear uncle and aunt, to Mesdemoiselles de Mars, milord and milady and all who belong to you.

I have the honour to remain, Mademoiselle, with my affection and respect, your humble and obedient servant

De la Tour.

The Louvre, March 5, 1770.

I must add a word to this letter which is still as unworthy of you, in my opinion, as many others which have been thrown into the fire. You will see how well I carry out my duties once I have really started to do so; this condition of mind, however, does me much harm and leaves me in a state of exhaustion and confusion from which I may never, perhaps, escape.

Dominated by the idea of perfection in everything, and, consequently, by that of the perfection of human happiness, I lose consciousness of myself like an atom in the empyrean. I ought to be weary, by now, of this passion for perfection, since it has made me spoil so many of my works. It is not out of vanity that I regret these failures, but it is a passion which crushes any feeling of gratitude for exceptional talents bestowed by nature. Poets and musicians can revert to the best of their first thoughts, when their corrections extinguish that inspirational fire which produces sublime effects. But, in my pastels, all is lost when I yield to a mood different from that of the original inspiration: the unity is broken. The painter in oils, by the use of alcohol and the bread rubber, may recover the first freshness of his conception.

Since I think that pictures should be characterized by a touch, a technique, a style which should differentiate them from one another as strongly as their subjects differ in nature, I also wish that our poets might have varied their style in accordance with the characters of the personages of whom they write: strong, vivid lines for the warrior; lines of a ceremonious nobility for the hero; terrible accents for the villain; and soft, flowing, smooth or tender measures according to the personality of the female characters; varied rhythms and rhymes, which might be repeated at times for the secondary characters. But such concerns are day-dreams; neither pictures nor poems are made as I should like. This perfection is beyond human achievement; at this very moment, I am experiencing the truth of this assertion; I have on my easel the portrait of the late M. Restout, painted and presented to

the Academy in 1744; since his death, I have wanted, by revising and improving this work, to bear witness to my gratitude to him for having taught me the fundamental principles of painting. Having made at least a hundred alterations, people said to me: 'What a pity!' There was some unfortunate change in the picture which was felt by all who saw it. I am still working on this portrait and continue to make corrections. I cannot say when it will be finished; some of my patrons are waiting for works completed previously and which I had taken back for retouching and revision. There is little likelihood that I shall be able to do what you want with the portrait of Madame d'Athlone. I am so sorry that you have not been amusing yourself as successfully as when I had the pleasure of staying at Zuylen; I would have advised you not to overwork the colours when they are right, to use your little finger as lightly as possible, not to employ too much colour and to keep the paper untouched wherever you wish to apply a heavy layer of chalk; the work will, in this way, be much more lightly done.

As for the mould resulting from the salt content of black chalk and of nearly all pastels, it is important to prevent it from coalescing, thickening; by simply rubbing it on the paper, a stain can be avoided; you then remove it with the point of a knife; but you should first hold a hot iron just above it, to dry up the humidity in the salt and facilitate removal with the knife. This is the process I have been employing recently; I have also been treating blue paper with a light wash, applied with a brush, of yellow ochre diluted with water and yolk of egg; this obviates the heavy effect which the quantity of colour necessary to cover the blue of the paper makes it otherwise difficult to avoid.

Post-scriptum.—Continuing to flatter myself that I might be in a position to tell you that my distresses were coming to an end, I postponed completion of this mumbling letter; the Academy's disappointment now compels me to restore, as far as I can, the original appearance of the portrait of M. Restout. What a quantity of time and effort wasted! Attempts to make better what is already good are fatal. We cannot correct ourselves; I have failed a hundred times in the endeavour. Let that be a lesson to you, Mademoiselle, who pursue this same occupation. If you are not ambitious to do too well, I shall consider you very fortunate to have acquired the means of cultivating such an agreeable recreation without any of the misery I have suffered from it. Someone has come to fetch me; I do not

know when I shall be able to continue this letter. I had a thousand compliments, well-merited compliments, to make to you and much to say about the kindness of your family; but fear lest my garrulity should make you impatient compels me to finish this letter by assuring you, Mademoiselle, of all the affection of this most humble and obedient of all your servants

<div align="right">De la Tour.</div>

The Louvre, April 14, 1770.
To Mademoiselle de Zuylen, at Utrecht.

# GREUZE

T HAT great record of corruption, *Les Liaisons Dangereuses*, contains one unexpected page, a page that contrasts with all that precedes and follows it. It is the scene in which Valmont sets out to save from seizure by the tax collector the furniture of a poor village family unable to pay the poll-tax. The collector counts his fifty-six *livres*. Rescued from destitution, the entire family, numbering five people, weep for joy and gratitude; tears flow, joyous tears which illuminate with happiness the face of its oldest member. The villagers throng round the group, murmuring their benedictions; and one of them, a young peasant, leading by the hand his wife and two children, overwhelms Valmont with their grateful adoration, making them kneel at his feet as if he were a personification of human Providence or the image of God.

This unlooked-for passage in Laclos's book is like the appearance of Greuze in the eighteenth century.

Greuze was born at Tournus on 21 August 1725. According to the biographers, his family, which originated in the district of Chalons-sur-Saône, was of the respectable middle class, and cherished a proud memory of one of its ancestors who had been *Procureur du Roi* of the *Prévôté Royale* and *Seigneur* of La Guiche. The painter's birth certificate casts some doubt on this claim, stating, as it does, that Jean Greuze was the son of a master tiler. From the age of eight, Greuze drew as he played, finding, indeed, in this exercise, his only amusement. His vocation already importuned and was beginning to dominate him. But the tiler had settled his son's future. He had decided to make him an architect. For this reason the practice of drawing was forbidden him, and the child was obliged to hide himself and go without sleep at night in order to escape his

father and to pursue his chosen recreation. A drawing in pen
and ink, a copy of a head of St. James, which his father mistook
for a print, finally secured him permission to adopt the career
of his choice. The tiler decided to send his son to Lyon to study
under Grandon, who was Grétry's father-in-law. Grandon's
studio was a veritable picture factory; Greuze learnt nothing
except the trick of producing a picture a day; and, having
mastered this exercise and becoming aware at once of its
restrictive effect and of his own developing powers, he went
to Paris,[1] impatient to exhibit his gifts on a larger stage, armed
with his dreams and ambitions, his already personal but still
immature talent and his picture, 'Père de famille expliquant
la Bible'.[2]

In Paris, Greuze vanished. There is no record of his having
been employed in any studio. He continued his work in
silence, obscurity and solitude. Unnoticed and unknown, he
painted small pictures for a living, contriving to develop his
talent without a teacher, forming himself alone. The public
were ignorant of his existence, and the picture with which he
arrived to seek his fortune found no purchaser. Pigalle, the
sculptor, was the only man to perceive his talent, to comfort
his discouragement, to promise him a successful future. Apart
from this support, he met with nothing but ill-will, hostility
and jealousy. At the Academy, where he went to draw, he
was relegated to the worst seat, without any regard for his
ability. In the end his pride, easily affronted, revolted against
such humiliations.[3] He took the step of calling upon Silvestre
and showing him his work. This former drawing master of

[1] *Greuze ou l'Accordée de village*, Paris, 1813. Text by Mme de Valori.

*[2] 'A Father Explaining the Bible to his Children.'

[3] Evidence exists of the arrogance with which Greuze submitted to the
lessons of the Academy professors. There is a male life study in a portfolio of
French eighteenth-century drawings, from the collection of the Bishop of
Callinique, now preserved in the Bibliothèque de l'Arsenal. A note at the base
of the drawing records that Natoire, then an Academy professor, having
praised the study, observed that it was distorted; to which Greuze replied:
'Monsieur, you would be a very fortunate man, if you were capable of any-
thing as good.' *Archives de l'Art français*, Vol. VI.

the children of the royal family was charmed and astonished.
Greuze obtained permission to paint his portrait, a work which
he executed under the very eyes of his rivals and to the great
satisfaction of Silvestre who took charge of his talent and
secured his official recommendation as a candidate for the
Academy on 28 June 1755.

But by that time Greuze had already emerged from the
obscurity in which his art had mysteriously developed. A
collector with a flair, with both taste and feeling, an intelligent
connoisseur both passionate and sincere, a man who, with
more perceptiveness than any other, could discern the fine
flower of an artist's production, could detect the budding
freshness of talent, the radiations of genius in an attic, M. de la
Live de Jully, had purchased the 'Père de famille' and arranged,
in his house, a kind of public exhibition of the picture to which
the world of artists and connoisseurs had been convened. The
picture had caused a sensation. The fine figure of the old man,
robust, healthy, serene, patriarchal and bucolic, recalling Rétif
de la Bretonne's aged rustics and suggesting a frontispiece for
the *Vie de mon père*; the two charming little boys, their fair
heads aglow with youth and sunlight that contrasted with
his white locks; the elder boy in a coat too short for him,
his curls carefully parted beneath his three-cornered hat,
standing in front of the old man; the head of the little child
visible behind the group of women, motionless and full of
wonder, his chin resting on the table; the quiet, attentive,
grave, trustful mother; the daughter, ingenuous and curious,
listening with all her eyes, her body relaxed, her arms falling
loosely at her sides; and the white village dresses whose
peculiar beauty was revealed by Greuze and was to imbue his
work with a kind of virginal voluptuousness; and the anima-
tion of the whole composition, the charm of the detail, the
intermittent obtrusion of the agitations of childhood in this
scene of tranquil leisure, of pious recreation; all this, down to
the mischievous infant on the floor near the grandmother at
her spinning wheel, who is amusing himself by teasing the
dog, all this had been admired and appreciated by the exclusive

throng which had flocked to M. de la Live's. And when the
picture was exhibited at the Salon of 1755, the public, already
curious about the man and his work, already predisposed in
his favour, greeted the picture with a kind of ovation.

Greuze, though intoxicated by his success, felt that his edu-
cation as an artist still required the crowning lesson of a visit
to Italy. He set off towards the end of 1755. Madame de Valori
asserts that he travelled at his own expense; but she was prob-
ably mistaken. Greuze was taken, and doubtless paid for, by
the Abbé Gougenot who was admitted as an honorary asso-
ciate by the Academy on 10 January 1766, while he was still
living in Italy, as a token of thanks for having 'taken M.
Greuze to Italy whose talents, so widely recognized today,
were then only developing and had only just won for him the
title of approved candidate'.[4] Until Prud'hon, Italy and its
museums, Italian and classical art, had only the most super-
ficial influence on our artists: their period, their tastes, France
and the eighteenth century resisted, through their agency, the
example of the past; they merely read the lessons which Rome
offered, absorbing nothing of their substance.

What did Greuze acquire from this journey to Italy, which
had no more influence upon his talent than on that of Boucher?
Simply a memory which was to remain vividly present to
him, throughout a life crowded with sentimental adventures,
the memory of a love story to which Greuze, in old age, some-
times involuntarily referred when women denied too em-
phatically in his presence the disinterestedness of men in the
affairs of the heart. The incident is charming, and the testimony
of Madame de Valori is sufficient authority for its repetition.
Occurring during the period of Casanova, it may seem to be
the last breath of those old legends to which Shakespeare
applied his genius. It may seem to exhale the last perfumed
sigh from the country of Armida, from that Italian garden in
which our youthful artists, for more than a century, had loved
so much and so often. And what a perfectly linked chain exists,
starting from those to whom Italy gave pleasure, happiness, a

[4] Obituary notice of the Abbé Gougenot.

mistress or a wife, and continuing onwards to those whom she dazed with passion, who expired in her embrace, kissed by a too ambitious dream!

Greuze had been given letters of introduction to the Duca del Orr . . . , by whom he had been hospitably received. The Duke, a widower, had a charming daughter who was fond of painting and of whom Greuze shortly became the drawing master. After a few lessons, Greuze, already in love, sensed that Laetitia, as his pupil was called, returned his affection. But, frightened by the disparity between them of birth and fortune, he fled from temptation and returned no more to the palace. Plunged in sorrow, pursued by the epigrams of his fellow-students at Rome, by the mockeries of Fragonard who persisted in referring to him as the 'amorous cherub'—his fair, curly hair invited the comparison—Greuze learnt that the young princess was ill and that no one could discover the cause of her sickness. He began to haunt the precincts of the palace, asking for news, seeking to find out how she was, ready to confess everything to her. One day, at the height of his anguish and distress, as he was drawing in St. Peter's, he met the Duke who took him back to the palace to show him two portraits by Titian which he had recently purchased. 'My daughter', said the Duke, 'is looking forward to copying them when she is well. I hope that you will come and watch her at work. It is her wish that you should do so.' And when the Duke also asked Greuze for a copy so that he could send it at once to a relation, the young artist found himself unable to refuse. He returned to the palace and worked there all day. Each morning, he inquired after Laetitia's health from the nurse, the eternal nurse of the *Novellieri*, who had already guessed Laetitia's secret, and sensed the secret of Greuze, and who hurried off to the sick maiden with assurances of the artist's passion who, according to her, refrained from an avowal only out of respect and from a fear of causing displeasure. She next went to fetch Greuze and introduced him secretly into the bedroom of the princess, thin and wan, but 'still reflecting the beautiful features of Cleopatra'. After a

few moments of silence, the princess, urged by her nurse, confessed to Greuze that she loved him. 'Yes, Monsieur Greuze,' she continued after an instant, 'I love you. Answer me honestly, do you love me too?' And since Greuze remained dumb with joy and ravishment, the princess mistook the cause of his silence, buried her head in her hands and burst into tears. Greuze thereupon threw himself at her feet, answering her with kisses, his heart overflowing. 'Then I can be happy,' exclaimed Laetitia. She clapped her pretty hands. Her joy was that of a child. She ran hither and thither, embraced her love, told and retold her happiness as we might repeat to ourselves in the morning a thought that has made us wake up laughing: 'Listen to me, both of you, here is my plan: I love Greuze and I shall marry him.' 'What are you thinking about, my dear child,' cried the nurse, 'And your father? . . .' 'Nurse, you were going to tell me that my father won't consent; I know that he won't consent, he wants me to marry his eternal Casa—the oldest and the ugliest of men—or the young Count Pallieri whom I neither know nor wish to know. My mother's wealth has made me rich, I can dispose of it as I like, I shall give it to Greuze whom I am to marry; he will carry me off to France, and you shall follow us.' And, intoxicated by her vision of the future, she began to plot and plan, with a delicious volubility, the life they would lead together in Paris: Greuze would continue to work, he would become another Titian, her favourite painter; and her father, in the end, would be proud to have him as a son-in-law. 'Don't you agree?' she said innocently to Greuze. And she began her daydream again, in a still wilder and more elated form. By the time Greuze saw her again, he had given the matter much serious consideration. The princess twitted him on his air of gravity and reserve, fought his objections with frivolity and affection, then lost her temper, accused him of treachery, reproached him for having pretended to love her the better to break her heart, and wept and tore her hair. In the end, Greuze fell at her feet and swore to obey her blindly. But when the interview was over, his presence of mind, together with a clear view of the situation,

returned. He foresaw the father's despair, his curse, his ven-
geance, and all the misery that would afflict their love; deter-
mined to yield no móre, never to see Laetitia again, never again
to allow his resolutions to be melted away by the breath of
words, he feigned an illness which very soon became a real one
and kept him for three months in bed with a delirious fever.[5]

When Greuze recovered, the princess was on the point of
marriage with another, but at a word from the painter, a word
for which she begged him, she would have broken it off.
Greuze had the courage not to utter it; but, overcome by a
terrible jealousy of the princess's fiancé, who was young,
handsome and formed to attract women, the painter fled, after
a last goodbye, taking with him secretly a copy of the portrait
of Laetitia which he had painted for her father, a copy precious
to the lover, which, later, was to be the inspiration of his
charming picture 'L'Embarras d'une couronne',[5a] which pre-
sents us with the very image of Innocence confessing herself
to Love, and suggests a bas-relief by Dorat. And surely he
still had the vision of this woman before his eyes, in the depths
of his heart and in his thoughts when he painted for his
'Prière à l'amour',[5b] the lovely brunette, her hair loosened, a
look of supplication in her black eyes, her hands clasped, her
body seeming to soar in the fervour and anguish of her invo-
cation. At the base of the engraving, after this picture, there is
a dedication to the Princess Pignatelli; we pause instinctively at
this name of an Italian princess inscribed there as a consecration,
perhaps, even as a key to the deceptive initials used by Mme
de Valori in her account of the incident as a veil, doubtless, for
the identity of the painter's beloved and loving lady.

### III

In 1757, Greuze exhibited a series of Italian subjects, Italian
only in the costumes, in the accessories, in the *fiascone* of
Orvieto wine. Greuze, it should be emphasized, remained a
Frenchman in Italy; he escaped the influence of the atmosphere

---

[5] *L'Accordée de village.* Text by Mme de Valori.

★[5a] 'The Encumbrance of a Crown.'   ★[5b] 'Invocation to Love.'

and the lessons of Rome, the contagion of the city's beauty and the greatness of Italian art. He remained the disciple of the Parisian master whose subjects, and even their titles, he was to repeat in his pretty imitations of 'Le Bénédicité'[6] and 'L'Écureuse'.[7] But, together with the mediocre works which he sent to the exhibition, flashy but producing no effect, works that might be described as offering us an example of Boucher's love of display in a composition by a pupil of Chardin, Greuze also contributed two portrait heads, one of a little boy and one of a little girl, which were the smiling inauguration of his charming gallery of children's portraits and the initial revelation of the gracefulness of his art. And today, the charm of Greuze, his vocation, his originality, his strength, are still only fully apparent in his children's heads. They alone compensate for all the weaknesses, all the falseness and poverty of colour so evident in his larger works, the slabbering whites, the general 'gamme', dull and grey, the faint iridescence, the diluted purples, equivocal reds, murky blues, the flabby, muddled backgrounds, the solidity of the shadows. We might say that no sooner had these pictures, once so much admired, ceased to be the fashion than the light went out of them; they recall the appearance of a painting on porcelain which has darkened. But when we turn to look at one of those little blond heads, vivified by a sunbeam, caressed and curled by the sun, we sense at once that the inspired hand of a genuine artist has touched these cheeks flicked by the brush with a salubrious pink, has arched and smoothed this little forehead on which the daylight sits, has set the lightning and the sky in these blue eyes, has flung a caressing shadow beneath this suggestion of an eyebrow, and has fashioned the cupid's bow of the mouth, compressed by the two cheeks, into a cherubic pout. Nothing could be fresher, nothing more vividly or more lightly brushed in; the tone is soft and as if drenched in oil, the skin flowers at the faintest touch of impasto; the budding features, their forms just discernible, seem to tremble, beneath the thin film of colour which plays over them, like objects in a dawn light.

★[6] 'Saying Grace.'    ★[7] 'The Kitchen-maid.'

An amplitude of life breathes in these small, chubby faces which we may feel we have already seen, more solidly alive, in the family portraits of Van Dyck.[8]

Greuze, as a painter of children, must be considered a master in his portraits of young girls. He excelled in the representation of that type of female beauty which emerges to linger, vaguely floating, in the features of a little girl. There are subtleties, adorable endearments of tone in his painting of the hair, of those fugitive locks, inadequately bound by a ribbon, which disperse into the air like grains of dust, and in his painting of that golden irradiation which crowns the forehead, of that tracery of little blue veins that embroiders the temples. He knew how to express the depth, the veiled flame in a girl's eye; how to render the liquid quality of a glance, to soften its expression, to moisten its glow, how to convey the quivering of emotion or passion in the gentleness of a tear restrained by the eyelashes. He put youth into everything: the nostrils tremble, the full lips are parted by a breath, the mouth strains forward in a vague aspiring movement. Glazes heightened by ridges and ribbings of dry impasto, streaks of light superimposed upon transparent half-tones and bursting vividly upon the insubstantiality beneath, suffice to produce upon the canvas all these charming faces, these rose complexions, this white, warm, downy skin, full of life from the blood flowing in its veins and

[8] It may not be without interest to quote here from a note addressed to Ducreux by Greuze, and which contains, so to speak, the catechism of his artistic practice:

'Put as much finish into work as you can. Finish and refinish it thirty times, if necessary. Load your backgrounds, and try to get the main effect at the first attempt; but never be afraid to work it up afterwards, provided you do so with glazes; do not use an impasto for lace or gauzes; be *piquant*, if you cannot manage to be truthful. Never, as far as may be in your power, make your heads smaller or larger than nature. Enrich your memory by sketching—particularly landscape which will help you to compose harmoniously. Never undertake anything of which you are essentially incapable, and paint with expedition but without haste. Try, if you can, to establish your shadows soundly and, above all, grade them carefully in the larger masses and do not, then, apply your colour until you have thoroughly observed the gradations. In this way you can always be sure of achieving solidity.

'Make sketches, drawings especially, before you begin to paint.' (Manuscript note by Greuze, contributed by M. A. Wyatt-Thibeaudeau.)

bathed in sunlight, these slender necks, these arched shoulders caressing the eye like a pair of doves, these newly formed breasts veiled by the changeful reflected lights of a gauze *fichu*; these are the felicities of a colourist, passages of painting instinctively executed, the expression of a momentary intuition, which sometimes recalls Rubens, the great master whose genius Greuze consulted, mounted on a ladder, with his friend Wille, at the Luxembourg, and the secrets of whose painting he sought to unravel. And surely we are right to quote repeatedly the name of Rubens as the source of all French talent at this period. Watteau, Boucher, Chardin, they are all descendants of this patriarch, this great initiator. For a hundred years, it seemed as if the Luxembourg gallery, where his scenes from the life of Marie de Medicis were displayed, served as the sole cradle, school and ancestral home of French painting; here, so to speak, was the very seat of the Muse.

Within the lifetime of Greuze, these portrait heads became the delight of connoisseurs and a temptation to the most fastidious collectors. We know with what feverish joy the engraver Wille acquired them, with what pride he recorded the purchase in his diary, and how firmly he protected them against the covetousness of the Comte de Vence. He would expatiate ecstatically on their beauties and held them more precious than the finest paintings of the period. The artist, in spite of his rising reputation, was far from wealthy; and, amid the embarrassments of his early years as a painter, his friends' enthusiastic admiration for the portraits of young girls which he produced with such a facile brush, proved providential. Wille helped him, pushed him, advertised him, made him known, and established a connexion for him in Germany, the great market, the great outlet for French art; he sent him foreigners who wished to be painted, and did him a thousand services for which Greuze was later to reward him with a portrait. One day, Wille, invited by Madame Greuze to take chocolate with her, was asked by her husband to come and sit near the easel; and Greuze, fired by gratitude and impelled by a certain emotional warmth, idealized the harsh features, the

pimpled cheeks, the small, ardent, frightened eyes of the Saxon in the admirable portrait whose strong, lively handling effaced all the unpleasant traits in the model's appearance.[9]

The pictures exhibited by Greuze at the Salon of 1759 were successful with the public. Two years later, in 1761, a picture on which he was still working during the exhibition, and which was only exhibited for the last six days, 'L'Accordée de village',[10] won universal admiration. There were acclamations, there was a riot of enthusiasm, a prodigious success which was the talk of every drawing-room and even penetrated the theatres: in the *Noces d'Arlequin*, produced in the same year, the Théâtre Italien paid the painter the unprecedented tribute of representing his picture on the stage.[11] The public closed their eyes to its discordant colour, its ill-matched tones, the disagreeable quality of the gradations, the tinsel of the lights, the blemishes and inadequacies in the execution of the master-piece; they were fascinated, enchanted and moved by the scene, the idea, the emotion which animated the canvas. They saw simply the amiability of the old father, the telling gesture of the mother clinging in a last embrace to her daughter's arm, the sorrow of the younger sister hiding her tears, the ingenuous curiosity of the child standing on tip-toe, the charming group of the engaged couple, the bashfulness of the young girl's happiness, the sentimental conflict, revealed in her expression, between the regrets of a child's heart and the thoughts of the prospective bride. They applauded the delicate discretion of the details, that nice sense of the trifling to which the artist had here and there yielded, the ingeniousness of all his allusions, the indulgent gesture of the arm of the young woman allowing the tips of her fingers to glance on to the hand of her betrothed, the allegory, in the foreground, show-ing a hen with her chickens, and, perched on the edge of an earthenware pan, a young chicken, with neck outstretched

[9] *Mémories et Journal de Jean-Georges Wille*, published by G. Duplessis. Renouard, 1857.

*[10] 'The Village Betrothal.'

[11] *Histoire du Théâtre Italien*, by Desboulmiers, Vol. VII.

and beak in the air, testing its wings. The triumph continued for ten days; and the picture was still the event, the topic of Paris in the world of artists, connoisseurs and critics when it left the Louvre to enter the private collection of Monsieur de Marigny.[12]

## IV

The success of this picture confirmed Greuze in the tendency he had adopted, in his chosen themes, in the representation of the manners and morals of the middle class and of the people, themes which appealed to the curiosity and interest of fashionable and cultivated society, tired of mythological gallantries, of suggestive nudes and erotic cabinet pictures. The painter set out in search of material and inspiration, ideas and models in the Paris whence Mercier[13] had gleaned his observations,[14] seeking, like that painter of written pictures, the subjects of his notes and sketches, in the streets, in the suburbs, in the markets, on the quays, in the midst of the people, of the crowd. He walked, wrote, sought to grasp human passions in action, in the raw, in the heat of their uprising. In the evening, he observed the restless night-life of the capital, visiting out-of-the-way theatres, taverns, fairs, the cafés of these sleepless streets. He walked the streets, encountering from time to time a face or a gesture, which might perhaps be suddenly illumined by a word, a word that might provide him with an idea for a picture.[15] Here is his account published in the *Journal de Paris*

[12] 'L'Accordée de village', acquired on behalf of the King at the sale of M. de Menars for 16,650 *livres*, is now in the Louvre.

★[13] The writer, Louis Sebastien Mercier (1740–1814), is chiefly remembered for two compendious works, *Le Tableau de Paris* (1781–90) and *Nouveau Paris* (1799–1800), in which he described the manners and customs of the time. He remained a Republican under the Empire, and later became a Professor of History at the École Centrale and a member of the French Institute.

[14] As an old man, Mercier, sitting on a *banquette* at the Restaurant Labbaye told Delort: 'Greuze and I are two great painters—at least Greuze acknowledged me as such. . . . He had a great affection for me and wanted to hand over to me his lodgings in the Louvre, Rue des Orties, where there was no sun to disturb my writing.' *Mes voyages aux environs de Paris*, by Delort, Paris, 1821, Vol. II.

[15] *Nouvelles des Arts*, by Landon, the year XIII, Vol. IV, and *L'Espion Anglais*, Vol. X.

of how he caught in the act, so to speak, the subject of his 'La Belle-Mère'[16] while crossing the Pont-Neuf:

'Allow me, gentlemen, to take advantage of the medium of your newspaper to give a historical note on my print to be published on the 28th of this month, and which I have had engraved by Monsieur Le Vasseur. It is entitled "La Belle-Mère". I have long wished to delineate the character of a step-mother. But in all my oil sketches, her expression seemed to me to be unsatisfactory. One day, as I was crossing the Pont-Neuf, I noticed two women engaged in vehement conversation; one of them wept, crying out: "What a step-mother! Oh yes, it's true that she provides her with her daily bread, but she breaks her teeth on it." For me, this was a sudden illumination. I returned home and drew out the plan of my picture which contains five persons: the step-mother, the daughter of the deceased wife, the orphan's grandmother, the daughter of the step-mother and a little boy aged three. I have imagined that it is dinner-time and that the unfortunate orphan is about to take her place at table like the others; at that moment, the step-mother takes a piece of bread from the table and, holding down the girl by her apron, flings the bread in her face. I have tried to picture in this moment that type of deliberate hate that usually develops from an inborn hate. The young girl tries to evade her and seems to say to her: "Why do you strike me? I do you no harm." Her expression is one of fear and modesty. Her grandmother is at the other end of the table: pierced by grief, she raises her eyes and her trembling hands to heaven as if to say: "Ah, my daughter, where are you? What misery and bitterness!" The daughter of the step-mother, not greatly affected by her sister's lot, laughs at the sight of this respectable woman's despair and, by her mockery, calls her mother's attention to it. The little boy, whose heart is not yet corrupted, stretches grateful arms towards his sister who takes care of him. To sum up, it was my intention to represent a woman maltreating a child who does not belong to her and who, in a double crime, has corrupted the heart of her own daughter.'

★[16] 'The Step-mother.'

Greuze liked to describe and explain his compositions in the *Journal de Paris*. And, on the subject of the print 'La Veuve et son curé'[17] engraved after his picture, he gave another long explanation of the subject he had treated, of his motives, and of his search for psychological truth in the faces; this explanation he addressed to the parish priests of France.

### Letter to Messieurs Les Curés

Messieurs,

A print is about to be published entitled 'La Veuve et son curé'; the subject is a sequel to the various types of human character which I have already treated. It represents a parish priest who has come to help a widow and her children with advice and to give them lessons in virtue.

The scene is laid in the country; in a simply furnished drawing-room, the mother, still young and attractive and wearing a morning *négligé*, is represented surrounded by her children; the priest has just come in; he has been offered the best chair in which he is seen seated, a large dog at his side; he is in the act of addressing, with an air of dignity and kindness, the eldest daughter who, embarrassed but respectful, her right hand on her breast, offers ingenuous excuses for the faults he imputes to her; the mother smiles with gentle, modest glances looking towards the priest; her outspread hands express her esteem and gratitude.

The youngest boy, hidden behind his sister, and leaning against a chair, trembles with fear lest he should be seen; his mischievous expression makes him look as if he was planning to escape; the younger sister is shown behind her mother, leaning on the back of her armchair; she observes with pleasure the discomfiture which assails her sister; this malicious enjoyment suggests that the elder sister was the regular recipient of favours that were denied to the younger, a situation which at all ages is wounding to a sensitive spirit and sows the first seeds of mutual indifference in hearts intended by nature to love one another. Seated on a little chair next to his mother

---

*[17] 'The Widow and the Parish Priest.'

is the spoilt child of the family, the eldest son; he has no reason to be jealous of his sister; he loves her, dislikes to see her scolded, and assumes a fierce expression which announces at the same time his attachment to his sister, and the displeasure he feels that she should be reprimanded.

It is to you, the protectors of religion and morality, the spiritual fathers of all classes of citizens, it is to you that I owe the idea of this picture: I trust you will do me the honour of accepting the present dedication together with the assurance of my humble respect.

<div align="center">I have the honour to be, etc.</div>

<div align="right">Greuze.[18]</div>

Unfortunately, the genius of Greuze was more prompt to appreciate what was genuine and sincere than to dare to express it, more ready to seek inspiration in nature than to respect it. Truth was for him no more than a point of departure. He felt obliged to rearrange the subjects with which chance presented him. He added wit to sentiment, purpose to passion, elegance to grace. He put mannerism into naïveté, convention into pathos. His sketches, his notes taken in the street lost, in their passage from the paper to the canvas, from his sheet of studies to the scene in his picture, all sincerity of action, all the honesty, so to speak, of actual life. Idea, expression, line, everything, by a kind of fatality, took on an air of amiability beneath the brush of the man who was to transform the cross in the hands of Marie l'Égyptienne into a broken arrow. Examine his work: you will observe how, having sought to embellish beauty, he proceeds to adorn poverty and destitution. Look at his children, his little tatterdemalions with their torn trousers; are they not, in fact, Boucher's cupids who have dressed themselves up as chimney sweeps and broken into the house by coming down the chimney? It is as if the hand of a theatrical producer had had a finger in all his compositions: the figures act, group themselves in a *tableau vivant*, their occupations are artificially regulated, their work is a mere semblance;

---

[18] *Journal de Paris*, 5 December 1786.

laundresses, in a picture by Greuze, do no actual laundering. Even the backgrounds, the walls of rooms and their furnishings display the conventional, ornamental rusticity of the cottage of the period, built for amusement in a gentleman's park.

'L'Accordée de village' not only determined the scope of the artist's subject matter, but also the tenour of his ideas. He became the painter of virtue. He became the disciple of Diderot, of Diderot who was at once his sycophant and his master; he drew and composed in accordance with the rules, the poetics of the philosopher; he aspired to realize the aesthetic programme with which Diderot prefaced his theatrical works; he aimed, like his master, to play upon the heart-strings of his public, tremblingly or with resonance, by sounding the note of moral decency. He wished, by means of colours and lines, to touch the spectator intimately and pro-foundly, to stir his emotions, to inspire in him the love of virtue and the hatred of vice. He wished to create a moral art out of an art of imitation; to found a school whose ideal should be based upon the dramatization of sentiment, as this had been achieved in his 'Père de famille' or his 'Fils naturel'.[19] His great ambition was no longer to display the capacity, the spirit, the genius of the painter, to render palpable to the eyes the human body, the sun, life itself; he assigned moral duties to his talent and felt called to assume a spiritual fatherhood over the flock of his admirers. To penetrate, like a poet, orator or novelist, the heart of the public; to achieve the emotional success of the *Doyen de Killerine* or *Cleveland*;[20] to exhibit forms explanatory of ideas, to express materially a system of domestic morality, to induce virtuous conduct by the efforts of his brush, to propagate morality by imagery—such was the dream which deluded the painter who was destined to found in France the deplorable tradition of literary painting and moralizing art.

★[19] 'The Illegitimate Son.'

★[20] The *Doyen de Killerine* and *L'Histoire de M. Cleveland, fils naturel de Crom-well ou Le Philosophe Anglais*, both by the Abbé Prévost, were published respectively in 1735-39-40, and in 1732-9. In both, virtue and the fatality of passion are major themes. *Cleveland* in some measure anticipates the social and religious ideas of Rousseau.

The idea of moral instruction pursued the painter through-
out his work. Greuze was ceaselessly concerned to point it out
and emphasize it; for him, it was never visible enough, legible
enough; he indicated it in the titles of his subjects; to augment
its eloquence, he sometimes even recorded on the margin of
his sketches a commentary, an explanation, an expansion of
his pictorial intentions. His allegory is all morality. Thoughts
rose with the waters, spontaneously, around his ship of For-
tune representing the felicities or the miseries of the home.
'The object of marriage: two beings unite to protect them-
selves against life's misfortunes. . . . I imagine that life is a
river. . . .' I have seen these words, in his handwriting, hastily
pencilled beneath a drawing of a boat, guided only by the
waves and carrying a man with his wife and two children.
Hogarth, in his series of plates of the Rake's Progress, offered
an example which tempted him. Greuze dreamt of great dis-
plays of character, passion and adventure which would have
unfolded, from one picture to another, the moral content of a
novel by Rétif de la Bretonne. He nursed the project of paint-
ing a double series of pictures representing the virtuous and the
sinful life. And if we would discover the essence of the man,
the soul of the painter, we shall find it in that confidential
record of his imaginings in the notes for 'Bazile et Thibaut, ou
les deux éducations',[21] the draft of a novel in twenty-six
pictures which was to conclude with the pronouncement of
the death sentence on Thibaut, the murderer, by his old friend
Bazile, who has risen to the magistrature.[22]

## V

It was now ten years since Greuze's candidature for the
Academy had been officially accepted. But, in spite of repeated
solicitations, he had not yet sent in the picture normally sub-
mitted by candidates within six months of their reception, and
which was required to confirm their nomination as Acade-
micians. The painter's growing success, the esteem in which

---

*[21] 'Bazile and Thibaut, or the Two Educations.'

[22] *Annuaire des Artistes*, 1861. *Un Roman de Greuze*, by Ph. de Chennevières.

the Academy held his talent and its fear of appearing to envy
or misjudge an artist who freely expressed his contempt for it,
determined the Academicians to demand his immediate com-
pliance with the regulations and his assumption of that place
in the Academy to which the public felt he was entitled. In
1767, having failed to give satisfaction in this matter, Greuze
was forbidden by the Academy to participate in the Salon.[23]
But the severity of this measure was attenuated and explained
in a curiously complimentary letter from Cochin, in which
Greuze was officially informed of the Academy's strong desire
to include him among their members. Greuze's reply to this
letter was, according to Diderot, a model of vanity and im-
pertinence: 'only the production of a masterpiece could excuse
it'. Finally, on 29 July 1769, Greuze consented to submit the
required picture to the Academy. He had chosen as his subject
Septimius Severus reproaching his son Caracalla for having
attempted his assassination in the wilds of Scotland, and saying
to him: 'If you desire my death, instruct Papinian to accom-
plish it.'

The Academy assembled, and the picture, exhibited on an
easel, was submitted to the criticism of the Academicians,
while Greuze, in no great state of anxiety, waited in an adjoin-
ing room. At the end of an hour, the double doors of the
exhibition room were thrown open. Greuze entered. 'Mon-
sieur,' said the Director, 'you have been received into the
Academy. Approach, and take the oath.' When the formalities
of reception were over, the Director added: 'Monsieur, you
have been received into the Academy, but it is as a painter of
genre. The Academy took into consideration the excellence
of your previous productions; it has closed its eyes to the
present work, unworthy both of it and of you.' Greuze felt
the force of this rebuff; the words pierced him. Professorial
appointments, honours, titles—with a word, the Academy had
denied to his ambitions all that was the exclusive privilege of
the painter of history. Dazed, unhinged, Greuze, who had at
the same time the pride and the timidity of a child, started to

---

[23] *Mémoires pour servir à l'histoire de la République des lettres*, Vol. III.

reply, to defend himself, to assert the excellence of his picture. The Academy listened smiling, and in the end Lagrenée, drawing a pencil from his pocket, went up to the picture and demonstrated the faults in the drawing.[24]

The Academy had done no more than pronounce an equitable judgement on the merits of the picture. Diderot himself, who had so much unctuous affection for the illustrator of his moral ideas and who treated him with such absolute indulgence, was obliged to renounce any defence of the picture in question. It was in vain that he endeavoured to detect some merit in it: he found nothing that was even tolerable except the heads of Papinian and of the Senator. Against the judgement of the Academy, Greuze appealed to the judgement of the public, to that public by whom he had been so spoilt and inflated; he turned gazetteer and addressed the following letter to *l'Avant-Coureur*:

## LETTER FROM M. GREUZE
## TO THE AUTHOR OF L'AVANT-COUREUR

In the continuation, in your last number, of your account of the pictures exhibited at the Salon you have committed, with respect to me, two injustices which, as a gentleman, you should repair in your next issue. First, instead of treating me as you treated the other painters, my colleagues, by according to each, in the space of a few lines, the tribute of praise they deserve, you enlarged with much affectation on the subject of my 'history' painting with the principal object of informing the public how, in your view, Poussin would have treated the same theme. I have no doubt, Monsieur, that his treatment of it would have resulted in a sublime picture, but, certainly, he would have dealt with it otherwise than you assert. I beg you to believe that I have studied, as well as you can have studied, the works of this great man, and that it was above all the art of rendering facial expression that I looked for in his paintings. You, it is true, carried your observations further, since you

[24] *Supplément aux Œuvres de Diderot. Lettres sur le Salon de 1769.* Bélin, 1818.

noticed that he placed the clasp of a cloak on the right side, whereas I have placed that of the robe of Caracalla on the left; that, I agree, was a grave error; but I am not prepared to yield so easily with regard to the character which you claim he would have given to the emperor. Everybody knows that Severus was one of the most hot-headed, the most violent of men; and you would propose that, when he says to his son: 'If you desire my death, instruct Papinian to accomplish it with this sword', he should appear, as Solomon might have done in similar circumstances, calm and tranquil. I would appeal to the judgement of any reasonable man: is that the expression which the artist should have bestowed upon the physiognomy of this redoubtable emperor?

Another and a much greater injustice is that, having studiously attempted to guess how Poussin would have treated this subject, you then voice the supposition that it was my intention to depict Géta, the brother of Caracalla in the personage placed behind Papinian. In the first place, Géta was not present at this scene; it was Castor, chamberlain to Severus and, according to Moréri,[25] 'the most faithful of his servants'. Secondly, on your gratuitous assumption that I intended to represent Géta, you should have reproached me for having painted him too old; he was the younger brother of Caracalla. Thirdly, I should, in that case, have committed the further mistake of failing to depict him in military costume. Such, Monsieur, are the absurdities with which you credit me in your desire to exercise your power of criticism. I believe you to be too honourable a man to refuse me the satisfaction of publishing this letter in your issue for Monday. I surely have the right to explain my picture as I conceived it and to correct the interpretation you have given of it without consulting either its author or History.

Would you wish to discourage an artist who would sacrifice all in order to remain worthy of the goodwill with which the public has so far honoured him? Why, at my first attempt,

★[25] The scholar, Louis Moréri (1643–80), was the author of a *Grand Diction-naire Historique ou Mélange curieux de l'histoire sacrée et profane* (1674).

attack me so openly on the adoption of a new genre which I flatter myself I shall be able to perfect with time? Why compare me, alone among all my colleagues to the finest painter of our native school? If you did so in order to flatter, the device was not a happy one, for I saw nothing in the article but a marked intention to disoblige me. And I cannot recognize that such was not your intention, an intention unworthy of any impartial critic, until you have had the goodness to print my letter in your paper.

<div align="center">I am, etc.[26]</div>

The public remained cold, and a short pamphlet expressed their disappointment, the cooling of their enthusiasm by asserting that Greuze was 'truthful in his treatment of simple themes, sublime in his rendering of naïveté, but incapable of dealing with a heroic subject'. Why, inquired the critics, should Greuze have unearthed such an obscure event, a complex and mysterious incident that it was impossible to express in terms of painting? And, after analysis of the defects of composition, drawing and colour which marred the picture, they asked whether Teniers was less Teniers because he never painted the court of Augustus or whether Préville was not still one of the finest actors of the Comédie-Française though he had never played the part of Mithridates. *In pelle propria quiesce* was criticism's last word, summarizing in a phrase the advice and the hopes of public opinion.[27]

Was there a reason for this failure, this abortion, this inability to achieve the grandeur, the nobility, the severe pathos required by a heroic theme, some reason other than the temperament of the painter, the lack of distinction to be expected from a facile but narrow talent, the ill-judged ambition of an emasculate draughtsman? Diderot, his defender and confessor, maintained that Greuze failed to achieve the highest levels of art, not from any innate deficiency, but because his

---

[26] Published in the *Avant-Coureur*, Monday, 25 September 1769.

[27] *Lettre sur l'exposition des ouvrages de peinture et de sculpture au Salon du Louvre, 1769.*

life at home was subject to a fatality, a torment, a daily misery which weighed him down, which crippled the faculties of the artist beneath the distresses of the man and the woes of the husband. Greuze, according to Diderot, was bound down and oppressed by domestic life. The wife he had introduced into his home, the pretty Gabrielle Babuty, mutilated the spirit of the artist by imbuing him with a passion for money. Her continual demands, violent bickerings, fatuous chivyings and stupid spitefulness deprived her husband of the peace, the resilience, the courage of endeavour, the freedom and the tranquillity of mind which favour the creation of noble and powerful works. Diderot pictures her as wearying the painter by her nagging, degrading him by her pettiness, exhausting his moral strength, interfering in his working hours, perpetually disturbing his thoughts, obstructing the progress of his compositions and sketches, creating an inferno round his easel and frustrating his labours by her capricious inconstancy. The failure of the Academy picture was her doing; it was due to her that the work languished, dragged on, eight months after it had been begun; it was she who ordered and inspired the unfortunate alterations which destroyed the sublimity of the original sketch. Diderot may have exaggerated, may have succumbed to an illusion, in supposing that a woman is so far capable of governing the inspiration of a painter, that she could be the auspicious or ill-omened genius of his palette, but his testimony is none the less a valuable one. If it contributes nothing to criticism, it reveals the secret of the painter's sorrows to the biographer, it sheds a light on the misfortune of his life.

Let us return to the time of the painter's marriage, to this woman whom at first he adored, to the magic of her attraction, to her loves. She lives, talking and smiling, in Diderot's pen-portrait, like a medallion beaten out of a flash of sunlight: 'I loved her well when I was young and she was still Mademoiselle Babuty. She worked in a little bookshop on the Quai des Augustins; she was doll-like, white and upright as a lily and pink as a rose. I entered the shop with the mad, wild air of

my youth and said to her: "The Fables of La Fontaine and a Petronius, please." "Here they are, sir. Are there no other books that you require?" "Excuse me, Mademoiselle; but——." "Yes?" "*La Réligieuse en Chemise*——." "Really Monsieur! Has anyone, does anyone read such obscene productions?" "Oh, so it's an obscene work, Mademoiselle? I had no idea." And some days later, as I was passing by, she smiled at me, and I at her.'[28]

Greuze passed by this same shop a few days after his return from Rome. Like Diderot, he went in, and one fine day, as a result of his repeated visits, he married, or rather he awoke to find that he was married, without having specially exerted himself to secure this result. But he rapidly made up his mind that he was going to be happy. His wife was charming. She had the pretty face whose features her husband's brushes were to remember always, and with which his talent was to remain in love; a child-like expression, a round, smooth forehead, the eyebrows widely separated from the eyes, long lashes which bestowed a shadow and a caress on all her downward glances, the small nose of a young girl, slender, straight, alert, a moist mouth, delicately shaped and coquettish, a full, youthful oval outline, a charming rotundity, a tender, velvety skin and a sentimental expression which enlivened and relieved what was slightly sheepish in her general appearance—such were the components of the beauty of Madame Greuze, the beauty whose characteristic charm, whose traits are reflected in what may claim to be the authoritative likeness of her in Massard's small engraving.

But the woman herself is more truthfully represented in another portrait; the resemblance is more intimate, the individuality more apparent and more pronounced in the picture in which Madame Greuze is shown at home under the title 'La Philosophe endormie'.[29] In this work, the sensuality of the sitter is apparent beneath the juvenile exterior; we have here the image of Madame Greuze asleep; a smile induced by her

[28] *Œuvres de Diderot, Le Salon*, 1764.

★[29] 'The Philosopher Asleep.'

dreams betrays her repose. Seated in a deep armchair, rather
as if she had glided into it, her head is thrown back to one side
against the pillow on the back of the seat. A linen cap, a
*battant l'œil*, its flaps open and floating on the air, rings her
hair with the buoyancy and whiteness of its creases. The
unbuttoned waistcoat fitting closely over the breast and sup-
porting the throat, is parted at the neck beneath a *fichu*. Her
arms are relaxed and listless, one of them lying across an open
book on a table, the other falling along the body to the lap
where a pug dog with clipped ears, frowning muzzle and
angry eyes, sits on guard.

At her feet, next to the high-heeled slippers, lie her em-
broidery frame and her bobbin. Her whole body sleeps; sleep
possesses her, loosens her limbs beneath the ruched, festooned
*négligé* whose lines and folds seemed to have assumed the
laxity and indolence of the sleeper. The stuffs have, so to speak,
subsided, the dress is half open, the pose is dead and the eyelids
closed; the mouth is faintly titillated, and the breath trem-
bles—we may feel that some delicious dream implants a kiss
upon her eyes.

Greuze was also to paint his wife, much less adequately
draped, in 'La Mère bien-aimée',[30] raising her head above the
garland of children's heads smothering her in kisses, with a
laughing expression which drew from Diderot an exhortation
to modesty addressed to both the painter and the husband.

It must be said, as an excuse for Greuze, that in painting his
wife thus he was doing no more than representing her as she
was. Madame Greuze, morally as well as physically, was the
*voluptueuse* depicted in his art. Less than eight years after their
marriage, she had caused Greuze all the bitter sorrow that
conjugal infidelity could inflict, carrying her adultery to the
point of cynicism and effrontery, to that extreme of insolence
of which the only adequate account conceivable is the painful
memoir set down by the unhappy husband, and which we feel
justified in quoting here as the most revealing extant document
on the disordered home life of the eighteenth-century artist.

★[30] 'The Beloved Mother.'

We preface this memoir with the painter's deposition on the misconduct of his wife which he submitted to the police commissioner, Chenu, in 1785 and which was published by the *Bulletin de l'art français* in 1875.

'In the year 1785, on Sunday, December 11, at noon, at the residence of Gilles-Pierre Chenu and in his presence, the sieur Jean-Baptiste Greuze, painter and member of the Académie Royale, resident in the Rue Basse-Porte-Saint-Denis, in the parish of Bonne Nouvelle, appeared as plaintiff: he stated that, overwhelmed by work, he had for some time closed his eyes to gross instances of depravity in his domestic life which would have brought about his total ruin if he had not finally set himself to discover its source, a discovery which had caused him infinite pain and vexation, and provoked the most violent scenes on the part of his wife; nevertheless, in spite of his numerous and pressing occupations, he had taken it upon himself to exercise an effectual authority in his home, and to watch over his interests more closely.

'Having learnt about a month ago that persons of the most mixed character were frequently received into his house, he took it upon himself to fight a *war with the eyes* [sic] and noticing one day that a man was admitted to the apartments of Madame Greuze and remained closeted with her, he knocked at her door and was admitted by Madame Greuze in person: he found in her room a man dressed in grey, with a pale face, turned-up nose, and of common appearance. Questioned as to his business there, the man replied that he had come to speak to Madame Greuze. The plaintiff then retired.

'Yesterday, towards five o'clock in the afternoon, the plaintiff was about to go out when he noticed before the door had closed that Madame Greuze was receiving a visitor. The plaintiff entered and saw a man, unknown to him, about 5 feet 4 inches in height, thin, with an aquiline nose, thin lips, small eyes and a yellowish complexion. On being asked what he wanted, he replied with an insolent air: "I have come to see Madame." To which the plaintiff retorted: "Monsieur, my

wife only receives visitors whom I know. Since I have not the honour of your acquaintance, I must ask you to be good enough not to return." The man thereupon flew into a passion and assured the plaintiff with threatening gestures that he would return in spite of him and whenever he felt inclined. The plaintiff, surprised by such audacity, endeavoured to control his just fury and was preparing to make representations to the man with regard to his threatening attitude when Madame Greuze took up the latter's defence; fortified by this support, the man repeated, with greater insolence than before, his threat to return, in spite of the plaintiff's objections, as often as he felt inclined and as would be agreeable to Madame Greuze, who at once concurred with everything he said. The plaintiff, fearing the consequences of such insolence and doubting whether he could further control himself, decided, out of prudence, to return to his own apartments, leaving the man with Madame Greuze where he remained for half an hour after the plaintiff's departure. His two daughters and his servants might well have overheard this scene of whose consequences for the safety of his person the plaintiff was justly in fear. It was therefore of great importance to him to discover who was the man in question, what he came to do at his house, and why Madame Greuze had supported him against her husband.

'The plaintiff might continue to ignore the visits received by his wife from these persons unknown to him, if he had no other grievances against her and if he did not consider it important for himself and his affairs to supervise, more closely than he was doing, what took place in his house and what sort of people were received there. All that he had hitherto borne and the extent to which his affairs had suffered he reserved for the more detailed account he would submit later, and he confined himself today to proposing that only persons known to him and whom he was willing to receive should be allowed to enter his house. And in view of the second intruder's threats, supported by Madame Greuze, to return to the house, in spite of the plaintiff's objection, whenever he should wish

it, an interference he will not and cannot tolerate, he has laid before us the present plea.

> '(*Signed*) Greuze, Chenu
>
> '(File 882, Commissaire Chenu).'

Here is the memoir [31] itself:

'Citizen, I propose to reveal to you, in spite of myself, events over which I have hitherto preserved a veil of secrecy. You will see that outrage has been heaped upon outrage; my honour, my life, my fortune and that of my children have been wrecked by an unnatural mother.

'A few days after my return from Rome, I happened to be passing, I know not by what fatality, down the Rue Saint-Jacques, when I noticed Mademoiselle Babuty at her counter. She was the daughter of a bookseller; she had a very beautiful face and I was overcome by admiration; I inquired about the purchase of books so that I might have time to examine her; her face was without character and almost sheepish; I paid her as many compliments as she could have desired; she knew me; I already had some reputation and my candidature had been admitted by the Academy. She was over thirty years old and had therefore to face the possibility of remaining a spinster all her life; she employed every conceivable cajolery to induce me to return and see her, telling me there was no need to seek a pretext since it would always be a pleasure to see me. I continued to visit her for the period of about a month. One afternoon I found her more animated than usual; she held one of my hands, and looking at me with a passionate air, she said to me: "Monsieur Greuze, would you marry me if I was agreeable?" I must confess that I was confused by such a question; I said to her: "Mademoiselle, would not a man be too happy to spend his life with such a charming woman as you are?"

[31] This memoir, in the possession of M. Jules Boilly, has already been published, with an interesting commentary, in the *Archives des Arts* by our friend, M. de Chennevières, who considers it to be a memoir dictated by Greuze about 1791, with the intention of obtaining a legal separation.

I believe that this manner of replying bore no special signifi-
cance; she was not withheld, however, from making up her
own mind on the spot, and the next day she was off with her
mother to the Quai des Orfèvres and there ordered from M.
Strass a pair of ear-rings in artificial·diamonds, and the follow-
ing day her most urgent business was to display them. Since
she passed the daytime in a shop, all the neighbours were able
to compliment her on the rings, and to ask who it was who
had given them to her; and in a soft voice, her eyes lowered,
she replied to each: "They are a present from M. Greuze."
"Then you're married?" "Oh, no!" (this uttered in a tone
suggesting a secret "yes" to everybody). My friends hastened
to congratulate me; I assured them there could be nothing more
untrue and that I was not rich enough to get married. Incensed
by such effrontery, I no longer returned to the shop. I was
then living in the Faubourg Saint-Germain, in the Rue du
Petit-Lion, in a hotel known as l'Hôtel des Vignes. Three days
went by and I heard nothing more; I was even beginning to
forget her when one morning she came knocking at my door
accompanied by a maid; I made no reply; she knew that I was
there and redoubled her efforts, knocking on the door with
both hands and feet like one of the Furies. At this, realizing
that she might entirely lose her reputation, I admitted her; she
rushed into my room in floods of tears, saying: "I am to
blame, Monsieur Greuze, but it was love which led me astray,
it was my attachment to you that impelled me to resort to
such a trick, my life is in your hands." Whereupon she sank
to her knees declaring that she would not rise until I had
promised to marry her and clasped my hands bathing them
with her tears; I was overcome by pity and promised all that
she wanted. We were not married, however, until two years
later, in the parish of Saint-Médard (which was not her parish),
as I feared the mockery to which she might have been exposed
seeing that she had already said that she was married. I started
a home, the day after my marriage, with only thirty-six *livres*.

'The first seven years of our marriage were not accompanied
by any unusual events; we had three children; two survived,

and it was necessary to look after them, provide them with religious instruction and take them to Mass at least once on Sunday; but since she is quite without religion and since, during the twenty-seven years that we have spent together, she has not once been to church, this task was too much for her; she placed the children in a convent where they have remained, one for eleven, the other for twelve years; there, they were more or less abandoned by her or, at any rate, it was only very rarely that she visited them. My eldest daughter told me on one occasion when I went to see her: "It is a year and seven days since mother came to visit us." She was quite over-come by grief at this absence.

'I had given my picture "Le Paralytique"[32] to M. Flipart to be engraved, and he had undertaken to publish it during the course of the year. Madame Greuze supposed that there was here a chance of making a large sum of money; she said to me: "Monsieur, I require a servant." I replied: "You know that we have no private income and that therefore your proposal is not one that we can afford to carry out, above all at the present moment; but, if you can wait until after Easter, I will do what I can to satisfy you in this matter." Her only reply was to slap me in the face as hard as she could; I freely confess that I lost my temper and returned the blow.

'I must now revert to the matter of the sale of my prints, which comprise the main body of my work, and which have been engraved by four separate craftsmen: M. Massard, M. Gaillard, M. Levasseur and M. Flipart; these gentlemen are my business associates.

'Madame Greuze had removed her children, who might have become her judges; it now seemed necessary to her to divide me from my associates; she did so with considerable skill; from that time on, I had no part in my own business; everything was done without my participation; I had, more-over, little aptitude for business affairs; the love I have ever had for my art made me forget the interests and the future of my children. Sometimes, I presumed to say to her: "Your

★[32] 'The Paralytic.'

accounts do not seem to be very clear." She replied: "Monsieur, you know nothing about such things; I can assure you I manage your affairs much better than you could yourself." I would then retire to my studio with my brushes and was soon oblivious of the world and its affairs; a new idea, and the pleasure of rendering it, prevented me from perceiving the abyss beneath my feet. With her accustomed cleverness, she calculated that I might one day demand a clear account of her activities and since she had already dissipated substantial sums out of my earnings which I might require her to account for, she said: "I have had a great misfortune, I invested without telling you—and I now repent it—thirty or thirty-six thousand *livres* in a ship, believing that I would thus make your fortune; but I now hear that the English captured it as it left the port." But I said to her: "How could you have done such a thing without guarantees and what was the captain's name?" This information she has never been able to give me. As the time of our separation approached and it became necessary to produce accounts of some kind and to put some order into our affairs, she took the masterly step of destroying the registers; I was thus left in permanent ignorance of the sums she had received. The accounts had always been very exact with my associates and everything settled by the regular procedure. "But, Madame, why did you tear up the registers?" "Because I wanted to, and because I do not consider that I should submit accounts to you." The business had brought in three hundred thousand *livres* and a hundred and twenty thousand were missing, excluding any sums derived from prints which I had given her to sell as a remuneration for the trouble she took with the business; she was supposed to limit the printing of these to an edition of fifty proofs for herself and for our associates; but in fact she printed five hundred which she sold for her own profit at three or four *louis* each. There were in all nine engraved plates, during the time we lived together, which she disposed of in this way for her own gain.'

(End of the deposition respecting the business affairs of the plaintiff.)

## INCIDENTS IN THE HOME

'Beginning seven years after the marriage.

'It was M. Dazincourt (Blondel D'Azincourt), who was the first to cause disturbance in my household. He came first simply as a connoisseur and collector; but Madame Greuze soon took possession of him, falling violently in love with him; she one day confided to me this cruel information, but stated that her attachment was a platonic one. M. Dazincourt had a large share in the unpleasantness which I experienced at the Academy, for he had the most extensive connexions in the artistic world; I strongly suspect Madame Greuze of having plotted with him the rebuff which I received. She had ceased to be my wife and had become an enemy with whom I was obliged to live and who was to stand in my way at every step.

'Towards the end of M. Dazincourt's ascendancy, Madame Greuze was attracted by a pupil whom I had taken in; I returned one day about nine o'clock, and found Madame Greuze looking very embarrassed and the pupil standing in front of the fireplace at a loss how to behave; I thought it right to dismiss this young man and I did so; despair then reigned in the house. Madame Greuze went about armed with a dagger with which she threatened to commit suicide; she refrained, however, from accomplishing this act, and I remained firm. She soon changed her affections: a certain greengrocer, who used to supply me when I lived in the Rue des Vieux-Augustins in a furnished room let by a glazier, had been supplying me with firewood; he came to see me and told me that his son had a talent for painting and that he would be very much obliged to me if I would be good enough to give him my advice. The son was about sixteen or seventeen years old, and Madame Greuze was about fifty. The young man attracted her and she took him under her protection. She trusted him with a number of things of considerable value up to the amount of some fifteen thousand *livres*. The young man had fallen into bad ways. I believe that Madame Greuze had some further reason of her own to complain of him, for she engineered

his arrest for having stolen the above-mentioned sum; he was taken to M. Muron, a police officer, and the father was advised of the position; this worthy gentleman, grief-stricken that his son should be suspected of theft, could not help saying: "My son is little more than a child, and you are a sensible woman; why did you trust him with such a large sum? But since I am an honest man and have no wish that you should lose it all, I will give you two thousand *livres* on my house in the Rue des Vieux-Augustins to be realized after my death." This settlement was drawn up by M. Prévot, a notary in the Rue Croix-des-Petits-Champs, from whom she received the money on the death of this honourable man; a part of it was spent on the purchase of a carriage. But Madame Greuze's various difficulties merely increased; she was obliged to have recourse to a M. de Veluose who was said to purvey an excellent anti-venerial syrup, which, however, was not successful, and to a M. Louis, a surgeon secretary of the Academy of Surgery, who completed the cure. If Mme de Veluose is still alive, she can testify to the truth of what I say; for Madame Greuze tried to avoid paying her. Shortly afterwards, she made the acquaintance of M. de Saint-Maurice, then a Councillor in the Parliament, and now an emigrant. His artful face, with its sullen, grasping expression had to be seen to be believed; he had so corrupted her character that the most atrocious behaviour now cost her no effort. Returning home on one occasion, I found her behind the screen in the drawing-room in circumstances that could have but one interpretation; I withdrew; to my reproaches the next day, she replied: "That is true, but I don't care a f——." Such things could no longer affect me, I knew too much about her behaviour, and one crime more or less could make no difference; for a number of years I had ceased to live with her as a husband. It was with this man's advice that she absorbed my entire fortune; it was to him that the sums she embezzled from my business must have been paid; by means of arrangements whereby he made her yearly payments, she had agreed contractually to a fixed rate of interest in respect of the capital sums he held from

her; other arrangements provided an annuity in her son's name, of which she gave at once a third of the necessary capital so that she might dispose of the income during her lifetime. The object of these complicated arrangements was to keep me in ignorance of the moneys she had stolen.'

## ANOTHER INCIDENT

'One of my friends, calling at the house to see me, discovered, concealed behind the fatal screen in the drawing-room, the same man. When we were on the point of separation, Madame Greuze sought this friend's advice; on her describing herself, quite improperly, as an honourable woman, he said: "Ah, madame, you have forgotten the screen."

'We left the Rue Thibotodé and established ourselves in the Rue Notre-Dame-des-Victoires.[33] More depraved than ever, and now in possession of a separate property of her own, she abandoned our house entirely to the servants, neglecting even the kitchen to the probable extent of allowing the cooking utensils to collect verdigris; at least I supposed this to be the case, for a bouillon which had been heated up for me, and which I took on Christmas Eve, nearly brought about my death; for about fourteen hours I was the victim of convulsions without any medical aid; surgeons and doctors were sent for in vain; not one of them was ready to see me before about seven in the morning; by chance, M. Le Doux happened to call and prescribed theriac; this took place about twelve years ago, and left a pain in the chest which survives to this day.

'We always occupied the same bedroom; I awoke one night with a start and caught sight of Madame Greuze, in the glow of the night-light, preparing to batter in my head with a chamber-pot. As you can imagine, I remonstrated violently. "If you don't stop arguing," she said, "I shall scream at the window for the night watch and tell them that you're attempting to murder me."

'I subsequently left the Rue Notre-Dame-des-Victoires and moved to the Rue Basse (Porte Saint-Denis) where I am now

[33] By a decree dated March 1769, Greuze was granted lodgings in theLouvre.

living. Here we established ourselves in different rooms; and
from that time on, we have been entirely separated.

'Various people told me that Madame Greuze was in the
habit of receiving very undesirable company, and since I had
two daughters it was essential that I should refuse to tolerate
such behaviour. I made my resolution, and, on the selected
day, remained at home; at about seven in the evening I saw a
man enter Madame Greuze's room, a young man, about thirty
years old, who had been a barber and was now in some quite
insignificant employment which had been privately secured
for him. I entered her room at once, asked him what he
wanted, and informed him that I hadn't the honour of his
acquaintance; he baldly replied: "I've come to see Madame
Greuze." I continued: "My wife sees only the men whom I
have introduced to her, and I have never met you," and he
said: "That doesn't matter to me; I shall come to your house
as often as Madame requires me." I realized that this was a trap
which had been set for me in the hope of provoking a scene.
I retired without saying anything and resolved to submit my
case to a magistrate; I addressed my complaint to M. Chenu,
Commissioner of Police, in the Rue Mazarine.

'Our legal separation was then decided. We agreed to divide
our joint possessions into two equal shares, although we were
three opposed to one. I gave her all the necessary domestic
utensils, a transfer of which I hold the legal certification by a
notary, and an annual allowance of one thousand, three
hundred and fifty *livres*, for which three contracts are held by
M. de Saint Maurice, one for a thousand and the other two for
three hundred and fifty *livres*; this allowance she has now
enjoyed for almost seven years.'

## VI

The humiliation of having been accepted by the Academy as
a genre painter exasperated Greuze, and enraged his vanity.
Contemporary books, pamphlets, and Diderot's *Salons* all
remark upon this excessive vanity, nervous, irritable, inflated
and overflowing, which Greuze advertised and displayed with

a brutality and coarseness worthy of the meanest workman of the time.[34] The slightest criticism of his work provoked in him fits of the most ingenuous and sometimes the most ludicrous rage. When Madame Geoffrin allowed herself to pass criticism upon the 'fricassee of children' in 'La Mère bien-aimée', he exclaimed: 'What right has she to speak about a work of art? Let her tremble lest I should be moved to immortalize her! I shall paint her as a school-mistress, with a birch in her hand, and she will strike fear into the heart of every child, both of the child of today and of those yet to be born.'[35] Drawing-room society laughed at him in vain; Greuze continued to anticipate the exhibitions with an exordium conceived approximately in the following terms: 'Ah, Monsieur, you are going to see a piece of painting which surprises even me, its author. . . . It is incomprehensible to me that a man could, with the aid merely of a few powdered minerals, so animate a canvas and, indeed, in pagan times I should have feared the fate of Prometheus. . . .'[36] This self-admiration, this worship of his own works and genius were unshakable traits of the man's character. Ridicule had no effect upon him, irony failed to pierce him. 'That is a fine work,' said M. de Marigny, pausing before his 'La Pleureuse'[37] at the Salon of 1765. 'Monsieur, I know it;' replied the painter; 'and what is more, I have been praised for it, but I lack commissions.' 'That is because you have a cloud of enemies,' put in Vernet, his fellow-lodger in the Louvre, 'and among them is a certain person who appears to love you exorbitantly but who will prove your undoing.' 'And who is this certain person?' 'Yourself!'[38]

Vernet exaggerated; Greuze was not quite so self-destructive. His pride had a kind of immodest innocence, a kind of

[34] There was something, states Mariette, of the brutal crudeness of a peasant in his nature. To the Dauphin's request, when Greuze had finished his portrait, that he should also undertake a portrait of the Dauphine, the artist replied, in the presence of that lady, that it was his wish to be excused from that task *because he was incapable of painting such faces*—an allusion to the heavy make-up which the Dauphine affected.

[35] *Le Salon de 1761*, by Diderot.     [36] *Correspondance Secrète*, by Metra, Vol. V.

★[37] 'Girl Weeping.'     [38] Diderot, *Salon de 1765*.

insolent candour, which were disarming. And, in any case, the
painter compensated for the man. Every allowance was made
for this headstrong temperament, for this artist, burning with
inspiration, absorbed in his art, plunged with all his heart and
mind in his productions, animated, engrossed by what he
was painting, living, so to speak, on his pictures so much so
that in the evenings, in company, the sadness or the gaiety of the
day's composition lingered like a reflection in his expression
and state of mind.

Under the contempt of the Academicians, this pride, accus-
tomed to caresses, revolted. In the first moment of exaltation,
Greuze announced to the Academy that he had no wish to
become one of their members; to which Pierre replied that
'His Majesty would command him'. Greuze did not insist, but
he voluntarily excluded himself from the Academy's exhi-
bitions. In this sulky mood he left Paris and went to stay with
friends at Anjou and there painted the canvases which were
for so long admired in the Livois collection, and the portrait
of Madame de Porcin now in the museum at Angers. On his
return to Paris, his resentment remained unabated. He affected
to be struggling single-handed against the Academy, declaring
that at the Salon there were nothing but 'coloured prints', and
that people had to come to his studio to see pictures.[39] The
public favour with which Greuze was surrounded encouraged
him in this war against the Academy and in his scorn of their
exhibitions. He exhibited at home and the crowd thronged
about his works. Such pictures as 'L'Éloge de l'impertinence'[40]
or 'Adèle et Théodore' made a visit to the studio of Greuze an
item on the daily programme of a fashionable woman. The
highest society, the most important people, the best company,
the court, the nobility, the Princes of the Blood, kings passing
through Paris,[41] came to voice their admiration, in the painter's

[39] *L'Espion Anglais*, Vol. X.

★[40] 'In praise of Impertinence.'

[41] In August 1777, the Count of Falkenstein commissioned a picture from
Greuze and at the same time presented him with the title of baron and 4,000
ducats.

studio, of the portrait of Franklin, 'La Dame de charité',[42] 'La Malédiction paternelle',[43] 'Le Fils puni',[44] 'La Cruche cassée'[45] or 'Danaé'. All Paris went there.[46] In the wake of the nobility came the bourgeoisie who were, at this period, concerned or interested in all aspects of the arts; and Madame Roland has handed down to us, among her letters, this interesting account of a visit to the painter:

'September 19, 1777.

'I was moved by tender memories last Thursday of the pleasure we tasted together, Sophie, when we visited two years ago the studio of M. Greuze. I was there for the same reason that induced us to go on that occasion. The subject of his picture is "La Malédiction paternelle"; I shan't attempt to describe it to you in detail; it would take too long. I shall be content merely to observe that in spite of the quantity and the variety of passions expressed by the artist with force and truth, the picture as a whole fails to produce the touching impression we received when we looked together at the other work. The character of the subject seems to me to explain this difference. M. Greuze might be criticized for the predominant greyness of his colour-scheme which I should be ready to accuse him of employing in all his pictures, if I hadn't seen this same day a work of quite another kind which the painter, with exceptional kindness, was good enough to show me. It represents a little girl, naïve, fresh, charming, who has just broken her jug; she holds it in her arm, near the spring where the accident took place; her eyes are not too open, her lips are still parted. She is trying to realize the full import of the accident and is not sure whether she is to blame. One could hardly conceive anything more piquant and attractive; the only fault with which M. Greuze could possibly be reproached, is not to have made his

---

[42] 'The Benefactress.'   [43] 'The Paternal Malediction.'

[44] 'The Chastised Son.'   [45] 'The Broken Pitcher.'

[46] When public interest began to wane, when Parisian society began to forget the way to his studio, Greuze endeavoured to sharpen it by addressing epistolary dedications to the newspapers which contained, as in the case of 'La Veuve et son Curé', a description of his latest picture.

little girl look quite cross enough to show us that in future she would no longer be tempted to return to the spring. I told him that his witticism amused us.

'He has not been criticizing Rubens this year; altogether I was more satisfied with him as a man. He was very willing to tell me of the compliment paid him by the emperor: "Have you ever been in Italy, Monsieur?" "Yes, M. le Comte, I lived there for two years." "It wasn't there that you discovered this style; it is a style that belongs to you alone; you are the poet of your pictures." It was a compliment of great delicacy: it has two meanings and I was malicious enough to emphasize one of them—pursuing my remarks, however, in a complimentary tone: "It is true," I said, "that if anything could augment the expressive power of your pictures, it is the descriptions you write of them." The egotism of all artists came to my aid in this instance: M. Greuze seemed to be flattered. I remained at the studio for about three-quarters of an hour; there were not many people present; I had him almost entirely to myself.'[47]

<center>VII</center>

When centuries grow old, they become sentimental; their corruption melts. It was a strange moment for the aging eighteenth century, as if the heart of a rake had declined into its second childhood! Humanity, charity, these words seemed suddenly to have the quality of a revelation. Unhappiness became interesting, destitution touching. Montyon founded his prizes, philanthropy was born. Charity was the imaginative ideal. Family life was revived. Marriage was rediscovered. The gravity of happiness succeeded the buoyancy of pleasure. Bourgeois felicity was in apotheosis. Home life was glorified. The gods of Duty returned to the household. It was fashionable to be a mother and splendid to be a nurse; between the lips of a suckling the maternal breast rose in pride. On all sides, the prevailing aridity sought dew, the mind required freshness, tears prepared to flow. A sweet and warm emotion floated in

[47] *Lettres de Mlle Phlipon aux demoiselles Cannet.*

the atmosphere of these troubled, trembling years, during which arose the dawn and storm of a revolution. Rousseau provoked a passionate admiration, Florian[48] exhaled an enchantment. There was an idyll in the breeze, a Utopia in the gale. Society caressed an image of virtue which it adorned like a doll. Dukes, in their hereditary villages, crowned the rustic virgin and the least chaste luminaries of Paris were present to lend their applause. Roses of innocence flourished at Salency. Morality flourished on children's slops. Financiers designed such retreats as the Moulin-Joli.[49] In the shadow of Versailles, Trianon became an operatic village designed as a background for the plays of Sedaine.[50] The illusion was universal, the intoxication was nation-wide; History itself seemed to smile upon this childish dream when she set upon the throne a family who recalled the characters in a comedy by Goldoni: the King's good nature was quite bucolic; he was the beneficent overlord who, in the stories of the period, goes to visit his farmers on foot. He might have been seen rolling up his sleeves to assist a carter with his mud-bound vehicle. And the Queen was still rich in the 'traits d'humanité' of her past as the Dauphine.

Greuze, in painting, was the representative of these feelings. He was the painter of the illusion. His inspiration was the supreme example of the soaring trend towards rejuvenating affections, towards thoughts, pictures, plays which might recover the lights of morning for the spirit of a sinking society. He spoke directly to the sensibilities of his period, he was attached to its sentimentalities. He represented, personified Charity, in his 'Dame de la charité'. He caressed and satisfied the instincts of the time, materialized its dreams by his narration, in the pages of his art, of the celebration and enthronement of virtue, by providing, in his pictures, the themes, in

★[48] Jean Pierre Claris de Florian, the great-nephew of Voltaire (1755–94), was the author of fables and plays (*Le Bon Ménage*, *Le Bon Fils* and others), and of prose pastorals in a tender, moralizing vein.

★[49] Watelet's country house. See footnote, page 61.

★[50] Michel-Jean Sedaine, the writer of sentimental comedies (1719–97), won lasting fame with his *Le Philosophe sans le savoir* and his *La Gageure Imprévue* which have remained in the repertory of the Comédie-Française.

outline, of the Abbé Aubert's[51] moral tales. 'La Paix du ménage',[52] 'Le Gâteau des rois,'[53] 'La Maman',[54] 'La Grande-Maman',[55] 'Le Paralytique servi par ses enfants'[56]—such were the subjects, the titles of his pictures. His poetry revolved within the family circle. His art was unfolded against the rustic background of industrious felicity; his very dramas, 'Le Testament déchiré',[57] 'Le Belle-Mère', 'La Malédiction paternelle', were taken from domestic life. The relenting tenderness induced by childhood is diffused throughout his work—in 'La Sévreuse',[58] 'La Bonne Éducation',[59] 'La Privation sensible',[60] or 'Le Retour de la nourrice'.[61] The heart of his inspiration was in the cradle.

What visual and spiritual sensations are produced by this work, by the paintings of Greuze, by the prints engraved after his pictures? What is our lasting impression after looking at one of his canvases, after a careful study of one of his compositions? Is it the simple, healthful impression produced by a Chardin? Do we feel, confronted by these domestic scenes, the pervasive calm, the bourgeois serenity, the grave harmonies and instinctive decencies of 'Le Bénédicité' or 'La Toilette du Matin'? Does Greuze convey to our minds a clear image of the family, a frank representation of the joys of home life? Does he let us sense, like Chardin, the routine of the house, the felicities of mediocrity? Does he show us the sincerity of attitude, the reality of the austere clothes of the middle-class woman of the period? And, finally, do we leave a painting by Greuze with our minds becalmed, elevated by contact with an authentic, upright, moral conception, by such vestiges of gentle emotion and pure light as a charming dream of

---

[51] The Abbé Jean-Louis Aubert (1731–1814), writer and professor of literature at the Collège de France, published *Fables* in 1774.

[52] 'Domestic Contentment.'   [53] 'A Cake for Kings.'

[54] 'The Mother.'   [55] The Grandmother.'

[56] 'The Paralytic Tended by his Children.'   [57] 'The Torn Bible.'

[58] 'The Dry Nurse.'   [59] 'A Good Education.'

[60] 'An Affecting Separation.'   [61] 'The Nurse's Return.'

Happiness and Duty might leave in our thoughts? Greuze effects nothing of this kind. His work lacks such a penetrating harmony, such a moving simplicity, such an ennobling purity. The impression he gives is complex, disturbed, mixed. For his art suffers from something worse than a defect, it has a vice: it hides a kind of corruption, it is essentially sensual, sensual in its content and in its form, in its composition, its drawing and its very brush-strokes. The kind of virtue that reappears continually at his touch seems invariably to have emerged from the stories of Marmontel. A picture of family life, interpreted by Greuze, loses its seriousness, its gravity, its meditative calm. There is something airy and coquettish in his touch which deprives motherhood of its sanctity and dignity. When he would depict conjugal happiness in two figures leaning over a cradle, the parents seem to smile with the smile of sensual pleasure, the gesture of the mother is the caress of the demi-mondaine. In everything he did, the character of the times, the character of the man influenced the ideas of the painter, investing all these moral narratives with a suspicion of libertinage, at times allowing us to discern in his character of moralist no more than a Baudouin with an official veneer of virtue. His pictures involuntarily recall those *Pantins du Boulevard* in which, next to an indecent picture, appeared the epigraph: 'This picture made for Greuze reveals the shrine at which he worships.'

Even in his purest conceptions, we seem to detect the white locks—so admired and respected by Madame Lebrun—paraded, dragged and soiled in the cabarets of Nicolet, of the Associés, of the Beaujolais and of the Délassements-Comiques.[62] His women reveal the type of model he employed, young ladies such as Mademoiselle Gosset . . .

*[62] Jean Baptiste Nicolet (1728–96), was the director of a popular theatre in the Boulevard du Temple, celebrated for the audacity and the inexhaustible novelty of its various productions. The Théâtre des Beaujolais was built by the Duc de Chartres in 1783 for the amusement of his youngest son, the Comte de Beaujolais; it was devoted to puppet shows and mimes acted by children. The Théâtre des Délassements-Comiques was built in 1785, also in the Boulevard du Temple; its repertoire was confined to pantomime, comedy and comic opera.

Grouping, accessories, poses, attitudes, costumes, everything in the art of Greuze conspires to produce this sensual irritation. The poses are facile, abandoned; the necks project, invitingly from the nestling bodies. The dress, the whole attire reinforces the effect by adding to the voluptuous softness of its texture the amorous appeal of its colour. Between Woman, as represented by Greuze, and Desire, there subsists no longer that barrier— the rigid bodice, the sober *fichu*, the stiff, solid, almost conventual dress—which protects the housewives of Chardin; everything floats and flutters, all is cloud-like, capricious, freely flowing about the limbs; the linen seems to frolic with the very charms it is assumed to hide, and Greuze drapes it about his female models so that it titillates them at the small of the arm, at the top of the breasts; and it is no longer the rough household linen, newly washed from the farm laundry and faintly buff in colour: it is the linen of amorous undress prompt to fall into folds and creases, the linen of the kind of cap that easily drops off, of those lappets which tremble against the tips of blushing ears, the linen of gauze *fichus* which reveal the pink of the skin and palpitate in time with a beating heart, veils designed to be undone with a breath! The lacing of the corsets and brassières, tied with floss silk, is slack; it is a loose kind of attire, unresistant, unattached and ready to float to the floor at the first provocation. The peculiar subtlety of this art is in its transformation of the simplicity and heedlessness of a young girl into something sensually inviting. It bestows a mischievous coquetry, a thousand tantalizing creases upon the most virginal attire and yet contrives that it should be still suggestive of chastity. And white, the colour dedicated to youth, to the candour of women and the radiant modesty of their dress, becomes, in these pictures, an irritating stimulus, a delicate excitation to licence, an allurement, a light that persistently brings to the mind some aspect of the 'Lever des ouvrières en modes'.

From all this white, from these lawn transparencies, from this disordered cambric, what sort of woman comes to life beneath the touch of the painter of 'La Cruche cassée',

'L'Oiseau mort'[63] and 'Le Miroir brisé'?[64] A beautiful creature with defenceless eyes, her lips shining with a moist light, her gaze liquid, abstracted, and yet lively and very much on the look-out beneath the lowered pupils. It is Parisian innocence in the eighteenth century, an easy innocence lingering on the brink of defeat; it is the fifteen-year-old Manon; the miniature laundress so accommodatingly naïve in the little bedroom of Desforges.[65] Greuze has no other purity to bestow upon the young girl, whose features he repeats so often, except the purity of a smile, of youth, of fragility and of tears. Virginal modesty as he expresses it takes us back once more to the book of which he has already reminded us; the ingenuousness he personifies is the ingenuousness of a Cécile Volanges, an ingenuousness without strength or remorse, yielding to a surprise, to the senses, to pleasure with the charm and skill of a kind of angelic hypocrisy, a kind of natural duplicity. Consider thoroughly this *ingénue* who was the source of the artist's success, of his fame, and it will strike you that the painter introduced her to an aging world, offered her to the exhausted appetites of the eighteenth century, as a perverted child might be offered to an old man to reawaken his senses.

## VIII

Greuze had made a great deal of money. His pictures sold at very high prices and his association with Massard, Gaillard, Levasseur and Flipart for the exploitation of engravings after his works had brought him in a fortune. For several years, Paris, the provinces, abroad, had neither desired nor acquired the prints of other artists. Baudouin, Lavreince, all the producers of pornographic prints were relegated to the attic, expelled by morality in the image of Greuze, a morality of which representations may still be found on the walls of old

★[63] 'The Dead Bird.'   ★[64] 'The Broken Mirror.'

★[65] The actor and playwright, Pierre Jean Baptiste Choudard, known as Desforges (1746–1806), published in 1798 an autobiography, *Le Poète ou Mémoires d'un hommes de lettres,* in which he recounted the amorous adventures of his youth.

country houses. In addition to this vogue, Greuze and his partners also profited from collectors' whims, which they skilfully flattered, excited and stimulated, by inventions and peculiarities not hitherto employed by French print-sellers. There was the allurement of all kinds of 'states' and variations, a positive scale in the quality and differences of proofs after the same composition, designed to stimulate taste and provoke the vanity of the collector. No distinction was overlooked; proofs were printed before the insertion of the inscription, before the coat of arms, before the dedication, before the address, before the title of Court Painter. It was a kind of apparelling of the print from the underclothes to the ceremonial coat; it was sold in every possible vesture, it was bedecked with every possible ornament and the success was so marked that, in order to avoid faking of the various 'states' and to authenticate their productions, Greuze and his engravers signed them on the back.[66]

The Revolution robbed Greuze of everything. His fortune vanished in *assignats*,[67] his fame declined, his work was gradually forgotten. Slipping into poverty, he finally vanished in oblivion. He grew old, a survival of himself, dragging along with him the heavy burden of a dead reputation. His period was already the past, his public had lived their lives. At each new picture by David, silence and contempt gathered increasingly over the painting of the *ancien régime*. Greuze passed his last years listening to the sound of his renown fading out; he supposed himself to be witnessing the ingratitude of posterity. It was an unhappy end, like an expiation of success, a cruel test to which so many spoilt children of the eighteenth century were subjected, thrown over by the Revolution, removed from their natural sphere, bewildered, exiled in time, having neither a country nor a sun to reflect their fame, like lonely survivors from the wreck of a submerged world!

[66] Letters from a traveller to his friend Sir Charles Lovers, living in London.

[67] In 1792, Greuze was granted a pension of 1,537 *livres*, 10 *sous*, as an official recompense for his labours.

The groans of this wretched, poverty-stricken old age, for-gotten and heart-stricken, are audible in the following painful appeal addressed to the Minister of the Interior:

The picture which I am painting for the Government is half finished. The situation in which I find myself compels me once more to ask you to give instructions for a further advance to be remitted in order that I may finish it. I have had the honour of communicating to you all my misfortunes; I have lost everything except my talent and my courage; I am seventy-five years old and without a single commission; I have never in my entire life experienced a more difficult moment. You have a kind heart, I flatter myself that you will show some·consideration for my distress as soon as possible, for it is a matter of urgency.

Salutations and respects.

The 28th day of Pluviôse, in the year IX.                  Greuze.
        Greuze, Rue des Orties, Galerie du Louvre
                                                  Nº 11.

There remained, however, one aspect of the life of Greuze in which he could continue to rejoice; a woman worthy of the name of Antigone stayed at his side. The devotion of a woman of the streets clung and floated about him like a caress until the day of his death. Hers were the hands of the Family supporting the Paralysed Father.

Greuze died on the 30th day of Ventôse in the year XIII (21 March 1805), and to follow the bier of the man whose engravings had found their way all over the world, who had been visited by an emperor, and whom an entire society had adored, there were left only two persons: Dumont and Berthélemy.[68]

★[68] Jean Simon Berthélemy, the painter (1743–1811), was elected a member of the Academy in 1781. Two ceilings in the Palais du Senat (the Luxembourg) are from his hand. Dumont was the name of a family of sculptors; the reference is to Jacques-Edmé, a pupil of Pajou and the author of various works of sculpture in Paris, at the Louvre, the Luxembourg, the Palais de Justice, the church of Saint-Sulpice.

# NOTES

GRÉTRY, who married a daughter of Grandon and not Gromdon, as Madame de Valori called him, gives an interesting anecdote, in his *Essais sur la musique*, illustrating the amorous temperament of Greuze, during his period of study under the Lyon painter. Greuze was secretly consumed by a passion for his master's wife, who was very beautiful. One day, Grétry's wife, at that time still very young, found him lying on the floor of the studio and asked him what he wanted. 'I am looking for something,' was the reply; but she had already noticed one of her mother's shoes and that he was occupied in devouring it with kisses.

<p align="center">★  ★  ★</p>

In a letter which appeared at the sale of M. Sensier's collection of autographs, and is now in the possession of M. Henri-Lambert Lassus, Natoire, writing on 22 December 1756, speaks thus of Greuze:

'I have had the honour to receive your letter of November 28 on the subject of M. Greuze and the benefits you are good enough to confer upon him. I have communicated to him your views and intentions by reading to him the relevant parts of your letter to which he seemed duly responsive. After giving the matter serious reflection, however, he begs me to inform you, Monsieur, that since his health will not allow him to stay long in Rome, he has decided to leave in about two months time, and that if you can be good enough to continue your assistance, he will labour to deserve it, as soon as he arrives, by executing the two paintings for which you have asked. He is a young man who works with difficulty and, in spite of all his talent, easily succumbs to innumerable impressions which upset his tranquillity.'

Here is another letter from Natoire concerning these two pictures, which were commissioned by M. de Marigny in the name of Mme de Pompadour:

<p align="right">22 February 1757.</p>

I have informed M. Greuze of the contents of the letter concerning him which you did me the honour of writing to me on January 13th and in which you refer to the two pictures you require of him and consent to await his return to France before he paints them. He continues to be grateful for your kindness towards him. He has just finished the companion piece of a picture, for M. L'Abbé Gougenot, in

which there is considerable merit; it will be almost his last work executed at Rome.

I would also quote the interesting letter containing this commission which, in accordance with the instructions received on 13 January, Greuze postponed carrying out until his return:

at Versailles, 22 November 1756.

I learn with great pleasure, Monsieur, that the sieur de Greuze is wholly devoting himself to the cultivation of his gift for painting; I have seen in Paris pictures which he has sent from Rome and I was so satisfied with them that, knowing how very limited are his resources in money, I resolved to procure him opportunities whereby he might support himself by his work and by this means perfect his talent. Kindly arrange to set aside a room, in the apartments occupied by the late Mme Wleugelles, which he could conveniently live in and in which the light would be adequate for his work; and be good enough to offer it to him. He will thus be spared the payment of rent, a saving, which however exiguous it may be, will afford him some slight relief. Enclosed is a piece of paper cut into the shape of an oval which I should be obliged if you would give him so that he may paint two pictures of the same size. I leave it to his genius to choose, freely, the subject he may prefer. These two pictures are destined for the apartments of Mme de Pompadour at the palace of Versailles. Urge him to bestow all his diligence upon them. They will be seen by the whole court and might procure him great advantages if they are considered to be good. Recommend this commission to him particularly and assure him that I shall avail myself, with pleasure, of any opportunities for his advancement which may arise.

The Marquis de Marigny.

Greuze left Rome in the following April.
(Letter dated 20 April 1757.)
*Académie de France à Rome*, by Lecoy de la Marche, *Gazette des Beaux-Arts* (September 1870–1).

*       *       *

M. Renouvier quotes, in the *Revue universelle des arts*, 1855, a note by the Abbé Gougenot which is a revelation of the artist's character and habits of work during the Rome period:

'Greuze was the most capricious of artists. To satisfy him, it might be necessary to gather together at short notice all the models required

for the composition of the picture on which he was engaged at the moment. But then, no sooner were they assembled than he would announce that his inspiration had vanished and that he no longer felt able to work; and he would dismiss his models, who, nevertheless, received the agreed fee for the sitting. Such moody and fantastic behaviour was a frequent expression of this peculiar personality.'

\*    \*    \*

In the *Feuille nécessaire* for 1759, quoted in the *Revue universelle des arts* in 1863, we read the following:

'M. Greuze has just completed a copy, in his own hand and in a manner which proves his great resourcefulness in the practice of his art, of his picture "La Simplicité", exhibited at the Louvre and now the property of Mme \*\*\*. Since this picture very much attracted a certain lady of the Court to whom the arts are so indebted that nothing can be refused her [Mme de Pompadour] the proprietress of the work declared that, if it gave her pleasure, then she should consider it as hers. The painter wished to compensate Mme \*\*\* for a sacrifice that so greatly flattered him. He has just finished—from the same model whom he used for the first version, whose innocent features expressed so well the character of simplicity he wished to portray—a second picture in which his talent has surpassed itself. He has put in a background which sets off the composition more effectively and has corrected various faults which had found their way into the original version.'

\*    \*    \*

A curious caricature of the time satirized the ridiculous ill-nature of Madame Greuze and, at the same time, both pierced the vanity of the painter and mocked the rapacity of Levasseur, the favourite engraver of Greuze and his wife. It deals with the publication of the engraving 'La Belle-Mère'. It is an etching and represents an obelisk on which, above the print, appears a head without a brain and the inscription: *Creuse*. The obelisk has been made to totter by the movement, beneath its pedestal, of a head smoking a pipe. The smoke from the pipe forms the letters of the following legend: *La bourse et mes écus fit*. Behind, unshakably erect, rises a second obelisk, bearing Flipart's medallion surmounted by the word *Virtus*, crowned. The commentary, traced by the point of the etcher and pamphleteer, runs as follows:

'Dedicated to that very distinguished, powerful and ridiculous lady, the wife of J.-B. Greuze sometime admitted to membership of

the Academy as a *genre* painter, on the evidence of a history painting—
by her historiographer.

'One day, in the company of his old hag of a wife, and incited by
a residue of empty pride, G. said to Jeannette: "I want to cover you
with glory; I want to give birth to a subject that will horrify all decent
people. You, my sweet, shall serve as my model; I propose to paint
a wicked woman." '

'EXPLANATION OF THE OBELISK

'M. Levasseur (the engraver of 'La Belle-Mère'), crushed by the
fall of the obelisk erected in honour of the defunct celebrity of Greuze
—an accident caused by a pin-prick in one of the bladders serving as
a foundation to the monument on which may be seen the portrait of
Greuze crowned with thistles and peacock's feathers . . . the whole
completed by a catcall.

'New edition, revised, corrected and augmented, the first edition
having been sold out in three days.'

<p style="text-align:center">★     ★     ★</p>

Miger has given an interesting account of the vanity of Greuze.
'Only vain fools', he writes, 'can believe themselves to be perfect
beings. Such a one was the painter Greuze, for whose art there was
no inducement to risk the most modest expression of approbation,
for he assumed himself the function of encomiast. He lacked nothing
but a lamp in front of him in which to burn incense for his own
honour and glory. Here is one of his little observations on this subject.
At the time when general exhibitions of pictures were held, he said
that persons interested in the arts might rush through the Salon like
a post-boy, whip in hand, and exclaim, if they wished: "Ah, how
fine it is!" but that a real connoisseur would hurry off, as morning
broke, in dressing gown and night cap, as it were, and stop in front
of his [Greuze's] pictures, remaining there all day in a state of ecstasy.
*Ecce homo.*' (*Biographie du graveur Miger*, by Bellier de Chavignerie,
1856.)

In an address offered by the painters of Paris to Lebrun, who had
opened an exhibition in his own reception rooms, an address com-
posed during the early years of the Revolution and signed by Greuze,
the signatory expressed himself in these terms:

Monsieur, we have not forgotten that, in circumstances in which
France and Paris were ignorant of any conception of that splendid and

sublime liberty which is the life of the fine arts, you generously threw open your house for the exhibition of our works. Today, Monsieur, you repeat that favour. Monsieur, it is due to your attentions and it is under your auspices that our productions have been assembled. Moved by sentiments of a lively gratitude, we should be justified in inscribing over the door of the sanctuary you have offered us : Exhibition for the encouragement of the arts ! What finer name could be bestowed upon it since the honourable and virtuous Chief of the Commune [Bailly] and the general of our citizen's army have honoured our activities with their notice ? May this happy augury prove as great a stimulus to our emulation as our gratitude to you, Monsieur, is extensive and lasting.

<div align="right">Greuze.</div>

<div align="right">In the name of the Commission.</div>

(*Catalogues d'autographes*, by B. Fillon, 1874-5.)

<div align="center">*    *    *</div>

Greuze suffered from a horror of old women, and, on one occasion, his palette dropped from his hands—so great was the shock he received—when an ancient coquette, who was one of his neighbours, showed herself at his window with her simperings and her painted face. M. Pillet adds that he was fond of personal adornment and flashy clothes, and that he was seen taking a walk, at the height of the Revolution, in a scarlet coat with a sword at his side.

<div align="center">*    *    *</div>

With reference to the picture 'L'Accordée de village', purchased by M. de Marigny for 3,000 *livres* and acquired by the King for 16,650 *livres* at the former's sale in 1782, we may quote a few interesting documents, extracted from the *Nouvelles Archives de l'art français*. Here is Cochin's note determining the desirability of the purchase, ' "L'Accordée de village", by M. Greuze, is the finest picture he has painted in this genre and for this reason it is to be considered worthy to enter the royal collection.' And here is Pierre's : 'The finest picture by M. Greuze, excellent and even beautiful; the glazes applied by M. Greuze have evaporated with the result that the work now suffers from a general crudity of appearance which was not there before. Pictures painted in full colours improve with the years; those whose harmonies are superficial deteriorate. Every artist has been struck by the present instance.' The letter from the Director

General which follows, dated 3 April 1782, and in which he issued his instructions to the Chief Court Painter for the purchase of the picture, declares: 'There remains to be mentioned the picture by M. Greuze to be sold on Thursday; I was aware of this, and I had proposed to fix definitely, before now, the price which I considered should be put upon it in order to secure it for the Royal collection. Having due regard, on the one hand, to the disagreeable possibility of failure to purchase and the risk, in that case, of the picture going abroad and, on the other, to the state of the King's treasury, I feel obliged to fix the sum at 20 or 24,000 *livres* at the most. You can give the sieur Joullain his instructions, in accordance with this decision.' These documents conclude with a letter from Joullain, dated 6 July 1782, in which the expert applied for his commission on the sum of 16,650 *livres* at which the picture was sold.

# FRAGONARD

THE last century had no poets; I do not mean rhymers, versifiers, word-spinners; I say poets advisedly. Poetry in the noblest and most profound sense of the term, poetry which is creation through imagery, poetry which is an enchantment, an enhancement of the imagination, an ideal of pensive meditation or smiling delight offered to the human mind, that poetry which lifts up from the earth, with throbbing wings, the spirit of an age, the soul of a people, such poetry was unknown in eighteenth-century France; her two poets, the only two, were painters: Watteau and Fragonard.

Watteau, a child of the north, of Flanders, was the great love poet, the master of a serene and tender paradise whose art is like the Elysian fields of passion; he was the elegiac poet amid whose tristful autumn woods, around whose wistful image of pleasure, all the sighing of nature was magically audible; he was the *pensieroso* of the *Régence*. Fragonard sang in less elevated strains; he was the poet of the *ars amatoria* of the age.

You remember that mischievous, impudent cloud of naked cupids, vanishing into the sky of the 'Embarquement pour Cythère'? Their destination was the studio of Fragonard, where they shed the dust from their butterfly wings on to his palette.

Fragonard was the audacious raconteur, the gallant *amoroso*, pagan and playful, whose wit was Gallic, whose genius was almost Italian, whose bright intelligence was French; he was the creator of ceiling mythologies, of a hundred latitudes of dress, of blushing skies roseate with a reflection from the naked forms of goddesses, of alcoves luminous with the glow of a woman's nudity. Imagine the breeze of a fine day turning for you the pages of his engraved works as they lie on your table next to a vase of roses: from a vision of satin frocks, in mimic flight, escaping across the grass, the eye is rapidly diverted to glimpses of fields tended by a fifteen-year-old Anette, of barns

in which the gambollings of pleasure have upturned the painter's easel, of meadows where the milkmaid goes bare-legged with her pail of milk and mourns, like a nymph over her broken urn, a lost sheep or, it might be, a faded dream. On another page, a girl in love inscribes, as the summer light declines, the name of her beloved on the bark of a tree. The breeze still turns the pages; and to a vision of a shepherd and shepherdess embracing in front of a sundial, whose carven cupids compose a calendar of pleasure, succeeds the charming dream of a pilgrim, asleep beside his staff and his scrip, to whom a bevy of young fairies appears skimming the soup in a great saucepan. . . .

We are charmed by the illusion of a fête by Boucher staged by his pupil in the gardens of Tasso. In this entrancing magic lantern, Clorinda follows Fiametta, the light of chivalry illumines the smiles of the *novellieri*. Stories told by the fairy Urgèle,[1] playful comedies, gay shafts of sunlight such as brightened the canvas on which Beroald de Verville[2] depicted his little cherry-picker—of such elements the painting of Fragonard is compact. It recalls the felicitous spirit of Tasso, Cervantes, Boccaccio, Ariosto—the Ariosto whom the artist illustrated, an Ariosto inspired by Passion and Folly. It smiles upon us with the freedoms of La Fontaine; the scope of its inspiration ranges from Propertius to Grécourt,[3] from Longus to Favart,[4] from Gentil-Bernard[5] to André Chénier. It has,

---

[1] The fairy Urgèle appears in Voltaire's story *Ce qui plaît aux Dames*. She was the heroine of Favart's libretto for the opera, *La Fée Urgèle*, composed by Duni and produced in 1765.

[2] Beroald de Verville (1558–1612), Canon of Saint-Gratien, Tours, and the author of somewhat audacious love stories, including *Les Aventures de Floride* (1594–1601) and *Les Aventures d'Aelsionne* (1597).

[3] Jean Baptiste Joseph de Grécourt, a writer of facile, licentious verses (1683–1743), was appointed a canon of Saint-Martin, Tours, at the age of thirteen. He later left the church for a life of epicureanism.

[4] Charles Simon Favart (1710–92), the pastrycook and playwright, was one of the outstanding librettists of his time. *Les Trois Sultanes* (1761) and *Anette et Loubin* (1762) were among his most spectacular successes.

[5] Pierre Auguste Gentil-Bernard, the erotic poet (1708–75), was admired by Voltaire. His *Art d'aimer* appeared in 1775.

so to speak, the heart of a lover and the hand of a charming scoundrel. Within its frontiers, the breath of a sigh passes in a kiss. It is young with a perpetual youth; it is the enchanting poem of Desire, and it is enough to have written it as Fragonard wrote it to remain what he will always be, the Cherubino of erotic painting.

## II

Jean-Honoré Fragonard was born at Grasse, in Provence, on 5 April 1732. It was a delightful countryside, an orchard of laurel, lemon, grenadine, almond, citron, strawberry, myrtle, bergamot and other scented trees and shrubs; a garden of tulips, of carnations which grew only in the flower beds of the Alps and whose dazzling colours were unknown in the north; a region drenched in the perfume of thyme, rosemary, sage, spikenard, mint and lavender, and resonant with the gushing of innumerable fountains; a land 'interlaced with vines'—the phrase in which Salvien,[6] the Marseilles priest, described it— vines in whose shadow pass and repass continually the great flocks driven down from the mountains of Provence to its plains; a land bounded by the azure horizon of the Mediterranean! It was a joyous landscape, a place of pleasure, enlivened by laughter, music and dancing, full of the light-hearted happiness, the songs, the dances, the volubility of a local population who, in the eighteenth century, made of their lives a festival to Pan beneath the softest and purest sky in all Europe. Among the many bowers in this garden, Grasse, the cradle of the painter, shone forth; it was the distillery of this paradise, a town of sweets and scents, of perfumers and confectioners; a place where gardens rose one upon another, a place of golden fruits, silver blossomings, and forests of wild orange trees, with the river Foux curling amid the verdure of its immense meadows, a place whose southern prospect carries the eye to Monans, La Mougins, Châteauneuf, the plain of

---

*[6] The priest and writer, Salvien (c. 390–c. 484) married the pagan Palladia and converted her to the Christian faith. His ordination as a priest was authorized c. 480. Little of his prolific writings has survived.

Laval and the sombre Esterel, and vanishes far away into an infinite blue softness—the sea in which Italy is lapped!

Here Fragonard was born, and it was here that his spirit was nourished. His character and temperament were the fruit of his native soil. As he grew up, he absorbed the atmosphere of this southern region, of this climate whose serenity sustained the poor, was almost their sufficient diet. And we may recognize throughout his work an artist whose earliest youth had been blessed by a southern sky, had received the accolade of Provençal sunlight. He reflects the gaiety and the happiness of light like a man whose childhood had been saturated in its glow. The least of his sketches exhales a warmth, a scent, an effluvium arising from the country of his birth. He held in his hand the reflection of his native sun and, in his heart, its beams. In composing his palette, he favoured exclusively the blues, whites and red-browns of the Midi. The light that flashes in his pictures is the same as flickers over the Provençal orange-groves; and when he flings open a window in one of his interior scenes or in the background of one of his illustrations to La Fontaine, the view is always of a Provençal landscape, preluding the beauties of Italian scenery. His rustic figures assume the undress of an open-air life, the semi-nudity of those blessed lands where the corn can be ground in the open fields; and here and there, throughout his work, appear the white Provençal hat and the characteristic cap of the Mediterranean sailor. For preference his scenes are laid in the shadow of those arched structures, those low vaults or arcaded alleys, the caves of Romanesque art which provide the region of Provence with shade and coolness. The earthenware utensils remembered from his childhood and often, also, those great jars, in which were stored the oil and wine of the country, reappear in the backgrounds of his works. And the scenery of his youth dominates his landscapes in which are entwined, in a fine confusion, its bright vegetation, its wild, rugged bushes, and the medley of green and flowering shrubs which grows near the fountains of Traconnade, of the Foux and of Merveilles and is watered by their streams; and his best-loved plant,

which reappears in his compositions with capricious recur-
rence, as in a Japanese album, is the tall, trembling reed, full
of Oriental grace, light and wildness, which struck his infant
eye on the banks of the Provençal canals. It is as if he had
carried thence armfuls in which to frame his work.

Every aspect of his art derives from the Midi, his palette, his
imagination, the flower of his ideas, sentiments and colours;
we might say of all his paintings that they were improvised,
beneath a blue sky, upon an easel in a garden, wrapped in the
serenity of the atmosphere, in the breath of summer, sur-
rounded by musical sounds and echoes amid which die away
the mingled strains of a troubadour's song, of a *canzone* by
Petrarch, the last sighing notes of the Courts of Love and the
harmonious splashing of the Vaucluse fountains.

But his birthplace is the clue not only to the quality of his
painting, but also to his character as a man. Surely Provence—
then familiarly known as *la Geuse parfumée*—was the fairy
godmother who baptized him at birth. He seems to have
derived more than his talent from his native province, to have
been indebted to it also for his breeding and his temperament,
for the graciousness of his destiny, for his benevolence,[7] for a
nature that was delighted to be alive, a gaiety which hovered
above the seriousness of life, a gentle obstinacy in pursuit of
success, a leisured activity, an indolent diligence, an ambition
to gather, in life and in art, only the rosebuds, a love of flowing,
effortless existence, an indifference to the future—and all this
was sustained, heightened by a bright trust in Providence, a
confidence which inspired the amusing reply to a question on
his beginnings as an artist and the manner in which he devel-
oped his talent: 'Manage as best you can, said Nature, and
pushed me into existence.'

[7] The benevolence of his character was laced with the eccentricities, crotchets
and caprices which we associate with the artistic temperament. On one
occasion, Saint-Non, who with a numerous company of friends was awaiting
the arrival of the artist in his drawing room, greeted his entry with outstretched
arms and the words: 'Here is my king, my prince!' Fragonard evaded the
proffered embrace, turned his back on his host, regained the front door,
and departed.

## III

Fragonard's father was a tradesman of Grasse. He invested his entire fortune in a speculative undertaking of the brothers Périer, the establishment of the first steam-pump in Paris. On the complete failure of this project, he came to Paris with his wife with the object of recovering some part of the funds which had been invested in this ill-starred enterprise. But his endeavours met with so little success that he was reduced to accept employment as a draper's assistant. His son was then nearly fifteen years old. Without the means to educate him, he obtained for him a place as junior clerk to a notary. But the young clerk, instead of attending to the task of engrossing documents, spent most of his time drawing caricatures. In the end, the notary persuaded his parents to apprentice him to a painter, and one fine morning he was taken by his mother to call upon Boucher; Boucher, however, told her that it was not his practice to instruct pupils in the ABC of painting, and that he could only take her son when he had acquired the rudiments of the art. His mother then took him to see Chardin who employed him to lay out his palette and, though, in Chardin, the action must strike us as a somewhat shocking one, gave him contemporary prints to copy, the only form of education which was then ordinarily available in the studios. Fragonard, who had no liking either for the style or the subject matter of his master, whiled away his time in idleness and produced so little evidence of his talent that Chardin informed his parents that there was nothing to be done about him and that he would never succeed. But at the very moment he was proving such a bad student under Chardin, Fragonard spent a part of the time that he was assumed to be wasting looking at pictures in the Paris churches; these he was able to commit to memory and copy when he got home. One day, armed with a group of such copies, he decided to call again on Boucher who, this time, was astonished by their skill, accepted Fragonard as a pupil and employed him on the large-scale designs ordered by the Gobelins factory on which it was his

habit to set his pupils to work. This was Fragonard's real
apprenticeship. His skill as a colourist was developed by
working for tapestry. At the end of two or three years, Boucher
made him this simple announcement: 'Enter for the Prix de
Rome'; and when Fragonard objected that, since he had not
taken the Academy course, he was ineligible as a competitor
'No matter,' replied Boucher peremptorily, 'you are my
pupil'. Acting on this curt recommendation, Fragonard com-
peted in 1752 and won the prize, an extraordinary achieve-
ment for a youth of twenty-one, and an achievement which is
probably unique in the history of the Prix de Rome. One of
his rivals was Gabriel de Saint-Aubin, who won the second
prize. The official subject was 'Jeroboam sacrificing to the
Idols'. Fragonard's picture can be seen today at the École des
Beaux-Arts. The animation in the grouping, the impetuosity
in the draperies, the reds and white which recall de Troy, but
a de Troy more vaporous and *gouacheux*, are an early pledge
of the quality of the mature Fragonard.

As the successful competitor for the Prix de Rome, Frago-
nard was enabled to work in Italy; but the charming painter,
brought face to face in Rome with the model, lost his head,
lost it so well that Natoire, surprised by the inadequacy with
which he worked from the life, was moved to accuse him of
having deceived the Academicians, and of not being the
author of the picture whose success had entitled him to make
the journey to Italy. He threatened to write to Paris about this,
and it was with great difficulty that Fragonard persuaded him to
postpone this action and to grant him a respite of three months.
Fragonard took advantage of this interval to work night
and day both from the life and from anatomical casts. Natoire
soon recognized that he had been mistaken; a friendship grew
up between them and it was due to Natoire that Fragonard
subsequently obtained an official extension of his stay at Rome.

The truth was that, at first, Boucher's pupil was out of his
element at Rome. The old masters spoke to him in a language
that was too severe and which he did not understand. He con-
fessed as much on his return: the most celebrated paintings

struck him at first as gloomy and monotonous and then completely discouraged him. 'The energy of Michelangelo terrified me,' he said; 'I experienced an emotion which I was incapable of expressing; on seeing the beauties of Raphael, I was moved to tears, and the pencil fell from my hands; in the end, I remained for some months in a state of indolence which I lacked the strength to overcome, until I concentrated upon the study of such painters as permitted the hope that I might one day rival them; it was thus that Baroccio, Pietro da Cortona, Solimena and Tiepolo attracted and held my attention.'[8]

Having once discovered the more accessible charms of these decadents, Fragonard lived in their company. He studied, questioned, copied, penetrated them. He entered into their works and might almost be said to have despoiled them. From Tiepolo, he took his cleverness and his scintillation; from Solimena he borrowed the sensuousness of his brushwork; from Pietro da Cortona, his trembling sunbeams, his uncertain, dancing light; and from Baroccio, his miraculous dabblings and the floating vagueness of his paint. This passionate labour, in which he held the masters he loved in the close embrace of his emulation, taught him to apprehend their secrets and their style, to discover their processes and techniques, to find their very handwriting in his own. It was thus that he became the painter who was one day to fling on to the canvas a Rembrandt with all the smoked gold of its lighting or to suffuse his painting with all the crimson animation of a Luca Giordano; he was an inspired *pasticheur* who had always with him, even in his most personal moments, the memory and the support of this familiarity with the technique of his masters.[9]

[8] We are indebted for these details concerning the childhood and youth of Honoré Fragonard, as also for various other items of information on the more intimate aspects of his life, to the kindness of his grandson, M. Théophile Fragonard, the painter on porcelain attached to the Sèvres factory, who there carried on the traditions of grace and artistic probity associated with the name of Fragonard.

[9] The collection of M. Walferdin, who passed a lifetime in discovering, loving and preserving the art of Fragonard, was full of such *tours de force* by the master, of brilliant borrowings from nearly all the great colourists.

While in Rome, copies and drawings issued from him in a flood. He drew in palaces, churches, museums, going from Raphael to Lanfranco, from Correggio to Caravaggio, amassing a thousand studies, sketches in bistre dashed off in haste, sometimes glowing with touches of crimson lake, rapid notations in *sanguine*, in Italian chalk, a host of drawings which retained a charming Gallic savour, a polish and a flamboyancy derived from the Paris studios. But that was not enough: in rivalry with Hubert Robert, Fragonard scoured the vineyards, the villas, the ancient buildings, and here also he found subjects for his chalks at every instant of the route. At his touch and at that of Hubert Robert, the desolation of the Campagna assumed a smile, the amiability of a 'wilderness' in an eighteenth-century park. The majesty and the sorrow are no longer there; beneath the playful gaiety of their approach, ruins seemed to frolic with the foliage which overgrew them; the tombs of antiquity brightened the landscape; the classical relic in this guise would have been passed unrecognized by the archaeologist; monuments became a *décor*. The spirit of the two French artists bestowed upon all they saw the imaginative prettiness characteristic of their period; for them and for their time the only Rome was the Rome they painted, as if it were a fowl-house by Boucher installed among the debris of a ruined triumphal arch. And it was to them that the Abbé de Saint-Non applied as soon as he arrived in Italy. From 1759 to 1761, they acted as the titular draughtsmen of anything that roused the admiration or the curiosity of the abbé in the course of his tours. They were his habitual guests, his constant companions, at the Villa d'Este, at Tivoli, which had been lent to him by the Modenese ambassador, and where he stayed for several months at a time. They were his travelling companions in Southern Italy and the friends who made drawings—Hubert Robert of the scenery of Naples, and Fragonard of its museums —to be subsequently engraved as illustrations for his great book on Neapolitan antiquities.

In the midst of these ardent labours, of this incessant production of studies from nature, sketches for compositions,

views, landscapes and copies, Fragonard, perpetually active and alert, yet found time for the practice of etching (encouraged perhaps by the amiable Saint-Non, himself an etcher), somewhat after the fashion of the old Italian masters who sought relief from the brush by working with the needle. There existed at the time in Rome a small centre for the production of engraved illustration which proved an inducement to French painters, hitherto reluctant to reproduce by this means their pictorial fancies, to take up etching. And it was here that Vien, in 1748, immortalized in a series of plates, the ingenious Masquerade performed by the École de Rome,[10] which had compelled even the ambassadors of those powers then at war with France to acknowledge the excellence of our taste and had drawn from them a spontaneous cry of *Vive la France!* At Rome also was produced, in 1764, the charming little book[11] compiled by the students at the French School as a tribute, on her arrival in Rome, to Madame Lecomte, the mistress of Watelet. All had some part in the production of this work; Weirotter, Durameau, Hubert Robert, Radel contributed allegories amid which a cupid bearing a portfolio of drawings floats in the sky above a representation of the illustrious tourist; and Subleyras and Lavallée Poussin decorated the text, composed of Italian sonnets, with ornamental borders which developed into idylls, with arabesques that became views of Rome, and friezes formed out of miniature nymphs or of coquettish faces smiling beneath the papal tiara. It was at some date between the production of these two books, rather nearer that of the latter, that Fragonard made his first attempts at etching and discovered at once a natural aptitude for the free scratchy technique of the Venetians. He made engravings after Tintoretto, Lanfranco, Ricci, the Carracci and, again and again,

----

[10] *Caravanne [sic] du Sultan à la Mecque. Mascarade turque donnée à Rome par Messieurs les pensionnaires de l'Académie de France et leurs amis au Carnaval de l'année 1748.* Paris, Basan and Poignant, print-sellers, Hotel Serpente, Rue Serpente.

[11] Nella venuta in Roma di Madama Le Comte et dei Signori Wattelet e Coppette. Componimenti poetici dei Luigi Subleyras colle figure in rame di Stephano delle Vallée Poussin, s.l., 1764.

after Tiepolo, whom he regarded as his master in this medium, all small plates rapidly executed and resembling the sort of rough sketch that might serve to fix a memory or an impression on the page of a drawing book. And sometimes, on a plate the size of a visiting card, he would make a rapid record of the garden of some abandoned villa, a canopy of trees densely shadowed and pierced by a single shaft of daylight, or a terrace where slumbered the forgotten statue of a god caressed by overhanging foliage; and beneath the confusion of lines, the *grignotis*, as it would have been called at the time, the little landscape sparkles with light and life, with its cascades of branches and disordered mass of grass, its steps and balustrade guarded by two recumbent sphinxes.

But we should restrain our judgement until we have considered him, as an etcher, at his most entrancing, until we have examined the four satyrs included in the series of etchings engraved in Italy in 1763. In one of them, two satyrs squatting on their goat's feet form a seat with their linked arms for a nymph who keeps her balance by holding on with her small delicate hands to the muscles of their biceps. In another, as if in the shadow of a bending reed, proffering the broken barbs of its leaves, a single satyr lifts up a child and makes it offer its hand to an infant faun held in the arms of a nymph, kneeling on one knee, one of her thighs tickled by the hoof of the little faun, her whole pose alive with the gay innocence of the youth of mythic Greece. In a third, an oval, a slender, well-built satyr, his hands leaning on the back of a young man, turns round to bestow a kiss upon a nymph who almost sits astride him and keeps her position by gripping his loins with her legs. In the fourth, in a framework of branches, an ithyphallic satyr, one leg raised and beating out with his hoof the measures of a *kordax*,[12] holds tightly on his shoulders two sleeping children; between their tiny heads his own face peers out smiling like some intoxicated nurse; in front of him, preceded by an infant faun, his limbs waving in the air, the whole of his small body given over to the rapture of dancing, a nymph, whose

★[12] An early Greek dance of erotic character.

dancing steps seem to bear her aloft, her head and breast turned backwards and one foot thrown forward, flings into the air, with upstretched arms, the notes of her lyre.

These are conceptions as light and delicate as any in the Anthology; they are like exquisite bas-reliefs adorned by the engraver with the most charming borders of exuberant foliage and disordered undergrowth. We might conceive them to be wonderful terracottas fallen into the grass around the plinth of a statue of Priapus. Or rather, with their setting of moss, bindweed and reeds of a liquid freshness, we might imagine them to be cameos gathered by the painter from that nymph's grotto where Chloë was wont to bathe.

On his return to Paris, Fragonard could no longer find the time to continue etching; he had neither sufficient leisure nor sufficient patience. And he was hardly ever again to take it up except to assist with his skill and experience, the youthful endeavours of his sister-in-law to master its technique. His only large, important plate, subsequent to his return from Italy,[13] was 'L'Armoire',[14] engraved in 1778, tight and delicately intricate in handling, in which, brightly revealed against a sombre background made up of large areas of flat tone, a pair of angry parents, the father armed with a cudgel, confront a young man, surprised and crestfallen, nervously emerging from a big rustic wardrobe, next to which stands a country girl weeping sheepishly into her apron—a village drama which has attracted the curiosity of a group of children gazing in through the sunlit aperture of a half-open door on the further side of the big farmhouse bed.

Fragonard's Italian studies, his copies, drawings and etchings did not hinder him from also giving some part of his energies to creative painting. The diary of the Duc de Luynes mentions (29 April 1755) the arrival from Rome of a picture by Fragonard, 'Le Sauveur lavant les pieds à ses Apôtres'[15] [16] which was exhibited, in the usual course, together with other works sent

[13] Inscribed at the base: *Fragonard, 1778 sculp. invenit, chez Naudet.*

*[14] 'The Wardrobe.'    *[15] 'Christ Washing the Feet of His Apostles.'

[16] The picture is now in the parish church of Grasse.

by the students of the French Academy at Rome, in the royal apartments. While in Italy, Fragonard also composed, and carefully and patiently executed, a number of small pictures, charming interior scenes, one of which appeared at the sale of M. le Bailli de Breteuil in 1785. It shows a boy, in a rustic interior, trying to embrace a girl, to claim the kiss which he had won from her in a game of cards; the cards can be seen spread out on the table. The girl resists, but a laughing friend, seizing her by the arms, forces her to pay the debt. A note in the catalogue states that the picture was painted in Italy by Fragonard, and doubtless acquired by M. le Bailli during his residence of twenty years in that country. This picture, called 'L'Enjeu',[17] reappeared last year, its provenance unknown, at the sale of Dr. Aussant, when it astonished the public by the softness, the finish, the preciosity of its handling, qualities rare in Fragonard and at variance with his usual procedure and even with his temperament.[18] The little picture is very suave and subtle in colour, a shifting combination of pale mauves, straw yellows, moss greens, and tender pinks expiring in the faint, delightful hue of the tea-rose; it might have been produced from the graded palette of the master of *sfumato*, the great painter of Assumptions and Nativities. Fragonard was clearly seeking that blend of colour which was the source of the Spanish master's mellowness, of its vaporous lights and tones on which we look as if through gauze. And the bodice and the white sleeves worn by the young girl who tries to evade the forfeit of a kiss, her yellow skirt and red petticoat, the faces and the flesh tints in this picture, all its gay soft colour flickering in a grey-green light, indeed recall some little picture by Murillo.

Murillo—it is evident from this work—was then the love and admiration of the young painter, a love from which he was never to recover completely, even in his period of fluent,

---

*[17] 'The Forfeit.'

[18] It is doubtless this early manner of Fragonard to which Mariette refers in his *Abecedario* when he alludes to the timidity of Fragonard's technique, his dissatisfaction with himself, his continual erasures and retouchings.

expansive painting. He retained a permanent affection for those volatilized colours, those tones aspiring to a celestial softness, in the art of Murillo which, in Italy, inspired his religious compositions, his 'Visitation de la Vierge',[19] purchased by Randon de Boisset and his 'Adoration des bergers'[20] which all Paris crowded to see in the Marquis de Veri's gallery.

<div align="center">IV</div>

In spite of all this labour, in spite of the flood of his works, the thousands of drawings, the scattered progeny of his '*crayons flatteurs*', the young painter was hardly known beyond the frontiers of Italy, outside the country of his adoption where he chose to remain forgotten for five years. Paris had barely heard his name. Fragonard, however, was not content that time should remedy this ignorance. He achieved celebrity and success in a single stroke with his picture 'Callirhoé', the work he submitted, with his candidature, to the Academy, which secured his reception, by acclamation, into that body and which, at the Salon in August, enraptured the public and received by royal command the honour of reproduction in tapestry by the Gobelins factory.

Imagine an immense picture, nine feet high by twelve feet wide, in which the figures are life-size, in which vast buildings rise at ease, in which there is ample space for the movement of crowds and of the heavens above them. Between two columns of marble whose surface shimmers with almost iridescent reflections, upon a dull crimson carpet fringed with gold, its evenness broken by a pair of steps over which it has been fitted, this dramatic scene from classical antiquity has been staged as if upon a fallen theatre curtain. On the carpet, which serves as an altar-cloth for this pagan shrine, stands a great copper bowl next to a black marble urn draped with white linen. A column half conceals a large candelabra smoking with incense and adorned with ram's heads, a superb bronze that might have been wrenched from the lava of Herculaneum. A young priest falls to his knees before the candelabra, embracing its pedestal;

★[19] 'Visitation.'   ★[20] 'Adoration of the Shepherds.'

in terror, he has dropped his censer to the ground. At his side
stands the high priest, Coresus, crowned with ivy, enveloped
in draperies and appearing to float amid the sacerdotal white-
ness of his vestments; he is a beardless priest of dubious sex,
with the aspect of an enervated Adonis and the grace of a
hermaphrodite—a shadow of a man. With one hand turned
upon himself he plunges a knife into his breast; with the other
he appears to fling his life into the heavens, while the weakness
of a final agony and the painfulness of a violent death pass
across his androgynous features. Leaning against the high
priest in the moment of his death is the intended victim, alive
but unconscious, almost dead from the belief that she was
about to die. Her head fallen upon her shoulder, she has
slipped to the ground in front of the smoking altar. Her body
has collapsed on to her folded legs, her arms have rolled to her
sides; her eyes are unseeing, she can no longer control her
limbs; she has subsided, motionless, her throat hardly rising
as she breathes, and pale beneath her wreath of roses painted
in a hue not less wan than her own. Between her body and the
altar a young priest leans forward in an attitude of curiosity
and horror. Another, bearing on one knee, in front of the
swooning girl, the bowl intended for the victim's blood, re-
mains rooted to the spot in terror, with staring eye and gaping
mouth. Behind him, a group of grey-bearded priests point,
with affrighted gestures, at the appalling scene. Above them,
the smoke from the temple, the scents and exhalations from
the altar rise upwards to mingle with the atmosphere, with the
miraculous, infernal night, with its swift-rolling clouds, where,
wrapped in a sombre, boiling whirlpool of air, a spirit,
brandishing a dagger and a torch, carries off love, in the swift-
ness of his sinister flight, in a rift of his black cloak. From this
shadow in the sky allow your eyes to travel to the shadow at
the base of the picture: two women, convulsed by fear, recoil
veiling their faces; a little boy seeks refuge in their lap, pressing
himself against them, while a ray of sunlight clinging to one
of the women's arms illumines his hair and his two small,
pale pink hands.

Such is the description of Fragonard's great composition, of the dramatic conception, the idea of which must have been given him—and perhaps its effect, also—by one of the revivals of Roy's[21] *Callirhoé*; as a painting, it is operatic; it is from the opera that its spirit and illumination are derived. And yet, with what a magnificent illusion of reality it impresses us! When we look at it in the Louvre, we can take in at a single glance its bright warm splendour, the milky irradiation of the white vestments, the virginal light drenching the centre of the scene, fainting and failing upon the figure of Callirhoé, enveloping her swooning form like the last trembling glow of day, caressing her enfeebled breast. Shafts of light, wreaths of smoke mingle together; the whole temple seems to smoke; and the vapour of incense rises into the air on all sides. Night rolls across the day of heaven. The sun sinks into the shadow, its flames rebounding in its descent. The darting reflections of a sulphurous fire light up the faces of the crowd. Fragonard has cast upon the stage, in handfuls, the thunder and lightning of fairyland: and we may feel that Ruggieri has made a magical incursion into the world of Rembrandt.

And what movement, what winged agitation there is in this convulsive, unsettled painting! There is turbulence in the clouds and draperies; the gestures are precipitate; the attitudes are distraught; horror trembles in the poses and on the lips of the figures, and it is as if an immense mute cry rose up from this temple, from every corner of this lyric composition.

This cry, such an unprecedented phenomenon in eighteenth-century art, sounds the note of Passion. Fragonard sounded it auspiciously in this picture, which is so penetrated with tragic tenderness and which might have represented the obsequies of Iphigenia. The dissolving image of his Callirhoé constitutes an artistic return to the emotions of the Alcestis of Euripides; and it introduced French painting to a new potentiality, the potentiality of the pathetic.

*[21] Pierre Charles Roy (1683–1764), dramatic poet and epigrammatist, author of the libretto of *Callirhoé*, a great success at the Opera.

## V

When the Salon was over, the interested public busied itself
with anxious speculation about the composition that the 'new
painter' would contribute to the next exhibition. It became a
favourite topic of question and inquiry; and the public was
very disappointed, when in 1767 it was confronted by a small
oval picture representing a group of *putti* in the sky. We may
divine the quality of this picture, which Diderot compared
to 'an excellent omelette, well-cooked, very soft and very
yellow', we may virtually examine its features in the group
of three cupids, now belonging to M. C. Marcille at Oisème,
and of which an original replica belongs to M. Walferdin. It
is a reconfectioned, browned, hashed-up Boucher, dyed in
Venetian crimson, glinting with sapphire lights. Fragonard
endeavoured in vain to escape the influence; the example of
his first master rose spontaneously before his mind's eye.
Boucher's handling and colour, the milky consistency of his
paint dominated Fragonard at the very moment he supposed
himself to be rid of them. Boucher pierced, penetrated, resisted
his subtle borrowings from the minor Italian masters and even,
in his last years, diluted the warm, bronze harmonies he
derived from Rembrandt. How many sketches there are whose
attribution is uncertain, which are the joint work, so to speak,
of the two painters! Certain pictures by Fragonard, 'La
Bascule', for example, or 'Le Colin-Maillard',[21a] would be
acknowledged as Boucher's were it not for the signature in-
scribed by the engraver at the base of the engraved reproduc-
tions. Contemporary taste has vainly sought to elevate the
pupil at the expense of the master; Fragonard's colour, it should
never be forgotten, was fathered by the art of Boucher. It was
from the roseate heart of Boucher's painting that emerged the
charming artist who was to infuse life into the master's formal
arrangements, to animate the immobility of his compositions,
to inject passion into his mythologies and inflame them with
the southern, almost Gascon, heat of his temperament.

---

*[21a] 'The See-Saw', 'Blind Man's Buff.'

There was much disappointment at Fragonard's contri-
bution to the Salon. The two years of work that had elapsed
since the first exhibited picture had seemed to hold out the
promise of a 'big machine', a history painting on some new
tragic theme. People wondered what was the cause of this
renunciation, this apparent surrender on the part of an artist
the announcement of whose talent had been received with so
much clamour. The answer was sought in the painter's addic-
tion to pleasure. Bachaumont[22] claims that the motives of
Fragonard's indolence were the same as that of Doyen, who
was in love with Mademoiselle Hus. But it might be fairer to
attribute this abdication of the role of the great history painter
to a return to the more authentic qualities of his personality,
to a wise and modest recognition of the character of his genius,
the true nature of his vocation. He had achieved the *tour de
force* of 'Callirhoé'; that was enough, and he judged it mis-
placed to begin it all over again. Heroic painting was not, he
felt, his true domain. He had entered it armed with abilities
which were dazzling and startling rather than solid. A smaller
stage was better adapted to his spontaneous talent, his rapid
drawing and the capricious play of his light. He recognized
that he was a natural improviser. His triumphant success,
instead of blinding him, had taught him the measure of his
talent; he perceived his authentic greatness to reside where it
might best harmonize with the mobility of his imagination—
within the dimensions of the easel picture.

To the reasons that determined both the man and the
painter to confine himself to easel painting,[23] to become the
artist catering for a wealthy middle class, must be added a

★[22] Louis Petit de Bachaumont (1690–1771), the author of *Mémoires secrets
servant à l'histoire de la république des lettres*, begun in 1762 and continued by
others after Bachaumont's death. It is a valuable record of the political, artistic
and literary events of the time.

[23] Fragonard was also diverted from the pursuit of heroic subjects by the
difficulty of securing payment for his 'Callirhoé', which he failed to receive
until three years after the completion of the picture; perhaps he was also
influenced by the cold hostility of the critics which at that time could be very
prejudicial to an artist's material success and drew from Greuze the remark:
'Every exhibition deprives me of a year of commissions.'

certain laziness of character, a kind of lazzaronism, a boredom and fatigue at the idea of the effort of a great undertaking, and that fine indifference which the period fostered in artists, and especially in Fragonard, that indifference to gain and fame, to the future, to posterity, to everything which today goads on our activities to fever pitch. Though an associate of the Academy, he took no trouble to become a full member; that fact sums up Fragonard and his ambition. His paintings slipped out of him without a struggle, without any of the torments induced by pride. Did he ever dream of immortality? It did not even occur to him to leave his full name to posterity, to whom he casually vouchsafed one half of it, *Frago*—the negligent and familiar form of his usual signature.

Fragonard, then, renounced 'history' painting to devote himself, in smaller paintings, to the depiction of that charming world of convention, based upon the manners of the age, whose possibilities Madame de Pompadour was the first to recognize and encourage, and Vanloo was the first to realize[24] in his 'Conversation espagnole'. And surely, the very spirit of the century is there in embryo in the charming artificial Spain of Vanloo's invention. Beaumarchais borrowed the setting of this picture for his scene of the serenade to Madame.[25] And Fragonard flirted continually with the Spanish vogue which haunted the fashions of the century, which was evident equally in the productions of the elder Eisen and the clothes of Figaro. He scattered its colours, rosettes and ribbons upon

[24] A pamphlet (*Lettre sur le Salon de 1755*) published at Amsterdam by Arkstee and Merkus, 1755, provides positive proof of this initiative of Madame de Pompadour: 'A love of the arts has suggested to a lady who loves them for their own sake an idea which can assist the perpetuation of the charms of painting. Tired of seeing only Greek and Roman heroes, Alexanders, Caesars, Scipios, she proposed to artists, whom she receives into her house not as a patron, but as a friend, that they should look at contemporary European costume with a view to finding some subject capable of producing a fine effect. It was represented to her in vain that for the most part our short clothes could not be draped and were not adapted to the picturesque.... She herself removed these objections by commissioning M. Vanloo to undertake the Spanish subject which we may see here so delightfully treated.'

[25] *The Marriage of Figaro*, Act II, Scene iv.

his figures like the mantle of an incognito or some theatrical costume unearthed by the costumier of the *Menus-Plaisirs* in a wardrobe of the castle of Aguas-Frescas. Nothing could be more delicate, more tantalizing than his handling of caressing silks and shiny satins, the plumes of caps, the cloaks, the pourpoints, the maroon bodices with their sulphur-yellow sleeves— the trousseau of some Seville *carnaval* of fiction in which the painter mingled the luxurious ornaments of sixteenth-century dress with the flashing, ringing notes of burnt topaz which glitter on the bodices of Rembrandt's female sitters. It was in this mode, with much *brio*, that Fragonard carried out his various versions of 'La Leçon de clavecin',[26] his interior scenes, wild confusions of soft colour in which he so charmingly disguises and displaces contemporary romance which the current purveyors of cheap pictures were so delightfully fond of depicting in its own habiliment and in the locality and the mode of the moment.

Into such works, however, Fragonard put no more than his witty intelligence. His genius resided elsewhere, in a higher sphere, in the clouds of Fable and Legend. The inspiration of his small paintings soars upwards to the heavens of the eighteenth century, a sky painted on a ceiling, the Olympus of Louis XV.

## VI

In the age of Louis XV, love, taste, the senses, were animated by a renewed affection for mythology. Books and furniture, metaphor and ornament, art and archaeology, the manners both of the court and of the nation at large, exhaled a breath of paganism. Psyche's cloud and Psyche herself reappeared at Versailles. All the doves of Greece began to flutter their wings —on the tip of a rhyme, in the corner of a canvas, at the foot of a bed. Paris veiled herself under the pseudonym of Cnidus. The air of Cythera touched, caressed, floated over everything. For a fleeting moment, it was to seem as if all the arts of France, all her thoughts had combined in the utterance of a

★[26] 'The Piano Lesson.'

prodigious love song, an immense *Pervigilium Veneris*. And it was indeed Venus whose return was acclaimed. History recorded the details of her cult, and it was a cult which was begun anew.[27] The imagination of the corruptions of the time surrounded her with religious veneration. As she had once risen from the ocean foam, so, now, she sprang up out of the lightness of people's hearts. Her almost sacred figure symbolized the destiny of a Madame de Pompadour or a Madame du Barry. Her cult was so much celebrated that her charming form became the adored image of the century's ideal. She returned, she was reborn, goddess, mistress and sovereign of the aspirations, illusions and passions of the period. She was revived, reincarnated as a new divinity, a French goddess, subtle, gay, amorous and wanton. And in the work of Fragonard, she seems really to live again, luminous and radiant with the smile and the aureole of her last triumph, as the painter has shown her in his sketch of her descent into the body of Anacreon, exhausted by the poet's dove.

And surely we should consider as apparitions, as visitations of Venus, the pair of pictures by Fragonard whose description follows: In the lower half of the first, all is night; a young warrior slumbers upon an archaic couch, resting on his elbow, one hand supporting his cheek and one foot trailing on the ground, in an attitude of Virgilian calm; near him on the shadow-veiled steps of the couch, next to his shield and helmet, a cupid sleeps with his head buried in his arms, the warrior's sword resting between his legs; then comes a group of dogs and another cupid bearing a hunting horn across his shoulders; and out of this slumber and darkness rises a Jacob's ladder of cupids bearing on its apex an Assumption of Venus; within and about the vision, shines a light in whose glow all the flowers thrown by the cupids fade away and all the flames from their torches seem to gather; Venus herself smiling and white amid the gauze which flutters and creases around her, the fresh skin of the infant gods, the clouds coloured as if by

---

[27] *Mémoire sur Vénus qui a remporté le prix à l'Académie Royale des Inscriptions et Belles-Lettres*, by Larcher. Vallade, 1775.

the fire of a sacred tripod, all this seems to súrge forward, suspended in a radiant vapour. . . . And then, in the other picture, the scene changes; it is no longer the 'Songe d'amour',[28] but it is still night, a night of storm and mystery, pressing upon the black trees, the heavily perfumed groves; a pair of lovers, crowned with roses, rushes forward; the wind that was severed by Atalanta's onward course strikes the throat of the woman and flings back her tunic; she and her companion have only just reached the marble margin of a fountain—'La Fontaine d'amour';[29] and both, with burning eyes and famished mouths, lean forward to quench the thirst and desire of their lips at the magic cup borne by flying cupids while their little brothers tumble into the basin of the fountain, mingling their hands, entwining their fingers and dipping their wings in the proffered drink; water falls from the fountain and vapour rises from its basin, and everywhere there are cupids, some barely visible in the wreaths of vapour, others wet with the fountain's rain, glistening with light, and on whose backs the falling stream and the undulating vapour breaks into cascades and drops of pearl.[30]

From these exquisite dreams, Fragonard's imagination rose to miraculous visions, to heights of ravishment and burning sweetness, to a kind of ecstasy.[31] There exist, in his work, expressions of a worship of passion, almost mystical in their ardour and excitement. Here and there in his art, bathed in a caressing light, rise altars dedicated to the First Kiss, 'Au premier baiser', where the blood of a dove with torn wings seems to be the symbol of a tender Crucifixion, of a cult of the Sacred Heart, of the bleeding heart of love, where the dew of a divine wound falls in drops over the chalices of flowers, over

---

★[28] 'The Love Dream.'   ★[29] 'The Fountain of Love.'

[30] *Le Discours sur l'état actuel de la peinture en France* (1785) accuses Fragonard of 'a delirium of the imagination'.

[31] M. Walferdin possesses an exquisite small version of this subject, and to M. Eudoxe Marcille belongs a drawing of the same theme, the most delicate and accomplished ever produced by Fragonard. The composition was engraved, from a picture whose present whereabouts is unknown, by Marguerite Gérard.

wreaths, quivers or loosened garlands; and everywhere there are wing-feathers and rose-petals. Propelled, almost lifted from the ground by a band of cupids who attempt to carry her as they play among the transparencies of her veils, a girl is borne forward between two sunbeams, two balustrades of light rising before her and on which flights of cupids hover in a kind of trembling immobility. She smiles, weakens and, as if overcome by the blandishments of the light, lets fall a rose which a winged spirit fires with his torch. Such is the description of 'Le Sacrifice de la rose'[32]—an illustration by Parny[33] transformed by the breath of Saint Teresa!

Fragonard's colour took fire with his thoughts. It burst into flame on contact with these burning altars. It shone forth in the light of the apotheosis of Desire and Love which he painted. What a smoke and glow there is in these bright skies, intensely limpid, trembling with the nudity of cupids, alive with liquid fireworks, drenched in those glimmers revealed in the coloured engravings of Janinet, like reflections in water from some conflagration. They are triumphant skies, covered by transparent fire, glowing with iridescent smoke, whence flowers and feathers fall in showers, where crimson and azure tints meet and mingle on the transfigured forms of the seraphim of the senses!

Love is the perpetual theme. Consider Fragonard's poetry at a less exalted level, somewhere between heaven and earth, somewhere between his 'Rêve d'amour' and his 'Serment d'amour';[34] his subjects here are 'Le Baiser dangereux',[35] 'Le Baiser à la dérobée',[36] 'Le Baiser amoureux'[37]—every sort of kiss, stillborn in Dorat, is alive in Fragonard. Two heads leaning together, the meeting of two pairs of lips, rapidly delineated on the canvas, sufficed him for a picture—an eternally charming theme which he drew with unfailing freshness.

[32] 'The Sacrifice of the Rose.'

[33] Evariste Desiré de Forges, Vicomte de Parny (1753–1814), published a volume of graceful erotic poetry in 1778. He was praised by Voltaire and was Lamartine's teacher.

[34] 'The Love Vow.'    [35] 'The Dangerous Kiss.'

[36] 'The Clandestine Kiss.'    [37] 'The Amorous Kiss.'

It was a theme he varied, caressed, redisposed ; he could transform the mutual attraction of two mouths into the mutual attraction of two spirits. Nothing but a kiss—he scarcely troubles to include within the oval frame the figures of those who thus embrace. His lovers, cut off by the frame just below the heart, resemble the flying group of the Lorrain sculptor—that floating kiss with nothing but a pedestal to sustain its shared felicity and love.[38]

And when Fragonard descends to earth, to the life of his own times, when, so to speak, he sets up his easel in the eighteenth century, it is still Love that provides the theme, fashionable, polite, playful Love; Love disguised by a mischievous elegance, or in a moment of violence. For example, in the midst of a pleasure garden he flings into the air on a swing a delicate marquise out of Crébillon—so high that her slipper falls off the tip of her foot and her skirt shoots upward for the delight of the indiscreet eyes of a charming youth reclining among the flowers beneath her ; happily there hovers above him a cupid whose gesture enjoins him to keep the secret of what he has seen.[39] Or we may cite that other composition,

[38] Among the kisses of Fragonard, we may quote his picture of a Muse embraced by Eros, engraved by Mlle Papavoine under the title of 'Sappho' and of which M. Marcille possesses a delightful *grisaille* in which a silver light bestows, as it were, the kiss of moonbeam upon the body of the Muse.

[39] 'Les Hazards heureux de l'escarpolette' ('The Swing'). The interesting origins of this picture have been recorded by Collé (October 1766) : 'Would you believe', said Doyen, 'that a few days after the exhibition of my picture in the Salon (Sainte Geneviève des Ardents), a gentleman attached to the Court sent for me to commission a painting on the following theme ? This gentleman was with a mistress at his villa when I went to see him to find out what he wanted. He overwhelmed me with his praises and attentions and finally confided to me that he was very eager to have a painting by me of a subject the main idea of which he proposed to indicate in advance. "I should like you", he continued, "to paint Madame" (indicating his mistress), "sitting in a swing and being pushed by a bishop. As for me, I should like to appear somewhere in the composition so that I am in a position to observe the legs of this charming girl, and I should be even better pleased, if you should feel like enlivening the picture still further..." I must confess', said M. Doyen, 'that this proposition, which I hardly expected in view of the nature of the painting which had prompted him to make it, left me at first confused and speechless. I recovered sufficiently, however, to be able to reply almost at one: "Ah, Monsieur, I

so well known, that couple locked in an embrace in which
ardour and surrender are mingled, the man in breeches and
shirt sleeves stretching out one naked muscular arm towards
the lock of the door which he pushes fast with the tips of his
fingers, the woman, distraught, her face flung back, fear and
supplication in her eyes, despairing of herself, and repulsing
with already feeble hand the lips of her lover—her fall is
visibly imminent. And Fragonard was not the man to forget,
in the background of the picture, that object he knew so well
how to penetrate and disarray: the bed.[40]

And it is there, surely, that any consideration of Fragonard
must lead us. It is, so to speak, the nest of his art, the meeting
place of his brushes. The bed for him was woman's alluring
*décor*, the adored setting, the downy throne of her body. He
betrays its presence, reflects it afresh in a variety of pictures
whose oval might be the flowered framework of an alcove
mirror. He depicts the performance upon it of what the

suggest we supplement your idea of the picture by showing the lady's slippers
flying up into the air and caught by cupids." But, since I was not in the least
inclined to treat such a subject, I referred the gentleman to M. Fagonat [*sic*],
who undertook the commission and is at this moment engaged upon it.'
*Journal de Collé*, published by M. Honoré Bonhomme.

[40] 'Le Verrou' ('The Door Bolt'), engraved by Blot. This picture was
formerly in the collection of the Marquis de Veri, a collection almost entirely
composed of French painting, and of French painting, moreover, of the
eighteenth century. According to the *Biographie*, it was, surprisingly, the
companion piece to a Rembrandt *pastiche*. Fragonard, however, was to provide
a more suitable *pendant*; this is 'Le Contrat' ('The Contract') which was also
engraved by Blot to be ready for sale at the same time as 'Le Verrou', and to
serve as its counterpart and its excuse. In 'Le Contrat', Fragonard first gave way
to that cold and unsatisfactory fashion of the times, the imitation of the little
masters of Dutch painting so greatly favoured by the declining French school
at the close of the century. We recognize in this work the ermine-trimmed
cloaks of Metzu and Terburg's white satin dress, that ubiquitous garment that
was to be so persistently rendered by all the artists and so confuse attributions
that we might even mistake, as in this instance, a Fragonard for a Boilly. Here
also, as far as may be judged from the engraving, appears for the first time
Fragonard's cold, niggling, over-finished manner so entirely different from the
lively technique of those works which he conceived more as *esquisses* that we
hardly recognize the authenticity of the handling and are prompted to consider
the possibility of a copy.

M. Walferdin is the owner of a preparatory drawing, of enchanting softness
and faintness, for 'Le Verrou'.

eighteenth century termed its 'gaieties'; he releases upon it the winged brood of his cupids. He wrests the nudity of a sleeping beauty from its cloudy draperies. Merely to touch upon the cambric of the sheets, the creases of the pillow, the indiscretion of the bed curtains, the disorder of the mattress, suffices to inflame, illuminate, energize, intoxicate his muse. He was possessed by that sacred fire of the eighteenth century, a demon in the flesh, that very *diable au corps* of the epoch; and it was the caress of Correggio as it might transfigure a page from Andrea de Nerciat[41] which he flung, fresh and warm, upon his canvas.

The bed and all the feminine mysteries which it secretes, the chemise and its indiscretions, the bewilderments of waking, the tumblings of the counterpane, the heads tossed backward in surprise, the coy concealments behind the charming gesture of the raised arm, the fears and evasions of semi-nudity, that sudden inspiration—a stroke of delightful immodesty—that prompted the representation of a whole dormitory of beauties, the tricks played by the wind, the fugitive drapery of undress, the shyly hiding face, the back exposed in all its length—Fragonard conveys all such charms with unrivalled deftness. The ardour of his talent sparkles with the bundle of crackers dropped through a trapdoor in the ceiling which bursts, flinging in all directions its explosions and its smoke, its sparks darting here and there, upon a shoulder or a thigh, flickering all over the bed of the three charming heroines of the picture, and scurrying like lightning across their skin.[42] And in another work there is the same flurry, the same hurry to escape, and we hear the same cry: 'My night-gown is alight!'[43]—there is a fire in the house; and in yet another, water is hose-piped from a trapdoor in the floor, and again, there are the three charming victims; one is already in flight, her night-gown flying in the

---

*[41] Andrea, Baron de Nerciat (1739–1801), diplomat and erotic writer, failed in an attempt to assist Louis XVI to escape from France during the Revolution and was later imprisoned by the invading Republican army in the Castel St. Angelo at Rome, whither the Queen of Naples had sent him in a diplomatic capacity.

[42] 'Les Pétards' ['Fireworks'].

[43] 'Ma chemise brûle' ['My night-gown is alight'].

wind, her loins exposed to the attack of the hose-pipe; another, in the bed, her legs aloft, attempts to protect herself with an outstretched sheet held up by her big toe; the third, naked in her affright, her feet on the bed-stool, leans forward to investigate the source of this watery assault.[44] Fragonard delighted in such frolics of the period which splashed, as it were with a variety of light, the female form caught thus unawares in the unconsciousness of spontaneous movement. He renewed the prank of the water-spout in the glass of water held in readiness by a little girl at the foot of the bed, who lies in wait, with a smile, for its charming occupant, reclining with her thighs exposed, with one leg folded up and the other nervously outstretched on the withdrawn sheets, the upper part of her body and her eyes still benumbed and heavy with sleep, and her fingers curled up in the frill of the pillow.[45]

But Fragonard was, above all, charmed by the playful gestures and movements of a woman alone, in the morning, in the whiteness and warmth of her bed, when she turns over, stretches out her body and exerts her limbs in the moment of waking. He loved those relaxed moments when her skin breathes in the sun, exposes itself heedlessly to the light, when her body escapes from the sheets, recovers its suppleness, and her night-gown, creased up during the night, only half covers her. It is the innocent voluptuousness of this recreative hour, the happy, unhampered movement of an awakening, that he sought to express in the delightful picture in which a young girl, her cap fallen off her head, her eyes sparkling with her sixteen years, a broad smile upon her lips, careless of what might be revealed by the night-gown rolled up to her waist, balances in mid-air on the soles of her feet a curled poodle with a face like a bewigged councillor; full of laughter, she presses her feet into the dog's coat and offers it a ringed biscuit with her hand; meanwhile a shaft of light from the foot of the bed streams between its curtains, strikes the bedclothes and dances with joyous leaps and bounds over the girl's pink limbs. This

[44] 'Les Jets d'eau' ['Aquatic Sports'].

[45] 'Le Verre d'eau' ['The Glass of Water'].

work is 'La Gimblette',[46] a flower of erotic art, full of freshness
and Gallic wit, whose seed, in the eighteenth century, was
sown in the dunghill of La Popelinière's book, *Les Mœurs*, in its
earlier scenes. It is one of the two masterpieces of Fragonard in
this genre, only comparable to 'La Chemise enlevée',[47] which
is perhaps the most fragrant of his erotic paintings.

Fallen at the base of the bed, and still smouldering, lies the
torch of Love. Seen from the back, one leg hanging out of the
bed and the other pushing back the sheet, her head turned
over on her shoulder, her hair undone with its curls scattered
behind her in the hollow of the pillow, a woman, the shadow
of whose lashes falls upon her closed eyes, and on whose
mouth there hovers a languid smile, endeavours, somewhat
faintly, to retain the night-gown that has already been ravished
from her body and is slipping off her outstretched arms,
dragged by a cupid who winds it about his arms and has fallen
backwards in the effort to pull it off, a winged cupid who
almost brushes with his foot the breast he has left uncovered.
It is a charming, a poetic vision, delightfully balanced by the
struggle it depicts, a graceful image of almost classical nudity
which might represent the angry Eros violating vanquished
Modesty as it expires in the arms of the very dream whereby
it was despoiled.[48]

How does Fragonard excuse these miniature nudities, these
lively little works, these libertine poems? What is their secret
charm which exacts forgiveness? It is the unique charm of
partial revelation. His decency consists in the lightness of his
touch.[49] His colours are not the pigments of a painter but the
suggestions of a poet.

---

★[46] 'The Ring-biscuit.'    ★[47] 'Cupid Stealing a Night-gown.'

[48] 'La Chemise Enlevée' has been engraved by Guersant with a sensuous touch
worthy of the original. M. Lacaze tells me that he found the oil sketch for the
picture in the Louvre exhibited on the pavement outside a shop in the Place de
la Bourse and paid one *louis* for it.

[49] We know of only one example of this type of picture by Fragonard in
which the artist has carried his degree of finish beyond the limits of the *esquisse*.
This is the 'Verre d'Eau' in the possession of M. de Villars. In a setting some-
what broadly and vaguely conceived for the benefit of the engraver, against a

He sketches the movement, hints at the rhythm of a body. He seems to paint with the colours of a dream. For him, the bed becomes a veil, like a cloud, and woman is a phantom. On the crumpled, blue-white, almost celestial cambric of the sheets, between the waves of silk produced by the billowing of the heavy bed-curtains, he tumbles his milky forms hardly touched with pink in the cheeks, at the elbows and the knees, at all the flowered places of the skin; his flesh tints are pale as if illumined by the glow of an alabaster night-light. Voluptuous apparitions, at once confused and radiant, vague, magical diffusions of light; human shapes like the dawn rising in a shining mist—these pictures are no more than fairy visions. Their blood faintly tinged with pink, their skin reflecting a delicate, silvery animation, their limbs filling gently out within the fluidity of the artist's contour, the drawing of their faces fading in the oil of the medium, Fragonard's women live only by virtue of a breath of passion. His art, even at its most fervent, remains floating, suspended between earth and heaven. When he over-steps the limits of 'La Chemise enlevée', when he goes so far as to represent the ultimate fires of love in the audacious picture which has been called by its owner 'Le Feu aux poudres', impurity itself, under his treatment, has nothing indecent, repellent or shameful about it; the picture is still a luminous inspiration, a confusion of torches, a vague swarm of cupids just perceptible beneath a film of burnt sienna, a conflagration on Olympus whence issues, barely glimpsed, the flame of an idea. Every audacity in Fragonard's art takes flight in this way, trembles, half-hidden beneath the modesty of his handling, that modesty which is expressed in the *esquisse* in which the nude is almost lost to the eye in its shimmer, in which the female form is veiled by a dazzling vagueness.

But the *esquisse* is more than the excuse for Fragonard's art, more than its veil; it is, in a way, its ideal. A writer who is

vigorously brushed background of bitumen, and curtains painted in bold, heavy strokes, the principal nude figure has been patiently and finely finished, the impasto being more polished and revealing greater revision than in the artist's other nudes.

himself a painter and a poet, M. Paul de Saint-Victor, has
charmingly said: 'The touch of Fragonard resembles those
accents which, in certain languages, give to mute words a
melodious sound. His figures, though merely indicated, live,
breathe, smile and delight. Their very indecisiveness has the
attraction of a tender mystery. They speak in low voices and
glide past on tiptoe. Their gestures are like furtive signs
exchanged by lovers in the darkness. They are the voluptuous
shades of the eighteenth century.'

## VII

Fragonard was a sketcher of genius. It is in his sketches that
the fullness of his talent bursts upon us. He was a master of the
first thought, of the preliminary indication, as, for example,
when he improvises a group of graces or nymphs, and at his
winged touch rippling naked forms rise up on the canvas.
From the diluted oil, from the scratchings of dry impasto
which seemed to draw the marks of a comb over the flow of
the muscles, from the dusty colour, like pastel, with which he
powders and heightens his tones, from the wonderful
*maquillage*, with its bluish shadows, of his painting, there
emerge flower-like fragments of the human form, of the
female body, shining surfaces of pale golden skin which have
the charm, the sweetness, the harmonious drowsiness of a
faded Beauvais tapestry; there is, in his art, a diffused white-
ness, a cloud-like blending, a pallor in the tones which pre-
serves hardly more than the memory, say, of a thread of silk,
the wan, delightful recollection of its colours. It is painting
which dies, expires, faints, burdened by that soft caress which
the arts seem to cultivate in their most exquisite moments of
decadence and corruption. Sometimes, also, Fragonard invests
his female figures with the memory of Rubens, piercing the
brightness of Boucher; at such moments, they cease to be
those soft, indolent creatures lost in the whiteness of sheets
and the last shadows of sleep; they are no longer the pale
goddesses of love, born, it would seem, simultaneously from
the sea-spray and from the froth of a whipped white of egg,

the blond, sheep-like divinities whose roseate matutinal apotheosis recalls the levée of Mademoiselle Duthé;[50] they become vigorous, brightly hued, sunlit figures; the light and shade, the reflections on their arms are given by touches of unmixed vermilion, prussian blue and chrome yellow; their elbows are rendered by a stroke of vermilion floating in a reflection of pure golden yellow; and the painter half pierces the transparency of their skin with subcutaneous reds, browns and greens, with the hidden aspects of anatomy. For it was Fragonard's talent, the miraculous gift of this generator of dreams, with his misty palette, his tender *esquisses* which glazed the naked form with those greenish or bluish tints that we should perceive it to assume under water, which changed it into a drowned flower—it was Fragonard's gift to put forth, suddenly, the most vivid tints, poppy, sulphur, ash green, to allow himself to be transported by a loud range of colour, to set his paint on fire, to embroider his canvas with flashes of lightning; and the hand that lately flowed and glided at its work was capable of so loading an impasto that the brush-marks might be taken for the traces of a sculptor's tool in the clay. There exist, in this manner, sketches of unprecedented warmth and dash, so frankly and solidly brushed in that they may make us think of the large spoon that Goya used for his wall-paintings; they include such subjects as the mutual love declarations of a shepherd and shepherdess, in strong burnt colour, painted with a solidity which is almost that of a bas-relief, and interior scenes, lit by a tent of vivid blue sky, raining down upon an untamed vegetation—they are the furious embryos of projected pictures in which the Venetian sun reappears with the muffled reds and potent browns of Bassano.

It was in this style, powerfully, vividly loading his canvas, that Fragonard attacked and dashed off his landscapes, not the cool, northern views in which he is no more than a skilful

*[50] Mlle Rosalie Duthé (1752–1820), one of the more illustrious *courtisanes* of the time, was the mistress of, among others, the Duc de Durfort, the Marquis de Genlis, the Duc de Chartres and the Comte d'Artois (later Charles X).

*pasticheur* in thrall to Hobbema and Ruysdael, but those land-
scapes in which he is himself, in which he painted the scenery
to which his feelings responded, his own province, the country
of his remembrance, furrowed by those floods which inter-
mittently ravaged Provence, stripped of its pines and its oaks,
throughout the whole of the eighteenth century.[51] What a
burning inspiration, what a tempestuous technique animates
'L'Orage', the masterpiece in the collection of M. Lacaze!
The smoky, sinister, electric sky, pierced by shafts of wan
light, the heavy air, the hot breath of the afflicted earth, the
quivering trepidation, the panic of Nature, the bewilderment
of distracted sheep, the lowing of huge oxen, the whirlwind
tearing up the grass, twisting awry the great canvas hood of
the cart pushed forward by a group of men in red—all this has
been rendered in its wild mobility and the brush seems to roll
with the wind throughout the scene.

More than any of his contemporaries, Fragonard cultivated
this rapid manner of painting which grasps the general im-
pression of things and flings it on to the canvas like an instan-
taneous image. There are extant, in this genre, miracles, *tours
de force*, figure-pieces in which he reveals himself as a prodi-
gious *Fa Presto*. In the Lacaze collection, there are four
half-length, life-size portraits. On the back of one of them is
inscribed—according to my opinion, in the painter's own
handwriting—the following: 'Portrait of M. de la Breteche,
painted by Fragonard in 1769, in the space of an hour.' An
hour! No more. An hour sufficed him to pose, despatch and
polish off, with swagger and confidence, these large portraits
in which is set off and displayed all the Spanish fantasy with
which painters of the time attired and ennobled their con-
temporaries. An hour to complete this canvas! He scarcely had
time to apply his paint; the faces were rough-hewn with a
few broad strokes, merely suggested, as in the various planes
of the initial stages of a bust. His brush laid on the colours
in great thongs, in the manner of a palette knife. Beneath
his fevered, agitated touch, the lace collars frothed up and

[51] *Essai sur l'histoire de Provence*, by Boucher. Marseille, 1785.

stiffened, the folds coiled themselves up, the cloaks were dis-
arrayed, the coats stood out, the materials swelled into great
hectoring draperies; blue, vermilion and orange flowed on
to the caps and coat collars; the backgrounds, beneath a wash
of bitumen, framed the heads with a shell-like substance, and the
heads themselves sprang out from the picture, leaped forward
from these furious sweepings, from this hash concocted by a
possessed, an inspired painter.

## VIII

The magical artist who could produce so rapidly the effects
of light and sun was naturally destined to decorate all those
walls which the century was reluctant to leave unpainted in
their naked whiteness, to depict false skies upon the ceilings
beneath which the financiers and courtesans of the time took
refuge from the grey sky of Paris. Fragonard rapidly became
the fashionable decorator, sought after, summoned, fêted in
the budding Chaussée d'Antin, the extravagant private estab-
lishments in the new quarter of the city. In 1773, he was
engaged on decorating with paintings the salon of the pleasure
palace erected by Mlle Guimard. And he had already painted,
in the central panel, the apotheosis of Terpsichore, on whom
he had bestowed the features, the attributes and the charms of
the divinity of the household, when, after a quarrel with his
patroness resulting in his dismissal, he took occasion to revenge
himself by a joke, a studio trick in which his wit and malice
were only too apparent. One day, he managed to penetrate
the hotel as far as the salon, and, with the palette and brushes
of his absent successor, he effaced, in an instant, the smile of
the goddess, substituting a pair of angry lips and the expression
of Tisiphone, whom Mlle Guimard in fact closely resembled
when she entered the room a minute later to show her
drawing-room to friends; the painter's revenge at once
aroused her fury.[52]

---

[52] *Correspondance Littéraire de Grimm*, Vol. VIII. Furne, 1831. The account
given by Mme Fragonard to her grandson differs from Grimm's version.
According to her, and she must have been more accurately informed than

At that time, Madame du Barry had already commissioned Fragonard to paint four panels for Luciennes: 'Les Grâces',[53] 'L'Amour qui embrase l'univers',[54] 'La Nuit',[55] and 'Vénus et l'Amour'.[56][57]

Grimm, Fragonard was not dismissed but decided himself to hand in his notice. He was tired of Mlle Guimard's aristocratic airs and of the scant consideration she gave him. One day, when she said to him for the hundredth time: 'This is impossible, Monsieur le peintre, will you never be finished?' he replied that the work was already complete, left the house and could never be persuaded by his patroness to return. It is a detail of considerable interest that, much later, David, who had not yet gone to Rome and was working in Paris in the manner of Vanloo, sought out Fragonard and asked his permission to finish the paintings he had begun and which Mlle Guimard had commissioned him to complete. Fragonard readily granted this request with a good grace, it must be admitted, which the grateful David never forgot.

★[53] 'The Graces.'    ★[54] 'Love Enflaming the Universe.'

★[55] 'Night.'    ★[56] 'Venus and Cupid.'

[57] *Mémoires des ouvrages de peinture de Drouais, mélanges des bibliophiles*, 1857. It was Drouais who sold these four Fragonards to Mme du Barry for 1,200 *livres*. Mme du Barry commissioned four other works from Fragonard in which the artist represented the four ages of man. [★These paintings, which in fact represent the awakening and progress of love ('Le progrès de l'amour dans le cœur des jeunes filles') were originally intended for Mme du Barry's château at Louveciennes, familiarly called Luciennes; they are now in the Frick collection, New York.] As a result of a disagreement with the favourite, the painter had the pictures rolled and later took them to Grasse, where he used them to decorate the house in which he lived and where he completed his conception by painting a fifth picture, 'L'Âge de la désillusion' [★'The Age of Disillusion'] which remained unfinished. Fragonard had a taste for decorating his surroundings. He executed decorative paintings for his country house at Carrières and later, also, for his house at Petitbourg where his son collaborated in the work. At Grasse, in his godfather's house where he went to live about 1792 and where he remained throughout the Terror, he painted various overdoors and additional canvases to accompany the paintings originally carried out for Madame du Barry. He even adorned the staircase with republican emblems, revolutionary insignia, masonic signs, symbols of Liberty and allegories of Law in the midst of which the portraits of Robespierre and the Abbé Grégoire [★1750–1831, constitutional bishop of Blois and member of the Revolutionary Convention]. For this information we are indebted to the kindness of MM. Pihoret and Malvilan.

To these decorative undertakings by Fragonard, we should add the series of forty-two portraits of the princes and princesses of the royal branches of the houses of Bourbon and Condé, executed, after original portraits, for the Château de Chantilly. Among them are portraits of Louis XVI, Marie Antoinette and Louis XVII. They belong to the Duc d'Aumale and were exhibited for the visit of The Fine Arts Club on 21 May 1862.

An anecdote, the mention of a receipt, a few traditions are
almost all that remains of Fragonard's decorative paintings.
They have disappeared with the walls on which they were
painted, with the houses they embellished. They enjoyed the
brief eternity imposed by the progress of demolition on the
very stones of Paris.

## IX

Fragonard's memory survives almost exclusively in his art.
Behind the painter, the man is scarcely visible. We know
almost nothing of him, he has left no record of himself. Little
or nothing remains in the memoirs and diaries of the time.
Grimm's anecdote about his vengeance on Mlle Guimard is
almost all there is. Newspapers, reviews, the obituary records
of the time are silent on the subject of this graceful artist who
achieved fame without clamour. Biography is at a loss for any
adequate account of him; research yields only a few dates, a
few references, the mere glimmerings of his personality. But
we should not too greatly bewail our ignorance. Too many
documents, too many facts might weigh unduly upon this
light and gracious memory. We should, perhaps, demand no
more than a hint of his personal history, sufficient to fix him
in our affections. Let the facts of his existence remain in a mist
of uncertainty as if floating in the vagueness of one of his
sketches; the half-light suits the poetry of his life; his persona-
lity is one of those we may prefer to envisage, like a blessed
Shade, with a finger upon its lips.

Even his features evade us. They have the same charming
vagueness as his life. His faint, smiling image reoccurs like a
wanderer throughout his work, concealed beneath the alert
passionate features of his young voluptuaries, beneath those,
for example, of the charming, curly-headed youth dragged
forth from the cupboard in 'L'Armoire'. The only portrait
is Lecarpentier's etched medallion in which he appears
crowned with the white locks of old age but in which we may
divine, behind the ripe vigour of the old man, the full quality
of his youth.

It is known that Fragonard married towards the age of forty, after a bohemian and amorous youth, during which he succumbed to that worship of women which he cultivated throughout his life—as an old man, he was described as 'a youth in an old skin'. Here is the story of his marriage as it was told us by his grandson. Mlle Gérard, the eldest of twelve children in a family of distillers at Grasse, had been sent to Paris to take up employment in the business of a distiller, a friend of the Gérard family, called Isnard, so that she might at the same time acquire a knowledge of commerce and earn her own living. But the young girl had no taste whatever for this mode of life. She amused herself by painting in water-colours, decorating fans, and with other light artistic pursuits. She soon recognized her need for the advice and instruction of a professional painter. In the course of her inquiries for a suitable teacher, the name of a compatriot, of Fragonard, was mentioned; and Fragonard, to whom she thereupon applied, declared his immediate readiness to receive her as a pupil. The lessons led to love and marriage. Fragonard's wife was not pretty. A portrait of her, belonging to M. Théophile Fragonard, shows her approaching forty years of age, with powerful features, a sensual facial structure, piercing black eyes beneath a pair of thick eyebrows, a short, fat nose, large mouth, dark complexion, glowing brown hair, and an indefinable expression, both satisfied and ardent, suggesting a solid Dutch housewife warmed up by a southern sun.[58] When Madame Fragonard was delivered of her first child, a daughter, destined to die at the age of eighteen,[59] she told her husband she had a little sister aged fourteen at home who would be of great use to her as a help in the care and upbringing of the baby; it was thus that Mademoiselle Gérard entered the family

[58] Another portrait of Madame Fragonard, drawn in Chinese ink by her husband, is now in the Besançon Museum, bequeathed by the architect, Pâris.

[59] I have in my possession a full-length study of this daughter, executed, probably, a short time before her death, a light and masterly drawing in black chalk, authenticated by the signature of Théophile Fragonard, who recognized his aunt.

in which she was to spend the greater part of her life. Paris waved its magic wand over her before many months were passed; she lost her naïveté, her provincial awkwardness; from having been a plain girl like her sister, she became, as she grew into womanhood, pretty and even beautiful. The most lovely black eyes, the most purely oval face, a Roman quality in the contour of her features invited comparison with a head of Minerva, and when it became the fashion for women to leave their hair unpowdered, the style of her beauty created a sensation at the theatre.

It was not to be expected that the former painter of fans should abandon her brushes after marriage to an artist. Under her husband's direction, she had taken up the painting of miniatures, and her productions are sometimes hardly distinguishable from Fragonard's miniatures, especially when embellished by his own retouchings and corrections.[60] It turned out that the little sister was also fond of painting, and that her talent for it was still more pronounced and more felicitous; it was a delightful stroke of providence that made of Mademoiselle Gérard, in emulation of Mlles Mayer and Ledoux, the pupils of Prud'hon and of Greuze, the ward, so to speak, of her brother-in-law's genius, the god-daughter of Fragonard's art.

I find the following almost touching comment on this innocent alliance of tastes and sympathies inscribed at the base of a proof of Fragonard's portrait of Franklin in M. Walferdin's collection: 'Engraved by Marguerite Gérard at the age of sixteen years, 1772. Homage to my master and good friend Frago. Marguerite Gérard.' 'My good friend', such was the name she bestowed upon the master who had first placed

[60] The mention of miniatures by Mme Fragonard occurs in the catalogues of various sales during the eighteenth century, particularly in that of the sale of the Marquis de Veri. Item 81 of this catalogue records the following by Mme Fragonard: 'Eight very valuable miniatures painted with the greatest lightness and grace, of the heads of boys and girls, each executed with a truth and freshness of tone that leaves nothing to be desired. To be sold in pairs.' Miniatures by Mme Fragonard appeared at the exhibitions of 1779 and 1782; a critic declared of her: 'This artist, who emulates Rosalba, has attracted and held the attention of painters and collectors by her lightness of touch and charm of colour.'

the etcher's needle between her child's fingers, supporting her hesitant schoolgirl's hand, giving his advice, instruction and encouragement over her shoulder; it was a charming initiation in which, at every moment, the teacher might sense the emotion in a woman's hand, or receive the gratitude of her smile, a delightful co-operation to which Fragonard contributed his retouchings and sometimes all his talent, as in the plate of 'Mosieur Fanfan jouant avec M. Polichinelle et compagnie',[61] a plate which the pupil believed to be hers and which the master made her sign to convince her of her authorship.[62] Here was the intimate core of Fragonard's home-life: the artistic education of a woman whom he taught to be a painter and etcher, and who surrounded him with a cult of affection, a tender veneration. The master and the pupil mingled their occupations, pleasures and studies as they were to mingle their two signatures on the picture 'Le Premier Pas de l'enfance'.[63]

With his sister-in-law and his wife, beneath the soft caress of a family atmosphere, Fragonard allowed the years to slip by, abandoning himself to the pleasures of domesticity. His existence closed up, concentrated itself within the confines of his studio, a studio full of life and pleasure, where money, easily earned, was always plentiful, where meals were always ready and where the greedy Lantara was tempted by the appetizing odours emerging from the kitchen; it was also a treasury of works of art, decorated with the master's paintings, amply furnished with tapestries, with Boule pieces, with all sorts of curios and rarities, among which was the pride of the collection, a silver vase by Cellini which passed subsequently into the possession of Mlle Lange and thence into that of the Rothschild family; it was a museum of Fragonard's tastes, in the midst of which one seemed to hear the laughter and song of a comfortable bourgeois existence in the studio of Solimena!

★[61] 'Mosieur Fantan playing with M. Polichinelle and Company.'

[62] 'Mosieur Fanfan' is the portrait, in his night-gown, of the painter's son, Alexandre-Evariste, born in 1780.

★[63] 'The Child's First Steps.'

There is little that can be said to complete this bare sketch
of the life of Fragonard. His friends were Hubert Robert,
Saint-Non, with whom, ever since the journey to Italy, he had
remained on the closest terms of intimacy, Greuze, and
Taunay, whose budding career he assisted and whose first
picture he acquired. There was also Bergeret, the Receveur
Général des Finances and former friend of Boucher, the
collector who took Fragonard and his wife on a second trip
to Italy. He was the owner of the first sketch for 'Le Sacrifice
de Callirhoé', and it was to him that the painter addressed
those pages now in the Walferdin collection, pages covered
confusedly with curious and amusing drawings in which the
painter in relaxed mood, the wit, *l'aimable Frago*, as he liked
to be called, portrayed himself with so much humour in an
amusing account of the progress of a sprain. A first drawing
shows the fall: 'M. Frago,' reads the legend, 'mistakenly
opening the wrong door and falling heavily to the ground
where he had expected to find the lavatory seat, and contract-
ing a severe sprain, at eight hours, thirty minutes and two
seconds of the clock.' Another sketch shows the ladies raising
their hands to heaven, overcome by surprise and sorrow:
'Return of the ladies at ten o'clock, and their sympathy, which
is very comforting for *l'aimable Frago*.' In another, he has
drawn himself in bed: 'Situation for a fortnight, prescribed
by the doctor.' And yet another represents a row of people,
seen from the back and seated on a bench; first, two children,
'Rosalie, Fanfan', then 'Frago and his wife', over whom the
artist has added the note: 'Frago tells his wife a secret at half-
past eight.' Then comes 'M. de la Gervaisais', and finally
'Mlle Gérard'.

## X

Fragonard's drawing is his handwriting. It was, as we have
seen, his medium of correspondence, his form of letter-
writing. And it was still more than that: we might go so far as
to say that it was the diary of his imagination. It was a channel
for the expression of his slightest thought; in his drawings he

stands confessed, his intimate aspirations take wing. Assembled, his drawings would provide the airy poetic history of his life, his ideas, his taste, his opinions, his moods; they would be the memorials both of the painter and the man. We would find there his cult for Rousseau, 'the man of nature' in that pious group of drawings of the Île des Peupliers at Ermenonville; we should learn also of his musical enthusiasms, in the drawing of Gluck, crowned with laurel, seated at a symbolic desk between the busts of Homer and Virgil, his hand resting on a sheet of paper on which Fragonard has written: 'Both my heart and my works.' The painter's admiration for Franklin, who was a visitor at the house of Saint-Non, from whom he was anxious to learn the secrets of etching, burst out in a titanic drawing, an allegorical apotheosis of the great tamer of lightning. Fragonard's pictures are less self-revelatory: in his paintings he was *Fragonard*; in his drawings, he was both more and less than that: he was, quite simply and intimately, Frago.

Follow him in the first flutter of an idea, when he flings upon the paper the elements of a composition, when he is searching and groping amid the mist which precedes the light. Catch him unawares in those dawning sketches, those chalk notations that seem to waken into life; look at those faint washes, that delightful, speckled embroidery—those exhalations, charming trifles which aroused, alas, the jealousy of the daylight, which have been devoured by the sun, which have paled, faded, but which have, perhaps, only grown lovelier in their faint dissolution; [64] however small they may be we may

---

[64] Fragonard's *bistres* suffer from the sun. His paintings, particularly his more finished works, are the victims of another enemy: their surfaces tend to become sanded with litharge. The damage results from Fragonard's habit of using an English yellow lake in the guise of bitumen and which dried too slowly for him. Moreover, glazes, superimposed on this yellow lake, produced an agreeable blond tonality. But the procedure had this disadvantage that the lake, as we may now see, eventually pierced the glaze. Fundamentally, apart from his underpaintings, the main cause of the deterioration of his pictures is the impatience with which he worked. He was unwilling to wait. He flung fresh colours upon others that were not yet dry, thus causing a volatilization of the lower layers which split the surface colours.

feel in them the full presence of the master. His usual medium in such works was bistre, energetically applied over a pencil outline. Such was his favourite method of trying out an effect, fixing the vision of a future picture, of rapidly achieving his floating effects of light on the moistened paper which absorbed his contours. And how admirably he exploited this medium! His bistre is never black, heavy or impasted; it is alive with that lightness and transparency, that fiery warmth which must have prompted the adoption of this medium by Rembrandt. The use of wet paper which prevented effects of dryness, even in the thin washes of the foreground, which drenched, softened the most vigorous passages in a blend of tone like the stain of marble; the diluted quality of the backgrounds, the absence of emphatic outline; the magic of a brush which caressed the paper with no more than the emanation of a colour; the admirable dispersion of light in the midst of the brown-toned shadows; those beams darting all over the composition with the refracted effects, of sunlight in a mirror; those limpid aureoles with which the artist illumines a head or a naked shoulder; those shafts, from the southern sun, which strike at the centre of his drawing and under whose impact the bistre fades in imperceptible gradations until nothing is left on the paper but the grey softness of the pencil—all these qualities of technique and handling combine to produce in these drawings of Fragonard a soothing white light, an airy splendour that bathes his faces, figures and draperies.

And from this glitter and sparkle, what charming little figures emerge, subtle, refined, delicate, with their bunched locks darkened by a touch of bistre and bound with a dark ribbon, their profiles like those of a porcelain statuette, half in shadow beneath the faintest wash of tone, and full of that rebellious life with which the painter's brush has injected them, with its pin-pricks, so many specks, beauty spots of bistre, in the pupils of the eyes, in the nostrils and at the up-turned corners of the heart-shaped lips! We cannot but refer in this connexion to 'La Lecture'[65] in the Louvre. Next to a

★[65] 'Reading.'

woman whose back only is visible—a *fichu*, a *chignon*, a cap, a
corner of the book she is reading—emerges, from a fragile
medley of bistre touches, the figure of another woman, in
profile, a dark *pouf* on her buoyant, silky hair, a ribbon about
her neck; she is shown side-view, seated, one arm bent over the
back of her chair and the other in the lap of her wide, undulat-
ing, silvery skirt, broken up by the large folds of its white satin.
In no other of his works has Fragonard realized the figure of a
woman with such an extreme economy of means. She stands
out clear, slender, almost diaphanous from the dark, solid
foundation of drawing. She is a phantom of seductive charm,
'une petite reine' according to the expression of the time, the
very personification of the painter's elegance and grace. In
another drawing, beneath the zig-zag of a group of trees, a
white bull lifts up its head from the trough of a fountain and,
its muzzle still dripping with beads of water, gazes upon a pair
of lovers embracing in the background in all the warmth of
summer with which the tint of bistre can be made to invest a
landscape. In such works, Fragonard is at play; and we should
be prepared for more licentious themes. And here is one,
showing a dancing-master in a drawing-room of the period:
while a group of ladies, near the mantelpiece, are amusing
themselves with a little dog strutting and preening itself next
to a stool on which the violin has been placed, the elegant
young dancing-master whirling away with his lovely pupil,
making her pirouette between his arms, reveals, unconsciously,
a glimpse of her charming legs, for the benefit of a knowing,
artful abbé reading his breviary in the embrasure of the win-
dow. With what ravishing skill the scene has been grasped!
All the natural vivacity of its dash and movement is in the
brushwork: a little water, a little bistre, a wave of the hand—
and the trick is done.

Fragonard shed these drawings like leaves, using every type
of paper; some are of such softness, so drenched that they seem
to be dipped in water, while others are strong, sustaining
vigorous, forced accentuations. The subjects include studies of
bulls in the stable, working girls wandering about their

dormitory in dressing-gowns, dancing marionettes, portraits of women in all the confused adornment of contemporary costume, spiritualistic séances suggested by the magic arts of Cagliostro, crowds thronging public gardens beneath huge Italian pines, and landscapes in which the palpitations and tramplings of the brush have brought forth a teeming complexity of plants, animals and trees.

More rarely, for the sake of a limpid transparent realization of his ideas, Fragonard made use of water-colours, confining himself for the most part to the faintest tints, and producing a charming effect of softness and delicate glimmer. Sometimes, however, freeing himself from the timid colour range which, at the time, was characteristic of drawings in this medium, he risked the use of vivid, bold, brilliant hues, set off with the pen, producing a fully coloured painting in water-colour which might serve as a preliminary sketch for a picture. This bold procedure, in which he almost forced the qualities of water-colour can be examined in his gouaches, in those studies of storms built up like masonry with all the solidity of a sketch in oils, in which a brilliant note of red, like a signature, a private fanfare, invariably occurs in some corner or other of the picture. In pastel also, he achieves his effect by the brutal vigour of his black chalk line, by bruisings of red, white and blue chalk having all the breadth and extent of a broad brush-stroke in oil.

But it is in his drawings in *sanguine* that we may best realize the inimitability of his draughtsmanship. In this medium he outshone his rivals, even Hubert Robert who here seems cold, mean and thin beside him. The play of skies, the picturesque dishevelment of parks, deep clusters of trees, the delicate forms of architecture dimly visible in the faint pink tones of the background—this medium of red chalk responded to every such caprice of his imagination. His effects suggest that he used the chalk without a holder, that he rubbed it flat for his masses, that he was continually turning it over between his thumb and forefinger in risky, but inspired, wheelings and twistings; that he rolled and contorted it over the branches of

his trees, that he broke it on the zigzags of his foliage. Every irregularity of the chalk's point, which he left unsharpened, was pressed into his service. When it blunted, he drew fully and broadly, emphasizing the more strongly expressed areas of his composition; and when it sharpened automatically as a result of rubbing and shading, he turned to the subtleties, the lines and the lights—the whole process carried through with a feverish, desperate skill which seized the character of the landscape, made it copious, dishevelled, leafy, fused the grass and the foliage with the garden balustrade and the clouds with the summit of the woods. Still more vigorous are those studies in *sanguine* of women, drawn from the life, finished in a single rapid sitting, in which the red chalk, almost crushed under the artist's pressure, seeming to flog the backgrounds with its corkscrew markings, brutalizes the stuffs, the trimming of a dress, rumples triumphantly the fanciful fripperies and adornments of costume, attacks with the same force the features, hacking them with shadow, and performs the miracle of revealing, beneath such violent handling, the smile of a pretty woman.

They should all be perused, these drawings of Fragonard, these winged thoughts, these scattered leaves hovering in the commemorative chapel of his art, in the collection of M. Walferdin, the collections of M. Marcille, Mme de Conantre, etc., in the souvenir of the Villot, Saint and Norblin sales, in engravings and reproductions. Childhood is one of their constant themes, illumining them everywhere with its smile. It provides the youth, the innocence, the freshness in these little pictures. The little child, gambolling and dancing in the sun with something of the lightness and the nudity of a little god, the child with its small caressing hands wandering over the face and the bosom of its mother, the child with the heart-shaped mouth, the little companion of the dog or the donkey, riding on its back or clinging round its neck. The child in its big white night-gown, perched on top of a pyramid of children, watching the fritters cooking on the stove, the child with fair curled hair preaching from the eminence of a sideboard with

the air of a little waxen St. John [66]—all these little creatures
contribute to Fragonard's scenes a brightness and a joyful din
as of Paradise. The baby he puts to sleep—in some flowered
garden, watched over by its mother's tenderness, in a cradle
that might have grown up from the ground with the rose
bushes which shed their petals above it. [67] When it is a little
larger, he stands it upon a fruit-packing case, wrapped up, by a
mother's hands, in a blanket, only its face emerging. Sometimes,
like an ascent of angels, he shows us his children clambering
up on to their mother's knees. The grouping, the assem-
blage, the games and somersaults of all these *fanfans*, seems
to have inspired the artist with the joys of fatherhood; one
might almost say that he dandled these compositions on his
knee. And how well he drew their youth—the infancy, bright,
gay, rosy, wild, of these tiny little boys and these little slips
of girls. They are not the children painted by Chardin, already
serious, children who had grown up amid the sombre ob-
scurity of rooms with small windows and the grave lessons of
a severe, restrained existence. They are very much the progeny
of Fragonard, the children of his genius, mischievous, free,
blossoming, radiant, revealing a pair of cupid's knees between
their breeches and their concertina stockings, the spoilt children
of happiness and the country, of affection and of nature, the
favoured love children of the shepherdess and the prince, the
offspring, we may imagine, of such pairs of lovers as the artist's
lively brush threw backwards into one another's arms upon
a truss of hay.

Children brought Fragonard good luck; they were the
inspiration of a whole series of charming drawings, only a few
of which I shall describe here: there is the little girl combing
her dog's hair in the glass, the mother—a magnificently drawn
life study—sharing out bread from a pan to her children, and
the *Dites donc, s'il vous plaît* [68] in which, with a few touches

---

[66] E.g., 'Les Beignets' ['The Fritters'], 'Le Petit Prédicateur' ['The Little
Preacher'].

[67] 'La Bonne Mère' ['The Virtuous Mother'].

★[68] 'Say "Please!"'

of bistre, the painter has expressed so much embarrassment and such a charming pout on the features of his *bambino* in a little white shirt.

But neither drawing nor even painting proved an adequate vehicle of expression for that living, breathing childhood which Fragonard wished to incorporate into his art; he needed, and found, a technique, a peculiar art, one that he was to handle in an unprecedented manner, obscuring the achievements of his predecessors in the same field and defying the imitation of rivals; this was the art of miniature.

A miniature by Fragonard is the very quintessence of prettiness, a miracle of minuteness, an enchanted object which in its power of soothing and tantalizing the eye can only be compared, in the eighteenth century, to a terracotta by Clodion. All other miniatures of the period fade and darken in its proximity, reveal the labour of their execution, their thinness and triviality. The most brilliant, the freshest, the most freely handled, those in which professional aridity, the thanklessness of the medium is least apparent are, by comparison, simply miniatures and nothing more. Even those of Hall, so highly prized today, those spirited, gaily coloured little paintings, with their subtle sparkle and agility, their little points of *gouache*, fade, in spite of the skill and intelligence of their handling, beside a Fragonard. Their charm and brilliance vanishes. The little figures seem ashen. The artist is cold, petty, no more than an adroit craftsman working inch by inch. The radiance of flesh, the limpid hues of a complexion, the light of life upon a face—of young life, the pure life of childhood, full of healthful innocence and as if softened and whitened by the milk that had nourished its earliest infancy—Fragonard alone achieves such realizations in his miniatures. And it was his great triumph to render that spiritualized, almost ideal conception of childhood which is, we may feel, the image that rises up before a mother's eyes as she looks at a portrait of her child and dreams rather than perceives its lineaments.

Fragonard has shown us in these works the moist, dark, diamond eyes of children. He has been able to express the

flame in a child's eyes, to liquefy and illumine them far better than Greuze or the English painter, Lawrence, with all the resources of oil paint, were able to do. He has given the cloud-like consistency of their features, the soft, delicate uncertainty of their chubby contours, their velvet flesh, the smooth porcelain surface of their foreheads, the faint, azure markings at the temples, the pout or the smile that opens or closes the red flower of their lips. These miniatures are sunlit visions, in which you may seek in vain the evidence of labour, the hatchings, the stipplings, the dryness of the technique of miniature. Or, rather, we might say that these airy master-pieces, mysterious and magical, are like a ray of light caught in a drop of water. Their special quality is in a mode of colouring which has all the pallor and faintness of tints swimming in the water-colourist's glass. They bear no trace of the artist's brush. He hardly covers their entire surface. The warmth, the creamy whiteness of the ivory plays a ubiquitous role, gleams through the rose of a complexion, and is the depth and glow beneath these sparkling faces.

And so we may imagine that a playful gesture, a mere smile from the painter sufficed to create the beauty, issuing, as it were out of the air, of these children with their fine, fair curls, the colour almost of sunlight, their ruffled collars, their hats and coats floating in the air like Pierrot's, so that they seem to emerge from the frame with the air of carnival angels return-ing from a children's fancy-dress ball. These little girls are enchanting, with knots of blue ribbon on the breast, necklets of pearls, Medici collars rising from the nape of the neck, and *décolleté* bodices in the Spanish fashion. There are golden-haired beauties among them and fairy Infantas, seductive with the peculiar graces of the infancy of womanhood, its almost divine prettiness and elegance that seems not yet to have touched the earth. Never have the dawn, the budding charms of a woman's face, the transparencies of a little girl's com-plexion, the amber of its shadows that might have been cast by the wings of a dove, the glimmer of mother-of-pearl suffus-ing her shoulders in her first *décolleté* dress, never has the white,

virgin softness of a woman's skin been painted as by this miniaturist whose little portraits, so soft and free, so alive and radiant, recall the works of such great masters of flesh painting as Van Dyck and Rubens, reduced to the format of a medallion or, rather, seen through the small end of an opera glass purchased at the Petit-Dunkerque.[69]

## XI

The Revolution came; and with it, the first noble illusions of regeneration, the grand perspective of liberty; Fragonard's household was inspired with the enthusiasm which ran like wildfire through the studios and enflamed the mind of the artistic community. On 7 September 1789, Mme Fragonard figured, together with Mmes Vien, Moitte, the young Mme Lagrenée, Mmes Screvée and David in the procession of artists' wives who came to offer to their country, at the bar of the National Assembly, their rings, ear-rings, jewelled boxes, precious embroidery needles and gold and silver ornaments. And it is in the patriotic costume of the hour that she appears in M. Théophile Fragonard's miniature; the little gauze cap tied with tricolour ribbon and surmounted by a cockade, the hair unpowdered and falling to the shoulders like a boy's, the figure encased in a white *pierrot* with a small collar and broad, turned-down lapels and a red carnation in the bosom—no detail of the new national fashion has been omitted.

At the same moment, Fragonard dedicated his 'La Bonne Mère' to the nation. Through the influence of David,[70] who

★[69] The Petit-Dunkerque was a celebrated shop near the Pont-Neuf (Paris), where toys, bibelots and what the trade would now call 'novelties' of all kinds were sold.

[70] David's friendship for Fragonard remained constant. He proposed his appointment as a curator of the National Museum in the following terms: 'Fragonard's numerous works speak in his favour; warmth and originality are his principal characteristics; both a connoisseur and a great painter, he will devote his declining years to the preservation of the masterpieces of art whose number he himself helped to increase in his youth.' *Histoire des peintres*, by M. Charles Blanc.

Later, acknowledging reception of a work sent by Evariste Fragonard, David wrote the following generous letter: 'I was touched to hear from you, my

remained his friend and to whom he had sent his son Evariste [71] as a student, he was appointed a curator of the National Museum and, later, a member of the jury set up in the month of *brumaire* in the Revolutionary Year II, under the presidency of Pache to judge the works of painting, sculpture and architecture submitted under the terms of the public competitions. The triumph, however, of the new school of painting seems to have crushed and bewildered him; he seems to have wished to make honourable amends for his own genre, his bright, living style; and with his aged fingers, so prompt to seize and set down an airy fantasy, he worked away at laborious drawings, wearisome imitations of the wearisome line-drawing of the time, which he sold to some backward collector or some Brussels banker in whose ears the rumour of his name still sounded. [72]

Disappointment, privation and poverty soon overtook him. Fragonard possessed 18,000 *livres* in Government *rentes*; as a result of reductions and consolidations, this sum fell to 6,000. He was now so poor that he was induced to invest this amount

friend; it proves that I am in your thoughts. I was delighted to receive your work and it gave me great pleasure to look at it. Do not stop working, my friend; you are destined to go far. Anyone capable of such an achievement at the age of twenty-four must consider himself a happy man. I must congratulate your admirable father and trust that he will be fully rewarded for the artistic freedom he has allowed you; for, as an intelligent man, he has realized that there is more than one way of reaching the goal; the name of Fragonard will be illustrious in every genre. Remember me affectionately to your mother; nor could I forget to send my remembrances to Mlle Gérard—the reproaches of posterity would be too great. Your sincere friend, David. The 23rd *vendémiaire*, in the year XIV.' Copy of a letter from David in the collection of M. Moulin.

[71] Fragonard was the owner of a magnificent collection of contemporary prints. One day—it was after the school of David had triumphed—he noticed smoke issuing from the door of a room and came upon his son in front of a paper bonfire. 'Wretch, what are you up to?' said the father. 'This is a holocaust to good taste,' replied the son, in all seriousness. He was burning his father's print collection.

[72] The catalogue of the sale of the Prince de Ligne (Vienna, 1814), includes two drawings in *grisaille*: one representing 'Le Sénat assemblé pour décider la paix et la guerre' [*'Assembly of the Senate to decide between War and Peace'], and the other, 'La Fermeture du Temple de Janus' [*'The Closure of the Temple of Janus']. These two drawings had been sent by Fragonard to M. d'Aoust, a Brussels banker, who paid 400 *livres* for them.

in the form of life annuities taken out in the names of members of his family. Half ruined, he accepted the position of curator and was able, in the exercise of this function, to secure the approval of a motion, in spite of lively resistance, decreeing the separation of the schools. But his past as a painter made him enemies in the artistic world of 1790, who were able to circumvent the minister and obtain his dismissal on the ironic pretext of leaving him time to pursue his own important work.[73]

Fragonard endured the distresses of the end of his life, the loss of his money and position, the extinction of his earlier renown with youthfulness of spirit, light-hearted patience, gay courage and the fortunate support of good health. In this, he was the son of his father who died, at the age of ninety, from a rheumatic stiffening of the limbs, the result of a hunting expedition on which he had embarked with the object of providing game for a dinner in celebration of the christening of his grandson, Evariste. Nimble and active, Fragonard seemed destined for the same longevity when one day, returning from a walk in the Champ de Mars and feeling hot and thirsty, he went into a café and ate an ice; cerebral congestion ensued and he died almost immediately. He was seventy-four years old.

He died obscure and forgotten. He was not even honoured by the brief obituary which the *Journal de l'Empire* devoted to Greuze, the single line with which this paper recorded the deaths of artists. And there was nothing to recall his destiny

[73] Here is the record, as given by the Archives of the Louvre, of the various functions discharged by Fragonard in the administration of the arts. On the 12th *pluviôse* of the year II, his name occurs among the members of the National Museum of Arts, at the time of its inauguration. On the 19th of the same month, he was elected President of the Board of Curators of the Museum. On the 24th *ventôse*, he was delegated with Lesueur to arrange for the planting of a Tree of Liberty, and his name occurs as a member of all the Commissions nominated by the Board of Curators. On the 15th *thermidor*, Fragonard ceased to be a member of the Board of Curators, but continued to be a member of the temporary commission on the arts. During the year III, his name appears again among the members of the Board of Curators and, during the same year, he was appointed President. In the year V, he was no longer in the administration of the National Museum, and, in the year VIII, on the 22nd *prairial*, his office of inspector of the transport of works of art from the special museum at Versailles to the central museum in Paris was suppressed.

to his contemporaries, nothing but a memory, a picture
exhibited at the Salon of that year in which Mlle Gérard
piously bestowed upon the head of the bailiff in her picture
the aspect and features of her 'good friend, Frago'.[74]

## XII

Wishing to describe a great masterpiece by Fragonard, it
occurred to Diderot to imagine it as in a dream. He could not
have done better; Fragonard was the master of a dream world.
His painting is a dream—the dream of a man asleep in a box
at the opera.

The stage fades out, the lights in the auditorium are slowly
extinguished. The royal boxes disappear. The orchestra
retreats. The music expires and, amid the winged murmur of
invisible instruments, an air by Gluck sighs, flutters and dies.
Little by little everything is silent, everything stops—then,
softly, everything returns. Sleep silently lifts the curtain. And
the opera is resumed before the dreamer, a heavenly, trium-
phal opera. Palaces, temples, scenery, marble colonnades
wreathed in foliage rise up in a vapour. The transformations
are exultantly accomplished amid the play of Bengal lights.
The metamorphoses of mythology follow one upon another.
Allegories shine forth. The basket of Flora is emptied on to the
sky, spring falls upon the scene like a shower and the cardboard
clouds are changed into clouds of glory. Aureoles of light are
diffused from glowing tripods. A cluster of roses is trans-
formed into a burning bush. The actresses' dresses, divided,
floating about them, reveal the forms of goddesses. Cascades
and fountains glitter, splinter and leap, flinging into the air a
powder of diamonds. Then, of a sudden, the scene is thronged
with cupids rushing through a forest of cypress with torches
in their hands; and in the background, the Temple of Eros,
the Eros of Bouchardon, rises and spreads outward to a
dazzling accompaniment of flames as if lit by the vast wood
blaze of the festivities of the Trianon—the final bonfire of the
eighteenth century!

[74] The *Pausanias français*, 1806.

# NOTES

HERE is the Academy's judgement, dated 31 July 1758, on the roll of studies by Fragonard, sent from Rome to Paris in the same year: 'The male life study painted by the sieur Fragonard would have appeared more satisfactory, if we had had no knowledge of the brilliant aptitude of which he had already given evidence in Paris. . . . The same may be said of his study of the head of a priestess which we consider to have been painted in somewhat too sweet a manner; we were, however, better pleased with his drawings which, in our view, have been executed with subtlety and truth.' The following year (11 October 1759) the Academy appeared to be more satisfied with Fragonard, 'although excessive care seems to have replaced, with little advantage, that technical facility which, perhaps, he had previously carried too far'. (*Académie de France à Rome*, by Lecoy de la Marche.)

★　　★　　★

Natoire's letters confirm the intimacy which was at once established between the Abbé de Saint-Non and the young student. Natoire writes on 27 August 1760: 'M. l'Abbé de Saint-Non has been at Tivoli for a month with one of our students, Fragonard, a painter. This collector is enjoying himself greatly and is very busy. Our young artist is doing admirable studies which cannot but be useful to him and do him great credit. He has a very telling gift for this kind of landscape and successfully introduces pastoral scenes into his compositions.' Natoire writes again on 18 March 1761: 'Le sieur Fragonard is about to leave us; M. l'Abbé de Saint-Non, still anxious to be of assistance to this student (since he is taking him with him), recently sent him to Naples to examine the fine things preserved in that town, before beginning their joint journey. This collector has with him a quantity of charming sketches by the young artist which, I believe, you will be delighted to examine.'

Fragonard, who had arrived in Rome in 1756 with Brennet, left on 4 April 1761. (*Académie de France à Rome*, by Lecoy de la Marche.)

★　　★　　★

With reference to Fragonard's admission to membership of the Academy, M. de Marigny wrote to Natoire on 27 March 1765, as follows: 'M. Fragonard has just been received as a member of the

Academy with a unanimity and enthusiasm of which there have been
few examples; it is hoped that he may make some contribution
towards consoling us for the loss of Deshaies.' (*Académie de France à
Rome*, by Lecoy de la Marche.)

<p align="center">★     ★     ★</p>

Among the numerous pictures and drawings by Fragonard in the
collection of the miniaturist, Hall, the following curious item occurs
in the collector's manuscript catalogue:
  '*Fragonard*—A portrait head of myself, painted at the period when
he executed portraits at a single sitting, for a *louis*.'
  (*Hall, sa vie, ses œuvres, sa correspondance*, by Villot, 1867.)

<p align="center">★     ★     ★</p>

M. Groult is the owner of a large decorative canvas by Fragonard,
which appears to be a panel from the 'Salon de Terpsichore' in Mlle
Guimard's house in the Rue de la Chaussée-d'Antin. The dancer is
represented, life size, wearing the costume of a shepherdess from the
Opera; the powdered hair is crowned by a light garden hat, in a
charming turned-up style with ribbons fluttering out behind it; and a
pug is barking beneath her skirt. She wears a pink bodice, laced up
between the breasts, a dress with a tucked-up, green silk lining over
which is thrown a lace apron with pockets decorated by bunches of
ribbon and artificial roses. Shown in the act of trying out a dance step,
the ballerina is shod with white satin shoes adorned with pink
rosettes—charming shoes worn by a triumphant foot which provides
the target for a cupid kneeling in a rose-bush and preparing to dis-
charge an arrow from his bow.

<p align="center">★     ★     ★</p>

On his return from a journey to the South of France, M. Lagrange
published in the *Gazette des Beaux Arts* a long description of Frago-
nard's house at Grasse, the house in which he took refuge during the
Terror, and whose staircase he lavishly painted or caused to be painted
with revolutionary emblems.
  The drawing-room, whose doors are surmounted by a marble
relief in the manner of Clodion, is covered with paintings, and even
in the narrow angles at the corners, strips of canvas conceal the
panelling beneath their painted flowers. It is a complete decoration,
lacking only an ornamental framework in carved wood. There are
large pictures more than six feet in length between the doors, and

above the doors are smaller works; both illustrate the development of a love poem. The large paintings deal with progress of a sentimental adventure on the human plane, and in the smaller panels mocking cupids hover in an Olympian air. The first large panel represents a meeting of little boys and girls at the Fountain of Love—while overhead a cupid chases a dove. In the second panel two lovers seal their vows with a soft kiss. In the third, a youth appears from a ladder on the terrace where his mistress dreams and waits. The fourth shows the young victim dragged prostrate on to the steps of an altar to Eros. In the fifth, the final panel, beneath the foliage of a grove of trees, amid a plantation of orange bushes, strewn with guitars and music books, the ravished maiden crowns the kneeling figure of Eros while, in a corner, Fragonard himself sits sketching, his drawing-board on his knees. And as a kind of apotheosis to this fifth act, Hymen, bearing a torch in each hand, shines, flashes forth, in the panel over the fireplace, in the midst of a flaming sky streaked with cupids.

Only two of the large panels are signed, but M. Lagrange had no doubt that all the paintings in the room were executed by Fragonard—though considerable intervals of time must have elapsed between their commencement and completion, some displaying the bluish tonality of 'Les Hasards heureux de l'escarpolette', others the warm, blond scale of the painter's first manner.

<center>★    ★    ★</center>

Fragonard had the natural temperament of a painter; his entire organism was drawn instinctively towards the arts. Renouvier quotes this remark, characteristic of the painter: 'I would paint with my bottom!'[75]

---

[75] *Histoire de l'art pendant la Révolution*, by Renouvier. Renouard, 1863.

# THE PLATES

WATTEAU
1–30

BOUCHER
31–46

LA TOUR
47–56

CHARDIN
57–68

GREUZE
69–79

FRAGONARD
80–96

I. WATTEAU: SELF-PORTRAIT
Drawing. Chantilly, Musée Condé

2. WATTEAU: LA POLONAISE

Warsaw, Collection of the State of Poland

3. WATTEAU: MEZZETINO
New York, Metropolitan Museum

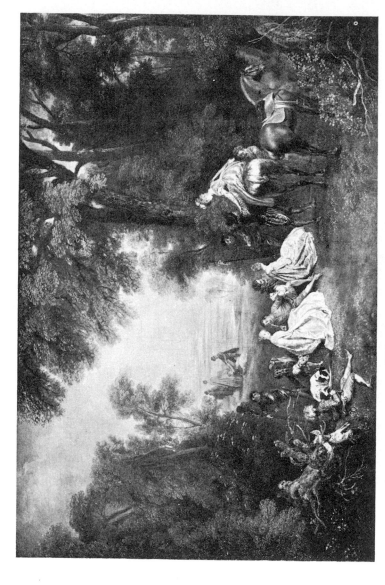

4. THE HALT DURING THE CHASE

*From the original in the Wallace Collection, London, by permission*

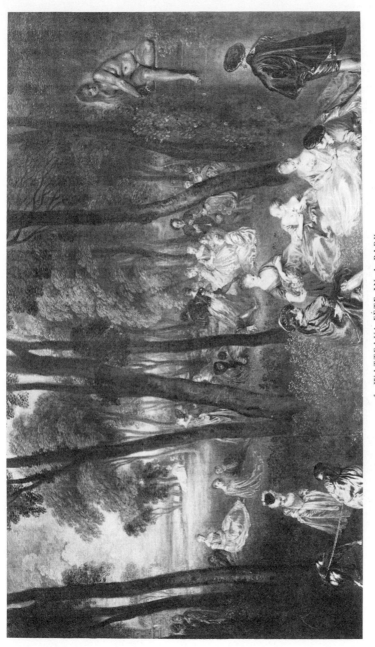

5. WATTEAU: FÊTE IN A PARK

*From the original in the* Wallace Collection, London, *by permission*

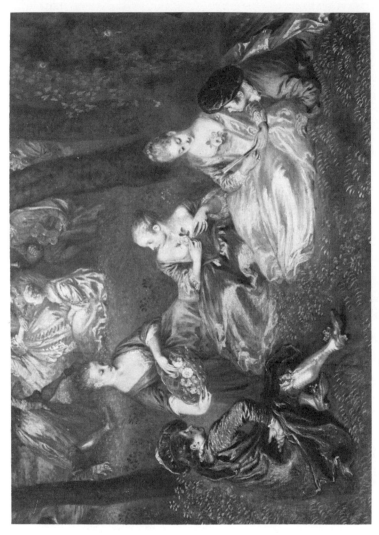

6. WATTEAU: A GROUP OF FIGURES
Detail of Plate 5

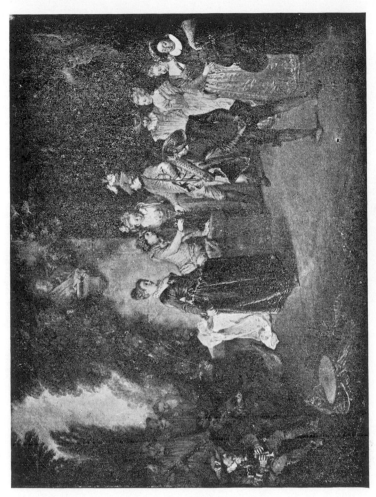

7. WATTEAU: FRENCH ACTORS
Berlin, Kaiser-Friedrich-Museum

8. WATTEAU: A FARMSTEAD

Drawing, Bayonne, Musée Bonnat

9. WATTEAU: COTTAGES AMONG TREES
Drawing, Bayonne, Musée Bonnat

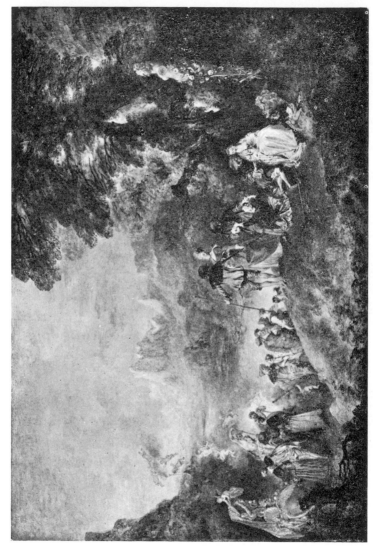

IO. WATTEAU: EMBARKATION FOR CYTHERA (first version)

Paris, Louvre

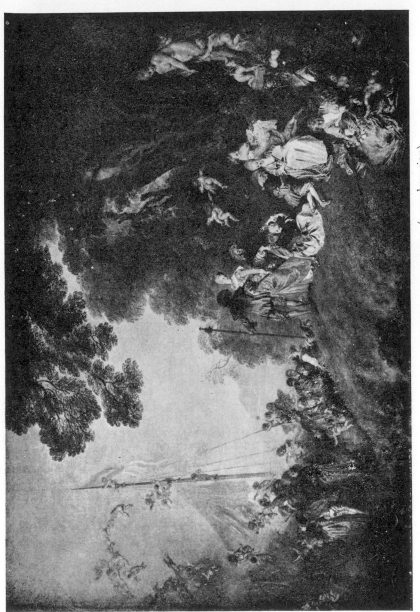

II. WATTEAU: EMBARKATION FOR CYTHERA (second version)
Berlin, Schlossmuseum

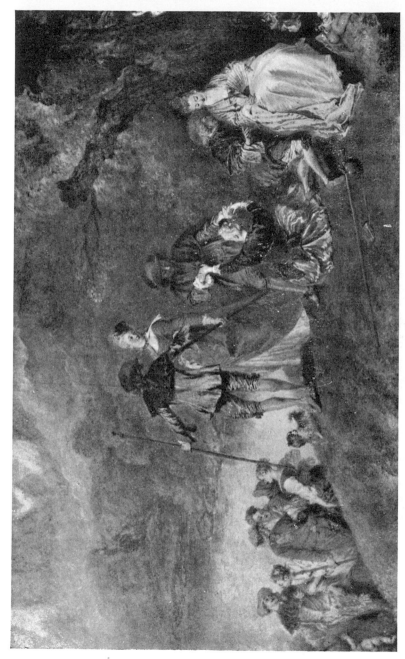

12. WATTEAU: A GROUP OF FIGURES

Detail of Plate 10

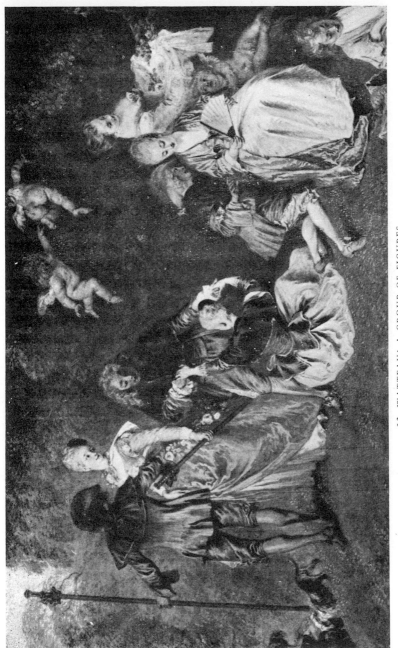

13. WATTEAU: A GROUP OF FIGURES
Detail of Plate 11

14. WATTEAU: FOUR STUDIES OF A MALE FIGURE DANCING
Drawing. Paris, M. Gaston Menier (*Formerly in the Goncourt Collection*)

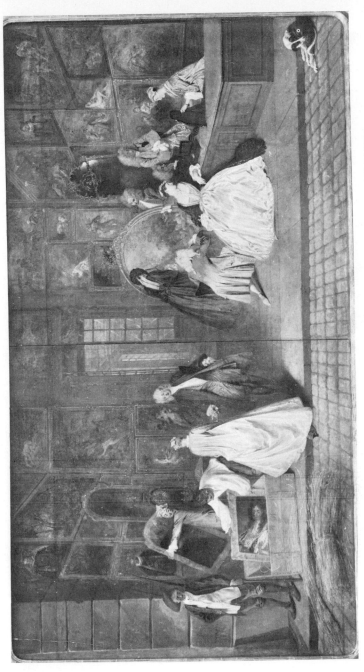

15. WATTEAU: SIGN-BOARD FOR THE SHOP OF THE ART DEALER GERSAINT

Berlin, Schlossmuseum

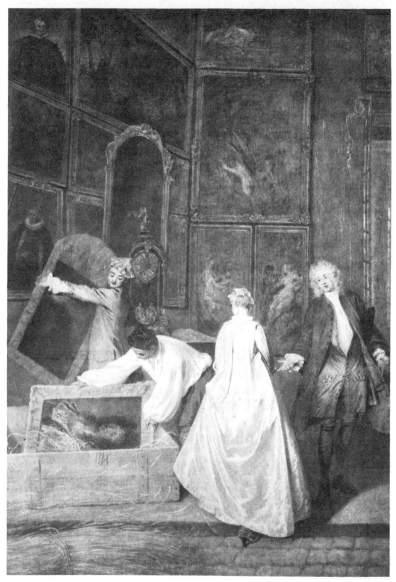

16. PACKING UP PICTURES
Detail of Plate 15

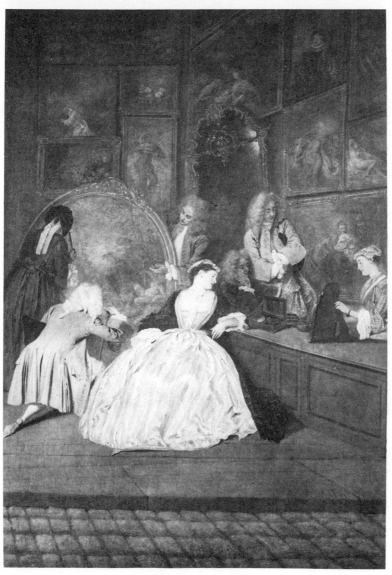

17. SELLING A PICTURE
Detail of Plate 15

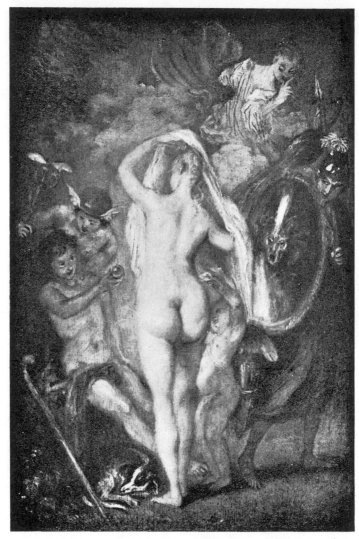

18. WATTEAU: THE JUDGEMENT OF PARIS
Paris, Louvre

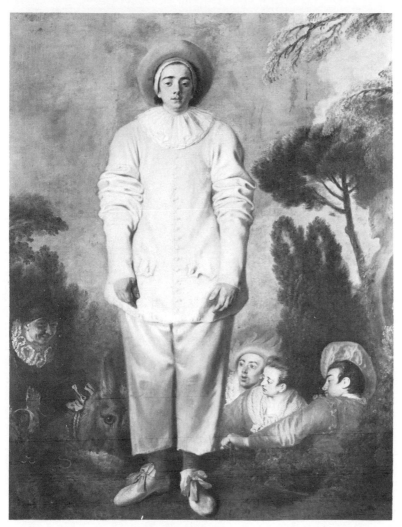

19. WATTEAU: GILLES
Paris, Louvre

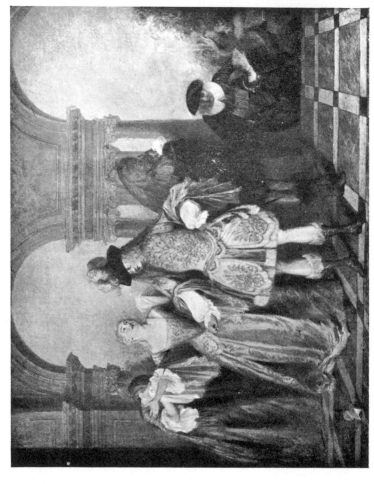

20. WATTEAU: THE FRENCH PLAYERS
New York, Metropolitan Museum, Bache Collection

21. WATTEAU: GROUP OF MASQUERADERS
Drawing. New York, Pierpont Morgan Library

22. WATTEAU: TWO STUDIES OF A GUITAR PLAYER
Drawing. London, British Museum

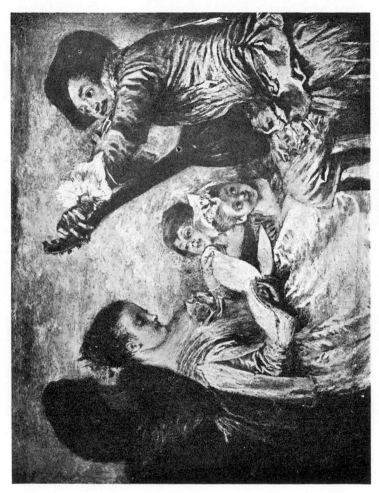

23. WATTEAU: THE MUSIC LESSON

From the original in the Wallace Collection, London, by permission

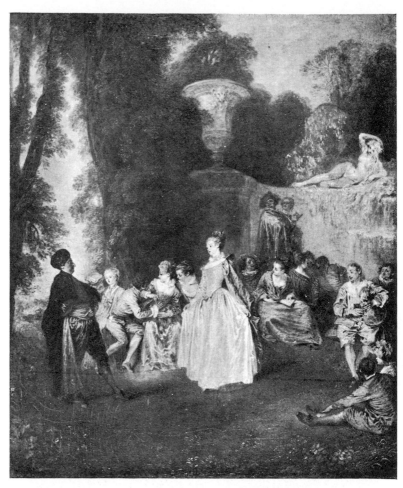

24. WATTEAU: DANCE IN A PARK
Edinburgh, National Gallery of Scotland

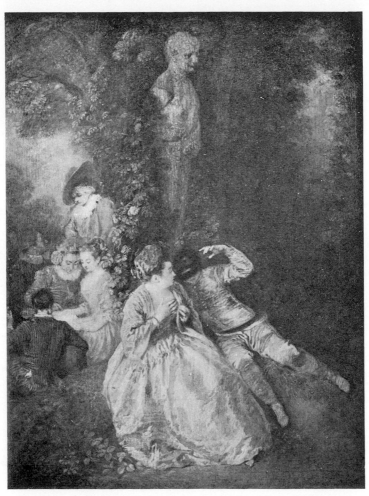

25. WATTEAU: HARLEQUIN AND COLUMBINE
*From the original in the* Wallace Collection, London, *by permission*

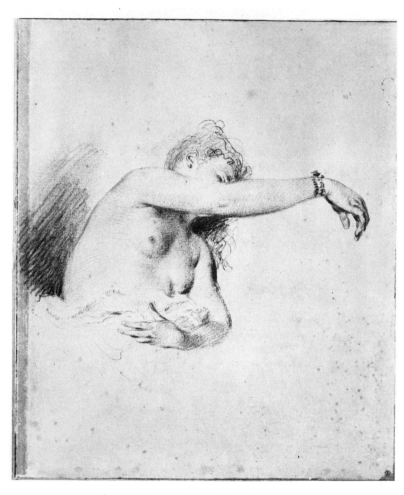

26. WATTEAU: NUDE FEMALE TORSO
Drawing. Paris, Louvre

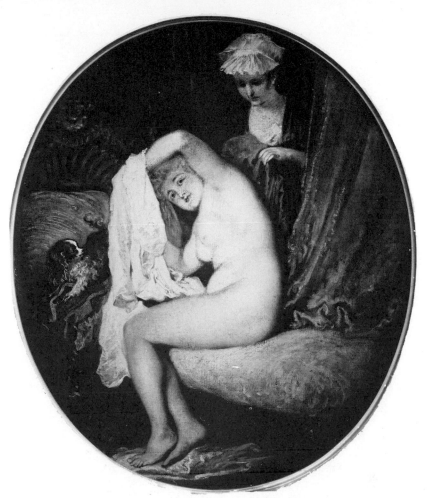

27. WATTEAU: A LADY AT HER TOILET
*From the original in the* Wallace Collection, London, *by permission*

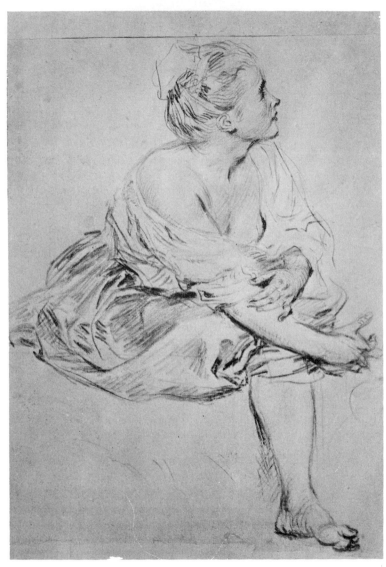

28. WATTEAU: A WOMAN SEATED
Drawing. New York, Pierpont Morgan Library

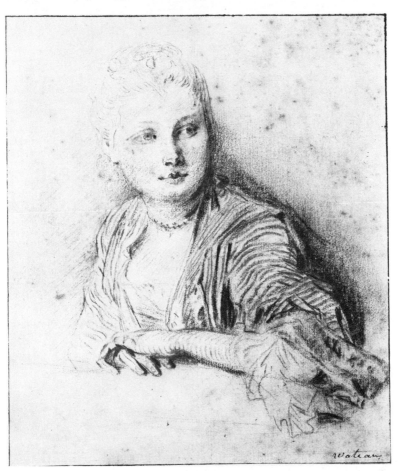

29. WATTEAU: YOUNG WOMAN
Drawing. New York, Pierpont Morgan Library

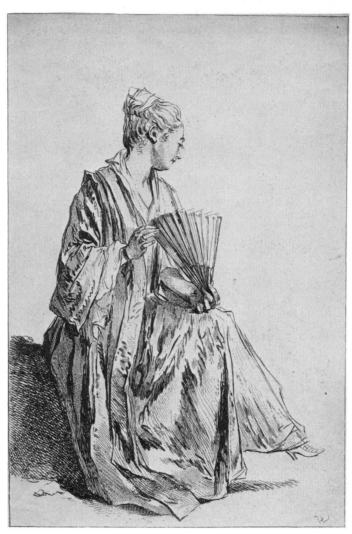

30. ETCHING BY BOUCHER AFTER A DRAWING BY WATTEAU:
LADY WITH FAN
Paris, Bibliothèque Nationale

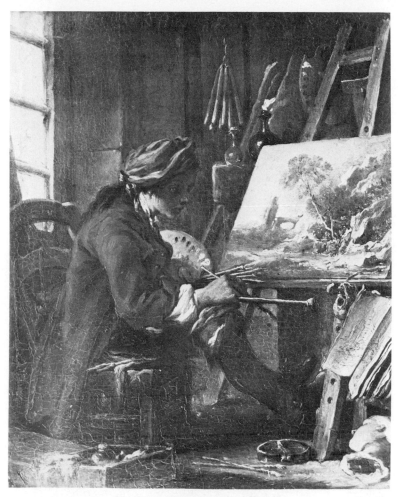

31. BOUCHER: SELF-PORTRAIT
Paris, Louvre

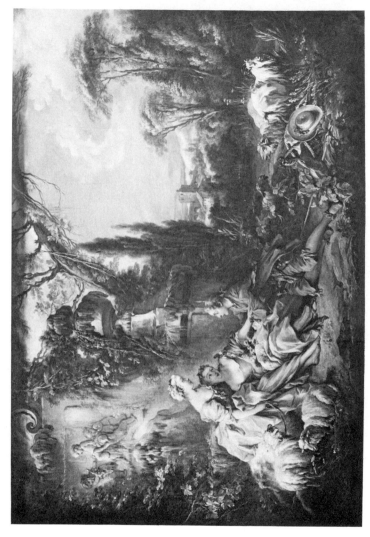

32. BOUCHER: PASTORAL SCENE

Paris, Louvre

33. BOUCHER: WASHERWOMAN AT A WELL
Drawing. Formerly in the Goncourt Collection

34. BOUCHER: AN AUDIENCE OF THE EMPEROR OF CHINA

Besançon, Museum

35. BOUCHER: COURTYARD OF A COUNTRY HOUSE
Drawing. Vienna, Albertina

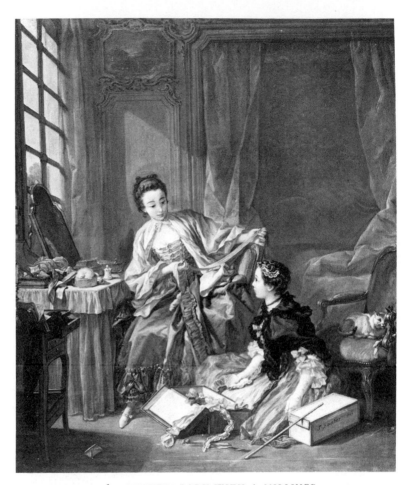

36. BOUCHER: LADY WITH A MILLINER
Stockholm, National Museum

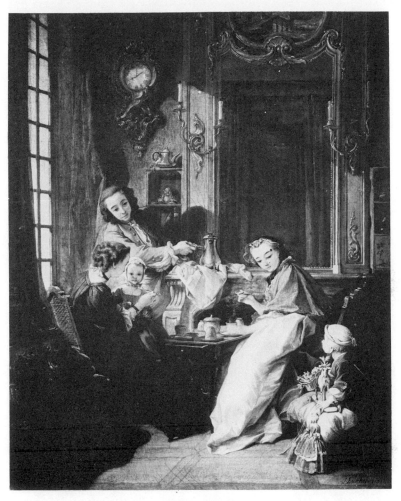

37. BOUCHER: BREAKFAST
Paris, Louvre

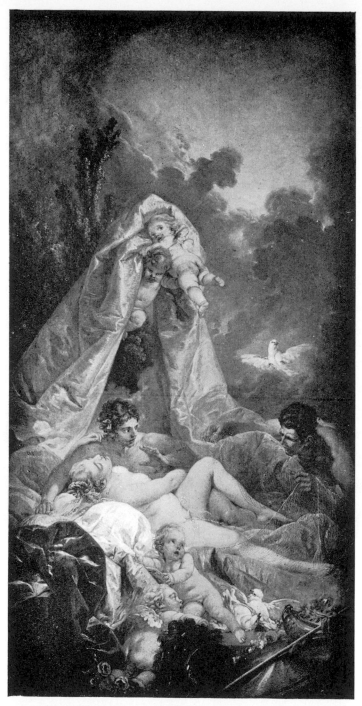

38. BOUCHER: MARS AND VENUS SURPRISED BY VULCAN
*From the original in* the Wallace Collection, London, *by permission*

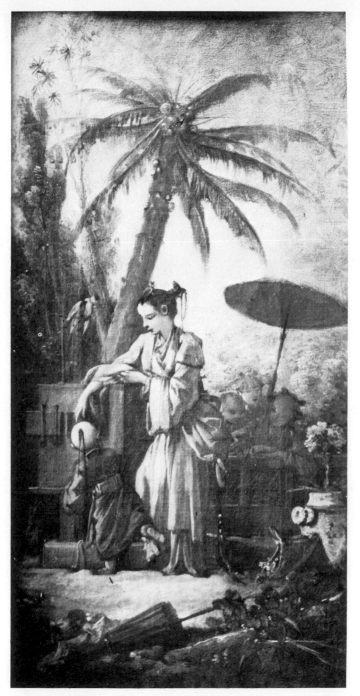

39. BOUCHER: IN A CHINESE GARDEN
Besançon, Museum

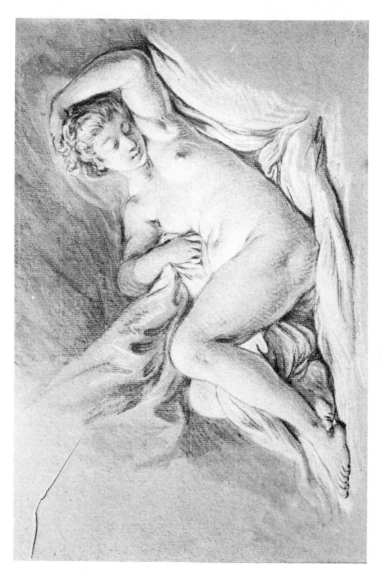

40. BOUCHER: NUDE GIRL ASLEEP
Drawing, Besançon, Museum

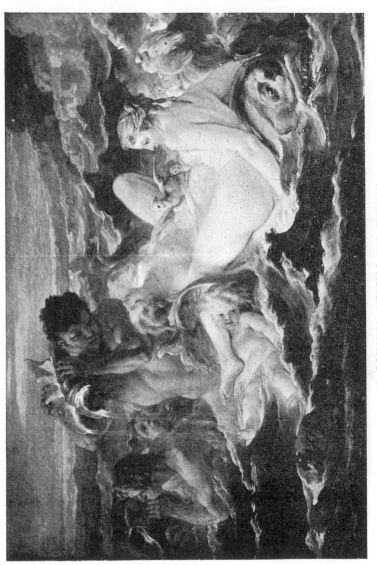

41. BOUCHER: NEREIDS AND TRITONS

Detail from the 'Triumph of Venus'. Stockholm, National Museum

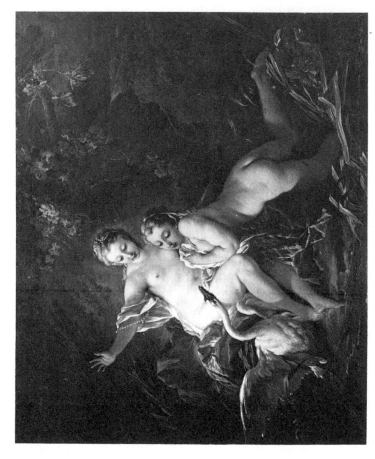

42. BOUCHER: LEDA AND THE SWAN
Stockholm, National Museum

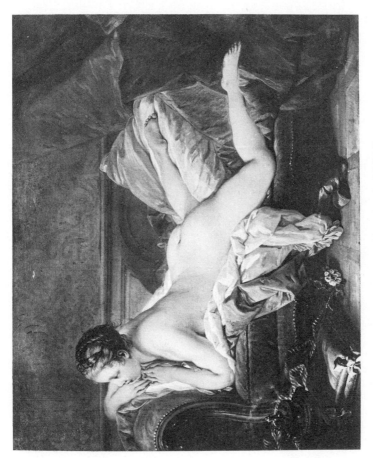

43. BOUCHER: GIRL ON A COUCH
Munich, Aeltere Pinakothek

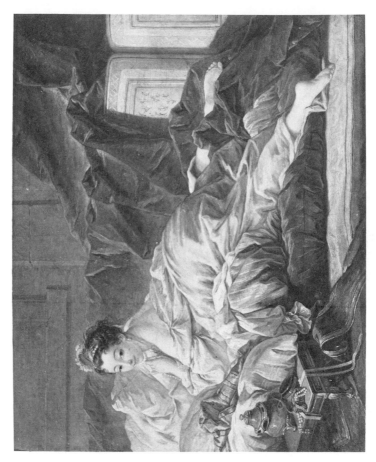

44. BOUCHER: GIRL ON A COUCH
Paris, Otto Edouard Bemberg

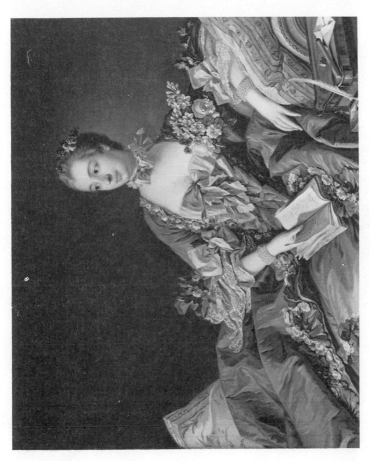

45. BOUCHER: MADAME DE POMPADOUR
Edinburgh, National Gallery of Scotland

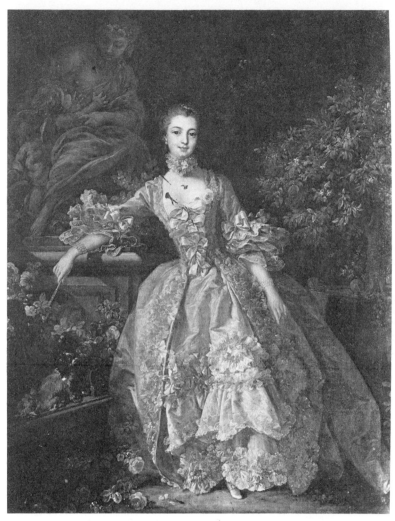

46. BOUCHER: MADAME DE POMPADOUR
*From the original in the* Wallace Collection, London, *by permission*

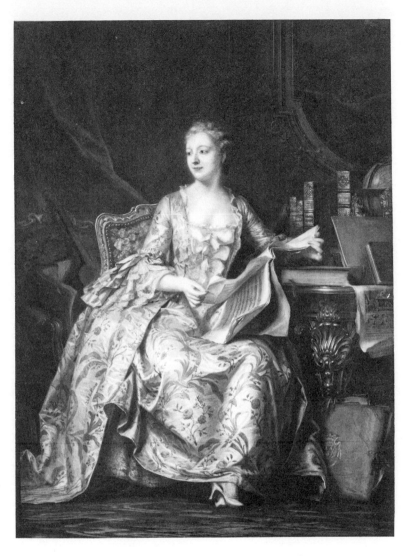

47. LA TOUR: MADAME DE POMPADOUR
Pastel. Paris; Louvre

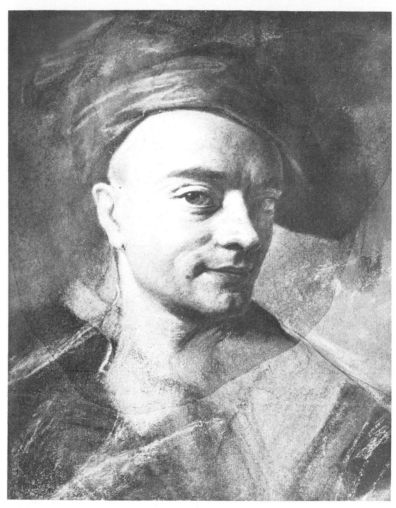

48. LA TOUR: SELF-PORTRAIT
Pastel. St. Quentin, Museum

49. LA TOUR: JEAN-JACQUES ROUSSEAU
Pastel. St. Quentin, Museum

50. LA TOUR: SELF-PORTRAIT
Amiens, Musée de Picardie

51. LA TOUR: MARIE LECZINSKA
Paris, Louvre

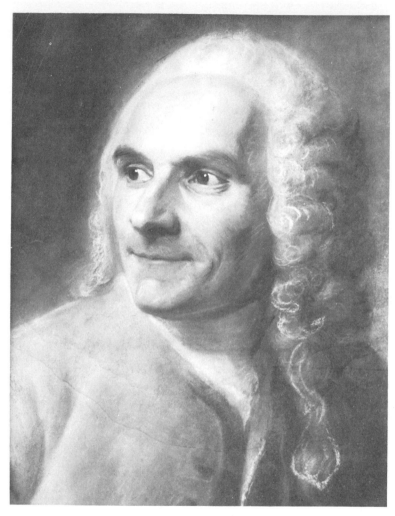

52. LA TOUR: JEAN RESTOUT
Pastel. St. Quentin, Museum

53. LA TOUR: THE DANCER MLLE CAMARGO
Pastel. St. Quentin, Museum

54. LA TOUR: HENRY DAWKINS, M.P.
Pastel. Steyning, Sussex, Charles Clarke

55. LA TOUR: DUVAL DE L'ESPINOY
Pastel. Paris, Baron Henri de Rothschild

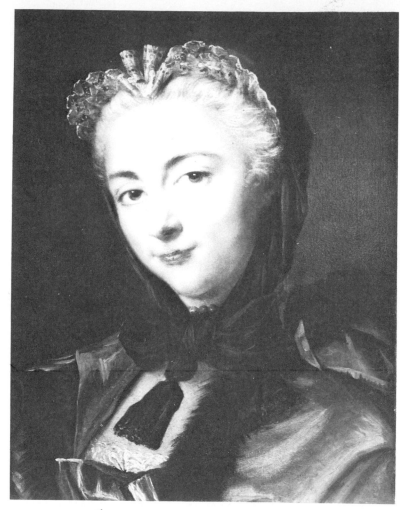

56. LA TOUR: UNKNOWN LADY IN PINK
Pastel. Epinal, Museum

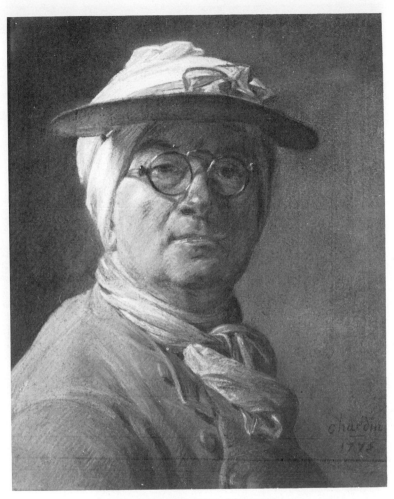

57. CHARDIN: SELF-PORTRAIT
Pastel. Paris, Louvre

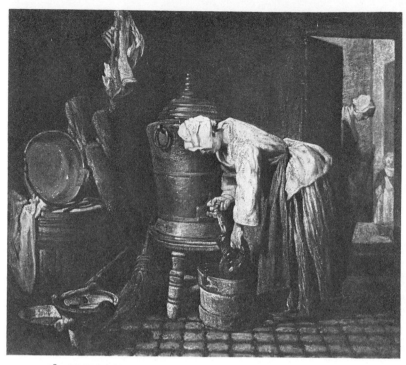

58. CHARDIN: A WOMAN DRAWING WATER FROM A TANK
Richmond, Surrey, Cook Collection

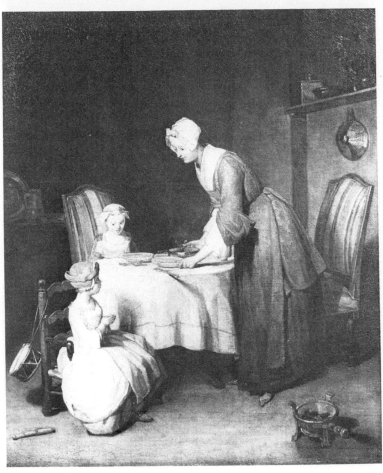

59. CHARDIN: SAYING GRACE
Paris, Louvre

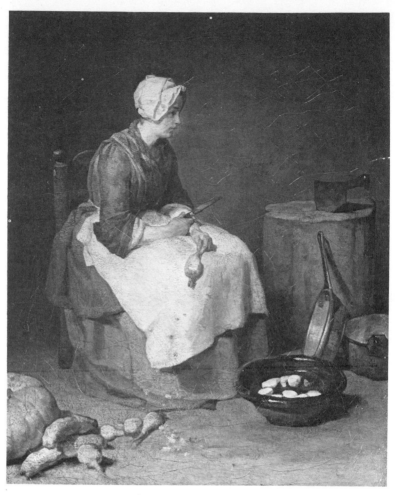

60. CHARDIN: THE COOK
Vaduz, Liechtenstein Gallery

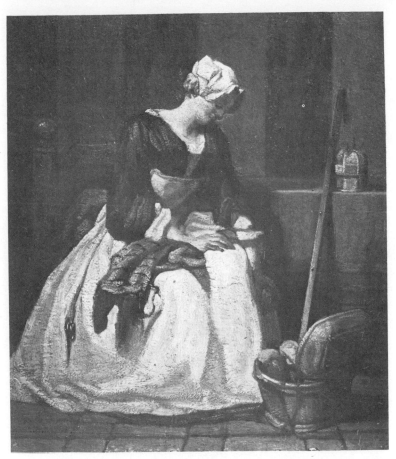

61. CHARDIN: WOMAN WINDING WOOL
Stockholm, National Museum

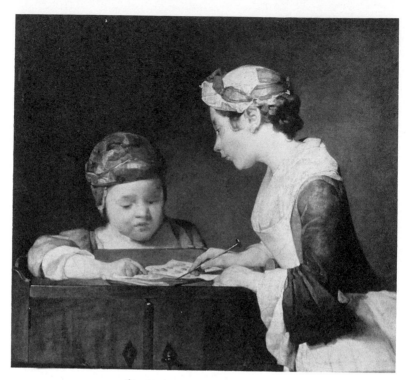

62. CHARDIN: THE LESSON
London, National Gallery

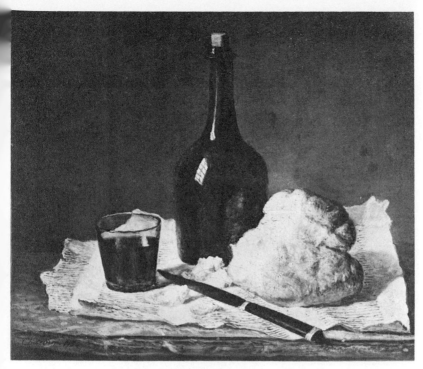

63. CHARDIN(?): STILL-LIFE
London, National Gallery

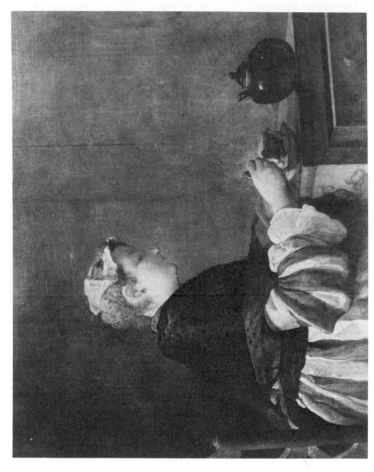

64. CHARDIN: A LADY TAKING TEA
Glasgow, University, Hunterian Museum

65. CHARDIN: STILL-LIFE
Berlin, Kaiser-Friedrich Museum

66. CHARDIN: AN ARTIST AT WORK
Drawing. London, Collection of G. Bellingham Smith

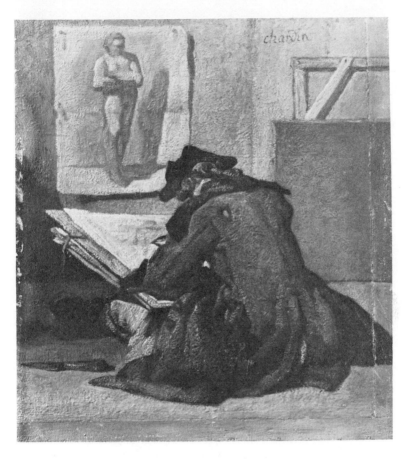

67. CHARDIN: AN ARTIST AT WORK
Stockholm, National Gallery

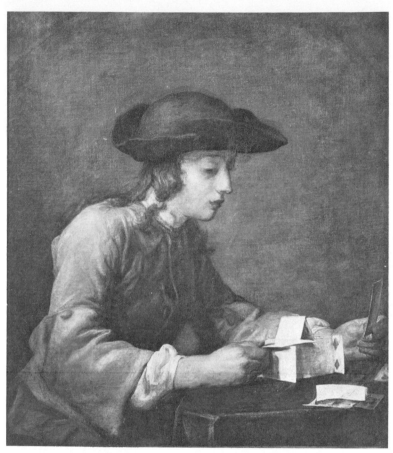

68. CHARDIN: A HOUSE OF CARDS
Paris, Louvre

69. GREUZE: BOY WITH LESSON BOOK
Edinburgh, National Gallery of Scotland

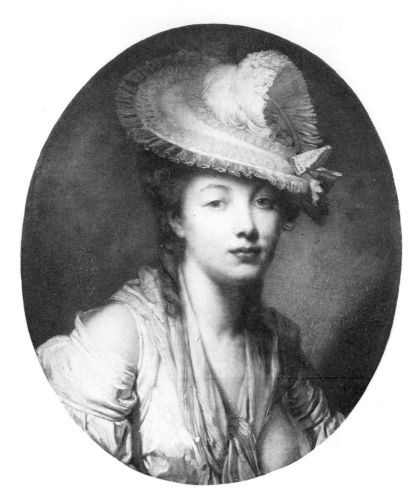

70. GREUZE: GIRL WITH PINK HAT
Boston, Museum of Fine Arts

71. GREUZE: MLLE SOPHIE ARNOULD

*From the original in the* Wallace Collection, London, *by permission*

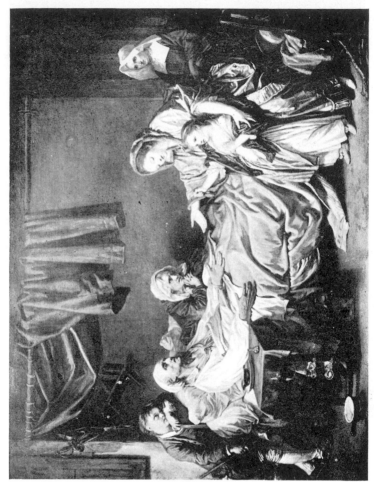

72. GREUZE: THE BENEFACTRESS
Lyon, Museum

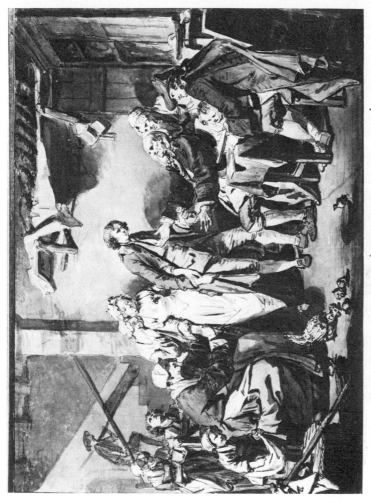

73. GREUZE: STUDY FOR 'THE VILLAGE BETROTHAL'
Drawing, Paris, Petit Palais

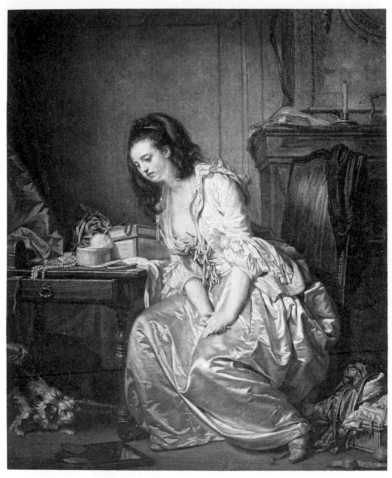

74. GREUZE: THE BROKEN MIRROR

*From the original in the* Wallace Collection, London, *by permission*

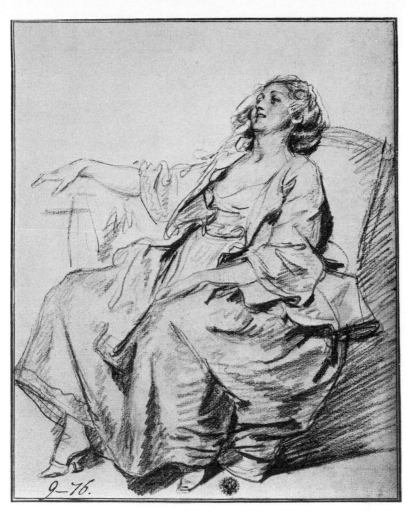

9—76.

75. GREUZE: SEATED LADY
Drawing. Leningrad, Academy

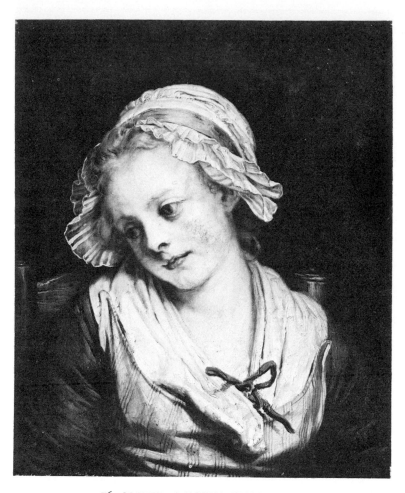

76. GREUZE: A YOUNG PEASANT GIRL
Chantilly, Musée Condé

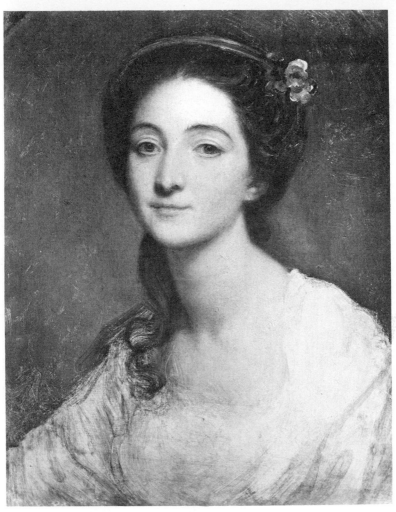

77. GREUZE: A LADY

*From the original in the* Wallace Collection, London, *by permission*

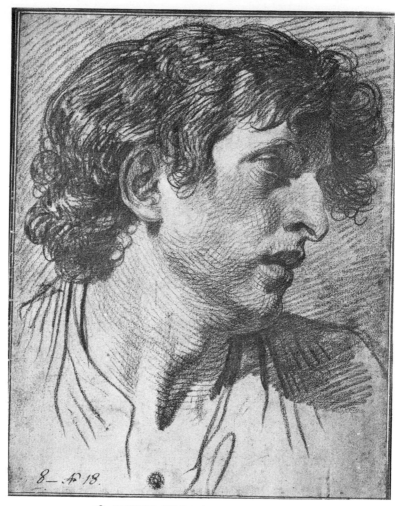

78. GREUZE: HEAD OF A YOUNG MAN
Drawing. Leningrad, Academy

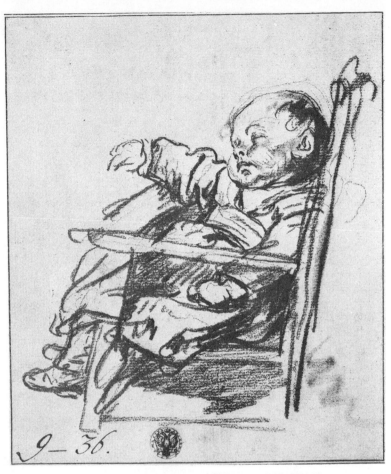

9 — 36.

79. GREUZE: A CHILD ASLEEP IN HIS CHAIR
Drawing. Leningrad, Academy

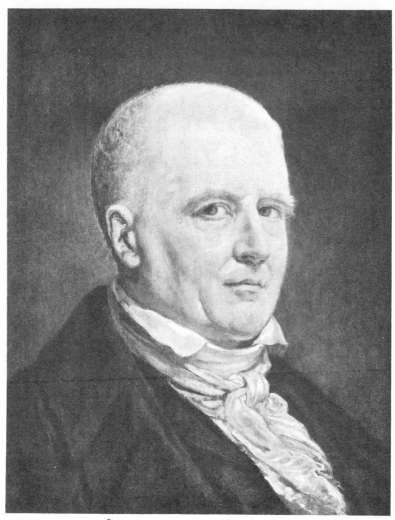

80. FRAGONARD: SELF-PORTRAIT
Paris, Louvre

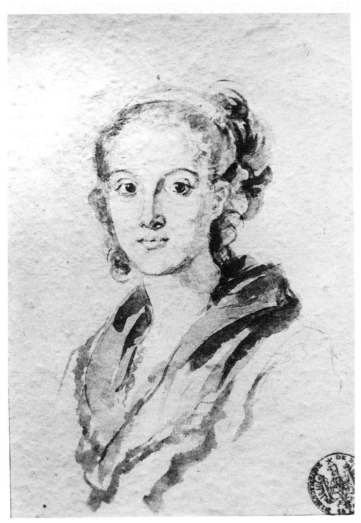

81. FRAGONARD: PORTRAIT OF A GIRL
Drawing. Paris, Petit Palais

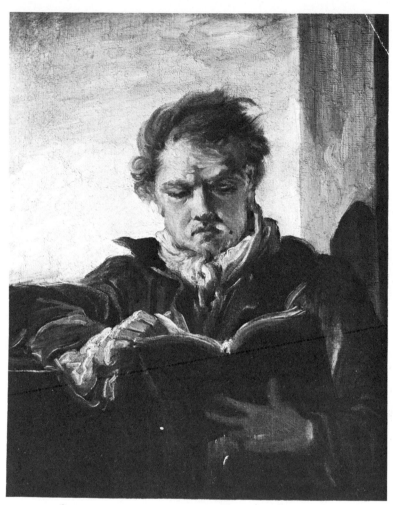

82. FRAGONARD: THE PAINTER HUBERT ROBERT
New York, Jacques Seligman & Co.

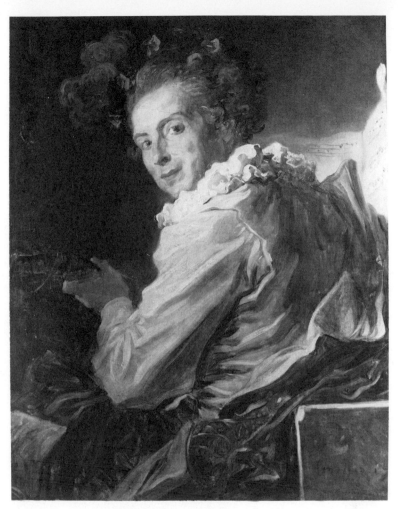

83. FRAGONARD: THE MUSICIAN
Paris, Louvre

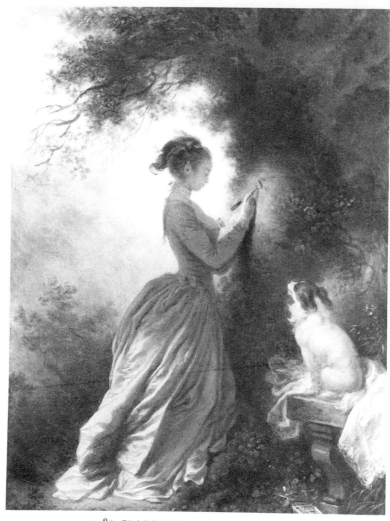

84. FRAGONARD: THE SOUVENIR
*From the original in the* Wallace Collection, London, *by permission*

85. FRAGONARD: THE GAUDY BED
Drawing. Besançon, Museum

86. FRAGONARD: VILLA D'ESTE, TIVOLI
Drawing. Besançon, Museum

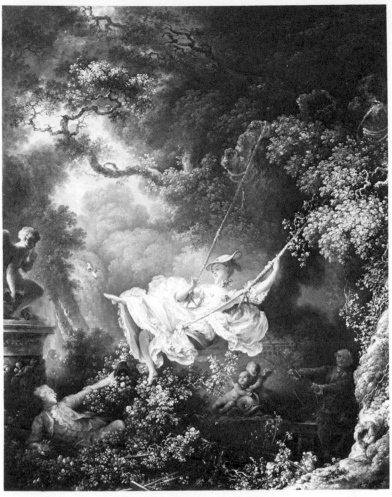

87. FRAGONARD: THE SWING

*From the original in the* Wallace Collection, London, *by permission*

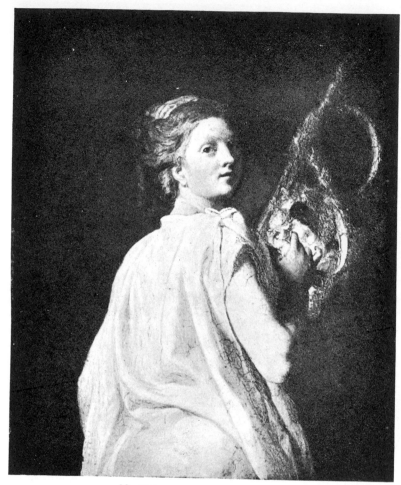

88. FRAGONARD: BACCHANTE
Le Puy, Museum

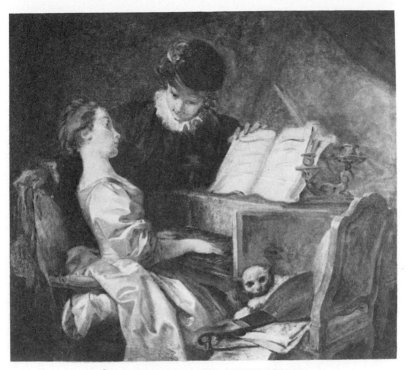

89. FRAGONARD: THE MUSIC LESSON
Paris, Louvre

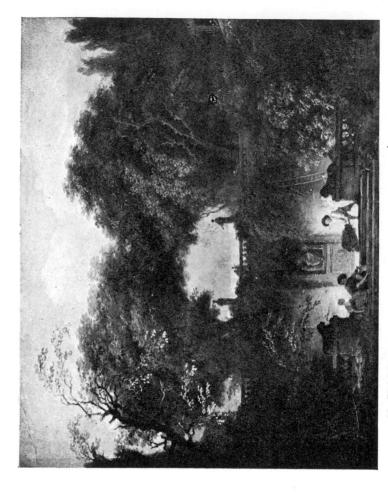

90. FRAGONARD: THE GARDENS OF THE VILLA D'ESTE, TIVOLI

*From the original in the* Wallace Collection, London, *by permission*

91. FRAGONARD: IN THE GARDEN OF THE VILLA D'ESTE
Drawing. Besançon, Museum

92. FRAGONARD: WASHERWOMEN IN AN ITALIAN GARDEN
Amiens, Musée de Picardie

93. FRAGONARD: AN ITALIAN GARDEN

Drawing. Besançon, Museum

95. FRAGONARD: BATHING WOMEN
Paris, Louvre

96. FRAGONARD: SATYRS PLAYING
Two Etchings. Paris, Bibliothèque Nationale

# LIST OF PLATES AND INDEX OF
COLLECTIONS

# LIST OF PLATES

## ANTOINE WATTEAU
### 1684–1721

1. *Self-Portrait*. Drawing. Chantilly, Musée Condé
2. *La Polonaise (A Polish Lady)*. Warsaw, Collection of the State of Poland
3. *Le Mezzetin (The Guitar Player)*. New York, Metropolitan Museum
4. *Le Rendez-Vous de Chasse (The Halt during the Chase)*. 1720. London, Wallace Collection
5. *Les Champs-Elysées (Fête in a Park)*. London, Wallace Collection
6. Detail of Plate 5
7. *L'Amour au Théâtre Français (French Actors)*. Berlin, Kaiser Friedrich Museum
8. *A Farmstead*. Drawing. Bayonne, Musée Bonnat
9. *Cottages among Trees*. Drawing. Bayonne, Musée Bonnat
10. *L'Embarquement pour Cythère (Embarkation for the Island of Venus)*. Paris, Louvre. (This painting is generally called 'The first version')
11. *L'Embarquement pour Cythère (Embarkation for the Island of Venus)*. Berlin, Schlossmuseum. (This painting is generally called 'The second version')
12. Detail of Plate 10
13. Detail of Plate 11
14. *Four Studies of a Male Figure Dancing*. Drawing. Paris, Collection of M. Gaston Menier (formerly Edmond and Jules de Goncourt)
15. *L'Enseigne de Gersaint (The Sign-Board for the Shop of the Art Dealer Gersaint)*. Painted in 1720. Berlin, Schlossmuseum
16. *Packing up Pictures*. Detail of Plate 15
17. *Selling a Picture*. Detail of Plate 15
18. *The Judgement of Paris*. Paris, Louvre
19. *Le Gilles (Portrait of the Actor Giuseppe Balletti with other Figures of the Italian Comedy)*. Paris, Louvre
20. *Les Comédiens Français (The French Comedians)*. New York, Metropolitan Museum, Bache Collection
21. *Group of Masqueraders*. Drawing. New York, Pierpont Morgan Library
22. *Two Studies of a Guitar Player*. Drawing. London, British Museum
23. *The Music Lesson*. London, Wallace Collection
24. *Fêtes Vénétiennes (Dance in a Park)*. Edinburgh, National Gallery of Scotland
25. *Harlequin and Columbine*. London, Wallace Collection
26. *Nude Female Torso*. Drawing. Paris, Louvre

27. *A Lady at Her Toilet.* London, Wallace Collection. (The rectangular shape of this painting as illustrated in the catalogue of the Museum, Brinkmann's book on Watteau, etc., does not agree with the original oval form; the corners—the addition of a late restorer—are now removed)

28. *A Woman Seated.* Drawing. New York, Pierpont Morgan Library

29. *Young Woman.* Drawing. New York, Pierpont Morgan Library

30. *Lady with Fan.* Etching by Boucher, after a drawing by Watteau. Paris, Bibliothèque Nationale

## FRANÇOIS BOUCHER

### 1703-70

31. *Self-Portrait.* Paris, Louvre

32. *Berger et Bergères (Pastoral Scene).* Paris, Louvre

33. *La Lavandière (Washerwoman at a Well before her Cottage).* Drawing. Formerly in the Collection of Edmond and Jules de Goncourt

34. *An Audience of the Emperor of China.* Besançon, Museum

35. *Courtyard of a Country House.* Drawing. Vienna, Albertina

36. *La Marchande de Modes (Lady with a Milliner).* 1746. Stockholm, National Museum

37. *Le Déjeuner (Breakfast).* Paris, Louvre

38. *Mars and Venus surprised by Vulcan.* London, Wallace Collection. (One of the four paintings on a screen in the boudoir of Mme de Pompadour, painted in 1754)

39. *In a Chinese Garden.* Besançon, Museum

40. *Nude Girl Asleep.* Drawing. Besançon, Museum

41. *Nereids and Tritons.* Detail from 'Le Triomphe de Venus', 1740. Stockholm, National Museum

42. *Leda and the Swan.* Stockholm, National Museum

43. *Girl on a Couch.* (Supposed Portrait of Mlle O'Murphy.) 1752. Munich, Aeltere Pinakothek

44. *Girl on a Couch.* (Supposed Portrait of Mlle O'Murphy.) Paris, Otto Edouard Bemberg

45. *Madame de Pompadour.* 1758. Edinburgh, National Gallery of Scotland

46. *Madame de Pompadour.* 1759. London, Wallace Collection

## MAURICE-QUENTIN DE LA TOUR

### 1704-88

47. *Madame de Pompadour.* Pastel, 1755. Paris, Louvre

48. *Self-Portrait.* Pastel. St. Quentin, Museum

49. *Jean-Jacques Rousseau.* Pastel, 1753. St. Quentin, Museum

50. *Self-Portrait.* Pastel, 1750. Amiens, Musée de Picardie

51. *Marie Leczinska.* (Wife of Louis XV.) Pastel. Paris, Louvre

52. *Jean Restout.* Pastel. St. Quentin, Museum

53. *Portrait of the Dancer Mlle Camargo.* Pastel. St. Quentin, Museum

54. *Henry Dawkins, M.P.* Pastel. Steyning, Sussex, England. Charles Clarke, Esq.

55. *Duval de l'Espinoy.* Pastel. Paris, Baron Henri de Rothschild

56. *La Dame vêtue de rose (Unknown Lady in Pink).* Pastel. Epinal, Museum

## JEAN-BAPTISTE-SIMÉON CHARDIN
### 1699–1779

57. *Self-Portrait.* Pastel, 1775. Paris, Louvre

58. *La Fontaine (A Woman Drawing Water from a Tank in a Scullery).* Richmond, Cook Collection

59. *Le Bénédicité (Saying Grace).* Paris, Louvre

60. *La Cuisinière (The Cook).* Vaduz, Liechtenstein Gallery

61. *Femme à la Pelote (Woman Winding Wool).* Stockholm, National Museum

62. *La Petite Maîtresse d'École (The Lesson).* London, National Gallery

63. *Study of Still-Life.* 1754. London, National Gallery. (This picture, exhibited in the Gallery till before the war, has been doubted by Wildenstein, and ascribed to an 'imitator of Chardin' by Martin Davies. But as it is fully signed and dated, it is just a fake if it is not genuine. We have reproduced it here as it is still open to discussion)

64. *A Lady Taking Tea.* 1736. Glasgow, University, Hunterian Museum

65. *Nature morte (Still-Life).* Berlin, Kaiser Friedrich Museum

66. *An Artist at Work.* Black chalk drawing. London, Collection of Mr. G. Bellingham Smith

67. *An Artist at Work.* Stockholm, National Gallery

68. *A House of Cards.* Paris, Louvre

## JEAN-BAPTISTE GREUZE
### 1727–1805

69. *Boy with Lesson Book.* Edinburgh, National Gallery of Scotland

70. *Le Chapeau Rouge (Girl with Pink Hat).* Boston, Museum of Fine Arts

71. *Mlle Sophie Arnould* (Singer and Actress of the French Opéra). London, Wallace Collection

72. *La Dame bienfaisante (The Benefactress).* Lyon, Museum

73. *Study for 'L'Accordée de village' (The Village Betrothal).* Drawing. Paris, Petit Palais. (The finished painting is in the Louvre)

74. *The Broken Mirror.* London, Wallace Collection

75. *Seated Lady.* Drawing. Leningrad, Academy

76. *Young Peasant Girl.* Chantilly, Musée Condé

77. *A Lady.* London, Wallace Collection

78. *Head of a Young Man.* Drawing. Leningrad, Academy

79. *A Child asleep in his chair.* Drawing. Leningrad, Academy

## JEAN-HONORÉ FRAGONARD
### 1732–1806

80. *Self-Portrait.* Paris, Louvre

81. *Portrait of a Girl.* Drawing. Paris, Petit Palais

82. *Portrait of the Painter Hubert Robert.* New York, Jacques Seligmann & Co.

83. *La Musique* (*The Musician*). Paris, Louvre. (Inscribed on the back of the canvas: 'Portrait de M. de la Bretèche, peint en une heure par M. Fragonard, en 1769')

84. *Le Chiffre d'Amour* (*The Souvenir*). London, Wallace Collection

85. *Le Lit d'apparat* (*The Gaudy Bed*). Drawing. Besançon, Museum

86. *Villa d'Este, Tivoli.* Drawing. Besançon, Museum

87. *Les Hazards heureux de l'escarpolette* (*The Swing*). London, Wallace Collection

88. *Bacchante.* Le Puy, Museum

89. *The Music Lesson.* Paris, Louvre

90. *Le Petit Parc* (*The Gardens of the Villa d'Este, Tivoli*). London, Wallace Collection

91. *In the Garden of the Villa d'Este.* Drawing. Besançon, Museum

92. *Les Lavandières* (*Washerwomen in an Italian Garden*). Amiens, Musée de Picardie

93. *An Italian Garden.* Drawing. Besançon, Museum

94. *La Chemise enlevée* (*Cupid stealing a Shirt*). Paris, Louvre

95. *Les Baigneuses* (*Bathing Women*). Paris, Louvre

96. *Satyrs Playing.* Two Etchings. Paris, Bibliothèque Nationale

## COLOUR PLATES

Chardin: *Self-Portrait.* 1775. Paris, Louvre (Frontispiece)

Fragonard: *The Clandestine Kiss.* Leningrad, Hermitage (facing p. vii)

La Tour: *Mlle Fel de l'Opéra.* 1757. St. Quentin, Museum (facing p. xiv)

Watteau: *La réunion champêtre* (*Garden Party*). Dresden, Gallery (facing p. 2)

## THE GONCOURT BROTHERS

Edmond de Goncourt. Etching by Jules de Goncourt. 1860 (facing p. vi)

Jules de Goncourt. Etching by Edmond de Goncourt. 1857 (facing p. vi)

Edmond and Jules de Goncourt. Lithograph by Paul Gavarni. 1853 (facing p. xv)

Edmond de Goncourt. Painting by Bracquemond. Paris, Louvre (facing p. 3)

# INDEX OF COLLECTIONS

AMIENS, Musée de Picardie
La Tour, 50
Fragonard, 92

BAYONNE, Musée Bonnat
Watteau, 8, 9

BERLIN, Kaiser Friedrich
Museum
Watteau, 7
Chardin, 65

BERLIN, Schlossmuseum
Watteau, 11, 13, 15–17

BESANÇON, Museum
Boucher, 34, 39, 40
Fragonard, 85, 86, 91, 93

BOSTON, Museum of Fine Arts
Greuze, 70

CHANTILLY, Musée Condé
Watteau, 1
Greuze, 76

EDINBURGH, National Gallery
of Scotland
Watteau, 24
Boucher, 45
Greuze, 69

EPINAL, Museum
La Tour, 56

GLASGOW, University, Hunterian Museum
Chardin, 64

LENINGRAD, Academy
Greuze, 75, 78, 79

LE PUY, Museum
Fragonard, 88

LONDON, Mr. G. Bellingham
Smith
Chardin, 66

LONDON, British Museum
Watteau, 22

LONDON, National Gallery
Chardin, 62, 63

LONDON, Wallace Collection
Watteau, 4–6, 23, 25, 27
Boucher, 38, 46
Greuze, 71, 74, 77
Fragonard, 84, 87, 90

LYON, Museum
Greuze, 72

MUNICH, Aeltere Pinakothek
Boucher, 43

NEW YORK, Metropolitan
Museum
Watteau, 3, 20

NEW YORK, Pierpont Morgan
Library
Watteau, 21, 28–9

NEW YORK, Jacques Seligmann
& Co.
Fragonard, 82

PARIS, M. Otto Edouard Bemberg
Boucher, 44

PARIS, Bibliothèque Nationale
Watteau, 30
Fragonard, 96

PARIS, Louvre
Watteau, 10, 12, 18–19, 26
Boucher, 31–2, 37
La Tour, 47, 51
Chardin, 57, 59, 68
Fragonard, 80, 83, 89, 94, 95

PARIS, M. Gaston Menier
Watteau, 14

PARIS, Petit Palais
Greuze, 73
Fragonard, 81

PARIS, Baron Henri de Roth-schild
La Tour, 55

RICHMOND, Cook Collection
Chardin, 58

ST. QUENTIN, Museum
La Tour, 48–9, 52–3

STEYNING (Sussex), Charles Clarke, Esq.
La Tour, 54

STOCKHOLM, National Museum
Boucher, 36, 41, 42
Chardin, 61, 67

VADUZ, Liechtenstein Gallery
Chardin, 60

VIENNA, Albertina
Boucher, 35

WARSAW, Collection of the State of Poland
Watteau, 2

UNKNOWN Collection
Boucher, 33